'This book's laser-sharp focus on the casenotes from one instance of colonial cruelty allows for a much more informed understanding of the wider issue. Whereas before the now highly valuable Benin Bronzes might have had us looking in the attic for some forgotten heirloom, perhaps now we are left examining our consciences.'

Tim Butcher, *Spectator*

'Persuasive... Phillips is scrupulously fair yet damning.'

Prospect

'Phillips has written a humane and thoughtful book, devoid of the sort of posturing that mars the debate over the repatriation of objects brought to the West during the colonial era.'

Wall Street Journal

'A balanced reconstruction of the Benin saga and probes the difficult choices facing European – and Nigerian – museums... Phillips excels at tracing the roundabout ways in which objects could find their way into museums.'

Times Literary Supplement

'Mr Phillips, a veteran British correspondent in Africa who knows Nigeria well, adds new and much-needed context to the story of the Edo empire and its bloody finale... [he] is clear-sighted about the political and financial obstacles that must still be overcome.'

Economist

'Well-balanced and highly readable.'

Peter Frankopan, *Air Mail*

'Compelling... It is balanced, sternly critical of the Brits when that is appropriate, but at the same time humane, reasonable, and ultimately optimistic.'

Evening Standard

'A comprehensive account... Phillips writes with ease and erudition, highlighting the many complexities that arise with each attempt at addressing this historical injustice.'

Alexander Herman, *The Art Newspaper*

'Timely, thoughtful and beautifully crafted… These are the kind of histories that change the way that we look at things we thought we knew – whilst shocking us at the things that we simply hadn't grasped.'

Gus Casely-Hayford, Director of V&A East and former Director of the Smithsonian National Museum of African Art

'Brilliant and evidenced-based… It is a highly recommended book that will thrill the reader to the last page.'

Dr Uyilawa Usuanlele, Associate Professor of African History, State University of New York

'This is a thoroughly researched, well written and timely contribution to the live debate about cultural restitution. Accessible yet nuanced… Barnaby takes us on a journey raising important questions about empire and the meaning of art, civilisation and culture.'

Clive Myrie, BBC Chief Correspondent and Presenter

'Phillips weaves a compelling and evocative narrative from the off, peopled by a cast that propels the story forward, sending the reader on a voyage of discovery that raises some very important questions indeed… accessible, packed with drama and utterly fascinating.'

All About History

'Rarely have books like *Loot* focused so in-depth on the perspectives of Africans. As *Loot* makes clear, whether in the form of Nollywood films or oral histories handed down across generations, Nigerians have had a lot to say about the Benin Bronzes.'

Art News

'Vivid, dramatic and colourful, *Loot* is a story of empire running amok.'

Kwasi Kwarteng, MP and author of *Ghosts of Empire*

ALSO BY BARNABY PHILLIPS

Another Man's War
The Story of a Burma Boy in Britain's Forgotten African Army

LOOT

Britain and the Benin Bronzes

BARNABY PHILLIPS

A Oneworld Book

First published by Oneworld Publications in 2021
This paperback edition published 2022

ISBN 978-0-86154-313-7
eISBN 978-1-78607-936-7

Typeset by Tetragon, London
Printed and bound in Great Britain by Clays Ltd, Elcograf S.p.A.

Plate section illustration credits: Ancient Benin line engraving © Granger/Bridgeman
Images. Men of war, human sacrifice illustration courtesy of Mark Walker. British
soldiers in the Oba's palace, British soldiers loading the spoils, Oba Ovonramwen on
board the *Ivy*, Chief Ologbosere, William Downing Webster, Oba Ovonramwen in
Calabar exile © The Trustees of the British Museum. Loot from the King's Palace ©
Look and Learn/Illustrated Papers Collection/Bridgeman Images. Admiral Rawson sketch
courtesy of Wikimedia Commons. British soldiers in blackface courtesy of the National
Army Museum. Benin flute man from *Le Monde Colonial Illustré* (1932). The Swainson
Horseman, from *Great Benin: Its Customs, Art and Horrors*, courtesy of Smithsonian
Libraries. Benin plaques on display © David Cliff/NurPhoto via Getty Images. The Ohly
Head © Woolley & Wallis. Mark Walker returns his bronzes © Kelvin Ikpea/AFP via
Getty Images. Enotie Ogbebor, contemporary bronze casters © Barnaby Phillips.

Oneworld Publications
10 Bloomsbury Street
London WC1B 3SR
England

To Emmeline and Mariella

CONTENTS

CLARIFICATIONS

1) The historic West African Kingdom of Benin is located in modern-day Nigeria, a former British colony. Benin City was, and is, at the heart of this kingdom. In 1975, Dahomey, a former French colony to the west of Nigeria, changed its name to Benin, in part because its coast lies on the Bight of Benin, and also because its government wanted a name that was ethnically neutral but evocative of past African glories. The territories of this Republic of Benin were only on the periphery of the historic Kingdom of Benin, and this country has no connection to the Benin Bronzes. Any references in this book to Benin are to the kingdom that is now in Nigeria, and not to the Francophone country next door, unless specifically mentioned as the Republic of Benin.

2) The cast metal sculptures of the Kingdom of Benin are referred to collectively as 'the Benin Bronzes', although most are made of brass and only a small proportion are bronze. The term 'Benin Bronze' is often used to include all the kingdom's treasures, including ivory carvings, such as the wonderful mask on the cover of this book.

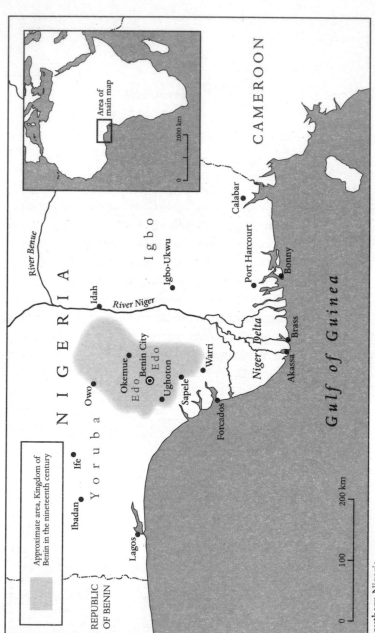

Southern Nigeria.

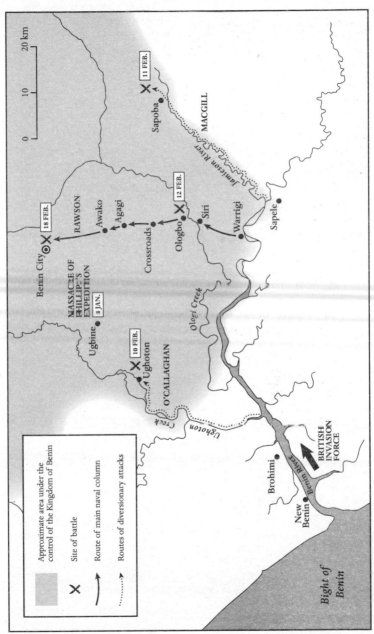

Benin, January–February 1897.

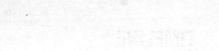

TIMELINE

c.900–c.1170 Ogiso dynasty rules Benin

c.1200 Beginning of Oba dynasty, Eweka I

c.1280 Oba Oguola. One tradition says bronze and brass casting in Benin begins during his reign

c.1440 Ewuare 'the Great' expands Benin's empire and builds inner city walls and moat

1486 First recorded European contact: Portuguese sailor João Afonso de Aveiro arrives in Benin City and is received by Oba Ozolua 'the Conqueror'

c.1504 Oba Esigie ascends throne. Benin is in a golden age of cultural and military power

1515 First Portuguese priests arrive in Benin

12 August 1553 An English fleet, under Thomas Wyndham, sails from Portsmouth for Benin

1593 Dutch ships arrive off Guinea coast

1719 Capuchin mission returns to Europe, marking unsuccessful end of pre-colonial attempts to convert the Edo to Christianity

1807 Britain abolishes slave trade in its empire

1837 Royal Navy seizes last Portuguese slaving ship in Benin River

1861 Lagos annexed as a British colony

1884–5 Berlin Conference. European powers agree the Niger Districts fall within Britain's sphere of influence

1885 Britain establishes protectorate on Niger coast

March 1892 Vice-Consul Henry Gallwey visits Benin. Oba Ovonramwen 'signs' treaty of British protection

1893 Oil Rivers Protectorate becomes Niger Coast Protectorate. British presence expands

February 1896 Ralph Moor appointed Consul-General of Niger Coast Protectorate

3 January 1897 Deputy Consul-General James Phillips and party arrive at Ughoton en route to Benin City, and ignore Ovonramwen's pleas to delay their visit

4 January 1897 Phillips's Expedition massacred at Ugbine

9 February 1897 British 'Punitive Expedition', under command of Admiral Harry Rawson, disembarks from Royal Navy ships and begins journey into Niger Delta

18 February 1897 Rawson takes Benin City. Ovonramwen flees. British find, and loot, the Benin Bronzes

21 February 1897 Fire sweeps through Benin City

May 1897 First auction of Benin Bronzes in London

June 1897 Celebrations of Queen Victoria's Diamond Jubilee

5 August 1897 Ovonramwen surrenders

15 September 1897 Ovonramwen sent into exile in Calabar

September 1897–January 1898 First Exhibition of Benin Bronzes in British Museum

28 June 1899 Chief Ologbosere executed by British after a brief trial, marking end of organised Edo resistance

1900 British create Protectorate of Southern Nigeria

13 September 1909 Sir Ralph Moor commits suicide in London, after which his widow hurriedly sells his two Queen Idia masks to a dealer in Chinese art

1 January 1914 Protectorates of Southern and Northern Nigeria merged to form Nigeria

14 January 1914 Ovonramwen dies in Calabar

July 1914 Ovonramwen's son Aiguobasimwin installed as Oba Eweka II, marking end of interregnum and restoration of Oba dynasty

February 1933 Eweka II dies and in April his son installed as Oba Akenzua II

1933 Chief Jacob Egharevba publishes *Ekhere Vb'Itan Edo* in Edo. In 1936 it comes out in English as *Short History of Benin*

December 1953 Benin Bronze head sold at Sotheby's in London for £5,500

March 1957 Nigeria's National Museum opens in Lagos

1 October 1960 Nigerian independence

December 1968 Benin Bronze head sold at Christie's in London for £21,000

22 April 1972 Kenneth Murray, founder of Nigeria's museums, killed in car crash en route to Benin City

July 1974 'Ingersoll Flute Man' aka 'Toochly-Poochly' sold at Sotheby's in London for £185,000

January–February 1977 Nigeria hosts FESTAC, Black and African Festival of Arts and Culture. British Museum refuses to lend its Queen Idia ivory mask

1978 Akenzua II succeeded by Oba Erediauwa

July 1989 Benin Bronze head sold at Christie's in London for £1,320,000

1997 Benin City commemorates centenary of British invasion

2007 Formation of Benin Dialogue Group, bringing together the Oba, Nigerian government and key European museums, including British Museum

May 2007 Benin Bronze head sold at Sotheby's in New York for $4,744,000

20 June 2014 Mark Walker returns two Benin Bronzes to Oba Erediauwa

2016 Benin Bronze Ohly Head sold for £10,000,000

October 2016 Erediauwa succeeded by Oba Ewuare II

March 2017 Prince Gregory Akenzua (uncle of the Oba) informs Benin Dialogue Group of plan to establish a Benin Royal Museum

28 November 2017 President Emmanuel Macron of France, in Burkina Faso, says European museums cannot hold on to Africa's cultural heritage

November 2018 Sarr-Savoy Report, commissioned by President Macron, says France should return 'objects taken by force or presumed to be acquired through inequitable conditions'

April 2021 Germany's government and museums announce that 'substantial' returns of Benin Bronzes will begin in 2022

October 2021 Jesus College Cambridge and Aberdeen University return their Benin Bronzes to Nigerian ownership

LIST OF ILLUSTRATIONS

Preface

RELATIVES BEHIND BARS

Walk across the British Museum's Great Court, through throngs of people and a babel of languages, down a stone staircase, and you will come to the darker and quieter gallery where Africa's treasures are kept. At one end of the gallery, a display of fifty-six brass plaques seems to float in front of a wall. The plaques are held in place by slim poles that run vertically behind. The intention is to suggest how they once decorated the pillars of a West African palace. They are cast in bas-relief, meaning they are three-dimensional, and on a relatively small space – about the size of an A3 sheet of paper – each one captures an abundance of exquisite detail: kings and courtiers, early European explorers, hunters and musicians, leopards and fish, rosettes and swords. The figures face outwards, on ceremonial display, their large heads slightly disproportionate to their bodies. The plaques are some 500 years old, and depict the stories and beliefs of a civilisation that traces its origins at least another 500 years further back in time. They come from Benin, in modern-day Nigeria. They were looted from the palace of the King of Benin, the Oba, in 1897, by British soldiers and sailors, who also took thousands of other objects, including statues, commemorative heads and ivory carvings.

On a spring day in 2017, a prince from Benin and a curator sat on a wooden bench side-by-side, looking up at the plaques.[1] For a long time

they sat in silence. Neither is an openly demonstrative person, but both knew this was a significant moment. Julie Hudson has spent more than twenty years in the African galleries of the British Museum, and is well versed in the controversies around the collection she curates. Prince Gregory Akenzua, who was a few months from his eightieth birthday, is the great-grandson of the Oba who was overthrown by the British in 1897. He has been tasked by the current Oba, his nephew, with ensuring the return of at least some of the kingdom's treasures.

They gazed at the display. The British Museum's subtle lighting of the plaques, warm and angled, highlights the relief and shade on each one. The word 'brass' may evoke a shiny, even tacky quality, but some of these plaques are gunmetal grey, and others – encrusted in fine red dust – have more of the rich hue of copper. Art historians and archaeologists debate if this coating of dust was a deliberate aesthetic effect, or is simply a result of the passing of time. Either way, in a twenty-first-century museum gallery in London, the red dust seems to emphasise the distance from an ancient West African forest kingdom.

Prince Akenzua is a professor of paediatrics as well as royalty. He is tall, very dark skinned, a man of aristocratic bearing. Back home in Benin City, when visitors come to his house they fall on their knees in front of him, and even in London he carries some of that authority. He has been coming to England for many years; he has children and grandchildren here, whom he visits regularly. But, as he told Julie Hudson, he had always avoided the British Museum. Now, in his new role as the Oba's special envoy, he felt he had to overcome his reticence. When he eventually spoke, still sitting on that bench, he talked of his people's pain, and trauma, and loss, and Julie listened in silence.

Later, Julie took Prince Akenzua into the 'stores', the vaults where the British Museum keeps the majority of its collection, unseen by the ordinary visitor. It was her idea, and he agreed. The British Museum has about 950 Benin Bronzes that were taken in 1897, but, including the plaques, it only displays around 100. Julie and Prince Akenzua were joined on this journey into the museum's hidden bowels by Prince Akenzua's son-in-law, a man called Enotie Ogbebor. Enotie is in his early fifties but

looks younger. He is an artist, confident and charming, and shares his father-in-law's good looks. He too is part of the team from Benin working on a plan for the return of the Benin Bronzes. In the British Museum's stores, Enotie felt overwhelmed. 'So many things in these foreign places,' he said later. He was upset, angry, but also, he had to admit, relieved to see how well looked after Benin's treasures were – everything neatly stacked and catalogued. Julie recalls that Prince Akenzua and Enotie were complimentary about the care the British Museum takes even over objects that the public rarely sees. They dwelled over specific ones, they discussed them, and Julie learnt new information about pieces she had studied for much of her professional life. 'Their engagement was striking. They took a lot of time, they were moved,' she said.

A few months later, another Benin artist, Victor Ehikhamenor, stood in front of those same plaques in the British Museum. He had come to London to open an exhibition of his work in a West End gallery. Victor's art is difficult to define. He paints, he works with fabrics, he takes photographs, he produces large pieces of installation art. For his London exhibition he displayed a series of patterns on paper made from thousands of tiny perforations, and mythical and historic figures made from rosary beads sewn onto lace textile. Many pieces explicitly referenced the 1897 British invasion of Benin.

Victor was in demand, riding a wave of international interest in contemporary African art and well known to leading London dealers.[2] Earlier in 2017, at the Venice Biennale, he caused a stir with a verbal attack on the British artist Damien Hirst, whom he felt had tried to pass off a new sculpture as original although it bore a close resemblance to an historic piece from Nigeria. Hirst said he had acknowledged that his inspiration came from Nigeria, but Victor accused him of exploitation and saw uncomfortable echoes of previous thefts of Nigerian treasures, above all the Benin Bronzes.[3] The dispute was picked up by British and American newspapers and widely commented on back in Nigeria. Victor is not a person afraid to speak his mind.

In the November darkness, Victor walked from his Bloomsbury hotel across Russell Square and into the British Museum. He stared at the

plaques. When I asked him how he had felt at that moment, he paused for a long time. It had not been easy for him to go to the museum. 'I was proud, I was very proud to have seen the mastery of the work of my forefathers. They were the finest, they were classical, even if their identity is not properly documented.'[4] But his culture felt diminished and out of context. What did the visitors who ambled by know or care of Benin and its Oba? He didn't like the way the plaques were displayed on poles. In an article he wrote for the *New York Times*, he said they were suspended like 'washed old underwear left to dry in the wind'.[5]

To the left of the plaques, the British Museum displays more Benin pieces in glass cases. Among these is perhaps the most famous of all Benin's artwork: an ivory mask (see cover photo), believed to depict Queen Idia, the mother of the sixteenth-century Oba Esigie. It's a small thing, only some twenty-three centimetres long, but I can't look at it without feeling moved. The queen's eyes are dark, inset with iron pupils and lids of bronze, making a lovely contrast with the aged ivory. She has a haunting feminine beauty. Her hair, in a humorous touch, is crowned by a tiara of ten miniature bearded Portuguese heads, inlaid with copper wire. The symbolism suggests an alliance between Benin and Portugal, and maybe what Benin perceived as its supremacy in that relationship.[6] I feel she exudes sadness, but perhaps this feeling comes from my knowledge of the mask's story as much as its aesthetics. For this mask was also plundered by the British in 1897, one of five similar ones often said to have been taken from a chest in the Oba's bedchamber. In the 1970s, Nigeria asked to borrow the Queen Idia mask to display at a major international festival celebrating African arts and culture. The British Museum refused, saying its conservation could not be guaranteed.[7] This still causes hurt and anger in Nigeria today. When Victor looked at Queen Idia, he felt he was 'visiting a relative behind bars. And you know your relative is innocent.' He spoke of her as if she was a living thing; he wanted to tell her 'I'm proud of you for holding up', but afterwards he felt 'heart-broken, angry, all those emotions'.

★

The British Museum is often characterised, not entirely without reason, as a closed and defensive institution. But after that first visit, Prince Akenzua and Enotie were given a standing invitation from Julie Hudson to return and see any part of its Benin collection, and they both did so. They felt they were always treated respectfully. They also believed an ongoing dialogue between the Kingdom of Benin and a group of Europe's leading museums with Benin Bronze collections was bearing fruit. 'I think their mindset is changing,' Enotie told me. These included museums from Austria, Germany, the Netherlands and Sweden, but the British Museum was the most important. This was in part because it had more – and arguably more important – pieces from Benin and received more visitors than the others. But also, after all, it was the British who took the treasures back in 1897. The British Museum has often stressed its autonomy from the British government, but it's not a distinction the rest of the world has always taken on board.

The European museums and the Benin Kingdom, joined for its part by the Nigerian government, have been meeting since 2007 in what they call the Benin Dialogue Group. Benin City, the capital of the kingdom, is in Edo State, one of thirty-six states which comprise the Nigerian federation. The people who live there are also known as Edo, and although the hereditary Oba is still venerated as a spiritual leader, it is the elected state governor who controls the budget and has more political power. In 2017, Prince Akenzua, speaking on behalf of the Oba, and with the support of the Governor of Edo State, Godwin Obaseki, made an offer to the Benin Dialogue Group: they would build a 'Royal Museum' in Benin City.

From there, an outline of a compromise emerged. The European museums would give this new museum some 300 Benin Bronzes. Initially, they talked of loaning these for a few years each, instead of permanent returns. The idea was that if all the European museums co-operated, the practical effect would be, in Prince Akenzua's words, a 'permanent display in rotation' of Benin City's long-lost treasures. 'I would be very, very happy that the people, the young generation, could see the achievements of their ancestors,' he told me. But it was a difficult compromise

for some to accept. Victor Ehikhamenor was blunt; the lending back of stolen objects was an insult. 'We shouldn't have to ask, over and over, to get back what is ours.'[8]

This is the story of the Benin Bronzes; of who made them and why, what they say about African history, and of how Europeans interacted with them and Benin's Obas for many centuries. It's also the story of how they were taken in 1897, what happened to them next and whether they should now be returned. It's a dramatic and tragic tale, but it's much more than that. It's a story about the way the meaning and value of objects changes over time, and of how the Western world, and especially its museums, is struggling to respond to changing assessments of the past. For Benin City and the Edo people, indeed for Nigerians and people of African descent as a whole, this is a story about the quest for restitution after an historical injustice. This cry, barely heard in Britain and Europe for many decades, has grown louder and more insistent. In the summer of 2020, as people in cities and towns across Britain protested against racial injustice and statues of slavers came down, it seemed more urgent than ever. On a personal level, as a British person enriched by years lived in Nigeria, I wrote this book with an urge to understand, and cast light on, one of the ugliest episodes in British colonialism.

Some argue that the return of the Benin Bronzes would not just be a source of pride in the past, as Prince Akenzua had told me, but would help inspire a new generation of Nigerians. 'If there was an opportunity to get these objects back,' says Enotie, 'so that people could see what their illustrious forebears were able to achieve, and to understand that we're a proud civilisation that has been sustained for over 1,000 years, then I think people will sit up and strive for what is better in the present day.' But hidden in that very hope is a tacit admission that much has gone wrong in Nigeria in recent decades. For this is also a story about past failures and disappointments, and whether Nigeria is doomed to repeat them. The success, or otherwise, of current efforts to return at least some of the Benin Bronzes will have a significance way beyond

the world of museums, or even Britain and Nigeria. They could be a harbinger of a more equitable relationship, at last, between Africa and the countries which colonised it. And, on both sides, a more honest understanding of the past.

THE CLOSER ONE GETS TO BENIN, THE FARTHER AWAY IT IS

They wave their arms in the direction of the palace, wailing and shouting. There are some fifty of them, men and women standing in separate groups, dressed in traditional robes. They have travelled to the palace from surrounding villages as supplicants, hoping the Oba will hear their case. They could have gone to the law courts, but they prefer to come here, for they revere the Oba. Perhaps they want him to mediate in a family feud, or a dispute between neighbours over a piece of land, or an issue of traditional protocol – whether such and such a person may conduct a ceremony even if they are not a chief. But for now, they must wait. They are held back by a fence. On the other side, guards look on indifferently, rifles hanging at their feet. Palace chiefs, distinguished by their white robes and orange-red coral necklaces, lounge in the shade by the entrance of the two-storey neoclassical building. They can hear the cries – they look up each time these reach a crescendo of distress – but they make no effort to be helpful.

As a distinguished historian of Benin, Philip Igbafe, put it, 'there is much that is old in the New Benin'.[1] The old chieftaincy titles are still used, the old ceremonies and customs still practised. People pray in church in the morning, but they take care to worship at ancestral shrines

in the evening. The palace compound sits in the very centre of the city, just as it always has done, six roads converging on the adjacent King's Square from the different points of the compass. The metal gates to the palace are silver-coloured, decorated with motifs of elephant heads, eagles and the faces of elegant queens. Palace wards, or perhaps just young men who pretend to be, hover by these gates. They whisper of special access and a guaranteed appointment with an important person within, as others might do outside a Nigerian airport, or a government ministry, or a telecoms office. They explain with sincere faces that there is a pain-free shortcut on offer, but it will cost a small fee.

When the Oba is ready, he will listen sympathetically to the stories of his subjects, pronounce judgment, and they will accept his verdict. *À dàá nọ́bá ọ̀ ọ̀rè ifuẹ̀rò óghé árrè mwá*; 'The fear of the King is the wisdom of our culture.' So I'm told by Patrick Oronsaye, a genial man in his sixties, whom I meet one Sunday morning in Benin City.[2] He is an artist, an historian and a philanthropist. He is also royalty; like Prince Gregory Akenzua, he is a great-grandson of Ovonramwen, the Oba overthrown by the British in 1897. When Patrick speaks of Benin's history, he gets animated. Names and dates and anecdotes tumble out in quick succession, a dense tangle of local and Western cultural references. It's hard to keep track, all the more so because of the interruptions from Vivaldi's *Four Seasons*, the ring tone on his ever-buzzing mobile phone. His history is littered with phrases of communal lore illustrating the Oba's tight hold over Benin society. *Òhá i gú óghiọnbá*; 'There is no hiding place for the Oba's enemy.' *Tá gà ọ̀bá, tá gówáàn ẹ̀bọ̀, tá rù ẹ̀rinmwì, tá rù ésù*; 'You worship the Oba, you placate a deity, you venerate the ancestors, and you appease the devil.' And instead of saying that an Oba has died, a Benin man prefers to talk in metaphors: *Ẹ̀kpẹ̀n vbìẹ́*; 'The Leopard is sleeping'; or *Òsórhùe bùúnrùn*; 'The White Chalk has broken'; or simply, *Òwẹ̀n dé òkún*; 'The sun has set.'

Benin City's traffic-clogged and potholed streets, its hazy polluted air, its sprawl and red-rust metal roofs don't always evoke past glories. I first visited twenty years ago, to see its famed earth wall, which dates to the thirteenth century and rings the city with a circumference of some eleven kilometres. Archaeologists have measured a height of more than

seventeen metres from its top to the bottom of the adjacent moat.[3] It is compelling evidence of how Benin's rulers could mobilise manpower; one archaeologist estimated that if the wall had been built in a single dry season, it would have required 5,000 men to work for ten hours each day.[4] It is listed as a Nigerian National Monument. Unfortunately, this offers no protection, as I discovered on that first trip. Rogue constructors dug away at the earthworks with impunity, looking for house-building material in the red, clayey sub-soil of the banks, and rubbish accumulated in the moat. Twenty years later, it was in an even more pitiful state. At a junction on the Sokponba Road, beneath a heaving market, the wall was obscured by five billboards celebrating evangelical churches. The pastors and their wives, in garish outfits, looked down from the posters with compassionate expressions. I ducked under the billboards, away from the shouts of the traders, the music, car horns and revving engines, and climbed gingerly up the earth bank, holding onto bushes for balance. The ground was coated with the slime of human excrement and plastic bags. When I reached the top I saw that the moat on the far side was full of sewage. Everything stank.

Benin's historic earth walls – today sadly neglected.

This degrading sight jarred with the picture Patrick Oronsaye was painting for me, of Benin as a society of intricate hierarchies and elaborate rituals, of old customs and beliefs rigidly adhered to. And yet Patrick also conceded that some traditions were under strain. We were meeting in the orphanage his mother had founded in 1951, and which he'd taken over upon her death. In the early days, Patrick explained, the typical child brought to the orphanage had a single mother who had died in childbirth. But after the economic downturn of the 1980s and 1990s, something changed. Parents started to abandon their own children. 'For the first time, the centre does not hold. The extended family concept has died. Every man for himself. People find children on the street and bring them to us,' said Patrick, pointing to a solemn little girl in a blue dress who had emerged from the gloomy building behind us. She was perhaps three years old and held tightly to Patrick's leg. 'Try telling her I'm not her father,' he said. She had been left with him when she was five days old. 'People are throwing away their children.'

Patrick Oronsaye, artist, historian and philanthropist, at his Benin City orphanage.

Patrick is a born raconteur. He could talk and talk, about the great Obas of the fifteenth and sixteenth centuries, the breadth and reach of the Benin Empire at its zenith, the art and culture of the court at its centre, its achievements and its cruelties, the forests and animals which surrounded it. But any conversation about Benin and history inevitably leads back to one fateful year, to a certain Vice-Consul Phillips brushing aside the warnings and marching into the forest, and to everything that followed. 1897. Before and after. 'A world turned upside down,' says Patrick. There is, he adds, another saying about Benin's history. *Èbò rhìa òtọ̀, rhìa úkhùnmwù kèvbè èmwí hìa rá*; 'The British man has spoilt the earth and he has spoilt the skies – he has ruined everything.'

If you walk from the Oba's palace, it might take you five minutes to reach Igun Street. Much depends on the traffic around Benin City's central roundabout – whether it fleetingly relents and you have the courage to plunge through the cars, buses and motorbikes, and ignore their urgent horns. At the turning for Sokponba Road, you'll pass a statue, erected in the 1980s. A Benin warrior, cast in dark metal and carrying a spear and shield, stands triumphant, a silhouette against the harsh bright sky. At his feet are strewn four British soldiers. Three are slumped and clutch their stomachs in agony, the fourth has collapsed and appears to be dead. The statue captures a moment of heroism from 1897, even if the invaders' uniforms and weapons appear more Second World War than late-Victorian. Asoro, the Oba's trusted warrior, is said to have fought valiantly at this spot, slaying the enemy until finally he too fell. From a crushing defeat, the statue seems to say, an eventual victory emerged. Benin did not die. Asoro's battle cry – *Sókpọ́nbá*; 'Only the Oba dare pass this spot' – has been immortalised with the naming of the Sokponba Road.

Igun Street, the next turning on the left, was there long before the British marched in. You enter through a red arch inscribed with the words 'Guild of Benin Bronze Casters, World Heritage Site'. The street runs ramrod straight, lined by modest single-storey clay houses. The casters and craftsmen display their wares on the front terraces; rows and rows

of twice life-size brass leopards, American bald eagles, Greek and Roman gods and mermaids, monstrously long brass tusks, shiny icons of Benin history glued onto wooden or red felt backgrounds, wooden giraffes and paintings of scantily dressed women. Christian, classical and Benin traditions are carelessly merged together. It's easy to be unkind about what Igun Street has become, and many are. Young artists in Benin or Lagos, and the more discerning expatriates in Lagos, dismiss most of its offerings as kitsch, 'tourist' or 'airport art'. One long-time American observer of Benin City likened the street to Tijuana.[5] Even Igun Street's claim to global recognition is dubious – when I checked the website of UNESCO, the body which awards World Heritage status, I was deflated to find no mention of it there.[6]

The miracle of Igun Street is not what is sold at the front of its humble stores, but what happens in the workshops and studios behind. On patches of broken land, surrounded by cast-offs and piles of breeze blocks, men sit on plastic chairs and wooden benches and work on their bronze and brass casting. They are the roughly 120 members of an exclusive guild – *Igun Eronmwon*.[7] They use skills learnt from their fathers, who in turn learnt from their fathers, and so on and so on, all the way back, they say, to the thirteenth century. A few of the families that make up *Igun Eronmwon* have moved to other parts of the city, but most remain on Igun Street, working as they've done for the past 800 years. Until very recently, this was an exclusively male craft; one prominent caster said that if a woman learnt the skills and then married there was a danger she would take her knowledge to her new family.[8]

They call their technique 'Lost Wax'. It was practised by the ancient Greeks and Romans, and across Europe during the Middle Ages and into the Renaissance, often referred to by its French term, *cire perdue*. But there is nothing inherently 'European' about Lost Wax. It was used in ancient Egypt, from Mesopotamia to the Indus Valley, in South-East Asia and in ancient China. It was used by the people of Central America before the arrival of Christopher Columbus. And in Sub-Saharan Africa, Lost Wax was used on Igun Street, in Benin City, before the first white man appeared.

It is a complex process that requires skill but allows for intricacy and detail. Imagine a member of *Igun Eronmwon* wished to make a ceremonial head of an Oba. He would begin by shaping a solid core of sandy clay with his hands, maybe using a wooden or metal file to refine it. Today, as in the past, the casters get their clay from the banks of the Ikpoba River, which runs through the north of Benin City. Once he has shaped the core into a rough form, he covers it in a thin layer of beeswax. Now he introduces detail, not just in sculpting facial features, but also, perhaps, by adding extra wax threads to make the beads of a headdress or the coral bead coat an Oba might wear. The wax must be soft enough to allow such detail, but hard enough to keep its shape. Next, the caster covers his wax model in finely grained clay. He is trying to ensure this outer covering takes a faithful impression of the wax beneath it. Then he adds a layer of heavier clay to the outside, while ensuring there is a small furrow through which the wax can escape. He dries the piece in the sun, and then bakes it in charcoal embers, until it reaches such a heat that he can pour away the melted wax.

Now the critical moment; the caster takes molten metal – bronze or brass – from a furnace and pours it into the mould left behind by the departed wax, filling every hollow and tiny crevice. If he has failed to heat the piece sufficiently, it may crack when he pours in the liquid metal, and he must throw everything away. Often the caster must wait for a tense half hour, as the piece cools. He may seek the blessing of Ogun, the patron divinity of craftsmen, spilling spirit on a shrine. Then he begins to prise away the clay exterior, in the hope of finding a perfect metal cast underneath.

Some things have changed. Traditionally, the members of *Igun Eronmwon* used bellows and human sweat as they toiled to heat their furnaces, whereas nowadays many use compressed air from air-conditioner motors.[9] The supply of metal ebbs and flows. In the late 1960s, as the Biafran War raged to the east, Benin City's casters revelled in a windfall of spent bullet cartridges.[10] Today, old engine parts are a staple source of raw material. Enterprising women deliver bags of discarded taps, valves and pipes. Dealers bring ship propellers on their trucks, salvaged

from the rusty hulks of the Niger Delta. For hundreds of years, the *Igun Eronmwon* guild worked for its one and only patron, the Oba. He provided security – slaves, money and other gifts – but little freedom. Now, members of the guild can sell their work to passing tourists, or hope that a hotel or bank will commission a monumental statue for a foyer, or that a wealthy man is looking for a metal design for his mansion gates. Or perhaps an evangelical pastor would like a giant pair of praying hands to decorate the exterior of his church.

Other things are much as they were. The successful caster has always been more than an artist; he must also be a master of pottery and metallurgy. The Lost Wax method is still laborious and unforgiving of shoddy shortcuts, poor raw material and bad craftsmanship. The caster can make only one piece from each wax mould. There are no replicas, no way to run off a few extra copies. Each piece, masterpiece or mediocre, is unique. These days, many people in Benin City and beyond complain that there is too much of the latter, not enough of the former. They criticise casters for being stuck in the past, unimaginatively churning out lacklustre imitations of their ancestors' work. A Lagos art dealer, his home a temple of refined taste in traditional and contemporary Nigerian sculpture, told me how saddened he was that members of the *Igun Eronmwon* guild spend all their efforts 'to replicate rather than using those skills to represent what is happening in their own time'.[11] But this is hardly surprising; Benin City's casters, like so many in Nigeria, are struggling to get by. They need food on their table before they can think of experimentation and creativity.

The Omodamwen family are pillars of the *Igun Eronmwon* guild. Phil Omodamwen, the head of his foundry, says his family have been casting for 500 years. An impressive but self-effacing man in his late forties, Phil has good connections with wealthy expatriates in Lagos and international art dealers. Many of his biggest pieces are commissioned from overseas. 'We have standards, the Omodamwen family,' he says. 'We're very careful with the materials we have.'[12] Phil has travelled to the United States, Belgium and France to exhibit his work. He has two children in private universities – 'with the help of God'. He employs fifty people and has a

Using skills learnt from their forefathers – the brass casters of Benin City.

gas-fired foundry to handle larger orders. And yet he says the future is precarious. Phil used to sell his work for good prices to foreign workers in Nigeria's oil capital, Port Harcourt, but kidnappings and insecurity in the Niger Delta have made journeys to that city increasingly dangerous. His own children are not interested in becoming casters, and he is not surprised that young people want to make their fortunes in other ways. 'I have cousins who left. They went across the Sahara Desert. They tried to cross the rough sea. Not all of them made it. Some are in Europe right now, maybe seeking asylum. The work here is very capital intensive. If you don't have good customers, you won't be encouraged to do more.'

The members of *Igun Eronmwon* have no formal training. They are not taught to sketch, they are not draughtsmen. They learn by watching and listening to their fathers and elders, and studying photographs of the celebrated pieces of Benin art. But just as they are criticised for rigidly adhering to traditional designs, they are also criticised for failing to attain the high standards of the past. Where, some have asked, is the sensuous

subtlety of their predecessors?[13] But this begs the question of where inspiration should come from. Today's casters can see only a small proportion of the old art, and rely on magazine and internet photographs to study their ancestors' greatest works. The canon of Benin's art, the encyclopaedia of its civilisation, was stolen, and is scattered across the globe.

According to one tradition in Benin's oral history, bronze and brass casting began in the time of Oba Oguola who ruled from about 1280. Oguola wanted his people to master a new craft, and asked the King, or Ooni, of Ife, some 200 kilometres to the north-west, to send him a brass caster. This man, still venerated by the *Igun Eronmwon* guild, was called Iguegbae.[14] Oguola instructed the casters to live at the current location of Igun Street, where they have remained ever since. Other oral traditions trace the origins of metal casting hundreds of years earlier.[15] If mythology suggests this culture was thriving long before the first Europeans came to Benin in the late fifteenth century, so does more tangible evidence. In 1938, in the town of Igbo-Ukwu, 170 kilometres to the east of Benin, a farmer called Isaiah Anozie was digging near his house when he discovered a series of sophisticated ceremonial bronze pieces which archaeologists dated to the ninth century. In the 1970s, archaeological digs in Benin City showed that metal casting was taking place in the thirteenth century.[16]

Bronze and brass are copper alloys. Bronze is made primarily of copper and tin, while brass is primarily copper and zinc. Both alloys are easier to cast with than pure copper, as they melt at a lower temperature. They are also harder and more resistant to corrosion. To a person seeking to make a weapon, or an object of beauty, bronze and brass offer a significant improvement on copper. People living around the lower stretches of the River Niger would probably have had access to copper and tin deposits, both of which are found within a few hundred kilometres. They were therefore in a position to make bronze.[17]

The origins of brass in this part of Africa are more mysterious, as there is no evidence of zinc production. And yet the magnificent brass heads of Ife, excavated in the early twentieth century and often compared

to the finest sculpture of ancient Greece and Rome, are believed to date from between the thirteenth and early fifteenth centuries, again before the first Europeans. This suggests that brass came to the region overland from the north, on a trans-Saharan trade route, perhaps originating in the Mediterranean, the Middle East or as far away as India.[18]

The Oba, in the words of historian Philip Igbafe, was 'the pivot around which everything revolved, the supreme religious as well as the civil authority'.[19] The *Igun Eronmwon* guild worked to command from the palace. 'Bronzes were produced and distributed only on the orders of the Oba and any other persons wishing to obtain a casting would have to apply through him,' wrote the British anthropologist Raymond Bradbury, who studied Edo society in the 1950s.[20] Some Edo historians say that a guild member risked execution by making a bronze or brass casting for anyone except the Oba. Pieces might be lent out to an important official, but would be returned on their death.[21]

Little wonder, then, that so much of Benin's historic art is dedicated to exulting the Oba, to affirming his power and mystique. Most famously, each Oba is commemorated with a brass head, or series of heads, one of Benin's defining artistic legacies and a tradition said to date from the fifteenth century. The Crown Prince was obliged to commission a head of the just-deceased Oba, to be placed on an altar inside the palace as the focus of ceremonies in honour of royal wisdom and authority. On brass staffs, the Oba stands atop an elephant. On ancestral altar pieces, he holds an *èbèn*, the fish-shaped ceremonial sword with which he dances to honour his ancestors.

The Oba is prominent on many of the hundreds of rectangular brass plaques which decorated his palace. He is often the largest figure in the middle of the plaque, cast in the highest relief, wearing the most elaborate headdress and robes, flanked by a pair of courtiers who support his arms, which are weighed down with regalia. Sometimes he is seated on a throne. He might be sacrificing a cow, or even a pair of leopards, a demonstration of his mystical powers. Or a plaque might record a specific moment of royal triumph, such as the Oba Esigie's famous victory over the neighbouring Igala in 1515.[22]

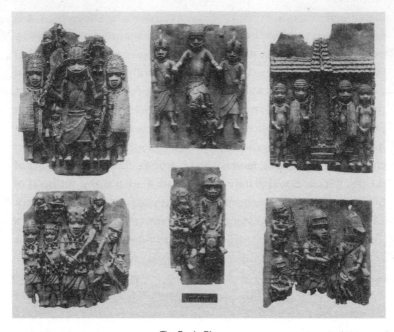

The Benin Plaques.

Benin's art features a glorious repertoire of other characters and animals. There are statues of horsemen and hunters, musicians and messengers, courtiers and dwarves. The leopard, the mudfish and the elephant, all emblems of the Oba, are depicted on stools, staffs, hip masks and vessels, as are rams, snakes, crocodiles and birds. Many of these pieces decorated the shrines and altars of the Obas of the past.[23] The human figures represent his retinue, the recurring animal figures various spiritual properties. The art reflects the Edo people's animist beliefs, that it wasn't only humans who possessed souls and spirits, but also animals and plants, even the earth and sky around them.

The people of Benin have a poetic saying: *À ghà sẹ Èdó, Èdó yèé rrèé*; 'The closer one gets to Benin, the farther away it is.'[24] The interpretation of its past is always in flux. The great twentieth-century historian of Benin, Chief Jacob Egharevba, writes, 'Many, many years ago, the

Binis [as the Edo were often called] came all the way from Egypt to found a more secure shelter in this part of the world.'[25] There are other mythologies, passed down in oral history. The youngest child of the High God Osanobua was sent to live in the world with his elder brothers. He sailed in a snail shell across the world looking for dry land, until a bird told him to pour sand from his shell, which created land and he thus founded Benin. Another more prosaic myth is that there were people living in the present location of Benin, and they needed a leader. They chose a prominent man, Igodo, who became the first Ogiso, or 'ruler of the sky'.[26] Igodo is said to have built a palace in what is now the heart of Benin City, and to have tried to bring some centralised control over the scattered communities in surrounding forests. The Ogisos, Benin's first royal dynasty, are believed to have ruled from approximately 900 to 1170. In this time, there were the initial stirrings of artistic expression, with the creation of guilds for wood and ivory carvers, and weavers. There were thirty-one Ogisos, but their authority fell apart under the last one, Owodo, whom Egharevba says was responsible for a long period 'of misrule, failure and anxiety'.[27]

The Obas – the second dynasty of Benin kings which would rule uninterrupted until 1897 – rose in the power vacuum that followed the fall of the Ogisos. According to one theory, it was the Kingdom of Ife which bestowed the new dynasty on Benin. The chiefs of Benin, tired of the anarchy of the late Ogiso period, sent a deputation to the King of Ife, the Ooni, asking him for a ruler. He sent his eldest son, Oranmiyan, who spent only a brief time in Benin but impregnated the beautiful daughter of a nobleman. The child, Eweka, would be the first Oba, and would enjoy a long and glorious reign.

An alternative theory reverses the primacy of Benin and Ife; this time it was the son of the last Ogiso, a prince called Ekaladerhan, who fled from Benin to Ife to escape his would-be executioners. Blessed with magical powers, he became king there. The chiefs of Benin sent a delegation asking him to return, but he said he was too old to travel and could not abandon his new kingdom. He offered his son in his place, but only if the chiefs could master a curious challenge – to domesticate seven lice for a

period of three years. This they did, having cultivated the lice on a slave's head. Suitably impressed, Ekaladerhan sent his son, Oranmiyan, to rule Benin. Oranmiyan's son was Eweka, the first Oba. In this way, the new dynasty was not an alien imposition, but a continuation of the old.[28] To an outsider, the credence given to one ancient myth over another might seem an unlikely cause of contemporary controversy. But in the fraught world of Nigerian politics, where ethnic groups thrown together during British colonialism compete for access to resources, the claim that one civilisation may be older, more sophisticated and therefore more legitimate than another is highly contentious. In the first years of the twenty-first century, a very public row erupted between rival traditional kings and intellectuals on the origins of Benin and Ife, which rumbles on to this day.[29]

There is nothing obvious about Benin's location that helps explain its rise. It is on a rolling plain, surrounded by thick forests. Inland from the sea, on neither lake nor river, it is not especially well placed to prosper from trade and communications. Its people have no tradition of exploiting by canoe the network of Niger Delta rivers to the south, let alone seafaring in the open waters of the Atlantic beyond. Predominantly farmers, they trade yams for fish with the neighbouring peoples who live closer to the coast and are more comfortable on the water – the Urhobo, Ijaw and Itsekiri. And yet, by the sixteenth century, when the name 'Benin' started to appear on European maps of Africa, the kingdom was in a golden age, not just of military power and territorial expansion, but also cultural wealth and artistic expression.

The period from the establishment of the Oba's dynasty, at the beginning of the thirteenth century, to the arrival of the Portuguese, at the end of the fifteenth century, was one of consolidation of royal authority. It was Eweka's son, Oba Ewedo, who compelled his chiefs to stand, not sit, in rows before him, a custom that served to emphasise his power and which would endure for centuries to come.[30] In the late twentieth century, an archaeologist in Benin, using radiocarbon dating, estimated that a mass grave of at least forty-one young women was from the thirteenth century. The bodies lay at the bottom of a shaft 12.5 metres deep; an apparent ritual sacrifice, a suggestion that Benin was a place of 'fear

and power'.[31] Ewedo is credited with giving his kingdom the name of Ubini, from which 'Benin' is thought to be a later, European derivation.[32]

Ewedo's son, Oba Oguola, began building trenches around Benin City. Archaeologists' estimates of the full extent of these earthworks have undergone a dramatic escalation in recent decades. They have mapped outer walls, some 145 kilometres of earthworks, which ring the inner city walls. But these pale into insignificance if we accept the conclusions of an eccentric and untiring British scholar, Dr Patrick Darling, who spent many months in the late 1960s and early 1970s hacking at the jungle and interviewing villagers in the countryside around Benin. Darling traced a dense network of earthworks which surrounded settlements in cellular patterns, known as *iya*. He estimated their total length was four to five times that of the Great Wall of China, and involved the removal of 100 times the amount of material contained in the Great Pyramid. The rainforests around Benin, wrote Darling, had 'brooded silently over the remains of the longest and most massive earth constructions yet known from the pre-mechanical era'.[33] Darling's theory was disputed by some but given an imprimatur of recognition with an entry in the *Guinness Book of Records*.

Darling attributed much of this construction to the Ogiso period but it is Oba Ewuare, whom Egharevba says ascended to the throne in about 1440, who is traditionally credited with building those mighty – but now sadly neglected – inner walls and moats. These, presumably, were defensive, but Ewuare 'the Great' is remembered as a warrior king, 'powerful, courageous and sagacious'.[34] How far did his power stretch? Egharevba's claim that Ewuare 'travelled over every part of [modern-day] Nigeria, Dahomey, Ghana, Guinea and the Congo' seems fanciful. But, more plausibly, his armies are credited with starting an impressive series of conquests closer to home; these would eventually extend to the west along the coast to Lagos and perhaps as far as Ouidah, to the north-west to the Yoruba towns of Ekiti, Akure and Owo, to the north-east into the Ishan area, and to the east, to the banks of the mighty River Niger.[35] This means Benin's influence may have spread over an area, from east to west, of some 600 kilometres, and, in places, some 150 kilometres to the north.

The frontiers ebbed and flowed, but at home Oba Ewuare was con-
structing something more permanent: a divine kingship to dominate
politics and religion. He established the principle of primogeniture
to stabilise the line of succession.[36] Ewuare tightened his control by
organising chiefs into associations and societies, and introduced new
ceremonies – including the annual sacrifice of a leopard – to enhance
the mystique and spiritual authority of royalty. To this day, the people
of Benin say *Ègbé Ẹ́wúarè à gìe Ọ̀bá sẹ́*; 'Ewuare is the yardstick by which
all other Obas of Benin are measured.'[37]

Ewuare not only fortified Benin, he also deliberately burnt it to the
ground in order to rebuild it on a grander scale. It began to be referred
to as a city, and it had a new name. Ewuare is said to have chosen 'Edo' in
honour of a slave who had saved him from execution after the treacher-
ous plotting of a chief.[38] The word is used not just as an ethnic term but
also to refer to the city and the language that is spoken there (although
Benin and Benin City are the commonly used terms internationally, and
are widely used in Nigeria as well). Ewuare built broad roads radiating
outwards from the palace at the centre of the city to his newly acquired
territories, emphasising its significance as the political and spiritual heart
of the kingdom.

Ewuare is credited with beginning the tradition of the casting of
commemorative heads of deceased Obas.[39] But there is another character
who starts to be represented on the Benin Bronzes soon after his reign,
and thereafter appears with intriguing regularity. He might be shown
as a small man, floating in pairs behind the Oba on a plaque, identified
by his pointy nose, beard and long, straight hair. With a feathered cap,
he can make for a comical, flighty figure, especially in comparison with
the Oba in the foreground staring out from his throne. On other plaques
he is alone, with a crossbow, hunting birds, or drinking from a flask, or
smoking a pipe. Most impressively, he is depicted in a series of statues,
between thirty to forty-three centimetres high, wearing sixteenth- or
seventeenth-century armour, firing a musket or crossbow.[40] He is the
European.

2

EASILY AS BIG AS THE TOWN OF HAARLEM
AND ENCLOSED BY A REMARKABLE WALL

The first recorded encounter between Benin and Europe was in 1486, when João Afonso de Aveiro, an emissary of the Portuguese king, arrived in Benin City, and paid his respects to Oba Ozolua with gifts of guns and coconuts. It was the beginning of a peaceful relationship between Obas and visiting European delegations which would last for more than 400 years. There would be differences between them, but pragmatism invariably prevailed; each had things the other wanted to buy. Dealings were usually cordial, in fact often friendly.

By the mid-1480s Portugal's brave and skilful seamen were on the verge of rounding the Cape and sailing on to India. They had been trading along the Bight of Benin for some years, penetrating the rivers of the Niger Delta, and had surely heard stories of the kingdom a short journey into the interior. João Afonso wanted pepper, as West African spices – the Malagetta (*Aframomum melegueta*) and Ashanti or Benin pepper (*Piper guineense*) – were much in demand in Europe, bringing pungent aromas and strong flavours to dull cuisine. But above all, he was looking for slaves. This was not yet for a transatlantic trade, but as part of a barter process along the West African coast; the Portuguese exchanged slaves they bought in the Bight of Benin for gold with the Fante people on the

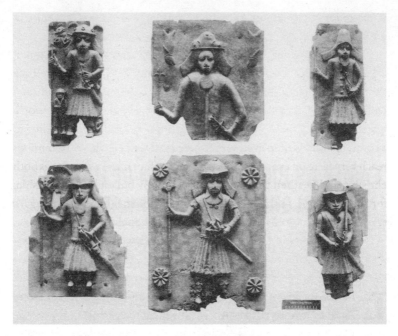

The European, as depicted on the Benin plaques.

Costa da Mina (what the English called the Gold Coast).[1] Indeed, the Niger Delta rivers to the south of Benin were already known as 'the slave rivers'.

Oba Ozolua, in the tradition of Ewuare, was a warrior king, known as 'the Conqueror'. According to Egharevba, he was 'respected at home and dreaded abroad. When he marched with drums and fifes against his enemies, the inhabitants of the towns and villages deserted their homes and fled into the bush at the sounds of his coming. In fact Benin became a terror to all other tribes in this part of West Africa and the Benin Empire became wonderfully enlarged.'[2] But the Portuguese encountered no hostility. The Oba agreed they should take back an ambassador from his people, and so a chief from the river port of Ughoton sailed to Lisbon to learn the language and customs of the fascinating newcomers. He was judged 'a man of good speech and natural wisdom' by the chronicler at the court of King João II and returned to Benin laden with gifts for his family and the Oba.[3] João's successor, King Manuel I, hosted two more

ambassadors from Benin, known as Dom Jorge and Dom Antonio, to whom he gave velvet capes and shoes, and camlet waistcoats.[4]

For both Africans and Europeans, these encounters were of political and economic, even religious, significance. The Edo associated the Portuguese with Olokun, the white-faced god who sent wealth and children from below the sea.[5] The Portuguese, for their part, were on a quest to find the mythical Christian king Prester John, who, according to a contemporary writer, lived somewhere in Africa and whose 'dominions reach very farre on every side; and hath under him many other Kings both christian and heathen that pay him tribute'.[6] By building a relationship, for the first time, with an African kingdom of the interior, Portugal's search for Prester John became that bit more hopeful.

The Portuguese, slavers though they may have been, were also out to save souls, and sent missionaries to convert the Oba and his people. Pacheco Pereira, who visited Benin four times in the 1490s, complained, 'The manner of life of these people is full of abuses, fetishes and idolatry.'[7] An Oba whose authority over his people depended on his own godlike status might not have welcomed Christian teachings, but there was a tempting quid pro quo. King Manuel, in a letter to the Oba in 1514, dangled the offer of a powerful new technology: 'For when we see that you have embraced the teachings of Christianity like a good and faithful Christian, there will be nothing in our realms with which we shall not be glad to favour you, whether it be arms or cannon and all other weapons of war for use against your enemies.'[8]

Thus a spiritual flirtation began. Portuguese priests arrived in Benin in 1515, the first of many European missions over the coming centuries. In Benin's oral history, they met the new Oba, Esigie, who allowed his son and several other young men to be baptised and taught to read and write. At least three churches are said to have been built at this time.[9] Nothing remains of them, but historians in Benin City point out their locations to interested visitors. Egharevba wrote that the Portuguese succeeded in baptising 'thousands'.[10]

In the meantime, it seems the Portuguese had kept their side of the bargain. In 1515, Oba Esigie was fighting a war of survival against

a local rival. The Attah of Idah, ruler of the Igala people, was a formidable enemy to the north, who, perhaps with the assistance of cavalry, forced Benin's army back to its city walls.[11] Disaster was narrowly averted, according to common lore, because the Portuguese stepped in with their guns. It was, Patrick Oronsaye told me, an intervention that 'changed the course of Benin's history'. Two white men – Ava and Uti – are said to have fired the weapons, with stunning effect. 'Noise, smoke, death at a great distance. The Idah army reeled back.'[12] It was a major victory; the Attah and his men were driven back across the River Niger, and Benin's hegemony expanded to the confluence of the Niger and Benue rivers.

The arrival of the Portuguese was also of profound cultural importance to Benin. It was a catalyst for artistic production. The Portuguese brought cargos of manillas – heavy bracelets, shaped like a horseshoe, made of copper, bronze or brass – as a currency of trade; a single ship could carry some 30,000.[13] The manillas were melted down by Benin's metal casters, raw material for thousands of Benin Bronze pieces which survive to this day. The sheer quantity of this influx gave impetus to an artistic tradition that was already established, and quickly made any trans-Saharan brass trade all but irrelevant.

The Portuguese had strange features, they wore unusual dress and they carried powerful weapons; all of these inspired Benin's artists. Other goods they brought with them – cowries and, especially, red coral beads – were incorporated into Benin's traditions and regalia. Benin's ivory carvers, who belonged to a separate, older guild, the *Igbesanmwan*, also responded to contact with the Portuguese, and produced pieces of astonishing beauty, enriched by a fascinating cross-cultural fertilisation. An intricate salt cellar depicts at its base four Portuguese men in dress from the 1520s to '40s, while a fifth rides in a boat above their heads, holding a telescope. The form is European, the style uniquely Edo.[14] The ivory sculptures also include the celebrated five pendant masks of Queen Idia, one of which so moved the artist Victor Ehikhamenor on his visit to the British Museum. She is also gloriously commemorated in metal, a rare female representation in Benin art, for the Oba's wives, said to number

between 600 and 4,000, and tended by eunuchs and young girls, lived a life of seclusion in the palace.[15]

The Portuguese legacy lives on. They came to be known in the Edo language as *Ìkpòtòkí*. The coconuts they introduced to Benin – *coqueiro* in Portuguese – are known as *èkòkódìa* in Edo. The Portuguese for ball, *bola*, is *ibǫ̀lù* in Edo. And warehouse, *armazém* in Portuguese, is *amagezemi*.[16] But trade with Benin came at a high price. João Afonso de Aveiro earned his place in Edo mythology with that initial journey of 1486, but Benin ultimately cost him his life, just as it did for so many Europeans who followed. He fell ill with fever on a return journey and died in Ughoton. According to Egharevba, he was buried in Benin City, and his death provoked great lamentations. Pacheco Pereira, in the 1490s, complained that 'all these rivers are very unhealthy because of the fever, which does grievous harm to us white men'.[17] The most common cause of death was malaria, and it would be another 350 years before Europeans developed effective ideas on how to avoid it. Already, the West African coast was acquiring its deserved reputation as 'the White Man's Grave'.

Benin in the sixteenth century was at the height of its power, the royal court a place of pomp and ritual, and there were limits to Portugal's influence. The Portuguese offered fine cloths, but Benin already had these in abundance. In 1538, King João III sent a second group of missionaries. These three men wrote a letter home, detailing their frustrations. They had been allowed to present a cross and statue of the Virgin Mary to the Oba, but he had since refused to see them and they were prevented from returning to the palace. The Oba partook, they complained, in 'superstitions, abominations and errors'.[18] Most grievous of these was human sacrifice, the first European reference to a practice in Benin City which would eventually assume a fateful significance. After a year of frustration and sickness in Benin, the missionaries were refused permission by the Oba to return to Portugal, and their final fate is unknown.

Nor does it seem Benin entered the slave trade with any great enthusiasm. There is an Edo saying: *Vbǫ̀ dá ǫbá nǫ̀ ná mù ǫ̀vìẹn khiẹn?*; 'What does the Oba lack that he would need to sell his slaves?' Benin was victorious in war, and presumably had many captives. The Portuguese paid for slaves

with manillas. In the first years of the sixteenth century, Pacheco Pereira wrote that a slave from Benin cost between twelve and fifteen manillas. By 1517, the price had risen to fifty-seven manillas, and Portugal's need for the bracelets rose accordingly. In 1548, a German merchant house agreed to supply Portugal with 432 tons of brass manillas for the West African market.[19]

The Obas' apparent reluctance to sell male slaves in the early years of European contact is indicative of their wealth and confidence. Perhaps, historians suggest, he and his chiefs had more use for them at home. Patrick Oronsaye draws a careful distinction on attitudes in Benin towards slaves: 'Slave trading was not part of our culture. Slavery was part of our tradition.'

The story of England and Benin begins on 12 August 1553, when a little fleet set out from Portsmouth, hoping to return from West Africa laden with pepper. The three ships, the *Lion*, the *Primrose* and the *Moon*, were 'well furnished…with men of the lustiest sort, to the number of seven score', according to a contemporary writer.[20] These included a teenage Martin Frobisher, later a famous explorer of the North-West Passage and hero of the defeat of the Spanish Armada. The expedition had two leaders: a naval officer from Norfolk called Thomas Wyndham, and a Portuguese knight, Antonio Anes Pinteado, who was fleeing enemies at home and presumably invited to bring Iberian expertise on a journey never before attempted by English ships. He was described as 'a wise, discreet and sober man', much respected for his knowledge of sailing.[21]

The fleet reached the Gold Coast – location of present-day Ghana – but Wyndham wanted to push on to Benin, where he was convinced he could buy a profitable crop of pepper. Pinteado, who may have feared the consequences of being captured on an English ship by his fellow countrymen, warned that it was too late in the season to carry on, and that the sailors would succumb to a smothering heat 'of such putrifying qualitie, that it rotted the coates of their backs'. Wyndham was having none of it. He cursed Pinteado as a 'whoreson Iew [Jew]' and threatened

to cut off his ears and nail them to the mast.[22] Pinteado, intimidated and against his better judgement, led the fleet eastwards.

What did those intrepid sailors in their wooden ships see as they approached the coastline near Benin? As one historian put it, 'a vague grey line pencilled in between an immensity of sea and sky', a dangerous surf-pounded beach, and the occasional river leading into a maze of mangrove swamps and creeks.[23] And beyond that, impenetrable forests and fever. The mouth of the Benin River is some three kilometres wide, but an underwater sand bar makes it too shallow for larger ships to proceed upstream.[24] Wyndham stayed with the *Lion* and the *Primrose* in open waters, while Pinteado took the smaller *Moon* over the bar, and into the mangroves and brackish creeks. He reached Ughoton and set off on the forty-kilometre north-easterly trek through forest to Benin City, where he was brought into the presence of the king, who sat in a great hall, long and wide, thronged with people.[25] This king, Oba Orhogbua, was treated with respect, even fear, by his people:

> When his noble men are in his presence, they never looke him
> in the face, but sit cowring...with their elbowes upon their
> knees, and their hands before their faces, not looking up until
> the king command them...Likewise when they depart from
> him, they turn not their backs toward him, but goe creeping
> backward with like reverence.[26]

Oba Orhogbua and his visitors were able to communicate, for he was the son of Oba Esigie who had been baptised by the Portuguese as a child, and taught to speak, read and write their language.[27] The meetings could hardly have been warmer; Orhogbua showed great 'gentleness' to the delegation, and offered them credit if their merchandise was not equal to the value of the pepper he was happy to sell them.

It could have been the beginning of a long and fruitful relationship, but at this point things went very wrong. While Pinteado waited for the Oba's men to collect pepper from the surrounding countryside, sickness – perhaps yellow fever – swept through the ships back at the

river mouth. Some four to five of Wyndham's men were dying every day. He wrote to Pinteado, demanding his return. Then, in a panicked rage, Wyndham smashed up Pinteado's cabin, destroyed his instruments and plundered his food and water supplies. By the time Pinteado made it back Wyndham was dead and the surviving sailors in a state of volatile fear. They sunk the *Lion* as they no longer had enough men to sail her. Pinteado argued they should wait for their companions who were still in Benin, but the sailors attacked him and forced him to set off for England with the remaining two ships. One week into the return journey, he too died, later mourned as 'a man worthy to serve any prince, and most vilely used'. The *Moon* and the *Primrose* limped home, more than two-thirds of the original crew dead and the fever still not spent. 'And of seven score men came home to Plimmouth scarcely forty, and of them many died.'[28]

The next recorded English journey to Benin took place at the end of 1588, just weeks after the defeat of the Spanish Armada. The *Richard of Arundell* was sent by two London merchants, John Newton and John Bird, carrying linen, wool, ironwork, copper bracelets, glass beads and coral, to be traded primarily for pepper and ivory. Once again, the delegation was well received by the Oba. This was Ehengbuda, the eldest son of Orhogbua, who was intrigued by the gift of a telescope from James Welsh, the ship's master. Welsh seems to have enjoyed his time in Benin. He feasted on fruits, honey, palm wine and yams, washed in a soap that evoked the smell of violets, and admired fine mats, baskets and ivory carving. The Englishmen observed that 'the people are very gentle and loving, and they goe naked both men and women untill they be married, and then they goe covered from the middle downe to the knees'.[29] The ship's chief factor, Anthony Ingram, wrote that the Oba provided 200 men to help the visitors on their journey from Ughoton to what he called the 'great Citie of Benin'.[30]

Unfortunately, once again, warm hospitality was no defence against the dreaded fever. As the English waited for the pepper and ivory to arrive from the fields and forests, they started to succumb one by one. The captain died, and so did the carpenter, the cooper, two merchants and several more, including William Bird, son of John Bird. The remainder

decided to leave, and staggered back to their ship deathly weak. More perished on the journey home. The survivors returned to London a year after their departure, grateful to have met a friendly captain at the Azores who had loaned them six able-bodied sailors.

For all the suffering of its crew, the *Richard of Arundell* had brought to England a promising cargo of pepper and ivory, and only one year later, Bird and Newton sent it back to Benin on a quest for more. James Welsh was still the master, and his account of this second voyage, which began in September 1590, suggests a successful mission. The *Richard of Arundell* spent three months at the mouth of the Benin River, receiving successive deliveries from the interior. 'This voyage was more comfortable than the first,' wrote Welsh, 'because we had good store of fresh water, and that very sweet...[and]...wee did kill great store of small Dolphines, and many other good fishes.'[31] On 18 December 1591, the ship anchored at Limehouse on the Thames. On that short winter's day, the sailors unloaded their exotic cargo – 589 sacks of pepper, 150 elephant tusks and thirty-two barrels of palm oil – onto the quayside. Elisabethan England had a glimpse of the wealth of a far-off African kingdom.

The oral histories of Benin portray a kingdom whose power waxes and wanes in the centuries that follow these first contacts with Europeans. Oba Esigie, who bestrode Benin's golden age of the sixteenth century, is said by the historian Egharevba to have 'lived to a great age and died peacefully after a long reign'.[32] In the decades following Esigie's death, Benin was still a major power, establishing the settlement of Eko as a garrison on the western frontiers of its empire. Eko subsequently grew into what we know today as the megacity of Lagos, and the Edo people are fond of saying, a little tongue-in-cheek, that 'Lagos belongs to Benin'. But for much of the seventeenth century, Benin appears to have been in decline. The Obas' reigns were short, and beset by wars of succession and power struggles with chiefs. In the eighteenth century, there was a revival of the Obas' authority, and with that a resurgence of Benin's brass casting and ivory carving. This was followed by a second decline in the nineteenth century, during which the Obas were again undermined by internal instability and succession disputes.

Throughout the centuries, European visitors to Benin left written accounts that complement, but sometimes contradict, the oral histories of the Edo and their artistic legacy. The Portuguese came first, and theirs was the enduring influence, but just as the power of West African kingdoms fluctuated, so did that of their European counterparts. Over time the Portuguese would be supplanted as Benin's main trading partners by the Dutch, then the French and, finally, the British.

The first Dutch ships arrived off the Guinea coast in 1593, and within a few years had established a trading relationship with Benin which excluded their European rivals.[33] A Dutch eyewitness, thought to be Dierick Ruiters, has given a vivid account of Benin City at the beginning of the seventeenth century. It was protected by bulwarks, wooden gates and permanent guards, and had 'a great broad street, not paved, which seemeth to be seven or eight times broader than the Warmoes street in Amsterdam'.[34] The Oba's palace was 'of vast Extent…It is so large, that you can feel no End; for when you have walked till you are tired…you see another Gate, opening into a larger Square.'[35] The people are 'sincere, inoffensive', and foreigners, under constant supervision, should feel safe, not least because any person who injured them 'is executed, their body cut into four parts and left to the wild beasts'. The Oba parades through the city twice a year, when 'he displays all his Grandeur, appearing attended with above six hundred Wives, though not all are legitimate'.[36]

Olfert Dapper, an Amsterdam doctor of medicine, did not travel to Africa but wrote a description of Benin City based on second-hand sources, which was published in 1668. Dapper wrote that Benin had 'thirty very straight broad streets, each about 120 feet wide'. The houses were single-storey but handsome and large. As for Benin's royal quarters, they were 'easily as big as the town of Haarlem and enclosed by a remarkable wall…[with] beautiful long galleries about as big as the Exchange at Amsterdam'. One of these galleries, resting on wooden pillars, was 'decorated from top to bottom with cast copper, which depict deeds of war and battle scenes'.[37] Houses in the court were adorned with pyramidal towers, each decorated with life-like metal birds. Dapper's engraving shows the Oba riding on horseback out of the city, surrounded

by courtiers and warriors. Men parade chained leopards at the front of the procession. Behind them musicians play tambourines, drums and pipes. Cavalry bring up the rear. Dapper says the Oba could raise 20,000 well-disciplined soldiers in a single day, and in times of crisis as many as 80,000 to 100,000.

Dapper's description, and an accompanying engraving, have come to define pre-colonial African greatness, powerfully rebutting the idea that the continent's history before the European takeover was no more than, in Hugh Trevor-Roper's cutting phrase, 'the unedifying gyrations of barbarous tribes'.[38] Can we trust Dapper, given he is collating the memories of others? Some of his details arouse scepticism; his engraving depicts Benin City as being surrounded by hills, which it is not (see illustration section). But overall, he presents a stunning description of a confident city-state, a place of artistic achievement and military power.

David Van Nyendael, an official of the Dutch West India Company visited Benin in 1700, and left a less flattering impression. Many houses were abandoned. 'Benin scarcely deserves the name of a city,' he wrote.[39] The soldiers were ill-disciplined and cowardly. But he also described a rich and powerful Oba, and gave a glimpse of Benin's cultural wealth; inside the palace he saw 'eleven Mens Heads cast in Copper...and on each Head was an Elephant's Tooth', as well as beautifully cast 'copper snakes' decorating the walls. Van Nyendael secured an audience with the Oba, whom he says was aged about forty, affable, and surrounded by fine tapestry and carved tusks. He was allowed to approach within eight or ten paces. But the Oba had become reclusive; in a city which had 'as many Festivals as the Church of Rome', he only appeared in public once a year, for the largest festival, which Van Nyendael called the Coral Feast.[40] From this point on, European accounts tended to portray the Oba as a secretive, mysterious figure, a very different ruler to the 'Warrior King' of earlier centuries. He was secluded in his palace with hundreds of courtiers and his vast harem, and only stepped outside for the most important ceremonies.

Christian missionaries, meanwhile, struggled on. In 1651, a Capuchin mission of some fifteen Spanish priests and friars, led by Father Angel of

Valencia, set off from Cadiz for Benin.[41] Three died soon after landing at Ughoton. Others had initial friendly encounters with the Oba, conducted through an interpreter who spoke Portuguese, but the subsequent months proved frustrating. The Oba refused to see them again. Nobody would teach them the Edo language. Eventually, one of the priests wrote later, they managed to enter the Oba's palace during a ceremony in which he presided over the sacrifice of five people. They thrust their way forward 'into the middle of the courtyard and began speaking aloud to the king and chiefs of the evil they were doing...that the devil whom they served was deceiving them'.[42] They were ejected 'with great violence' by the furious crowd, and forced to leave Benin. Later they learnt that the Oba's reticence to engage with them might have been because he had heard an oracle, warning that a King of Benin would die at the hands of a European.[43]

In 1692, writes Egharevba, a further mission to Benin sent by Pope Innocent XII, led by a Father Angelus, found the original Portuguese churches in 'a deplorable condition'.[44] Both Christians and the *Ohensa*, the indigenous clergy which traced its origins back to the first Portuguese missionaries, had lapsed back into idolatry and churches had become pagan shrines. In the early eighteenth century another Capuchin mission ended in failure, an Italian priest complaining he was abandoning Benin after three years because its people 'were most obstinate in their errors, and they worship the devil'.[45] This marked the end of 200 years of fruitless efforts by European missionaries to establish Christianity in Benin, although some of their symbols, the crucifix and the rosary, would endure in Edo culture. The failure of these small and intrepid groups of priests is hardly surprising. Most could barely communicate with the people they sought to convert, and the spiritual comforts they offered to the Oba were no match for the entrenched indigenous religious system that placed him at its apex.

European traders and missionaries came away with contradictory impressions of Benin. There was much to admire in a well-ordered society that was often hospitable to foreigners. Favourable comparisons with European cities were quite a theme; a Portuguese captain, Lourenço

Pinto, who visited in 1694, said, 'Great Benin…is larger than Lisbon… The city is wealthy and industrious. It is so well governed that theft is unknown and the people live in such security that they have no doors to their houses.' Pinto said that Benin's artisans have their own reserved parts of the city, and that in one square he 'counted altogether one hundred and twenty goldsmiths' workshops, all working continuously'. As Benin was never known for gold work, presumably Pinto mistook the shiny brass for gold.[46] An eighteenth-century English writer, summarising the findings of Dutch visitors, wrote, 'The Inhabitants are generally good natured and civil, and may be brought to any thing by fair and soft Means. If you make them Presents, they will recompence them doubly. If you want any thing of them, and ask it, they seldom deny it, even though they had Occasion for it themselves.'[47]

At the same time, visitors took a morbid fascination in the darker sides of Benin's culture, above all human sacrifice. From the first Portuguese complaint in 1538, it is a recurrent theme. 'On one occasion,' Dapper writes about Benin in the seventeenth century, 'a certain woman ordered on her death-bed that seventy-eight slaves were to be slaughtered, and eventually, to make the number up to eighty, a boy and a girl had to be added. Nobody important dies there without its costing blood.'[48] Dapper's accounts are often lurid, but he was not the only person to write of how deaths of prominent people were accompanied by massacres of slaves. And when the Oba himself died, it was reported, he would be buried in a great pit, joined by his most trusted followers, who clamoured for the privilege. Each day, the rock would be moved to one side, until those above were satisfied that there were no survivors.[49]

In an account of human sacrifice in the Yoruba areas immediately to the west of the Benin Kingdom, a Nigerian historian writes that the practice was driven by a number of beliefs: to bring good fortune to the community, to ensure success in warfare, to demonstrate the authority of the royal family and to drive out evil forces. Slaves might be killed as substitutes for sick people, to carry messages to a deity or to provide chiefs and rulers with attendants in the afterlife.[50]

Many of these motivations can be seen in Benin as well, where the complex traditional belief system is populated by a multitude of gods and spirits. It was the High God, Osanobua, who created the world and all things, and is the father of other gods, such as Olokun, who brings wealth, health and fertility, and was associated with the arrival of the Europeans. Ogun, another son, helps the Edo transform raw materials into tools and weapons, and is the patron of farmers, craftsmen, hunters and warriors. Osun is sometimes described as the god of medicine, with powers derived from herbal cures. And then there is Ogiuwu, known as the 'king of death'.[51] There was a shrine to him in Benin City. Many people were sacrificed here; sometimes, it was said, to induce him not to take a certain person away when it was their time to die. According to Paula Girshick Ben-Amos, an expert on Edo culture, 'Ogiuwu is said to be the owner of the blood of all living things. He uses sacrificial blood to wash down the walls of his palace, and has a particular preference for that of humans.'[52] Ogiuwu does not appear in artistic form in Benin's culture, but is represented by his messenger, Ofoe, depicted as a head with legs and arms growing out of it, with which he traps his victims.

The worship of Ogiuwu fell into abeyance in the twentieth century. But how much credence should we place on the stories of human sacrifice in Benin City in earlier times? Maybe the accounts of slaves being buried with their masters are metaphors of a journey into the afterlife, rather than literal truths. James Walsh, one of the first Englishmen to write about Benin, makes no mention of human sacrifice, and neither does Van Nyendael in his detailed account. Customs and practices surely changed over time. Captain John Adams wrote in the early nineteenth century of his experiences in Benin: 'Human sacrifices are not so frequent here as in some parts of Africa; yet besides those immolated on the death of great men, three or four are annually sacrificed at the mouth of the river, as votive offerings to the sea, to direct vessels to bend their course to this horrid climate.'[53]

European visitors could have exaggerated what was happening in Benin City. They may not have distinguished between sacrificial killings and what today we might call judicial or political executions.[54]

Patrick Oronsaye says that a condemned prisoner – for example, a war captive or convicted criminal – was kept alive and 'then during festivities he's brought out and publicly executed. It showed the Oba's power over life and death'.[55] In Britain, after all, public executions continued until 1868. An account by a British traveller to West Africa in the mid-eighteenth century suggests a cynical motivation for drawing attention to human sacrifice. William Snelgrave was a slaver who wrote a book about his trade, in which he reported, 'It is evident that abundance of Captives, taken in War, would be inhumanly destroyed, was there not an Opportunity of disposing them to the Europeans. So that at least many Lives are saved and great Numbers of useful Persons kept in being.' Slavery, in other words, was a humane practice if the alternative was sacrifice. In any case, Snelgrave argued, those taken to the sugar plantations of the West Indies 'generally live much better there than they did in their own Country; for as the Planters pay a great price for them, 'tis their interest to take care of them'.[56]

To what extent did Benin eventually succumb to the relentless European appetite for slaves, and did the slave trade change or corrupt Edo society? Some historians have argued the transatlantic slave trade may have been responsible for an increase in human sacrifice, because it created both great concentrations of wealth in African societies and a disregard for life.[57] An estimated one-third of the more than ten million Africans who were forced onto European ships came from what is today Nigeria.[58] It seems inconceivable that societies participating in this trade would not be warped by its brutalising impact.

The Obas did indeed put aside their initial reluctance to trade in enslaved males. The eighteenth century was the heyday of the trade, with English ships playing a prominent role. At times Benin was selling some 3,000 slaves per year.[59] European traders differed on the quality of the slaves bought there. A Dutch official of the early eighteenth century said they were 'very obstinate when they are sold to whitemen…and… once out of sight of land they become very dejected and in poor health', whereas a Liverpool slave-ship captain of the late eighteenth century believed they were 'the most orderly and well behaved of all the blacks'.[60]

The Oba sold prisoners and casualties of war and civil war, but there's little evidence of Benin waging war on its neighbours specifically in the quest for more slaves to trade with the Europeans.[61] Slavery had existed in Edo society before the Europeans arrived, and would continue after Europeans had abandoned the trade. Patrick Oronsaye says that 'even though the white man was here for 400 years they didn't change our concept of slavery. Our miscreants we sold...and the worst of our stock that we would give to them.' In Benin City today, he and others proudly say that Edo slaves were notoriously fierce, ready to commit suicide on the boats by leaping overboard, or joining rebellions in the New World. 'Because the Benin man values his freedom so much that he will die for it.'

From the European point of view, Benin's geography was always problematic. The perils associated with the whole stretch of coastline – 'Beware, beware the Bight of Benin, for few come out where many go in,' generations of British sailors warned – were amplified for those who wished to trade with the Oba. While larger ships waited at the mouth of the Benin River, smaller vessels that ventured to the port of Ughoton sometimes had to wait for months for a full cargo of slaves. This was expensive, but also dangerous, as Europeans were still all too prone to fever, and not much wiser as to how to avoid or treat it. An eighteenth-century English writer echoes the complaints of the first Portuguese traders of the fifteenth century: that the 'unwholsome' rivers south of Benin were plagued by mosquitoes, 'For the land, being woody, is intolerably pestered with these Vermin; especially in the Night, when they attack People in Swarms, and sting so severely.'[62] This implies that at least one author suspected mosquitoes were not just an inconvenience, but the cause of many of the Europeans' health problems, but it wasn't until the end of the nineteenth century that scientists were able to prove this. Captain John Adams, writing about the late eighteenth century, said Benin had been a source for a 'very considerable' numbers of slaves but English trade declined because too many sailors fell sick.[63]

After 1807, the British, who had energetically pursued the slave trade, led its suppression. This caused much confusion among the chiefs and kings who had been their partners. A British officer in the Niger Delta

wrote, 'We carried on the slave trade so shortly before ourselves, that I do not think they clearly understand why we should be so anxious to suppress it now.'[64] A colleague who visited the Benin River in the 1830s said no slaves were being traded there.[65] In 1837, a Royal Navy schooner seized a Portuguese slave ship on the Benin River, the last such recorded incident.[66] Other ports in what is today Nigeria, especially Lagos and Bonny, saw a final flurry of slave trading in the early nineteenth century, driven by the Spanish and Portuguese. But in Benin the trade in human beings was finished. The British, however, were not. By the 1830s the Liverpool traders on the Benin River were looking for palm oil, the lubricant for the machines of the industrial revolution, and the 'slave rivers' of the Niger Delta had been rechristened the 'oil rivers'. Palm oil exports from the Bights of Benin and Biafra increased from 200 tons in 1808 to 25,285 tons in 1845.[67] This trade needed to be protected. The nineteenth century would be one of British domination over this stretch of West African coast, culminating in a decisive conflict with the Benin Kingdom.

THE WHITE MEN, GREATER THAN ME AND YOU, ARE COMING SHORTLY TO FIGHT AND REMOVE YOU

On an August day in 1862, HMS *Bloodhound* set sail in a north-westerly direction from the Spanish-occupied island of Fernando Po for the Bight of Benin. On board was Her Majesty's Consul to the region, who intended to visit the coast and travel inland. He wrote of his destination with the confidence of his age: 'no one knows of it except a few palm-oilers from Liverpool; and it may now be treated as a terra incognita'.[1] His name was Richard Burton, and back home in Britain he was a famous man. Soldier, explorer, linguist, writer and diplomat, Richard Burton was in his early forties when he visited Benin and had already lived a life of barely plausible adventure, ambition and variety. From a journey to Mecca in disguise, to feats of exploration in Central Africa, to publishing the *Kama Sutra*, Richard Burton was an outsider and critic of Victorian imperialism, yet often worked at the spear tip of its advance. In his account of Benin, he exemplified its contempt for many of those it subjugated.

Britain was becoming more entangled with the region. In 1849, the Foreign Secretary, Lord Palmerston, appointed a Consul for the Bights of Benin and Biafra, and in 1851 it launched a short bombardment of Lagos – led by the same HMS *Bloodhound* – which was annexed as a

colony in 1861. The Liverpool and Glasgow firms that traded in the Niger Delta were pressing for more government support. Burton made his visit in response to a trader's request and hoped to persuade the Oba to influence the neighbouring Itsekiri people, who controlled many of the riverways, to be more co-operative with British merchants. He was the first British government official to set foot in Benin City, and it would be almost thirty years before another followed. His lively and caustic account painted Benin as a place of cruelty, decay and decadence and had an enduring impact. By the end of the century, when Britain invaded Benin, Burton's impressions were received wisdom among the British establishment and its newspapers.

He marched through the forest from Ughoton, his temper seething at the thieving of his carriers, his whips and fists flailing in rage, revolvers brandished in threat. He says Benin City was largely in ruins, a place of dilapidated houses and streets choked with bushes and grass. The people of Benin, 'a pilfering race', stole many of the presents – silks, rum and Indian spices – he had brought for the Oba. The Oba's quarter was 'in a most ruinous condition', and he was disappointed the chambers had none of the tapestries of silk he had expected. He did, however, find signs of culture. In the palace he admired fine carved tusks and wooden kola-nut boxes inlaid with brass. Benin's chiefs wore beautiful coral collars. The Oba, Adolo, a stout man of about thirty-five, entered their meeting with two men who supported his arms, dressed in a silk wrap and coral bracelets. Burton was struck by his intelligent and good-humoured countenance, 'the best-looking negro we had ever seen'. He was intrigued by Portugal's lingering influence in Benin; 'even to the present day the old men can speak a kind of Africo-Lusitanian'. Characteristically, Burton also took note of Benin's women; he was impressed by their beauty, with 'tall graceful figures and drooping shoulders'.

And yet all this pales beside the horrors which Burton described. Benin, he wrote, 'has a fume of blood, it stinks of death'. On their march to the city, his party passed a body hanging from the trees, and on the streets they saw the corpse of a strangled man tied to sticks. People walk by, holding their noses, but otherwise display no emotion.

They saw another woman lashed to a tree, vultures pecking at her eyes. People looked with 'utmost insouciance' at yet another butchered body. And then Burton came across what he described as a 'Field of Death...a Golgotha, an Aceldama', a place littered with bones with 'green and mildewed skulls lying about like pebbles', where vultures basked in the sun. In short, Benin had become a place of gratuitous barbarity, a place 'where the streets of the capital run red with human blood'.

What was going on? A comparison with the description of a previous British visitor to Benin City, from 1823, makes a striking contrast. That year a British newspaper of the West African coast, the *Royal Gold Coast Gazette*, published an anonymous account by an 'intelligent correspondent'. This eyewitness wrote, just as Burton would do, about Benin's decline; he (I assume) says a civil war over the succession caused much destruction a few years before his visit, which only ended when the younger brother of the Oba and many chiefs were 'barbarously put to death'. He says Benin's empire is fraying, as tributary states – which still extended all the way from Lagos in the west to the River Niger in the east – were becoming irregular in their payments and acquiring their own guns and powder. And yet he finds that Benin's government is 'vigilant and active, the people brave, and proud of their country'. Its laws are of 'a mild character'.[2] The Oba is no tyrant; there is a system of trials before he can order punishment, and there is no mention of human sacrifice.

Moreover, Benin City in 1823 was still a place of artistic splendour. The Oba's palace was vast and impressive, 'the apartments of the king are decorated on the panelling and the ceiling with brass plates...and the regal state is by far superior to any on this part of the coast'. This observer was taken aback by the sophistication of Benin's craftsmen. 'Mechanics have attained a perfection far beyond any idea that can be formed of a pagan people...All kinds of blacksmith's work is performed with an extraordinary degree of neatness: and trades people of every description are arranged in streets that no one else is allowed to occupy.' He admired tombs, where carved tusks were placed into the crowns of colossal busts of the deceased. These, and cast metal figures showing a blacksmith on an ass and a carpenter striking an axe, were 'altogether

so good it is almost beyond belief'. Not for the last time, there is a sense of incredulity at what Benin had produced. The art is hieroglyphic, in an Egyptian style. 'It is probably the Portuguese were the founders of this nation,' he concludes.

The *Royal Gold Coast Gazette* was published by Sir Charles MacCarthy, Governor of the Gold Coast. The *Gazette* wrote that the description of Benin 'will probably surprize [sic]', and provoke a correspondence with readers. It promised further observations from its mystery correspondent. Sadly, these never appeared. The newspaper was only produced for a few more months and Sir Charles was killed in a war with the Ashanti people in the interior of the Gold Coast in January 1824.

It seems that Benin's customs and society had undergone radical changes between 1823 and 1862. An Oba whose temporal power was on the wane may have tried to reinforce his spiritual authority through human sacrifice. This brought him, one historian has argued, the 'prestige of conspicuous consumption' and created an atmosphere of fear and veneration around the royal office.[3] Perhaps also by the 1860s there was a sense in Benin that the outside world, and its beliefs and moralities, were beginning to close in on the kingdom. Two great monotheistic religions performed a pincer movement; Islam had advanced through the kingdoms of Oyo, Bida and Idah to the north, while Christian missionaries progressed through Yorubaland to the west. By 1886, British soldiers were in Ondo, only 150 kilometres away, warning that any chiefs who practised sacrifice would be fined, imprisoned or punished with forced labour.[4]

Prince Edun Akenzua is a senior member of Benin's royal family, the older brother of Prince Gregory Akenzua. In 1960, in an article looking back at the events of the late nineteenth century, he wrote that human sacrifice was 'indeed reprehensible but because it was so much a part of the religion of old Benin, it could not be so easily dismissed'. Oba Adolo could not contemplate incurring 'the wrath of the gods on whom the welfare, not only of himself, but also of the whole of his people seemed to depend…Naturally he found it difficult to regard those men who had decried his gods as friends.'[5]

Perhaps also, Burton got things wrong. The chilling 'Field of Death' he describes may have been a common graveyard where bones of criminals and paupers were left to rot.[6] And if Benin's moral standards were changing, so were those of European visitors. It wasn't only that the British were now appalled by the slave trade they had once encouraged. In the second half of the nineteenth century the Victorian world view became increasingly shaped, or distorted, by theories of racial difference and hierarchy. Burton wrote that within Benin society the difference between the slaves at the bottom – with their 'black skin and negro features' – and the 'upper orders' who rule over them, provided as great a contrast 'as the wretched peasant of Western Ireland to the English patrician'. Benin was becoming a crueller and more capricious place, but the British were more fixated on these characteristics than before. Their actions were driven by a sense of moral necessity and racial superiority that no Oba could counter.

In practical terms, Burton's visit achieved little. He believed Britain's interests were best served by a 'forward policy', in which expanded political control would help the spread of both trade and civilisation.[7] Such a policy tended to be self-perpetuating, because the subsequent growth of commerce, investment and commodities only brought a greater necessity to protect what was at stake. Not all politicians in London were convinced of the wisdom of this course. Twenty years later, in 1882, the Colonial Secretary in the Liberal government, Lord Kimberley, warned Prime Minister William Gladstone of the dangers of involvement in the Bight of Benin: 'The coast is pestilential, the natives numerous and unmanageable. The result of a British occupation would be almost certainly wars with the natives and heavy demands upon the British taxpayer.'[8]

And yet European rivalry produced its own momentum. German traders were active on the Cameroon coast to the east, and French explorers were making their way down the River Niger. At the Berlin Conference of 1884–5, Europe's imperial powers divided up Africa. They agreed that the 'Niger Districts' – from Lagos to the Cameroon coast – were an exclusively British sphere of influence. The British government's solution was to take the cheapest option; it granted a charter

to the Royal Niger Company, which belonged to the former soldier and businessman George Goldie. In return for keeping the peace and a rudimentary administrative presence on the lower stretches of the River Niger, including many areas that had once been under Benin's influence, Goldie secured a monopoly of the palm oil business.

The production of palm oil was labour intensive – palm nuts had to be cut down from trees, boiled, pounded into pulp and pressed to make the oil which was transported downriver in wooden casks – but lucrative. Europe's demand for machine lubricants had grown during the nineteenth century, and palm oil was also used to manufacture soap, candles and margarine.[9] Goldie pressed the local kings and chiefs who controlled the trade into a series of disadvantageous treaties. These turned Goldie into a palm oil tycoon, but cut out the Liverpool and Glasgow traders, who lobbied Whitehall for more direct government control of the Niger coast. The Oil Rivers Protectorate was created in 1885, and the traders' wish was granted in 1891, when it acquired a Consul-General, Major Claude Macdonald. He was given funds to create a small civil service and an armed constabulary to 'maintain order and assist in opening up the country', and the protectorate worked in uneasy tandem with the Royal Niger Company for the next decade.[10] Britain had declared its interest and its responsibility. For now, that only applied to the coastline, but inevitably it would be pulled into the interior. Trade would lead the flag, and Lord Kimberley would be vindicated in his fears that conflict would follow.

The Benin Kingdom, with Britain's commercial interests now encroaching on its edges, was weakened by internal strife. In 1888, Oba Adolo died. His eldest son, Idugbowa, succeeded him as Oba Ovonramwen N'Ogbaisi – 'the sun that shines and is known across the world'. 'He was tall, stout and of a yellow complexion and had a majestic voice,' writes Egharevba.[11] The new Oba had four senior chiefs and a number of lesser men put to death; they had apparently supported the claim of a rival brother. Benin was beset by rivalries, fear and suspicion.[12] In 1890, the Oracles of Ife warned that a disaster would befall the kingdom. The following year a man who'd travelled from Lagos, Thompson

Oyibodudu, was sentenced to death in Benin. He was accused of working for British traders without permission – some say he was caught carrying a pistol and setting fire to rubber trees in an act of economic sabotage.[13] Oyibodudu had adopted the dress and manners of the white men with whom he worked – his name means 'black white man'– and he did not go quietly. As the executioner prepared himself, Oyibodudu struggled and the gag fell from his mouth. He shouted to the watching Oba that 'the white men, greater than me and you, are coming shortly to fight and remove you'. The crowd recoiled in shock. The executioner cut off Oyibodudu's head. His blood flowed over the sacrificial regalia as tradition demanded, but this was not enough to dispel the sense of foreboding.[14]

Consul-General Macdonald was now somewhat notionally in charge of more than 350 kilometres of the Niger Delta coastline. His headquarters was at the port of Calabar, in the far east. He established a handful of vice-consulates along the coast, which looked after the interests of some 200 British traders, missionaries and doctors. These 'old coasters' lived lonely lives at their trading posts on the riverbanks, always at risk of disease, often seeking refuge in the bottle and local female company. They depended on, yet were often contemptuous of, the Ijaw, Itsekiri and Urhobo people who navigated the network of creeks and brought the palm oil downriver.[15]

In 1891, a young Irish soldier, Captain Henry Gallwey, travelled out to West Africa. He'd been appointed to the most westerly of Macdonald's vice-consulates, at 'New Benin', close to the mouth of the Benin River. In old age, Gallwey would recall his adventures. His uncomfortable boat, the SS *Gaboon* – 'passengers and crew were outnumbered by the rats and cockroaches' – had no cold storage, no electric lighting and only one lavatory. It took a month to reach Bonny on the Niger Delta coast. From Bonny he took a smaller boat to New Benin, where he rented a room from a British trading company, and raised the Union Jack. His staff consisted of two Sierra Leonean clerks. The evening before he landed, he asked Macdonald what his policy should be for 'dealing with the natives', or, as he also called them, 'these curious folk among whom one's lot was cast'.[16] Macdonald replied, '"My dear Galway [Gallwey

changed the spelling of his name in 1911], I will visit you in about eight or nine months' time, and then you can tell me what your policy is". These were the only instructions I received!'[17]

Gallwey was delighted to have a free hand: 'I was my own master more or less, so could do whatever I felt inclined as the whim seized me.'[18] He befriended the white traders and few missionaries on the Benin River. He wrote that the moral climate among his British companions was better than he'd feared. They were still 'Palm Oil Ruffians', but 'pleasant social gatherings, in the shape of cricket, lawn tennis and such pastimes, now take the place of the debauches of the past'.[19] Unfortunately the shooting was disappointing – the antelope too timid, the crocodiles too slow, the hippos too rare – the only consolation an abundance of curlew.[20]

The traders complained to Gallwey of their difficult relationship with the Benin Kingdom, less than 100 kilometres inland to the north-east. From the first days of the Portuguese, the Obas had sought to keep exclusive control over trade with the Europeans, using the objects the outsiders brought – brass manillas, cowrie shells, coral beads, guns and so on – to boost the prestige of the royal court, ensuring rivals within the kingdom were not able to build up their own wealth and autonomy. By the 1890s, amid a profusion of competing interests and Benin's waning power, that was no longer easy. Previous Obas had sporadically shut down commerce with Europeans when they felt it threatened their interests, and now Ovonramwen frustrated British traders with periodic restrictions on exports of rubber, gum copal and timber. Moreover, he placed a ban on the sale of palm kernels, which also produce oil.

In March 1892, Gallwey set off in Burton's footsteps for Benin City, with a small and unarmed entourage that included a British trader, John Swainson, and an interpreter. In his old age, he wrote of the trip as 'a jaunt', and that he and his colleagues 'regarded the whole thing as a very interesting picnic' and were motivated by curiosity more than anything else.[21] The frivolous language is deceptive, for whereas Burton seemed to have been on an adventure of vague purpose, Gallwey had very tangible ambitions. He carried with him a treaty which he hoped to convince Ovonramwen to sign. It stated that the Oba had requested

his territory should come under the 'gracious favour and protection' of Queen Victoria.

Gallwey was kept waiting for three days in Benin City, during which he attempted to explain his treaty to the Oba's chiefs. But the Oba, Gallwey complained, was 'very rarely seen by his subjects and seldom quitted the seclusion of the compounds'.[22] He may have been playing for time. Gallwey only secured his palace audience after threatening to leave. Ovonramwen sat on a throne 'resembling a big drum with a linen cover on it', wearing red coral bead robes and hat.[23] One attendant held the royal ceremonial sword, the *ada*, and another supported Ovonramwen's left arm. Gallwey went over the treaty, article by article. It was a painful business, with Gallwey deciding halfway through that his interpreter was too afraid of the Oba, and needed to be replaced. The Oba conferred with his chiefs, but had only one question, which he repeated again and again: 'Is it peace or war?' Peace, assured Gallwey, and so the Oba assented. But neither he nor his chiefs could write, and he refused to touch Gallwey's pen. Instead he consented for his chiefs to mark the paper, and Gallwey wrote the Oba's name at the bottom of the treaty. Gallwey presented the Oba with his own copy.[24] Then they exchanged gifts; 'handsome silk and corals' for the Oba, 'a very fine elephant's tusk' for Gallwey.[25]

It is difficult to believe that the Oba fully understood he had signed away Edo independence, and many of the powers wielded by him and his thirty-four predecessors. The treaty specified that his territory was open to free trade, that he could deal with no other foreign power without British approval, that he would act upon British advice, and that British officials had exclusive jurisdiction over British citizens in Benin.[26] Maybe, given the murderous rivalries between Benin's chiefs, the Oba sought to use the British to shore up his own position. It is hard to know to what extent the Oba understood the implicit threat that Gallwey carried with him. After the negotiations were finished, Gallwey says the Oba told him that 'whilst the Great White Queen was ruler of the seas, he was ruler of the land'. Perhaps the Oba's words were mere bravado, but they suggest ignorance of what he was up against. Gallwey played it all very disingenuously; he wrote that he 'was careful not to hurt the

King's feeling by protesting…we disabused the King of his mistaken idea some five years later'.[27]

Gallwey's impression, like Burton's, was that Benin was a shadow of its former self; 'the glory has departed…the so-called city being but a straggling collection of houses…the number of ruins testify to the fact that it was once very much larger', although he did notice 'beautifully carved tusks' and 'many specimens of brass ware of very clever workmanship'.[28] His description is also full of gruesome details. 'In the King's compounds were several large sacrificial courts…and pits into which the bodies and heads of sacrificial victims were cast. There were five crucifixion trees in the City, one of which was inside the King's compounds'.[29] On his entrance to the city he saw 'a regular hecatomb of dead bodies, in all stages of decay, and skulls grinned at us from every side'.[30] He was told an epidemic had swept through Benin the previous month, killing hundreds, and this may account for many of the bodies.[31] But a British trader, Cyril Punch, who visited Benin in 1891, saw similar scenes, and said the Oba confided in him 'that he was sick of it all, but that he could not discontinue the customs of his ancestors'.[32]

Gallwey was shocked by what he saw, but although the British spoke of the necessity to end human sacrifice and any residual slave trading, his treaty mentioned these concerns only obliquely. It committed the Oba to 'order, good government and the general progress of civilisation', as well as full protection for Christian missionaries.[33] The trader Swainson said Gallwey did specify to the Oba that human sacrifices must stop, but he believed the interpreter chose not to translate this discomforting instruction.[34]

Whatever the truth, the Oba could now be held to account, and Gallwey had carried off a diplomatic coup. It was, writes the historian Philip Igbafe, 'the beginning of the end of the independence of Benin'.[35] Gallwey wrote to the Foreign Office that tact and patience would be required before the resources of the Benin Kingdom could be exploited, but that great possibilities lay ahead.[36] Back in London later that year, he told a meeting of the Royal Geographical Society that 'many valuable trade products are lying untouched in this dusky potentate's territories'.[37]

His superior, Consul-General Macdonald, endorsed his view: 'there is no doubt that the Benin territory is a very rich and important one… Minerals, gum Arabic, gum copal, palm oil, kernels, etc., exist in large quantities', and the only hindrance to these opportunities was the Oba's 'fetish practice'.[38]

By now, the cost of opposition to the British should have been obvious to the kings and chiefs of the Niger coast. The warning signs had been there in 1887, when King Jaja of Opobo, a former slave who'd risen to become a prosperous ruler but frustrated British control of the palm oil trade, was lured onto a Royal Navy ship and exiled to the Gold Coast, and eventually Tenerife, where he died in 1891.[39]

In 1894, another prominent Niger Delta chief would fall out with the British. Nana of Brohimi was a leader of the Itsekiri people and a neighbour of the Benin Kingdom. According to legend the Itsekiri nation was founded by a Benin prince, and even into the 1890s the Itsekiri paid homage to the Oba, but these ties had gradually weakened as the Itsekiri had prospered as middlemen to the Europeans, first in the slave, and now the palm oil trade. Nana had a hold on palm oil being transported down the Benin River, but was coming into conflict both with British traders, who wanted to deal directly with villages upriver, and with Itsekiri rivals.

At first Gallwey treated Nana with respect; the riverside town of Brohimi 'is kept scrupulously clean,' he wrote, 'Nanna's [sic] own house being built according to European ideas. This chief is a superior sort of native, and is very wealthy…I have seen Nanna with seven or eight hundred pounds worth of coral on him.'[40] But after Nana's guns opened fire on a British boat, two Royal Navy ships based at Cape Town were sent to remove him. They besieged Brohimi for weeks, at the end of which Nana fled.[41]

In an obscure manuscript in the National Maritime Museum in Greenwich, a British sailor describes entering Brohimi shortly afterwards. He discovered what was left of its population in a nearby creek, still trying to escape the Royal Navy's bombardment. In a tangled mass of canoes, stretching for 1.5 kilometres or more, was an 'appalling mass of

humanity huddled together...in all stages of starvation and wounds... Women were dragged out with dead babies at their breast. Babies were trying to get nourishment from dead mothers, Children were being born, Old Men's bones were standing through the skin from starvation, Some had dreadful wounds. One man came to me for help, who had his jaw shot away. A little girl of about fourteen had many shot holes through her legs.' An old woman approached the sailor and, with beseeching eyes, spoke of the 'terrible cruelty of the white men'. Leering European traders looked on, eyeing up the more attractive women, hoping to take them as wives. The sailor, his eyes 'wearied of the terrible procession', returned to the town, where he found hundreds of starving people gathered for food. A British official whipped them. Conscience-stricken, he handed out biscuits, for which the crowd fought like 'wolves'.[42]

Nana escaped as far as Lagos, where he surrendered to the British. He too was exiled to the Gold Coast. The lesson, surely not lost on Benin, was that a handful of old cannons and muskets, courage and spiritual powers were no match for modern British weapons. The wretched survivors of Brohimi were astonished to see just how few white sailors had been able to inflict such misery.

In the following years, the British noose tightened on the Niger coast, and on the Benin Kingdom in particular. The Oil Rivers Protectorate became the Niger Coast Protectorate, its profits grew and so did its administrative staff and constabulary.[43] In 1892, the British opened a consular station higher up the Benin River, at a place called Sapele, some forty kilometres south of Benin City, which they expanded in 1895.[44] But the Oba remained an obstacle, and British traders at Ughoton complained of his control over rubber and palm oil, and refusal to allow more exports of these commodities. The complaints were echoed by an Itsekiri chief, Dogho, who had good relations with the British, and accused the Oba of extorting his own palm oil dealers. Meanwhile, in Benin City itself, the feuding continued, as the chief, known as the Uwangue, who had convinced the Oba of the plot at the time of the accession, was accused by others of inciting the British to invade. The Uwangue was summoned to the palace but murdered en route. The insecure Oba ordered a further

round of reprisal killings, and conspiracies and rumours spread through the city. The expectation of conflict was heightened by a call from the Oba for every town and village to send soldiers for training at a war camp; some 10,000 men responded.[45]

In February 1896, Ralph Moor was appointed as the new Consul-General of the Niger Coast Protectorate. Moor's background was telling; after ten years in Ireland with the Royal Irish Constabulary enforcing British rule at a time of rising nationalism, he'd come out to the protectorate in 1891, with responsibility for the constabulary, which would become the Niger Coast Protectorate Force.[46]

A British journalist and actor, Raymond Blathwayt, described a meeting with Moor in the mid-1890s at the vice-consulate in Warri, to the south of Benin. 'A famous river pirate' was brought to the British, recalled Blathwayt, and Moor promptly sentenced him to death. The condemned man was chained to a pillar beneath the veranda where Moor and his companions dined. 'A couple of planters joined us,' wrote Blathwayt, 'and got merry with wine and made great fun of the poor wretch outside. To me it was all so horrible, so revoltingly cowardly... they jeered, "he's only a b----- n****r!"' (the dashes are Blathwayt's, the asterisks mine). The following morning the 'pirate', who had smiled and shown no fear throughout his ordeal, was shot by firing squad. The Vice-Consul, Dr Felix Norman Roth, ordered the body be thrown into the bush as carrion for wild animals, 'to teach these people a lesson'. A few days later, according to Blathwayt, Moor returned, looking serious. '"I say, Roth", said he, "do you know all this time we have been passing sentences of death and we had no right to do so! Don't do any more, there's a good fellow."'[47]

For better or for worse, Moor was acquiring a reputation as a man of action. As Acting Consul-General in September 1895, he suggested a decisive move against the Oba. 'At the first opportunity steps should be taken for opening up the country if necessary by force,' he wrote to the Foreign Office.[48] That month a British captain landed at Ughoton with twenty men, but retreated when confronted by angry Edo soldiers. A second incursion was similarly repelled.

Moor was being egged on by British traders such as James Pinnock, who argued that the Oba was not respecting the treaty of 1892. In the letter pages of the Liverpool newspapers, and directly to Moor himself, Pinnock made the case that the Oba had to go: 'this demon in Human form, the petty king of Benin...[must be] deposed or transported elsewhere, peace and order maintained, the roads and country opened up, teeming as it does with every natural wealth of the great hinterland of the world.'[49] That the Oba may have been shutting down trade not only to protect his own interests, but also in an attempt to protect his Edo nation against a looming threat, was something British officials and traders lacked the imagination, or incentive, to understand.

The rivalry between various British administrations gave Moor further reason to move quickly. The Royal Niger Company, which controlled territory immediately to the east of Benin, was looking for new trade opportunities; in 1894 one of its agents had appeared in Benin City with an armed escort, to the fury of protectorate officials, who saw this as an incursion into their territory.[50] To the west, British officials in the Lagos Colony made their own case for being allowed to approach the Oba. If Moor could take Benin, he would enhance his own reputation and prestige, but also that of the protectorate of which he was now in charge.

In April 1896, the Oba ordered a complete shutdown in all trade with the Itsekiri, complaining they were cheating him.[51] Moor again urged his political masters for permission to strike. He wrote to the Foreign Office, 'I consider that if the efforts now being made should continue unsuccessful until the next dry season, an expeditionary force should be sent about January or February to remove the king and his ju-ju men for the sufferings of the people are terrible.'[52] ('Ju-ju', or 'juju', had become British derogatory shorthand for traditional religion and its associations with human sacrifice.) But Moor's superiors in London were unmoved. 'The King of Benin may have to be dealt with, but it should be set about with care and with a sufficient force, and at our own time,' responded the Foreign Office.[53]

In the summer Moor returned to London on six months' leave. Presumably he was a frustrated man. A Conservative, pro-imperialist

government had taken power in 1895, with Lord Salisbury as Prime Minister and Foreign Secretary, and Joseph Chamberlain as Colonial Secretary. Chamberlain believed that British foreign policy should be based on the imperative to 'find new markets and defend old ones', the very sentiment which led Britain and other European powers into the Scramble for Africa.[54] Moor must have felt he ought to have been preaching to the choir. He took rooms in Piccadilly, briefed the Foreign Office, and prepared to meet his new Deputy Consul-General, James Phillips, who was passing through London en route to West Africa.[55]

Jan Morris wrote of the archetypal public school boy who manned the British Empire that the 'rarest of his virtues was human sympathy, the rarest of his vices cowardice'.[56] It could have been an epithet for James Phillips, whose name resonates in Benin City like that of no other Englishman. I've seen two photos of Phillips. He's wearing a bow-tie in each, and has the ubiquitous moustache, a weak chin and receding hair. He came from a comfortable background, the son of an archdeacon and grandson of a cavalry officer who fought at the Battle of Waterloo. Phillips was a good sportsman but mediocre student at Uppingham. In his final year, he finished fifteenth out of seventeen. But he was a joiner-in; he took part in readings of *Henry V* and *King Lear*, he edited the school magazine and he debated, on one occasion arguing in favour of greater coercion 'to improve the state of Ireland'.[57] In the family tradition, he went to Cambridge, where he read law at Trinity College, and after qualifying as a solicitor, looked to the colonies for opportunities. He spent five years in the Gold Coast, initially overseeing prisons before being promoted to Acting Queen's Advocate. At the age of thirty-three, his appointment as Moor's deputy in the Niger Coast Protectorate represented a further step up the ladder.[58]

In late October 1896, Phillips arrived on the Niger coast. He travelled up the Benin River, where he discussed with Itsekiri chiefs and European traders the Oba's continuing refusal to allow palm oil kernels to leave his kingdom. The solution, to this ambitious newcomer, was self-evident. He wrote to Lord Salisbury, 'there is only one remedy, that is to depose the king of Benin from his stool…I therefore ask his Lordship's permission

to visit Benin City in February next to depose and remove the king of Benin…and take such further steps for the opening up of the country as the occasion may require.'[59]

The weather was a factor in Phillips's calculations; British military expeditions in West Africa invariably took place during the dry season, from October to February. From March onwards, the tropical rains returned, jungle paths turned to mud and the fevers were at their worst.[60] Phillips had worked out what he needed. Four hundred soldiers, a Maxim gun and a couple of seven-pounder cannons would do the job, he argued. 'I do not anticipate any serious resistance from the people of the country,' he said, as they would be glad to see the back of a 'despot'. He added a telling postscript to his despatch, which implied both a sensitivity to the Foreign Office's parsimony, but also a knowledge that Benin City might be a place of treasures: 'I would add that I have reason to hope that sufficient Ivory may be found in the King's house to pay the expenses in removing the King from his Stool.'[61]

Phillips may have been trying to take advantage of Moor's absence to seize the glory for himself. For a few months only he was the most senior British official in the protectorate, the Acting Consul-General. In which case, his despatch, to the Prime Minister no less, was bold. Or perhaps he and Moor were working in tandem. Moor may have egged Phillips on, hoping that while he was in London his deputy would force the Benin issue on the ground, with plausible deniability should things go wrong. No record has been found of when, where or what was discussed when the two men held their fateful meeting in England before Phillips left for the Niger Coast Protectorate,[62] but rumours emerged that Phillips had been heard boasting in a London club one evening that he was going to lead an expedition to Benin.[63] When Phillips's despatch arrived in London, Moor was summoned to the Foreign Office for his views. On Boxing Day 1896, Moor wrote that he absolutely agreed with Phillips that the Oba had to be removed, although he thought a greater force would be required to conquer Benin. He was ready to break off his leave, and take the next boat back to West Africa.[64] And yet still Lord Salisbury hesitated. Even an imperial government worked at a languid

pace over Christmas. He didn't send his reply until 8 January 1897. He could not spare 400 soldiers, he explained, given unrest elsewhere on the Niger coast. Permission refused, at least for another year. But it was too late. Phillips had taken matters into his own hands, and by the time the Prime Minister wrote to him, he was already dead.

4

NO REVOLVERS, GENTLEMEN,
NO REVOLVERS

A pile of dead duikers – forest antelopes – heaped by the roadside in the village of Ugbine. They stare at me with glassy eyes, their flanks smooth and grey like the concrete platform on which they lie. A startling pool of crimson oozes out from the animal at the bottom. 'You want meat?' a woman calls from the shadows, and laughs at my hesitation.

Ugbine straggles along the road, a few houses and shops, surrounded by cassava fields and banana plantations. The people say the village was founded during the reign of Oba Adolo, Ovonramwen's father, 150 years ago. At that time, it was a cluster of huts by a footpath in the deep, dark forest, a stopover on the march between the port of Ughoton and Benin City. Today Benin City sprawls much of the way to Ugbine; the potholed road is lined with churches, schools, orphanages, wooden stalls and little shops for most of the thirty kilometres. The morning traffic moved along grindingly slowly as we left the city, but gradually fell away. We arrived in Ugbine at ten o'clock and the roadside traders took me to meet the elders. There were some thirty of them, already settled in lines of plastic chairs on a shaded porch, kola nuts and whisky to hand and readily offered to the visitor. The eldest five – in their eighties and nineties – sat

on an elevated platform, silver-haired men with penetrating eyes. There was much good-natured amusement at my surname. 'Phillips!' they guffawed, and slapped their thighs. No relation, I protested.

'None of us was born at that time,' said David Obazelu, ninety years old. He was the spokesman, and the chorus behind nodded, tut-tutted and shook their heads at appropriate moments. Ugbine is a village without electricity, books or internet, but its pivotal role in the history of the Benin Kingdom is common lore. 'Our king, Oba Ovonramwen, was busy in his palace. It was the annual festival of *Ugie Ague*. When the king is celebrating this festival he does not receive visitors. He was told the British wanted to come. He sent a message back saying he could not grant an audience because of the festival. But the British were already at Ughoton, and they insisted on coming. That is how it all started.'[1]

James Phillips's precise motives in January 1897 remain a mystery. Without waiting for London's reply, he set off for Benin. But despite having pushed for military action, his expedition included three officers but no soldiers, and carried no serious quantities of weapons. Presumably he thought the Oba would have to receive him, in which case he must have believed he could not lose. Either Ovonramwen would agree to comply with the 1892 treaty, or, if he explicitly refused to do so, Phillips could argue he had gone the extra mile, and the only solution was to return with a military expedition and remove him by force. And yet at a Christmas Day dinner at the Consular Headquarters in Calabar, Phillips told the gathered British community that he and his colleagues were setting out the following day 'on a perilous expedition from which some of us may never return'.[2]

The sense of impending danger was not shared by all. One of Phillips's party was Captain Alan Boisragon, commandant of the Niger Coast Protectorate Force, the most senior serving army officer in the protectorate. Boisragon's wife, Ethel, at home in Sunningdale near Ascot, had received a letter written in late November, in which her husband mentioned a forthcoming expedition to Benin. He expressed no apprehension, but was doubtful of a positive outcome; 'they would in all probability be stopped and sent back,' he told her.[3]

Phillips wrote to the Oba, telling him he was coming, unarmed, within a matter of days, and set off on the boat journey from Calabar to Ughoton, from where he would march to Benin City. Just as the elders of Ugbine told me, the Oba sent messengers back, saying Phillips and a single Itsekiri chief would be welcome, but only one or two months later, after the *Ague* festival.[4] *Ague* – the festival of the yams – is a time of self-denial and isolation for Benin's Obas, to strengthen their spiritual powers. Slaves and prisoners were sacrificed on the threshold of the Oba's chamber, to please the ancestors and keep epidemics and famine at bay.[5] Phillips received the reply en route, but sailed on to Ughoton. Such a festival, he would have thought, was the very kind of barbarity the British wanted to stamp out.

The warning signs were there, even before Phillips landed at Ughoton. Dogho, the Itsekiri chief whom the British regarded as a friend, pulled his canoe up beside Phillips's launch, the *Daisy*, in the Benin River. Their half-hour conversation was urgent and hushed. Dogho said his messengers had just returned from Benin City, where they'd overheard orders for the Oba's soldiers to head to the waterside villages. Dogho warned Phillips, 'It will be death to go on.'[6] Other chiefs the British met also spoke of disaster if they pressed ahead. Phillips's only concession was to send back the accompanying military band.

The villages and creeks around Ughoton were quiet, almost empty of people, when he pulled in there on the afternoon of 3 January. But in Benin's port – now no more than a few dozen dilapidated huts according to Captain Boisragon – the British were surprised by a warm welcome.[7] Priests washed their feet in a greeting ceremony. Three chiefs came forward who said they'd been sent by the Oba. 'Though very like monkeys in personal appearance,' Boisragon wrote, 'they looked quite a superior class of animal to the Gwatto [as Ughoton was known by the British] people. They were all three rather elderly, grave, and most respectable-looking men.'[8] The chiefs urged Phillips to wait for some days before proceeding to Benin City, but he brushed them aside and presided over a cheerful dinner for his eight British companions.[9] They were military officers, protectorate officials, a doctor and representatives

of Glasgow and Liverpool trading firms. They included veterans of the Niger coast and comparative newcomers, commercial men and sons of landed gentry. They were accompanied by some 240 African carriers, guides and servants.

From Ughoton, they set out on the morning of 4 January and marched into the forest, intending to reach Benin the following day. The undergrowth was thick, the iroko and mahogany trees towered over them. In this vegetation, a crouching man, a watchful buffalo, even an elephant, is difficult to detect at a distance of ten metres. It was harmattan season, the dry wind which carries Saharan dust from the north and brings a brief respite from the heat and humidity. The sky turns hazy shades of brown, but underneath the canopy all was shades of green. The carriers were bearing gifts for the Oba, the white men's clothes, six or seven bulky cameras, camp-beds, boxes of tinned food, drinking water for ten days and bottled stout. They also carried the white men's revolvers, locked in boxes, as Phillips had ordered these should not be visible.

On the narrow path they marched in single file, spread out for a length of nearly two kilometres. Phillips was near the front of the column. His orderly, a native policeman in a blue uniform, a man they called Jumbo, marched ahead. He was carrying the Consul-General's flag, a blue ensign with the protectorate crest in the corner. It must have been cumbersome work, carrying that flag, preventing it from snagging on branches and creepers overhead. The symbolism was clear; the flag showed that Phillips and his party came to Benin on behalf of the greatest empire the world had ever seen, even if it gave the false impression that he did so with the full knowledge and authority of his government.

After some ten kilometres they reached Ugbine, and paused to eat, rest and allow the carriers to catch up. There, the villagers say, the white men were friendly, shaking lots of hands and studying the path ahead with their binoculars.[10] They were in fine morale, talking of how they would celebrate the birthday of one of their number, Major Copland-Crawford, in Benin City two days hence, where they would also drink to Her Majesty's health. Now that they were really on their way, the tension of recent days had lifted. They looked at each other, and felt confident

in their respective abilities. In the words of Captain Boisragon, 'I think it would be hard to find a better lot of men the wide world over. Every one of them was fit and ready to go anywhere, and do anything. All of them were men, in polo language, "hard to hustle off the ball".'[11] And yet they missed an ominous sign. The chiefs from Benin City who had accompanied them this far suddenly made their excuses, and hurried on ahead.

The ambush happened shortly after the British resumed their march. It started with a single shot, followed moments later by a wave of gunfire that seemed to start near the front of the column, and then tore through the forest all the way back to Ugbine. The Edo soldiers had been hiding in the undergrowth adjacent to the track, where they had cut a parallel path. They were firing from point-blank range, their flint-lock muskets producing clouds of blue-grey smoke. Somebody suggested it was a salute in honour of the British. But all around the carriers were falling, screaming in pain. The war cries of the invisible enemy added to the confusion. Captain Boisragon and Major Copland-Crawford shouted that they were looking for the locked boxes that contained the revolvers. In reply, Phillips was heard to call his brave but foolish final words: 'No revolvers, gentlemen, no revolvers.'[12] He may have been killed moments later, shot or perhaps hacked to pieces. There are no eye-witness accounts of the moment of his death.

The survivors tried to return the way they'd come. Carriers lay dead across the path, some decapitated. Others had dropped their loads and run for their lives. The Edo soldiers were carrying machetes as well as guns. They fired rough, round bullets and 'pot-leg', jagged pieces of iron. The British pleaded, and swung their arms and cried with rage as the Edo soldiers drew closer. Someone beat a drum and the sound reverberated through the trees. The able-bodied tried to carry the wounded, but the British and their servants were falling one by one.

It took three days for rumours to trickle out of the forest, and a further four for a British official to reach the nearest telegraph station, 'the end of the wire', the small port of Brass at the southern end of the Niger Delta, some 200 kilometres from Benin City. So the news broke in

London, like a thunder-clap, a whole week later. 'Massacre of a British Expedition in West Africa,' announced *The Times*, 'a terrible disaster'.[13] A 'deplorable catastrophe', the *Daily Telegraph* declared, 'a gallant body of Englishmen have fallen victim to their efforts to bring West Africa within the outer fringes at least of civilisation'.[14] *The Times* warned there was not the slightest hope that any white men had escaped. The fate of their African servants – a mere seven were at first reported to have got away alive, although this number would increase over the coming weeks – was of only passing concern.[15] The *Telegraph* even poured scorn on these unfortunate men: 'The news, such as it is, has been brought by the remnants of the native carriers…who managed to make their escape. It may, of course, turn out that the patois of the craven negroes has exaggerated the extent of the disaster.'[16] These tenuous grounds for hope materialised, four days later, into what the same newspaper called 'a shock of almost incredulous surprise'; two of Phillips's British colleagues had escaped after all.[17]

They were Captain Boisragon and District Commissioner Ralph Locke. Believing they had no chance of evading capture along the well-guarded path back to Ughoton, they plunged into the bush, hoping to work their way round to the Ughoton Creek higher up its course. Their journey was nightmarish. Weak from gunshot wounds, terrified of capture, traumatised by what they'd seen – 'the horrible thoughts of all our dear old pals left murdered on the roadside' – they did their best to keep moving.[18] They had a compass, taken from the dead Copland-Crawford, but with no machete or axe to clear a path through the forest, they struggled through tangled thorns, their cloths shredded and ripped to ribbons. For the first two days enemy soldiers were all around, scouring the forest to capture anyone who'd escaped the ambush. They crouched, hearts throbbing, as patrols passed within metres. They were delirious from thirst. At night they lay on the forest floor and hallucinated, calling out for water to figures they saw passing under the trees. On the third day, at dawn, they licked plants frantically for droplets of dew, the first water of any kind they'd tasted since the ambush. They prayed for rain, but none fell.

Boisragon's arm, which had been bleeding almost continuously since he'd been shot in the ambush, began to stink. It was 'oozing a kind of red mud', which he wiped away with leaves, but the stuff kept coming, and as he lay resting in the bush, hundreds of flies settled around the wound.[19] Locke, disgusted by the foul smell, could not bear to be near him. By now, they were close to giving up and debated whether they should hand themselves in to a nearby village to plead for water and take their chances of being killed. But they struggled on, and came across a riverbed with a stagnant pool of water. They knew now they were near the Ughoton Creek, and the people who lived along it were Chief Dogho's Itsekiri. When they reached another waterway, they found a small settlement, a collection of huts.

The Itsekiri chief was astonished to see them, having heard that all the white men with Phillips had been killed. They were bundled into a dugout canoe, where they lay sweating under a cover of mats, as their protectors paddled them downstream, past watchful Edo sentries on the banks. It was only after they had travelled many miles that the Itsekiri felt it was safe for the white men to sit up. On that canoe in the midst of the creek they bathed their feet in the clear water and feasted on fufu (pounded yams) and palm wine. Further downstream, they came across the *Primrose*, a protectorate steamer, with a British official and the trader John Swainson on board. They drank champagne and whisky, and marvelled at their good fortune. Boisragon recalled, 'It was a very choky time for all of us.'[20] A few days later in Sunningdale, Ethel Boisragon, coming to terms with the news that her husband had been killed, received a one-word telegram: 'Saved'.[21] Boisragon and Locke would, in time, recover from their wounds. Both were at pains to stress they had left none of their white colleagues alive at the scene of the ambush, but rumours persisted that at least one, maybe more, had been taken prisoner by Edo soldiers and later executed.[22]

The elders from Ugbine took me to the memorial for the seven British men on the edge of their village. Their names – James Phillips, Major Peter Copland-Crawford, Captain Arthur Maling, Kenneth Campbell, Dr Robert Elliot, Harry Powis, Thomas Gordon – were just about

legible on the weathered stone, but the cross had snapped off and was propped up against the plinth. An additional inscription, from the British High Commission in Lagos at the time of the centenary in 1997, was already looking tired, the black letters bleeding down the grey stone, as if written with a blotchy biro. The ground was strewn with plastic bottles. A jerrycan lay on its side, split open, full of rainwater. We were surrounded by blackened banana plants, scorched from a bush fire. I've seen British war graves on remote and forgotten fronts – on the coast of northern Mozambique, in Burma, on the South African veldt – but none as forlorn as this.

The *Uppingham School Magazine* published a tribute from a Phillips family friend, Canon H. R. Rawnsley, one of the founders of the National Trust. He wrote that the victims of what was soon to be known in Britain

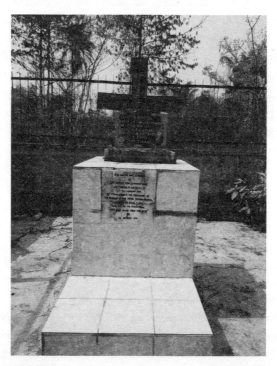

The memorial to James Phillips and six British companions, Ugbine village.

as 'the Benin Massacre' had died on a valiant mission to bring Christianity and Enlightenment to a fallen people.

> There in the city of night and fear and shame
> The dusky King shall own a mightier Lord
> A Prince of Peace shall rule with nobler sway,
> And Britain long shall name each martyr's name
> Who for that Prince went peaceful, without sword,
> And died, but out of darkness brought the day.

The pupils had their own memories of Phillips: 'He was not head and shoulders above the rest of us in anything, except, perhaps that priceless thing which was called "keenness".'[23] He is more kindly remembered on a lectern in the form of a brass eagle in Carlisle Cathedral, inscribed, 'In memory of James Robert Phillips, Deputy Consul General of the Niger Coast Protectorate, who fell in ambushe, when on an embassage of peace to Benin City, 4 January 1897.'[24] In Lagos there is another memorial, a tablet in Our Saviour's Church, (the former Colonial Church), which says Phillips and his companions were 'treacherously murdered… whilst engaged in a pacific mission'.[25]

A pacific mission? From the perspective of the Oba and his chiefs, Phillips's intentions were far from obvious. When news reached Benin City that a British expedition was coming, the Oba called a meeting. There were sharp disagreements. The Oba and his chiefs had worried about the British for a long time, but especially after they had so ruthlessly removed Chief Nana of the neighbouring Itsekiri. 'For three years the king had been expecting war,' said one source in Benin. Yet now the Oba argued that the British should be allowed to come. He told his chiefs, 'you must not fight with them – let them come and see me and say anything they bring. Perhaps they are coming to play, you do not know; you must allow them to come, and if it is war we will find out.' The chiefs disagreed: 'No! the king's word is not good.'[26] The Iyase and Ologbosere, senior chiefs, insisted that any British approach should be resisted, and instructed soldiers to prepare an ambush near Ugbine.

Ologbosere had been agitated for some time that Europeans were intruding on his people's traditions and was known to resent them for this.[27] When Phillips brushed aside appeals to delay his visit because of the *Ague* festival, the hardliners felt vindicated in their belief that Benin had to be defended by force.

As the British approached through the jungle on 4 January, one of the Oba's envoys said he pleaded on his knees with Ologbosere not to attack.[28] The Oba was portrayed in Britain as a tyrant, but the truth was that at the moment of crisis he had lost control. Many years later, his great-grandson, Prince Edun Akenzua, wrote that it was the fatal combination of 'the rashness and tactlessness of Ologbosere...and the impetuousness and foolhardiness of the Englishman, James Phillips' that were responsible for 'the Benin Massacre'.[29] For Edun Akenzua, 4 January 1897 was not a day of resistance, but 'the day tragedy struck our country, the day we lost our independence'.

Even before Captain Boisragon and Locke staggered out of the forest, the British government had resolved on a course of action. It had not wanted a costly expedition in West Africa; now the affront to its authority was such that one was unavoidable. Even Queen Victoria had been moved to write in her journal, on 12 January, of the 'terrible disaster on the Niger, near a place called Benin'.[30] The *Manchester Guardian* reported that several of Phillips's companions were 'well known in official and club circles in London'.[31] Lord Salisbury rushed to town from his country estate at Hatfield. Ralph Moor was summoned to the Foreign Office, reported to be in a state of 'considerable commotion', where he met Lord George Curzon, Salisbury's Under-Secretary of State for Foreign Affairs.[32] The Cabinet met the day after the news reached London. Within a couple of days the newspapers were briefed; the British were sending a Punitive Expedition, and the Niger Coast Protectorate Force (NCPF) would be led by a rising star of the army, Lieutenant-Colonel Bruce Hamilton, who had already served in a plethora of small Victorian wars: Afghanistan in 1879, Transvaal in 1881, Burma in 1885 and Ashanti in 1895–6. He would sail from Liverpool before the end of the week, accompanied by Ralph Moor and a group of senior officers.[33] There

was according to the *Morning Post*, some competition to be in this select group; the impending expedition had caused 'much interest in military circles, and it is understood many officers are offering themselves for employment'.[34] A contingent of marines and a hospital ship would sail from London the following week. With the rains due in March, time was of the essence. Moor, in an eve of departure interview, told journalists the British hoped to have men ashore by the second week of February.[35]

Moor would have wanted his own NCPF – West African soldiers mainly from the Hausa and Yoruba ethnic groups and led by British officers – to do the brunt of the fighting, and this chimed with the government's wishes, which had no desire to expose any more British sailors or soldiers to the health risks of a campaign in the West African jungle than was necessary.[36] Overall command of the Expedition, however, went to the Royal Navy, and Rear-Admiral Harry Rawson, commander of the squadron at the Cape of Good Hope. He promised the Admiralty that Benin could be taken by a force of about 1,500 men, and within a mere six weeks.[37]

ENGLISH JUSTICE, WHEN OUTRAGED, IS SOMETHING TO BE FEARED

Rear-Admiral Harry Rawson was fifty-three years old in 1897, at the zenith of his powers, a successful career already behind him. His biography paints a vivid portrait of the man chosen to topple the Oba of Benin:

> His great frame is built for strength, endurance, fortitude, patience, nerve, daring, valour, determination, and if need be, desperate death. One can conjure up images of this giant in action, hurling his squadrons to certain destruction, sacrificing ships and men in order to tear from the bloody jaws of destiny the glory and pride of England...The head is huge – too huge for an ordinary man...The deep jaw, the fiercely shaggy eyebrows, the steady, stern, unsoftening eyes, the masterful nose, the tumultuous mane of curling hair, the rough beard and moustache...it is the front of a sea-king! And the voice... deep as the roar of the Admiral's own guns.[1]

Rawson joined the Royal Navy from Marlborough College at the age of thirteen in 1857. The following year he was in China and saw action for

the first time, at the attack on the Taku Forts in the Second Opium War. 'Before they began to fire it was beastly as you had all kinds of thoughts going through your minds,' he wrote in his diary. At close quarters, he saw men stab and bludgeon each other to death, an enemy soldier's brains dashed out, and the skin of some forty Frenchmen caught in an explosion 'hanging down in lumps as if it was a shirt'.[2] In 1860, he took part in the sacking of the Emperor's Summer Palace. Rawson was brave, enterprising and popular; twice he risked his life to save drowning sailors and he was an enthusiastic thespian in on-board theatricals. He rose rapidly, and by 1877 he was a captain. He fought in Egypt in 1882, served on the Royal Yacht and as Aide-de-Camp to Queen Victoria, and was given command of the Cape Station in 1895. There he sharpened his skills in gunboat diplomacy. In August that year, he led a punitive expedition to East Africa, marching inland from Mombasa for five days, before storming the town of Mweli. The rebellious chief, Mharak bin Rachid, slipped away and continued his guerrilla war against the British. Many of the officers and men who took part in the assault of Mweli belonged to the Cape Squadron's flagship, the cruiser HMS *St George*, and would accompany Rawson to Benin.[3]

In 1896, Rawson returned to Africa's east coast, leading an attack on the island of Zanzibar, to remove a Sultan who was unfriendly to British interests. This 'war' lasted only forty minutes and is often called the shortest in history, but was long enough for a point-blank bombardment by the British ships to kill hundreds of near-defenceless Zanzibaris and smash the Sultan's flimsy wooden palace to shreds. It was, said *The Times*, 'no very glorious achievement but a necessary act of punitive discipline conducted with promptitude and fairness'.[4] The verdict of a later military historian was damning: 'little more than mass-murder using the latest military technology'.[5]

The British installed an alternative, puppet Sultan. And yet, for all the brutality of Rawson's attack, British interference in Zanzibar was driven in part by a high-minded determination to end the slave trade. As the Edo would soon discover, the Victorian cocktail of moral zeal and lethal weaponry had grave consequences for those who resisted.

Rawson emerged from Mweli and Zanzibar with his reputation enhanced, but perhaps his conscience not entirely clear. When his private papers pertaining to these two campaigns were auctioned in London in 2014, they were accompanied by an unusual note: 'These papers are to be kept STRICTLY PRIVATE and are NOT to be given to anyone to read except the family – If they get out they may do me much harm, HHR.'[6]

In 1897, Britain celebrated Queen Victoria's Diamond Jubilee. It was the high noon of imperialism. Lord Curzon at the Foreign Office said that 'in the Empire we have found not merely the key to glory and wealth, but the call to duty, and the means of service to mankind'.[7] Britain – 'the heirs of Rome' – had not only the right but also the responsibility to rule less fortunate parts of the world.[8] By conquering new territories, Britain improved the morality of those who lived in them. Religion was a driving force of Empire; to rescue the heathen through the spread of Christianity was a noble calling. Charles Dickens's Mrs Jellyby of *Bleak House* was a parody of the Victorian middle-class obsession to save native souls; in her case through an ambitious coffee-growing scheme – which also involved the emigration of impoverished Britons – in the fictitious Borrioboola-Gha, which, just like the real Benin City, is 'on the left bank of the Niger'.[9] Reliable victories in small and far-flung wars – Kipling's 'savage wars of peace' – heightened the self-righteousness and sense of superiority of those who ran and served the Empire. Their outlook had taken on increasingly racial tones by the 1890s, and if, in the ugly phrase of the time, 'n****rs begin at Calais', what chance did the Benin Kingdom ever have in the court of British public opinion?

Certainly the British newspapers did their best to drum up outrage over the massacre, and to frame the coming conflict in moral terms. From the start, they emphasised the debauchery of the Oba and his people. Burton's description from 1862 coloured much of the coverage. According to the *Daily Telegraph* on 12 January, 'Benin has long been known as the centre of a particularly fanatical and diabolical community of fetish worshippers, with whom human sacrifice has been a commonplace ceremonial…Very speedy retribution will be surely executed.' Britain,

the paper chorused, had to confront barbarism.[10] The *Illustrated London News* wrote of 'habits of disgusting brutality and scenes of hideous cruelty and bloodshed, ordained by the superstitions of a degraded race of savages'.[11] And yet some awkward questions lurked in the background. 'The only wonder,' *The Times* pondered, 'is that experienced officials should have ventured to approach the habitation of such a savage without adequate preparations'.[12] The *Manchester Guardian*, uniquely, tried to look at things from the Oba's perspective. True, he was 'an African savage of the degraded type', but given that he would have understood the British intended to remove him, if not immediately then soon enough, 'it was not difficult to understand why he attacked' Phillips's expedition.[13]

Why had Phillips and his companions marched unarmed into this apparently bloodthirsty lair? An anonymous gentleman with 'considerable experience in West Africa' expressed his bemusement in another *Telegraph* article: 'I cannot understand what they were doing, for a large expedition to go in such a manner is little short of madness.'[14] Gallwey was away on another mission in a different part of the protectorate ('chasing two murderers, who I caught without firing a shot'), but said if only he had been around, he would have persuaded Phillips not to press on. Phillips, he felt, had 'committed a grave error of judgement... although a clever handler of natives, he did not know anything about the Bini [Edo]. Different tribes require different handling'.[15] When Lord Curzon was asked in Parliament what the expedition had hoped to achieve, his rather stiff reply was that those who took part 'had not in this case sought the previous sanction of Her Majesty's Government'.[16] Phillips's death had to be avenged, but there was no need to defend his reputation.

On the evening of Friday 15 January, Consul-General Moor, Lieutenant-Colonel Bruce Hamilton and thirteen other officers and officials boarded the sleeper train from London to Liverpool. They included William Copland-Crawford, younger brother of Peter who had been killed on the ambush, and who had volunteered to be a replacement official with the Niger Coast Protectorate. The following morning, after a lie-in at Lime Street Station, the men boarded the steamer *Bathurst*. It

was a bitterly cold day, but they were in good spirits.[17] A small group of spectators cheered as their ship moved down the Mersey.[18] These, most likely, included members of Liverpool's trading community, reported to have been in a state of consternation and sadness at the news from Benin.[19] The chill still held Britain in its grip the following Saturday, 23 January. There were blizzards from Aberdeen all the way down to Kent, and when the hospital ship the *Malacca* left London's Royal Albert Docks as darkness fell, the snow was falling heavily.[20] The *Malacca* had been requisitioned by the Royal Navy and hurriedly converted from a cargo ship, with accommodation for ninety patients and the latest ice-making machinery to treat those who fell to the expected fevers. Some 120 marines were on board; they had travelled from barracks in Portsmouth and Chatham, seen off by enthusiastic crowds and brass bands playing 'Auld Lang Syne' and 'Au Revoir'. Young women and girls lined the docks, waving handkerchiefs, but when the *Malacca* attempted to blow its horn as it moved off into the Thames, there was a deathly silence. The brass tubing had frozen solid. 'A poor shivering Lascar [a sailor of Indian descent], swathed in half a dozen slop-suits and many mufflers, was given a kettle of boiling water, put in a sling, and hoisted up to the siren,' the *Telegraph* reported. 'There he…poured the hot water over the brass cup and tubing, thawing out the fog and ice. A minute later the *Malacca* was roaring loud enough to be heard half-way down the Thames.' The marines cheered, and the *Malacca*, painted white in the previous days, dissolved into the snowflakes.[21]

From Cape Town to the Mediterranean, the Royal Navy was assembling its forces. Two cruisers based in Malta, HMS *Forte* and HMS *Theseus*, had been chosen for the mission. Some of their officers – who had brought their wives out from England for the social season, at considerable personal expense – were dismayed by the unexpected news they were being sent to West Africa. But a young lieutenant in Malta, Vernon Haggard, nephew of Rider Haggard of *King Solomon's Mines* fame, wrote that 'great was my joy at the prospect of…seeing some interesting service'.[22] There were frantic preparations in Valletta harbour as the cruisers' engines were reassembled, and coal and other provisions

loaded. They called in at Gibraltar for more ammunition, tents, medicine and khaki clothing.[23] On deck, sailors were drilled in bush fighting and marching in boots, and carpenters worked day and night to assemble machine-gun mountings and other equipment.[24] Rawson, meanwhile, left Simonstown, the naval base near Cape Town, on board *St George* on 20 January. The remainder of his squadron, six cruisers and smaller gunboats, spread across the Southern Atlantic and up the West African coast, was ordered to rendezvous with the other British ships off the Niger Delta port of Brass, with its telegram station. This they did on 3 February, amid a flurry of gun salutes.[25]

The fleet had assembled across thousands of miles, and arrived in waters close to Benin City less than one month after the ambush of Phillips's expedition. The British were masters of moving soldiers and supplies swiftly around the globe. The Royal Navy gave them an unrivalled reach. In Europe, other powers watched on. The German newspapers had caused some outrage in Britain by referring to the massacre as 'the Defeat of the English in Benin'. Now the Oba would be taught, responded the British press, 'the wholesome lesson that not only is English faith to be trusted and English friendship to be sought after, but that English justice, when outraged, is something to be feared'.[26] It was surely not an irrelevant lesson for more dangerous foes, closer to home than West Africa.

In Benin City, the Oba and his people believed that war was now inevitable. Henry Gallwey had hurried to the mouth of the Benin River when he heard what had happened to Phillips, and, in light of the rumours of British survivors, sent a message to the Oba demanding the safe return of all persons and their property.[27] The Oba's reply – that there were no survivors – came accompanied by Phillips's finger rings.[28] Whatever regrets the Oba had about the ambush, he must have known there was no appeasing the British now. He began to make military preparations of his own, and across his kingdom soldiers and their retinues were ordered to the palace.

One of those who received the call-up was a man named Aisien. He lived in a distant village, some two days' walk from Benin City, but

reported to the palace as soon as he was summoned. Aisien had made his name as a fierce soldier some years previously, fighting against Nana of the Itsekiri, before that chief was toppled by the British. In one battle he is said to have crucified seven of the enemy. In another, the story went, he sliced both an enemy fighter and a tree in half with one mighty swipe of his sword.[29]

Aisien's description of the 1897 war is one small but invaluable correction to the overwhelming preponderance of British accounts, a welcome relief from the near uniformity of the invaders' perspectives. The Edo people, with no written language at the time their kingdom was attacked, were ill-equipped to tell a wider audience what happened to them. Aisien passed on his memories to his son, who in turn told them to his son, Aisien's grandson, who is called Ekhaguosa Aisien, in the middle part of the twentieth century. Ekhaguosa finally published them in 2013.

When Aisien arrived at the palace, the Oba told him the British were expected to invade either along the Ughoton path where Phillips had fallen, or from a southerly direction, arriving through the creeks to a place called Ologbo, some thirty kilometres away, from where they would march to Benin City. The Oba asked Aisien to go to Ologbo, and assess the defences being prepared by Edo soldiers there. When Aisien got close to Ologbo he found the soldiers were led by a man called Urugbusi. Preparations were well in hand; for many kilometres on each side of the forest track, Urugbusi and his men had painstakingly cut parallel paths, from which they intended to ambush the British, just as the Edo had done so successfully with Phillips's expedition.

Urugbusi and his commanders carried flint-lock pistols and swords. Their soldiers carried flint-lock guns, much like the 'Dane Guns' which European traders first brought to West Africa some 300 years before. The blacksmiths of Benin City were adept at producing these, but the gunpowder, *ékhàe-ósísí*, still had to be bought from European traders. Other Edo soldiers carried bows and arrows, or long clubs with nails. The commanders were dressed in the spotted pelts of the genet cat – *èrìn* – sewn into tunics, shorts and tall hats. Some soldiers wore cotton

shirts to their midriffs. They tied gourds containing war-charms to tassels, and attached scraps of pangolin skin and tree bark to their clothes. Thus camouflaged and protected, they waited for the British.

Rawson had enough men and weaponry to be confident of victory; his concern was what price he would pay in casualties. To some degree, this depended on how determined the Edo soldiers were in defending their kingdom. Phillips had been dismissive of their capabilities, but had paid the ultimate price. For all the bombast of the English newspapers, there were also voices of caution. Sir Alfred Jephson, the former Agent-General of the protectorate, warned that as the Oba knew retaliation was coming 'he will strain every nerve to put his place into a state of defence'.[30] An 'Old West African', familiar with Benin, told the *Telegraph*, 'How much fighting there will be no-one can say. But from my knowledge of the king, I should not expect him to submit without a contest.'[31] This would be in dense forests, an unfamiliar experience for many British sailors and marines. Rawson acknowledged as much; in his General Orders to his officers, based on the experience of British soldiers fighting the Ashanti Kingdom in the Gold Coast, he warned: 'fighting in the bush is very much like fighting by twilight. No one can see further than a few files to his right and left. Great steadiness and self-confidence are therefore required from everyone engaged.' The British should not become demoralised, but remember that because of their superior weapons, they were a match 'for at least twenty of the enemy'.[32]

But Rawson's greatest concern was the health of his men. Before he landed he wrote that 'much sickness was expected'.[33] Because of these worries, he was persuaded by Moor to reduce by a few hundred the force that would attack Benin; it eventually numbered some 1,200 fighting men.[34] He planned on the basis that the longer his men were on the ground, the less effective they would be. As one of his officers wrote, 'the success of the operations greatly depended on having no fever till after the major portion of the work had been accomplished'.[35] Another was blunter: 'unless he [Rawson] could get all his force up to Benin, attack the city and get his force down to the coast and back on board in a matter of 2–3 weeks he would lose almost all through fever.'[36]

To the European of the 1890s, West Africa still had a dreadful reputation for disease. Many ascribed the health risks to racial differences between white and black people.[37] The *Telegraph*'s 'Old West African', something of a prophet of doom, warned that the swamps to the south of Benin City would be fatal for many British sailors: 'the boat-loads of men traversing these "sewers", I can use no other word – will prove easy victims of the deadly fever'.[38] In fact, the mortality rates of the few British soldiers based in West Africa had fallen dramatically during the nineteenth century. The statistics from the first part of the century are staggering; in Sierra Leone, the British expected twenty-five per cent of their troops to die from disease each year, compared to 1.5 per cent in the same period at the Cape Colony. But in the 1890s, disease killed only four per cent each year of British troops based in West Africa. A 'mortality revolution' had taken place in the middle part of the century, among Europeans based in West Africa, just as it had in Europe itself.[39]

Malaria was the biggest danger, and the first breakthrough had come in the form of quinine, extracted from the bark of the Cinchona tree. By the 1830s, the French in Algeria were using quinine to treat malaria. From the 1870s, the widespread use of quinine in British colonies was having a beneficial impact.[40] Unfortunately for Rawson, the second breakthrough came immediately after the Benin Expedition. On 20 August 1897, a British doctor in India, Ronald Ross, learnt that malaria is transmitted by mosquitoes, a discovery that would earn him a Nobel Prize. Rawson and his men had sailed to West Africa months earlier, knowing that quinine could help prevent and treat malaria, but not knowing mosquitoes spread the disease.

This partial state of medical knowledge is reflected in the instructions Rawson gave to his officers. Some of these were sensible – men were to avoid the sun, drink only boiled water and dig latrines away from the tents. But although Rawson ordered that everyone on the Expedition should take a daily dose of quinine, he did not suggest they take measures to avoid being bitten by the mosquitoes which tormented them every night.[41] Rawson told his men never to remove their outer garments after a march, not because this would leave skin exposed,

but, he said, because 'a chill is the most fruitful cause of illness'. This was why he also insisted his men wear a 'cholera belt' at all times. This large flannel, wound tightly round the waist, was intended to prevent cholera, dysentery and other diseases which many doctors still believed were caused by a cold abdomen.

The diaries and memoirs of Rawson's officers reflect his confusion; they treat mosquito bites and malaria as two unrelated inconveniences. One senior officer, an apparent subscriber to the obsolete miasma theory, wrote that he could detect malaria in the 'rank smell of decaying vegetable matter'. He also lamented that if only fresh beef had been available, the disease would not have had such an impact.[42] At the end of the Expedition, Lieutenant Vernon Haggard is surprised by how many sailors are succumbing to fever even as his ship, HMS *Forte*, heads out into open waters. He wrote, 'I should have thought that going to sea would blow it out of the ship'.[43]

Rawson and his officers were meticulous with logistical details, their notebooks full of scribbled calculations of rations and weight, ratios of carriers to men.[44] They could not afford to be anything less; the Expedition had no vehicles and no livestock and so would be carrying all its food, water, weapons, ammunition, tents and tools. The marines and sailors received a daily ration of tinned meat, chocolate, sugar, tea, rum, coffee, lime juice, biscuits, rice, onions and tobacco. Rawson fretted over how much water his men would need. He decided on an allocation of two quarts (just over two litres) of drinking water per white man per day, and one quart for African soldiers and carriers.[45] Some of his officers contested the received wisdom that black people could cope with less water in the tropical heat, but even these meagre allowances presented challenges.[46] Rawson needed roughly twice as many carriers as he had fighting men; in the event he was able to hire some 2,000. About 600 of these came from Sierra Leone, but most were reluctant recruits from the Itsekiri chiefs who traded palm oil with the British in the lower stretches of the Benin River.[47] They carried the precious water in kerosene tins on their heads, each one weighing some twenty-three kilograms.[48]

If the leaders of the British Expedition worried about aspects of the task ahead, there was also an expectation of ultimate reward. Moor, in his interview in Liverpool before embarking for the Niger Coast, justified the invasion of Benin in economic terms: 'The country is teeming with very rich products and with the removal of the King and the "JuJus" this will be opened up, it is only this small block of country which prevents the opening up of trade into the interior.'[49] Moor was talking about new commercial opportunities for British companies, but what of loot to be taken from the fallen kingdom? Phillips had alluded to this in his cable of the previous year, when he suggested that the cost of removing the Oba could be offset by the sale of ivory. Such calculations did not frame British policy, but may have helped motivate some of the men involved. Ralph Locke, one of the two white survivors of the 'Benin Massacre', wrote to his brother saying he had heard 'the King is rich in ivory, his own palace being surrounded by a stockade of the finest ivory in the world'.[50] Phillips and Locke were presumably getting their information from Gallwey, who had written in 1893 of the Oba's 'tremendous stores of ivory'.[51] The *Telegraph* had every expectation of plunder ahead: 'Possibly the bluejackets and marines will have a lucky haul, for it is reported that the King's Palace, or Ju-ju House, contains big stores of gold dust and ivory.'[52]

Back in 1860, following the storming of the Summer Palace in Peking, the teenage Rawson wrote, 'The Emperor's Palace was looted, but I was not there, so I did not get any valuables, of which there were a tremendous lot taken, one officer getting £1,000 worth in the shape of a solid gold picture-frame.'[53] Benin had no gold, but it did have other prizes, as Rawson and his men would discover. 'All plundering and unnecessary destruction of property are to be strictly repressed', he wrote to his officers as they prepared to disembark.[54] These words would soon ring very hollow.

NO FORCE ON EARTH CAN STOP THE
BRITISH FROM GETTING TO BENIN

Aisien, it turned out, had been sent by Oba Ovonramwen to the most critical front of all. Admiral Rawson had decided on a three-pronged attack on Benin City. He landed smaller British forces at Ughoton, to the south-west, and a village called Sapoba, to the south-east. But these were diversionary strikes comprising fewer than a hundred fighting men each, intended to weaken and confuse the Edo.[1] The main British force would land at Ologbo, where Aisien was waiting.

On 9 February, the British landing party disembarked from the Royal Navy cruisers – too large to enter the rivers and creeks of the Niger Delta – and boarded a small fleet of steamers.[2] As the British travelled up those waterways, they did not find them to be the fetid 'sewers' they had been warned of, but places of wonder and beauty. This was the Niger Delta before the twentieth-century ravages of the petroleum industry. At first the wide rivers were lined by mangroves, but upstream the vegetation changed. The narrower creeks, of clear and swift flowing water, were draped by palm fronds and creepers. Kingfishers watched from overhanging branches, and darted downwards in flashes of iridescent blue. Basking crocodiles heaved themselves reluctantly off sandbanks and slid into the depths as the boats approached. Clouds of swallow-tailed

butterflies and flies quivered over the water.[3] Then the creeks narrowed further, the banks were impenetrable, and scouts began to report Edo soldiers flitting through the forest ahead.

Captain Herbert Walker was an intelligence officer who travelled from Liverpool on the *Bathurst* with Lieutenant-Colonel Hamilton and Consul-General Moor, and kept a diary on the Benin Expedition. He was a sombre-looking man of thirty-two, with drooping moustache and mournful grey eyes. Educated at Rugby and Sandhurst, Walker was well connected socially, and had been invited to dine with Admiral Rawson on the protectorate launch, the *Ivy*, on 9 February. Walker's father had been Surgeon-General of the Indian Medical Services, and he had himself served ten years in India, but this was his first experience of West Africa.[4] He'd been assigned to the NCPF under Hamilton's command, and anticipated being in the thick of the fighting in coming days.

Walker, with a small reconnaissance force, disembarked downstream from Ologbo to assess the possibility of reaching it by land. He spent hours struggling through the jungle, often up to his waist in mud. He wrote, 'Awful heat…Both bank of creek a mass of dense jungle & swamp…A most pestilential place. Encountered some of the worst stinks it has ever been my misfortune to face…On return took ten grains quinine, a stiff whisky & soda, & a gin cocktail, by medical advice!'[5]

Ologbo, the British concluded, would have to be taken by boat. Early the next morning an advance party of around 100 soldiers and sailors, led by Hamilton, crowded onto one of the protectorate launches and smaller surf boats, and chugged upstream, raking the surrounding vegetation with gunfire.[6] They landed on a small beach, where Edo soldiers fired on them from the trees, and shouted cries of defiance. By mid-afternoon the British had fought their way into the now deserted village, where they made their camp for the night.

Aisien and two of his men, Oduduru and Tuoyo, were waiting in the forest. That evening they crept towards the British camp. Aisien took in an extraordinary scene. British reinforcements were pouring in from the river, marines in red coats, sailors in blue, the NCPF also in blue, with red fezzes. Their tents stretched in lines back towards the village. Carriers

were cutting trees and clearing the bush, others testing the weight of wooden pallets loaded with biscuit tins full of rations which they would be carrying on their heads during the advance. Aisien sensed at that moment that Benin was doomed; the British had come in such numbers, and were so organised, that resistance was futile. But as he lay pressed against the ground, he could not resist a tempting target. An officer's orderly had set up a table and chair by the entrance to one of the tents, and prepared a pot of tea and some food. The officer emerged, and the orderly saluted and disappeared. Aisien stared at the white man, who sat alone, calmly sipping his tea. He took out a charm pouch, *ùkòkọ̀ghọ̀*, and poured black powder onto the trigger of his Dane gun. His weapon could not let him down. He murmured his prayer: *Èmùnẹ̀mùnẹ̀ ghà rhàn ifùẹn, ọ́ ghì bàà nàsọ̀n*; 'When a fire-fly spreads out its wings, it lights up the night!'[7]

Aisien stood up and fired his gun, shattering the evening calm which had fallen over the camp. Oduduru and Tuoyo did the same. But before they could see what had happened, let alone reload, Aisien recalled that 'the earth under their bellies began to quiver with the concussion of the noise of war'. The sharp crack of rifles, their bullets tearing through the trees, was joined by the unrelenting rattle of Maxim guns. Aisien looked around in horror: 'The forest itself began to move. Huge branches of mahogany were cut…as if sliced off with a giant pair of scissors…They crashed to the earth like giant umbrellas.' The three of them squirmed away on their bellies as quickly as they could, before running back to the Edo camp to report their findings. From there, Aisien was sent all the way back to Benin City, to inform the palace of what he had seen. His warning to the Oba was blunt: 'no force on Earth can stop the British from getting to Benin'.[8]

This was the account Aisien handed down to his descendants. Ekhaguosa Aisien, his grandson, always believed it to be exaggerated, until his own encounter with war in 1967. He was working as a doctor in a town called Uromi, east of Benin City, which was captured by the secessionist Biafran army. A few months later, the Nigerian Federal Army returned and drove the Biafrans out. The battle raged around Ekhaguosa's

house. He lay under his bed, listening to the sharp ta-ta-ta of the rifles, and the unhurried da...da...da of the machine guns. The next morning, he drove through Uromi, and saw the gunfire had cut big branches off trees, which lay scattered on the road. He thought of his grandfather's experiences, seventy years earlier. 'I saw with my own eyes, I heard with my own ears, what my granddaddy had told my father, and what my father had told me,' Ekhaguosa recalls.[9]

An American living in England, Hiram Maxim, developed a new gun in 1884. Earlier machine guns, such as the Gatling, had been prone to malfunction but the Maxim was much more reliable.[10] It used the energy from each detonation to spit out another bullet, at the rate of ten per second. The British army and navy were quick to adopt it. The use of repeating rifles had already given Europeans the upper hand in colonial wars, but the Maxim was a devastating weapon that no contemporary African force could match. In 1892, in his poem 'Vitaï Lampada', Henry Newbolt famously wrote, 'The Gatling's jammed and the Colonel dead'. By 1898, however, Hilaire Belloc struck a different tone:

> Whatever happens, we have got
> The Maxim gun, and they have not.[11]

The Maxim was portable as well as lethal; Admiral Rawson's main force on the Ologbo route carried sixteen by hand (Phillips had predicted one would be sufficient to take Benin). Captain William Heneker was an officer in the NCPF who wrote a guide in 1907 for British soldiers, *Bush Warfare*, partially based on his experiences fighting the Edo. His advice was that 'Maxim and machine guns are of immense service against savages, especially so when the enemy is given to charging home with cold steel.'[12]

H. G. Wells's novel *The War of the Worlds* was published in 1898. The Victorian public was thrilled by the sci-fi horror story of a Martian invasion of Earth. The Martians had vastly superior weapons and a chilling indifference to the civilisation they destroyed. *The War of the Worlds* was an instant hit, but Wells's intended analogy with imperialism was lost on many.

As the British advanced on foot on the narrow path leading north from Ologbo, their tactic was similar to that they'd employed on the boats; they fired volleys ahead and into the forest on either side, hoping to disrupt ambushes and lure hidden Edo soldiers into giving their presence away with return shots. It was crude, and wasteful of ammunition, but not ineffective. The extent of casualties in the forest around Ologbo only became apparent when the bodies of Edo soldiers started to smell in the humid heat. Some days after the battle of Ologbo, the British found thirty-eight corpses in the surrounding bush.[13]

Both the British diversionary attacks ran into difficulties. At Ughoton, a large Edo force drove the British back to their boats, with two officers injured.[14] At Sapoba, things went even worse for the British. Lieutenant-Commander Charles Pritchard, captain of the gunboat *Alecto* and a large man with a red beard, was killed, as was another sailor. They'd been ambushed by an unexpectedly strong Edo force. Sapoba was some distance from Benin City, and the British had thought people there would be sympathetic to them; it was, an officer admitted, a 'district where such decided opposition was hardly looked for'.[15] The British fired back with a Maxim, buried their dead and retreated. There was a grisly footnote. When the British did eventually reach Benin City, they found a pile of heads, including Pritchard's, distinguished by his distinctive beard and hair.[16] The Edo had dug up the British graves, and carried body parts back to Benin.[17]

Confronted by this resistance, Rawson reverted to his original plan of landing a larger force at Ologbo, and sent a message back to the cruisers for reinforcements. An intelligence officer, Commander Reginald Bacon, wrote that 'things were far too serious to admit of doubting for a moment the courage of the enemy in the bush, or their skill as bushmen'.[18] This assessment of the Edo soldiers would only be confirmed over subsequent days.

'Imagine a country of 2,500 square miles one mass of forest,' wrote Bacon, 'without one break except a small clearing here and there for a village…Imagine this forest stoked with trees some 200 feet high… Imagine between all these trees an undergrowth…so thick that the eye

could never penetrate more than twenty yards, and often not even ten. Imagine the fact that you might easily walk for an hour without seeing the sun overhead.'[19] The British column moved forward, tentatively, stretched out over five kilometres along the path. They fired volley after volley into the forest, and yet the attacks from the Edo soldiers barely relented for much of the march. Dr Felix Norman Roth, the Vice-Consul from Warri who accompanied the Expedition as one of the few medical doctors in the protectorate, describes coming under ambush again and again: 'Our firing was pretty hot, the rattling of the Maxims and the rifles, the shouting of the officers, the howling of the enemy, and the excitement amongst our own carriers are beyond me to describe. The excitement in the dense bush, the smoke, the working of the seven-pounders, and the whizzing past of our rockets put the fear of God both into ourselves and the natives.'[20] Roth was busy; several NCPF soldiers and carriers were shot and injured, and he could not save all of them. It was the African soldiers, according to Roth, who were at the forefront of the British assault: 'our black troops with the scouts in front and a few Maxims, do all the fighting'.[21]

After four days of slow progress, the British officers wondered how much more they could take. 'Pretty tired & so hoarse with shouting that I can hardly speak,' wrote Herbert Walker in his diary on the evening of 17 February.[22] By then, Roth admitted, 'it is hard to imagine what our nerves are like, after firing away and being fired at for so many hours on a blazing hot day…in dense bush…where we never get a glimpse of those who are potting at us.'[23] The invisible enemy had won their respect. 'They were certainly very plucky, considering the weapons they had to stand against, and proved themselves most clever bushmen, thoroughly understanding that nature of fighting,' wrote Bacon. 'The estimate formed beforehand of their fighting qualities proved entirely erroneous, and there was present among them a large portion of the pluck and military spirit [which had once made] Benin the Queen of Cities of that portion of the Continent.'[24]

Rawson found the advance physically gruelling. 'He was a big and heavy man… the long marches through the bush was very hard on him,'

remembered one of his officers.[25] He plodded along with a wide-brimmed sun hat and a walking stick, sometimes discarding his navy uniform for light trousers and shirt.[26] In a letter to Sir Frederick Richards, First Sea Lord, he said his men had 'an awful time'. They knew they were close to Benin City but were not sure of its exact location, and Rawson confessed he 'felt the responsibility greatly'.[27] He is said to have wept like a father each time one of his men fell.[28] Roth worried that the Admiral was in poor health and under strain: 'he could not sleep at night, as he has so much on his mind'.[29]

The biggest problem was water. Rawson's men were desperately thirsty, and disappointed to find empty wells in the deserted villages along the path. Reconnaissance parties were sent into the surrounding bush, but failed to find springs or streams. Back at Ologbo the British were boiling creek water as fast as they could, and sending it by carrier up the line.[30] On 15 February, only two days into the march, Rawson felt compelled to cut the allowance. The white men and African soldiers of the NCPF would henceforth receive only one quart (just over a litre) per day, and the carriers were reduced to half this amount.[31] That evening three carriers were brought to the doctors in a state of collapse. The doctors worried that if they gave these men water, fifty more would come forward. 'The natives are cunning,' Commander Bacon wrote, implying they were merely trying it on.[32] A young Lieutenant from HMS *Barrosa*, Walter Cowan, had been given the job of controlling the carriers on the march; not easy amid gunfire, as 'they easily panicked and ran for it, throwing their loads down as they went'. Cowan's recollection, according to his biographer, was that the carriers 'became mad with thirst, and that, much to his distaste, he had to use stern measures to prevent them from looting the kerosene tins in which the water was carried, flogging the culprits on the spot...One way and another, either from thirst or straying outside the camp to look for moisture of any sort and being killed at once by the enemy, he lost about fifty on the way up.'[33] In other words, the shortage of water, but also the British allocation of it, caused deaths and desertion.

Rawson said that Cowan's performance 'was beyond all praise'.[34] But the water crisis was forcing his hand. He could delay the attack on Benin

City, potentially by a fortnight, and build water depots along the route. That brought with it the risk of fever, more carriers disappearing into the forest, renewed enemy attacks and the prospect of being caught in the first rains of the season.[35] He chose a second option. He formed a 'flying column' – 500 fighting men, supported by 840 carriers carrying enough water for three days – which cut loose from the main force and its increasingly cumbersome supply lines. This flying column – led by Rawson himself – aimed to capture Benin City by the end of 18 February. They would have to find water there, and the remainder of the British force would march in behind.

After a breakfast of biscuits and cocoa, Rawson and his men left the village of Awako at six in the morning on 18 February.[36] Benin City was still some thirteen kilometres away, although the British believed it to be less than ten.[37] They soon came under attack again. Chief Petty Officer Sydney Ansell, of the *St George*, was shot in the head from a distance of only a few metres, and died instantly.[38] His colleagues buried him by the path and moved on, but Edo soldiers continued to harass them. A stockade blocked their way, on a causeway over a deep ditch. The British had reached Benin City's old defensive walls. On the stockade, Edo soldiers manned several antique cannons – 'much the same as used in the Spanish Armada', according to Commander Bacon – but to little effect.[39] The British fired their Maxim guns, and used explosives to blow the stockade away and cross the ditch. They had breached Benin's defences, and were now less than two kilometres from the Oba's palace.

In Benin City, the atmosphere was febrile. People had heard the noise of the British guns all morning, but then a terrifying thing happened. Out of the blue sky came 'two hissing thunderbolts', metal streaks of fire, landing right in the palace compound. 'Not a white man in sight! Yet here were two messages from the sky,' said one woman who saw the rockets fall.[40] To Oba Ovonramwen, and the hundreds who had thronged to be at his side, it seemed the white men had the power of gods. They panicked, and abandoned the palace.

The British had got lucky. They knew the rocket missiles they had brought to West Africa – made at the Royal Arsenal Woolwich where

workers had stayed on the factory floor 'up to midnight' to supply the Expedition in time – had the potential to be effective weapons. Newspapers had brazenly assured readers that 'before bombarding any place with incendiary missiles the women and children will have an opportunity to leave'.[41] In practice, the British took no such precautions. Gunner Johnston of HMS *Philomel* had simply aimed his rocket tubes high in the direction of Benin City, not knowing he would score such a fortuitous hit.

But when the British emerged onto a wide grassy avenue which separated the palace from the town, they met their most furious resistance yet. These were the final moments of the battle for Benin City as the Edo soldiers, hidden in surrounding trees and buildings, fired their last bullets. This, according to Edo legend, is where Asoro made his stand, commemorated with the statue in the middle of Benin City. Captain Gervis Byrne of the Royal Marines collapsed in agony, a bullet lodged behind his spine. Private Alfred Batchelor, Captain Byrne's personal servant, watched in horror as 'native sharpshooters' in the trees picked off his colleagues, conspicuous in their red coats. Four other marines were killed and sixteen wounded. A surgeon, Dr C. J. Fyfe of the *St George*, who was tending to Captain Byrne, was himself shot in the neck and killed.[42] Then the British trained a Maxim gun on the trees, and, in Private Batchelor's words, the Edo soldiers 'fell like nuts'.[43]

Roth was also caught up in this frenzied climax, trying to stem the bleeding of wounded colleagues as he came under attack. From the heavy and rapid gunfire and repeated pings in the grass around him, he realised that at least some of the Edo soldiers were using modern repeating rifles rather than mere Dane guns.

> I was in the middle of it and feeling most uncomfortable...I have never seen anything like it before; the grass was in patches only about two feet high, and I was obliged to crawl with my black boy Charles from one wounded to another...I noticed three of the men in a dying condition; others were shrieking, cursing and damning the natives. One man implored me to let

him have his revolver back, that he might shoot himself, the
agony he suffered being so great…unseen by me he pulled
my loaded revolver out of its case, but I was just in time to
knock it out of his hand.[44]

By now Rawson was outside the Oba's palace, where the Edo mounted a
final defence. They fired another antique cannon, spraying shrapnel into
the legs of the advancing British. Rawson shouted, 'Now, men, before
they load again, charge!' The bugler sounded the charge, Hamilton roared
everyone on, and the Oba's men ran.[45] It was the end. For the first time
in its thousand-year history, Benin had fallen.

The British should have felt triumphant. Rawson's gamble had paid off. 'A
weaker man might have hesitated and been lost,' wrote *The Times*.[46] He
'took a risk and won, but not by much', according to one of his officers,
'the slightest hitch, the slightest delay could have been fatal'.[47] But in
the immediate aftermath of victory, Rawson's men seemed to feel only
disgust and rage. 'The city is the most gruesome sight I've ever seen. The
whole pace is littered with sculls [*sic*] & corpses in various stages of decay,
many of them fresh human sacrifices,' wrote Walker in his diary.[48] As the
British closed in on them, the Edo had killed many of their slaves and
prisoners, in a desperate attempt to appease their gods and protect their
city. The British had had an indication of what was happening earlier in
the day. Walker recorded, 'As we approached the city through the bush,
we found bodies of slaves newly sacrificed & placed across the path…The
first we came across was a woman, gagged, with her entrails tastefully
arranged in the form of a cross, & tied to her was a kid [baby goat] still
alive & covered with blood…Further on another slave with his head cut
off.' But this was just a foretaste of what was ahead.

As the troops entered Benin City, a man bleeding from his head
ran towards them to warn that the Edo were murdering their Itsekiri
prisoners.[49] The British could see people being hurriedly beheaded
outside the Oba's palace, even as they marched towards it.[50] Some of
these unfortunate victims had been carriers with Vice-Consul Phillips,

captured during the ambush the previous month. Roth wrote in his diary, 'Dead and mutilated bodies seemed to be everywhere – by God! May I never see such sights again!…The whole place reeked of blood.'[51] Major Frederick Landon wrote to his wife, 'I have got the smell of dead bodies and blood so thoroughly into my nose that I can't smell anything else… The place is like a hideous nightmare.'[52] Rawson, too, was overwhelmed: 'this place reeks of sacrifices and human blood, bodies in every state of decay, wells full of newly killed, crucified men on the fetish trees (which we have blown up), one sees men retching everywhere. I've got the taste of blood in my mouth till I often vomit. No one can realize what it is without seeing it.'[53] A Royal Marine, Private Albert Lucy, of the *Theseus*, also kept a diary. He was appalled by what he saw: 'the crucifixion tree with bodies stretched on it to dry and rot in the heat of the sun. Ju Ju houses all along the road with dead n****rs lying outside, men who had been killed quickly as an offering to their gods…poor ignorant savages.'[54]

Dr Robert Allman, the Chief Medical Officer of the protectorate, accompanied the troops into Benin. His record makes for difficult reading. On a large plain on the edge of the city, he 'witnessed one of the most horrible sights that it is possible for the human mind to conceive – i.e one hundred and seventy-six newly decapitated and mutilated human sacrifices strewn about in all directions, besides countless numbers of skeletons – truly, a most gruesome sight and one not to be easily forgotten.' Allman counted, in addition, seven deep pits, each one containing fifteen to twenty bodies. He could hear faint groaning from one pit and supervised the rescue, 'with great difficulty, of seven unfortunate captives, who for several days afterwards could hardly realise what had happened; two of them were carriers on Mr. Phillip's ill-fated expedition.'[55]

According to Moor, a traumatised survivor pulled out of the pits told the British that he'd seen four white men being brought into Benin City the day after the ambush on Phillips's expedition, and that he recognised Phillips himself among them. The following day, this survivor said, he saw the heads of the white men on display, gags in their mouths.[56] This story was widely believed by British troops in Benin City; Captain Walker wrote in his diary that they'd discovered the possessions of British officers

in the palace and 'four of them are known to have been brought up and sacrificed'.[57] This would explain why Dr Allman found what he took to be 'the decapitated remains of three Europeans, who had evidently been gagged and their hands bound behind their back before execution'. Whatever the truth, Moor advised the Foreign Office not to allow these stories to leak out, so as not to distress the bereaved families.

In total, Allman recorded some 600 bodies in Benin City, of which he believed about 450 were victims of human sacrifice.[58] Can we believe Allman, and other British eyewitnesses? Their accounts don't address the possibility that at least some of the bodies were victims of British firing during the invasion of the city. But their descriptions of atrocities are consistent, several were written in the immediate aftermath, and, awkwardly for those who would dismiss them as propaganda, some come from diaries and private letters that were never intended for publication. Surgeon Edgar Dimsey of the *Phoebe*, wrote to his father of how, moments after the British victory, he took 'the wounded into the priests' compound, but could not place them under cover as the houses were full of the remains of human sacrifices, covered in human blood.'[59] Commander Bacon, however, was hoping to reach as wide an audience as possible when he wrote the book *City of Blood* shortly after returning to England. The title resonated with the British public, and if the book itself was soon forgotten at home, its legacy endured. In Benin City, however, it still causes offence, not only because of its connotations of barbarism, but also because of its association with humiliating defeat. Bacon had reasons to exaggerate; he had a book to sell, and his argument, that the British had acted selflessly to stop savagery rather than with an eye to commercial opportunities, was what the Victorian public wanted to read. Bacon wrote that human sacrifice on the scale the British had encountered had been going on for centuries, and at the height of Benin's power 'must have been practised with, if possible, greater intensity than at the present day'.[60] He had no evidence to support such a sweeping claim.

I've found it difficult to discuss with people in Benin City what happened immediately before the British arrived. It was as if to acknowledge too much would somehow negate the wrong that was done against them.

Patrick Oronsaye, usually so forthcoming, brushed my questions aside with an impatient exclamation of 'Bullshit!' On Ezotie Street, behind the Oba's palace, is a modest library and study centre, where I met Aiko Obabaifo. His Benin Institute comprises two small rooms, and a collection of ageing books and journals, on shelves neatly labelled: *Benin History, Nigerian History, History of the World*. Aiko, in his youth a Baltic fisherman and to this day a fluent speaker of Polish, set up the institute with a group of Edo scholars to pass on their passion for Benin history, and to fill the gaps vacated by others. Aiko says, 'We used to have libraries in this town, the British Council library, the American Council library, the State library, they've all gone.' When I asked him about evidence the British discovered of mass killings in Benin City, he said, 'We had an invading force. There may have been some negligence on behalf of the defensive forces. Some people may have been court-martialled and executed by military sanction. We don't apologise for that. Some were executed, some were found to be doing espionage.' Then he paused for a long time, after which he said, 'When you use present-day parameters to assess Benin life of that time, you might be missing the point completely.'[61]

The political and economic power of the Obas and their chiefs had gradually eroded away during the nineteenth century. Benin's leaders had retreated, an anthropologist writes, 'into an elaboration of ritual violence and terror to maintain control over its population'.[62] The longstanding fear of a British invasion became a chilling certainty after the attack on Phillips's expedition, and so the process reached a dreadful climax. Kathy Curnow, an American academic who has studied Edo culture and history for many decades, said, 'It was panic. Extensive human sacrifice was not common in Benin, but it did happen at moments of vulnerability.'[63] In 1960, Prince Edun Akenzua, Oba Ovonramwen's great-grandson, wrote that sacrifices were intensified in those frantic final days and hours, 'in the slender hope that the gods would ward off the danger that seemed imminent'.[64] The killings were intended to keep the British away. They were in anticipation of the impending invasion, not the cause of it, yet they would enable the British to justify their actions.

A REGULAR HARVEST OF LOOT!

'I can practically get as much ivory as I like,' wrote a British officer.

The British had taken control of an all-but-deserted city. 'The whole population, which must have numbered some thousands, had fled away into the bush,' said an officer.[1] In fact, some elderly people, women and children remained, but the Oba and his chiefs were nowhere to be

seen. Admiral Rawson slept in the Oba's palace on the night of the 18th, and sent a party out the following morning to search for fresh water.[2] They returned with good news; a fast running river, the Ikpoba, was only three kilometres away, and there was no sign of Edo soldiers. Dr Robert Allman, meanwhile, had to act quickly; the stench of bodies was overwhelming, diarrhoea was already spreading through the troops, and within days six men – African soldiers with the NCPF and carriers – had died of sickness.[3] But while he set about organising burials and cremations, other officers had begun to rummage through the palace.

The storehouses of the palace, according to Commander Bacon, were at first glance full 'of cheap rubbish…old uniforms, absurd umbrellas, and the usual cheap finery that traders use to tickle the fancy of the natives'.[4] This cursory impression was misleading. As the British explored more, they made an unexpected discovery: 'buried in the dirt of ages…were several hundred unique bronze plaques, suggestive of almost Egyptian design, but of really superb casting'.[5] Elsewhere in the palace, they found the altars to some thirty deceased Obas, decorated with carved tusks, cast metal heads and more statues. Many of the altars, according to Bacon, were 'deluged in blood'.[6] The doors were lined with stamped brass, as were parts of the rafters. 'The king's house is rather a marvel,' wrote Dr Felix Norman Roth.[7]

The British had stumbled across the Benin Bronzes.

Henry Gallwey, who had persuaded Ovonramwen into the 1892 treaty and who returned to Benin City days after its fall, was the only British officer who had previously been to Benin and inside the Oba's palace. But even he was surprised by the extent of the 'wonderful collection' the British had now got their hands on. It was, he enthused, 'a regular harvest of loot!'[8] The British picked up whatever they could carry, and took it to the Oba's council chamber and a central courtyard, next to their makeshift staff headquarters and hospital. For the Edo, the shrines and plaques were a record of history, spiritual beliefs and artistic progression over the centuries; effectively Benin's national library, cathedral and museum. But for the British, they were instruments of the Oba's power and of the practice of human sacrifice, both of which they were determined to end.

They did not bother to record how many pieces they took, where they found them within the palace, which pieces belonged to which altar, or the relative position of shrines or altars. It was a moment of vandalism, a rupturing of tradition and knowledge, that scholars of Benin's art and history have spent many decades trying to repair.

The officers posed for photos, surrounded by their booty. They look tired and dirty, but satisfied, just as a white hunter looks pleased holding up the head of a fallen buffalo, or with his foot on a dead elephant. They sit in their pith helmets amid piles and piles of tusks, rows of brass heads, ivory and brass leopards, with their hands on their hips, or around the shoulders of their friends and colleagues. Already, seeing the amusement in their eyes, one can almost hear the questions which would be asked again and again in the coming years: 'Who would have thought they had all this fine stuff?' And, their faces betraying little smiles of incredulity: 'Surely they didn't make this themselves?' (See illustration section.) In Captain Walker's diary, his photos of the assembled tusks, watched over by an armed guard, are simply captioned 'Loot' and 'More Loot'.

British officers in the Oba's palace.

The senior officers had first pick. Walker grumbled, 'Two tusks & two ivory leopards have been reserved for the Queen. The Admiral & his staff have been very busy "safeguarding" the remainder, so I doubt if there would be much left for smaller fry, even if we had any carriers to take it down.'[9] Rawson had chosen well; the ivory leopards he selected for Queen Victoria were spectacular, unique in Benin's art. Standing about twice the height of a domestic cat, each was made from five separate tusks. The leopards' 'spots' were pieces of copper, knocked into round depressions in the ivory. Major Landon told his wife, 'I can practically get as much ivory as I like…and have also got a lot of little things to give to people.'[10] Captain George Egerton, Rawson's dependable chief of staff, was rewarded with about a dozen major bronzes and tusks.[11] Lieutenant Walter Cowan took, among other things, a 'most beautiful curved and balanced executioner's sword, very heavy, with an ivory and silver handle, and very old'. He gave it to a friend in Cape Town, who sold it at Christie's.[12]

It was not quite a free-for-all; Rawson and Consul-General Moor knew the British government would welcome a contribution towards the costs of the Expedition, just as Phillips had suggested. Moor kept the hundreds of brass plaques and a portion of the tusks to one side, as the intention was to sell these on behalf of the Foreign Office.[13] These were packed up and either shipped to Lagos or on to London, where most arrived in June and July, sitting in six 'very bulky' cases in the quadrangle outside the Colonial Office.[14] But Walker need not have worried; as he remarked, the whole camp was strewn with objects from the Oba's palace. There was plenty to go around, and not just for the officers. Even after they had taken the finest ivory carvings, brass heads and statues, there were still rattle staffs, bells, mirrors, necklaces, bracelets, rings, masks, wooden stools, boxes and even jars of gin for the junior ranks. Private Lucy of the Royal Marines wrote that he 'strolled around the city getting curios'.[15] Away from the Oba's palace, the soldiers found many chiefs' and priests' shrines, decorated with terracotta heads and wooden carvings. Even the carriers got in on the act; Walker describes how they strutted around 'decked out in the most extraordinary garments'.[16]

Cowan says the return march from Benin to the ships was chaotic, carriers 'stuffed with loot', in addition to heavy loads of equipment. The British were in a hurry to evacuate their sick and wounded, and some of 'the loot would be cut away from [the carriers] and scattered in the bush as a warning against lagging'.[17] Lieutenant Vernon Haggard was frustrated he didn't make it to Benin City. He was stationed at Crossroads Camp, on the Ologbo route, when Rawson and his staff returned on the evening of 23 February. Staggering behind them, according to Haggard, were 'carrier after carrier bearing tusks, carved and uncarved, bronzes, panels, and all sorts of loot'.[18]

The plundering carried on for some time. Commander James Startin of the *Barrosa* did not arrive in Benin City until 12 March. Startin – a fervent evangelical much admired for his courage – had walked through the night, all the way from Ughoton, losing his escort and carriers along the way but arrived feeling quite fresh. 'Mad as a hatter!' Walker wrote. 'Is now wandering round with chisel & hammer, knocking off brass figures & collecting all sorts of rubbish as loot.'[19] Walker himself left Benin on 15 March. He'd spent his final day busy packing his own spoils of war. He marched down towards Ughoton with Moor and a column of soldiers of the NCPF: 'Every Hausa with huge bundle on his head, chiefly loot, in addition to rifle, ammunition etc. Should be sorry to do it myself.'[20] The following evening, Walker and Moor were dining together on the protectorate launch, the *Ivy*. 'Delightful to get a decent bath at last & iced beer! Civilization can only be appreciated after six weeks' roughing it,' wrote Walker.[21] He arrived in Liverpool one month later, feeling fit and strong. There's little agreement on just how much was taken from Benin in the weeks after the fall of the city; a few years later a leading German scholar estimated 2,400 pieces, but a British expert of the late twentieth century believed the figure to be closer to 4,000.[22]

On Sunday 21 February, the British troops in Benin City held a morning prayer service and gave thanks for victory. In the afternoon Rawson retired to the palace to write a letter to the First Sea Lord, Sir Frederick Richards. At 4 p.m. he was called out by his staff because of

reports a fire was sweeping across Benin City. Rawson was astonished by its fury; 'I never saw or could have imagined the way the flames whirled through the air,' he wrote.[23] A strong wind fuelled the blaze, 'and the fire increased frightfully, the flames passing from house to house, and even setting light to the trees,' according to Roth.[24] The wind picked up burning branches, and threw them over the thatched roofs, spreading the fire faster and further. Within an hour the blaze had burnt itself out, but by then much of Benin City, and the palace itself, had been reduced to ashes.

That the British deliberately burnt Benin City to the ground is an article of faith among the Edo people, and exacerbates the sense of injustice left by the invasion and theft of their treasures. Prince Edun Akenzua wrote in 1960 that 'many people believe today that the British decided to burn the town as an "appropriate finale" to the punishment', and that conviction endures to this day.[25] Patrick Oronsaye told me 'they had to burn down the city to show the strength of British imperial power'.[26] Others, like Aiko Obabaifo, argue that the British did it to protect their health, given the number of decomposing corpses strewn around the city. Private Lucy would appear to confirm British culpability with his diary entry: 'our blue jackets went out and burned the Kings Palace'.[27]

There were precedents. In 1868, in Abyssinia, another punitive expedition, led by General Sir Robert Napier, attacked the fortress at Maqdala, with the stated objective of freeing a group of European hostages. British artillery overwhelmed the poorly armed Abyssinian forces, whose Emperor Tewodros committed suicide. British soldiers then ransacked the Emperor's library and treasury, and used fifteen elephants and 200 mules to carry away manuscripts, treasures and religious artefacts. The famous journalist Henry Morton Stanley watched as the British proceeded to burn Maqdala to the ground: 'three thousand houses and a million combustible things were burning. Not one house would have escaped destruction in the mighty ebb and flow of that deluge of fire.'[28] In 1874, the British burnt down the city of Kumasi, near the Gold Coast Colony, following General Garnet Wolseley's victory over

the Ashanti.[29] Rawson himself had form; from the callow midshipman who took part in the looting and burning of the Emperor's palace in Peking, to the Admiral who led the 1895 expedition against Mweli in East Africa, where, according to the British Consul-General, 'all the houses were razed to the ground'. So too was much of the surrounding forest, at Rawson's explicit instructions.[30] Captain William Heneker wrote in *Bush Warfare*, his guidebook for British officers fighting in the Niger Coast Protectorate, 'The capture and burning of towns is, of course, a concomitant to savage fighting.'[31]

Despite all this, there's strong evidence that the great fire of Benin was accidental. Rawson was forced to abandon his letter to Sir Frederick Richards. He resumed it four days later, with an apologetic explanation that the unexpected fire had interrupted his writing and of how the British had scrambled to move their wounded away from the onrushing flames, losing many provisions and half their precious water supply in the process.[32] This version of events is corroborated by Walker, who wrote in his diary for 21 February, 'A fire suddenly broke out, which in half an hour completely gutted this quarter of the city. Only just time to remove sick & wounded...many officers lost their entire kit. My two boys got most of my things out, by throwing everything on to the camp bed & carrying it out bodily...But I find all my leg gear, putties & gaiters, is missing. Shall have to do without for the rest of the time.'[33]

Some British officers blamed the fire on two drunken carriers who'd accidentally set light to a thatched roof while messing about with gunpowder.[34] Lieutenant Haggard wrote, without irony, 'the coolies they say started it so that they may loot undisturbed'. One of the burnt carriers was taken to the hospital at Sapele by boat, but 'he could stand the pain no longer and jumped overboard and was drowned'.[35]

The most compelling reason to believe the British did not deliberately burn down Benin City is that they would have felt little shame in admitting it if they had. Some even complained the fire had damaged many of the treasures they had just looted from the palace. Lieutenant William Crawford Cockburn was with the NCPF, and fought alongside Walker during the advance from Ologbo. The day after the fire, he wrote

a letter from Benin City to an officer at a rear camp, with an urgent request for pickaxes, shovels and machetes. He said that 'we had an awful catastrophe yesterday – whole city burnt and most fellows lost all kit. All mess stores were burnt and all best of loot.' Crawford Cockburn lamented he had 'lost a beautiful tusk and some fine masks'.[36] Among other destroyed treasures was the bronze serpent which had adorned the palace roof, and many tusks were blackened and charred.[37] (Crawford Cockburn does not write about how much of his loot was still intact, but he must have left Benin City with a substantial haul, as he later sold seventy-two pieces to the British Museum and donated a further two.)[38]

On the day before the fire, Admiral Rawson had sent out British troops with instructions to burn down a large compound belonging to a chief identified in the fighting along the Ologbo path – the thatched roofs 'made a good blaze' according to Bacon – as well as the Queen Mother's compound, and another twelve 'juju houses' which the British associated with human sacrifice.[39] Captain Walker wrote that he was 'busy demolishing houses' all of that morning in order to improve defences around the new British headquarters in the Oba's palace.[40] It may be that the widespread destruction and arson of 20 February became conflated in Benin folk memory with the conflagration of the following day.

The events of February 1897 make for uncomfortable reading. From the perspective of the early twenty-first century, the attitudes and language of the British officers are brutal and ugly. They use the 'n' word casually and frequently. There was one black officer on the Expedition – Lieutenant J. Daniels of the NCPF, who was injured at Ologbo but fought on to Benin City. He poses with his colleagues in two photographs in the Oba's palace, clutching a pith helmet, his expression inscrutable (p.88). They regarded him highly, and not only for his fluency in local languages; Boisragon wrote he was 'as plucky as any white man', while Heneker said 'he was an exceptional man. Fearless…and having natural ability to command.'[41] But more intriguingly, what did Daniels think of them? He left nothing in writing, and we can only imagine.

Lieutenant Vernon Haggard was supervising carriers on the supply routes to the troops. He wrote of them, in a letter to his 'Dearest Father

and Mother' no less: 'Their only redeeming feature is their fear and respect of the white man and the fact that one can whack them as much as you please. After knowing them a short time one ceases to look at them as men and to consider them as something lower than asses.'[42] This was how the British treated those they had cajoled to be on their own side. As for the enemy, Heneker admitted the Edo 'fought with great bravery and determination'. But in his handbook *Bush Warfare*, he recommends an approach of maximum cruelty: 'if…the enemy has not been made to suffer severely, difficulties and dangers are at once added to the commander's responsibilities'.[43] Heneker – whose own collection of twenty-two Benin Bronzes was bought at a London auction by the British Museum in 1900 – went on to fight with distinction in the First World War, where he was wounded in the trenches.[44] Upon his death in 1939 he was remembered in his *Times* obituary as someone who 'possessed a sure instinct in dealing with the natives'.[45] The British made no attempt to count how many Edo soldiers – or indeed civilians – they had killed, but given the discrepancy in weaponry, they must have inflicted terrible casualties. As for the human sacrifices carried out by the Edo defenders of Benin City, it was Edun Akenzua who wrote that his people 'were, almost to the point of fanaticism, devoted to their gods although those gods were insatiable in their lust for human blood'.[46]

There is little evidence of subsequent contrition from the British officers involved in the Benin Expedition. I've trawled through dozens of their obituaries. How remote their lives read today, encompassing the triumphs and disasters of the final decades of the British Empire. Those in the navy had been at sea since their early teens. They lived lives of adventure, hardship and sacrifice, and they carried, unquestioningly, assumptions of British superiority. Typically Benin is only briefly mentioned, for the younger ones an exotic precursor to the great conflicts which followed.

A handful of these men survived into the 1960s and even 1970s. Attitudes they formed in their youth only seemed to calcify in later years. In the 1960s, a retired Captain in his eighties who had enjoyed a long and

successful Royal Navy career, 'a very charming older man' according to *The Times*, reflected on his first adventures as a teenage midshipman in 1897: 'to me, after Benin, the n****r has always seemed to be of a lower creation…my recollection of the Benin Expedition is thirst and mosquitoes and the smell of unwashed humanity.'[47]

Admiral Gilbert Stephenson died in 1974, aged ninety-four, a legendary officer within the Royal Navy. He too had been a teenage midshipman on the Benin Expedition. He fought at Gallipoli, came out of retirement in his sixties to serve again during the Second World War, was at Dunkirk and played a key role in the Battle of the Atlantic, training sailors on how to locate and fight German U-boats.[48] In an interview shortly before his death, he maintained that Oba Ovonramwen had been 'evil'.[49] After the British had subdued 'the natives' in Benin City, Stephenson remembered, they had been obliged to gather all the Bronzes together, 'in order to prevent them from being looted'.[50]

Vernon Haggard, so sadistic in his treatment of the carriers, died as a grand old man of the navy in 1960, a former head of the submarine service and Fourth Sea Lord of the Admiralty, knighted and generously medalled. His participation in the Benin Expedition was not even mentioned in his *Times* obituary.[51] And yet, uniquely among the British officers, he wrote of a lingering feeling of unease. Clippings of exhibitions of Benin Bronzes are folded among his papers. Many years after the Expedition he wrote, 'The loot was beautiful stuff – richly carved tusks, delicate ivory armlets and fine bronze masks and plaques.' Then he reflected on what the British had done and its effect, not on the Edo, but on themselves: 'What I saw of looting on this expedition has made me set my face strongly against it on subsequent occasions. Nothing is more demoralising. It calls forth some of the worst human qualities and inevitably leads to quarrelling and neglect of duty.'[52] Within the confines of the constrained language and prejudices of the time, Haggard's was almost an admission: that the distinction between 'civilised' and 'savage' is not always clear.

THE WHITE MAN IS THE ONLY
MAN WHO IS KING IN THIS COUNTRY

On 23 July 1964, James Callaghan sat down in his office in the House of Commons to write a letter. He was replying to a young historian, who was curious about a detail of his father's career. Callaghan, fifty-two, had been a Labour MP since 1945 and was on the brink of a distinguished career in government. Labour would win the election in October 1964, and Callaghan would go on to become the first, and at the time of writing, only person to have occupied all of Britain's four great offices of state: Chancellor of the Exchequer, Home Secretary, Foreign Secretary and Prime Minister. When he eventually entered 10 Downing Street, in 1976, he was also the first Prime Minister to have served in the Royal Navy, in the Far East against Japan during the 1940s. Perhaps this was why James Callaghan was always interested in his father's own naval career. He was only nine years old when his father died. Despite this, and the fact that his father's records were destroyed in the Blitz, Callaghan had pieced together the details of his life.

James Garoghan was born in 1878, one of ten children. He ran away from home when he was fifteen – 'high-spirited and adventurous' – to join the navy, giving the recruiting officer a false surname and age so that his parents could not trace him.[1] His naval career, as James Callaghan

senior, lasted twenty-six years and took him around the world. He served on the Royal Yacht, and he fought at Jutland. He applied to go on Scott's expedition to Antarctica, but was rejected.[2] He was a qualified deep-sea diver and expert dancer of the hornpipe. His family were left destitute by his sudden death in 1921, and James junior was too poor to go to university. This was a source of lasting regret, but did not impede his political rise. James Callaghan was perhaps most fulfilled at the Foreign Office in the mid-1970s, where his interests included Africa and the fight against poverty in the developing world.[3]

James Callaghan answered the historian's query as best as he could. Yes, he was aware that his father had been a Leading Seaman on HMS *St George*. But no, he did not know he had participated in the 1897 Benin Expedition. In fact, he had to admit, he'd never heard of such an expedition before, and was grateful to the historian for bringing it to his attention.[4]

It was a telling confession. Not for what it said about James Callaghan – a public-spirited man – but about the vast gulf between Benin and Britain. For Benin, the British invasion will always represent the moment, as Patrick Oronsaye had told me, the 'world turned upside down'. For Britain it was another small campaign against a primitive tribe on the frontier of Empire, of little consequence after the brief thrill of victory. It's perhaps not surprising that the children of those who toppled the Oba and took his treasure should have been oblivious of those events. The winners get to write history. Often that means forgetting its less convenient chapters.

Admiral Rawson was carried in a hammock on the march back from Benin City. He said it was 'rather humiliating, but I was completely done'.[5] By 27 February, his landing force had boarded the river steamers at the little station of Warrigi, and was ready to sail towards the waiting ships in the open sea. Rawson's concern was to get the sick and wounded onto the ships as soon as possible – it had been 'an awful journey' for them – but also to embark the healthy before they succumbed to what he feared would be an inevitable outbreak of fever. Queen Victoria sent her

congratulations by telegram. She expressed anxiety to hear that all on the Expedition were well, as, in her words, 'the climate, the privations and the horrors they witnessed must have been most fearful'.[6] Her Majesty's concern was well received: 'The pleasure it caused everyone is difficult to describe, showing as it did such interest and sympathy,' according to Commander Bacon.[7] But Lieutenant Haggard reported an unsettling incident as the British prepared to leave. He and his fellow officers were on what he called 'a superior steamer' and, after three arduous weeks in the bush, were enjoying 'the luxury of soft bread and having meals off a table cloth' when their meal was rudely interrupted. The body of a red-coated marine from HMS *Forte*, Private B. Heath, who had been missing for days, suddenly floated up to the river surface, arms raised as if in supplication.[8]

The British got out just in time. By the time Haggard rejoined the *Forte* it had forty-nine men sick. He too came down with fever as the ships passed the Canary Islands.[9] The hospital ship, the *Malacca*, was full. Rawson wrote, 'Every ship has a great many sick and I am afraid [we will] have a great many more.'[10] Seventeen British troops died on the Benin Expedition itself – killed in fighting, accidents or of sickness – but several more later died of fever. Some 2,000 cases were reported from all the ships. When several of the *Forte*'s crew died in a typhoid epidemic in Athens later that year, they were thought to have been weakened by sickness from West Africa.[11] The British did not record the casualties of their carriers; even their deaths in fighting are only reported in passing. Surgeon Edgar Dimsey wrote that when Benin City fell there were 'no end of carriers wounded' but he 'had not time' to look after them and 'several died near me' while he operated on wounded white colleagues instead.[12] Bacon wrote that smallpox was 'fairly prevalent' among carriers, with as many as seventy cases under treatment at one time, but white troops were 'free from this horrid complaint'.[13]

The Royal Marines returned to Portsmouth and Chatham to be met, according to the newspapers, with 'unbounded enthusiasm…The streets were lined with enthusiastic spectators, civilians vieing [sic] with the military in giving vent to their feelings of joy, and swelling the volume

of cheers.'[14] Captain Byrne, in pain from the bullet in his back, was taken to St Thomas' hospital in London. He lay there for several days, paralysed in both legs, feverish, but coherent. He died on 24 March, 'a most excellent officer and greatly respected', the Coroner's Court was told.[15]

Imperial honour had been upheld, Benin City captured a mere forty-five days after Phillips and his companions were ambushed. The speed with which revenge had been enacted was, in Bacon's words, 'so marvellous that it is scarcely credible'.[16] Consequently, the Expedition had come in under budget; Rawson had estimated its cost at £50,000 but only £30,000 was spent.[17] The newspapers were effusive in their praise, and Rawson and Moor were knighted.[18] The *Illustrated London News* had sent a star reporter, Henry Seppings Wright, to accompany the Expedition and on 27 March published a thirteen-page Benin supplement. Seppings Wright, son of a Cornish vicar and once of the Royal Navy, was a war correspondent, artist and bon viveur. His career took him across the world; he travelled the Middle East, covered wars in the Balkans and was embedded with the Japanese navy during the 1905 war with Russia.

Seppings Wright had been to Africa twice in 1896, firstly to report on the Fourth Anglo-Ashanti War and then to accompany General Kitchener's campaign in Sudan. He'd just had time to turn around his latest book, *Soudan '96. The Adventures of a War Artist*, before he set off for Benin. 'Light, sketchy' was *The Times* review, although it made the list of Books of the Week, while the *Manchester Guardian* wrote that Seppings Wright's 'evident enjoyment of his trip is not without a certain infectious quality'.[19] On the frontispiece there is a photo of Seppings Wright in the African bush. Pith-helmeted and bearded, wearing knickerbockers and khaki jacket, pipe in mouth and hands on hips, he casts a swaggering figure. Like all the most successful foreign correspondents, he had an acute sense of what people back home wanted to read and, unlike those of later decades, little inclination to empathise with the people of far-off lands.

Seppings Wright arrived in Benin City with a group of other journalists and sailors from the *Forte* on the evening of 21 February, three days after the fighting was over but only hours after fire had torn through the

city. He travelled on the back of a donkey, carrying supplies for an assumed three-month campaign.[20] Even before he got to Benin, Seppings Wright had made himself popular, sharing a case of champagne with grateful troops at Crossroads Camp.[21] He found Rawson and his colleagues in a miserable state – 'in what a sorry plight...all the private provisions and stores, all the clothes that owners did not happen to be wearing at the time, were destroyed' – and proceeded to cheer them up with his lavish generosity.[22] He handed out cigars, ham, strawberry jam, bottles of pickles, chilli sauce, whisky and claret to the officers, who could scarcely believe their eyes. They feasted together. But Seppings Wright was not done; he produced folding chairs, cork mattresses and blankets, until, in Bacon's words, 'you went to sleep dreaming of him as a mixture of a first-class conjurer and a modern Santa Claus'.[23]

The next day the appreciative officers took Seppings Wright on a tour. His description of Benin City, and the sketches which accompanied it, reinforced its lurid image in Britain. A full-page drawing of the 'The Golgotha, Benin' shows a field of skulls and bones, and the twisted corpses of those who had suffered agonising deaths. Seppings Wright wrote, 'Nothing could be more satisfactory than the work and results of the expedition. The blood of our countrymen had been avenged, and a system of barbarism rendered hideous by the most savage, horrible and bloodthirsty customs that even Africa can show has been effectually broken up...the cause of civilization has been advanced in this benighted district.'[24]

The Benin Expedition was too peripheral to shape the national mood, but its success seemed to validate it. Beatrice Webb wrote in her diary of the Diamond Jubilee celebrations, 'imperialism is in the air... all classes drunk with sightseeing and hysterical loyalty'.[25] The military procession through the packed streets of London on 22 June was a dramatic display of imperial power and colonial fealty. It included eighty West African troops, some based in the Niger Delta, 'fine, soldierlike and athletic men'.[26] On 26 June the Royal Navy held the Jubilee Review of the Fleet at Spithead. It was said to be the largest gathering of warships in history; 173 vessels at anchor for inspection by the Prince of Wales. The

Theseus, its sailors still recovering from Benin and the ravages of fever (twenty-eight were hospitalised when it arrived in Portsmouth earlier that month), was among them.[27] Rudyard Kipling spent a fortnight at Spithead, and *The Times* begged him for a poem to mark the occasion.[28] 'Recessional' – with its presentiment of decline and warning of hubris – may not have been what the public expected.

> Far-called, our navies melt away;
> On dune and headland sinks the fire:
> Lo, all our pomp of yesterday
> Is one with Nineveh and Tyre!
> Judge of the Nations, spare us yet,
> Lest we forget – lest we forget![29]

It was a call for national humility, addressed to a nation wallowing in self-congratulation. Kipling was prescient. The Boer War, only two years away, would be the first shock. Greater ones would follow. But 1897 was not a year for self-reflection or modesty.

Seppings Wright's reports did not mention the looting of Benin's treasures, which he only referred to in passing as 'carved figures of ivory, brass and bronze, having the most grotesque appearance'.[30] I can find no evidence of any contemporary condemnation in Britain of the Benin Expedition for carrying off the contents of the Oba's palace. This is not surprising, given that all accounts of the British victory portrayed the Edo as the essence of depravity. And it was a 'punitive expedition', specifically intended to make the Oba pay for his perceived treachery. And yet the right of victorious armies to take whatever cultural or religious objects they wanted had been questioned in Europe long before 1897. The major powers were even working on a framework of international legislation that would, theoretically at least, prohibit the practice.

The turning point had come as far back as 1815. The Duke of Wellington was in Paris, representing the victorious Allies after the defeat of Napoleon at Waterloo. From Prussia, the Netherlands, Austria, the Vatican, Florence and other parts of Europe came a clamour, a demand

for the return of artworks and cultural treasures that had been seized by Napoleon's armies, or taken through treaties signed under duress. Wellington was convinced the demands were justified. In a letter to the British Foreign Secretary, Lord Castlereagh, published by *The Times*, he explained why he'd assisted the King of the Netherlands to retrieve the Dutch royal collection from the Louvre; he 'could do no otherwise than to restore them to those from whom they had been taken away, contrary to the usages of civilized warfare'. The French, in their 'arrogance…would desire to retain those works of art, not because Paris is the properest place for them to be preserved in, but because they have been acquired by conquests of which they are the trophies'.[31] Stolen goods had to be returned, in Wellington's words, to 'lawful owners', and the representatives of Britain, Prussia and Austria reached agreement that this should happen.[32] The French were not pleased – there were tense stand-offs between Allied soldiers and Parisians, and Wellington was booed at the opera – but most of the artworks taken by Napoleon were returned to their countries of origin.[33]

A principle had been established. In 1874, Great Britain, France, Germany, Russia and eleven other European powers met in Brussels to endorse a declaration on the laws and customs of war, which proscribed pillage and the confiscation of works of art.[34] In 1880, the British Institute of International Law produced the *Oxford Manual of the Laws of War on Land*, which said religious and artistic objects should not be seized; to do so violated the 'principles of justice which guide the public conscience'.[35] All of this suggests a change in values that would eventually be reflected in law. But Europeans were not prepared to apply the same rules to their colonial wars as they did to conflicts on their own continent. In Africa alone, the British had looted Maqdala and Ashanti before Benin City, just as the French had looted Ségou in 1890 and Abomey in 1892.[36]

The 1894 *British War Office Manual of Military Law*, still current in 1897, said the customs of war prohibited pillage, but these customs only applied 'to warfare between civilized nations'.[37] In the same year, a British legal scholar, John Westlake, argued that of 'uncivilized natives international law takes no account. This…does not mean that all rights

are denied to such natives, but that appreciation of their rights is left to the conscience of the state within whose recognized territorial sovereignty they are comprised.'[38] Put simply, European powers could do whatever they wanted in their African colonies.

And yet even at this time, there was the occasional voice of dissent. On 20 June 1871, the Liberal Prime Minister, William Gladstone, told the House of Commons he could not conceive of why the British army had looted Maqdala, and he regretted they had done so. 'They were never at war with the people or the churches of Abyssinia. They were at war with Theodore [Tewodros, the Emperor], who personally had inflicted on them an outrage and a wrong; and he deeply lamented, for the sake of the country, and for the sake of all concerned, that those articles, to us insignificant, though probably to the Abyssinians sacred and imposing symbols…were thought fit to be brought away by a British Army.'[39] Gladstone argued for the return of these objects to Abyssinia, and in 1872 Queen Victoria instructed the British Museum to give back one of Maqdala's holy books, the Kebra Nagast, to the new Emperor of Abyssinia.[40] In 1897, the Liberals were in opposition. Gladstone bemoaned the wave of jingoism that accompanied the Diamond Jubilee, but he was old and frail, and would die the following year. Even if he'd been at the height of his powers, it seems unlikely he would have protested at the looting of Benin, given its portrayal as a city of blood and horror.

In early 1898, the now Sir Ralph Moor, back in London, visited colleagues in the Africa Department of the Foreign Office, and handed out what he remembered as eight or nine Benin Bronzes as trophies to those who had assisted him.[41] This seems to have provoked a stirring in the Foreign Office of, if not quite conscience, at least mild concern as to whether the British force in Benin City had behaved entirely correctly. A Foreign Office lawyer, Mr Clarke, presented his opinion. He was confident that the 'principle of prize or booty had been recognized for years', and there was no reason to assume the Auditor-General or House of Commons would ask difficult questions.[42] Sir Ralph was asked to explain how the Benin loot had been divided up. This he did, writing in a memo that 'In consultation with the Admiral it was determined that reasonable trophies

should be allowed to all officers and others engaged in the operations.'[43] By now Moor may have felt it was prudent to downplay the significance of what had been taken. He told the Foreign Office that rumours that the Oba's court would be a source of great wealth 'were found to be of the fairy description'. A Foreign Office official, Clement Hill, signed off Moor's memo with a curt 'Quite Satisfactory'.[44] There the matter ended.

In 1899, fifty-one countries came together in the Netherlands to sign the Hague Convention on the rules of warfare. The Convention was unequivocal: pillage was prohibited, and any seizure, destruction or intentional damage to religious institutions, historical monuments and works of art should be subject to legal proceedings. The Convention drew no distinction between 'civilized' and 'uncivilized nations'.[45] Unfortunately for the Edo and their Oba, it came two years too late to make any difference to the fate of the Benin Bronzes.

The handful of British officers and administrators left in Benin City set about establishing an administration and building a Residency and barracks for the 100 soldiers of the Niger Coast Protectorate Force. In April, an officer wrote to a golf magazine in Britain, describing how the garrison had already laid out a nine-hole course:

> few people reading their morning papers three months ago at home, with the horrors of a city so graphically depicted, would have conjectured that within four weeks of the final charge on the city walls, the ringing sound of the cleek and the call of 'Fore!' would be heard resounding in the same sanguinary vicinity...The chief drawback...was the huge quantity of human skulls and bones which littered the course; and, sad as it is to state, our best green happens to have been made on the turf immediately beneath a tree known as the 'crucifixion tree', on which many a poor slave breathed his last.[46]

The forced jollity may have been intended to mask the difficulties faced by the British. Several members of the new garrison succumbed to fever

and died. The garrison was isolated; British officials communicated with the rest of the protectorate and the world beyond by sending runners through the forest to the river port of Sapele.[47] Gallwey's claim that the British quickly established 'equity, justice, peace and security' does not match the evidence.[48] Much of the countryside remained out of their control, and many Edo were reluctant to return to their capital. Slowly, methodically, the British set about looking for the most important individuals who had resisted the invasion. These included Aisien, the renowned Edo soldier who had tried to kill the officer at the Ologbo camp. He had returned to his village even before the fall of Benin City, grateful to be alive. But the British tracked him down.[49]

Aisien opened the door of his thatched house to find it surrounded by a cordon of Hausa soldiers from the NCPF. They had been waiting since before dawn. They put him in chains, and marched him back to Benin City as a prisoner of war. Aisien had heard the British were shooting their prisoners by firing squad. A chief called Ebeikinmwin, who had fought the British at Ughoton, had recently been captured and executed. He was said to have called out in defiance, moments before

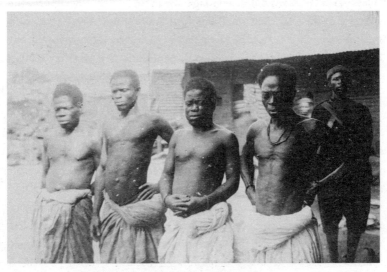

Edo chiefs captured by the British, Benin City, 1897.

he was shot, *Ì ghá khọ̀ọ́n ùwà mú àrríavbèhè, ọ̀yẹ̀nmwẹ̀ ghi khìọnghó wmẹ̀*; 'The pleasure will be mine again, in my next incarnation, to inflict on you the defeat you deserve!'

Aisien assumed he would share Ebeikinmwin's fate. From his cell in the new British barracks on what they called Forestry Road, he waited to die. But when he was brought before the court, he discovered he had allies. The British administrator who presided over the trial was helped by Edo chiefs. One of these, Agho Obaseki, who had been close to Oba Ovonramwen, was already becoming a trusted adviser to the British. Aisien's relatives, aware that Obaseki could help them, brought him gifts of money, even a cow. Aisien was pronounced guilty, but was surprised not to be sentenced to death. Instead, he was told he would receive sixty strokes of the birch. It seemed that Obaseki had intervened in his favour.

Aisien was flogged by Captain Ernest Roupell, the commanding officer of the NCPF in Benin City. The Edo already had a nickname for Roupell; they called him *àmẹ́hìẹn*, or Pepper Juice, because he was so fierce, or peppery, in his dealings with them. Aisien was held down, and Obaseki advised him not to resist. Roupell took a mighty swing, and the birch came down on Aisien's bare back. He let out 'a deep tortuous guttural grunt'. And so it went, fifty-nine more times. Aisien's back and buttocks were bruised and bleeding, he could not stand unsupported, but he was free to go. He spent the next three months in Benin City, tended to by his mother and three wives. Only then was he able to return to his village. When Aisien eventually died, sixteen years later, his back was still covered in livid scars.

Captain Roupell's most pressing concern was to find the Oba. Ovonramwen had a dwindling retinue of loyal chiefs but as long as he moved through the forest he was a focus for Edo resistance. The British sent intermediaries but also armed patrols into the surrounding country-side. A British journalist explained the reluctance of the Edo to hand over their king: 'the natives have not yet had time to appreciate the fact that they will be better under the white man's rule than under their former tyrants'.[50] The British burnt down villages and took chiefs as hostages, but it wasn't until 5 August that the Oba gave himself in.[51] He walked

into Benin City with hundreds of followers, some twenty elegant wives, many chiefs, and musicians. Messengers walked in front, carrying a white flag. He spent two nights at Obaseki's house, deliberating on his future. On 7 August the Oba walked to the new court building, which stood in front of his palace from which he had fled six months earlier. He was dressed in full red coral regalia, including a headdress, collar, bangles up to his elbows and ankle bracelets. A huge crowd assembled. The Oba hesitated, and then kneeled in front of Roupell. Three times the Oba lowered his forehead to the dirt ground. He had performed the traditional act of obeisance, in full view of his own people. It was a very public surrender, and exactly the humiliation the British sought. Roupell told the Oba that he'd been deposed, and that he and his chiefs would stand trial for the killing of Phillips and the six other white men.[52]

Moor, as Consul-General, returned to Benin City to preside over the trial, which started on 1 September. He said he was not interested in who had resisted the British invasion in February – the Edo had the right to defend their kingdom – but specifically who was involved in the ambush in January. He didn't seem to entertain the possibility that those who attacked Phillips may have also believed they were defending their kingdom. Four of the chiefs who were on trial with the Oba were kept in the same cell where Aisien had been detained. At the end of the first day in court one of the four, Agbonkonkon, a palace chief with the title of Obayuwana, waited until a British soldier was busy searching his companions, before swiftly cutting his own throat with a knife he'd concealed in his loin-cloth. The British hung his body in front of the palace for one day, and then buried him.

Moor listened to a number of witnesses who had been in and around the village of Ugbine on that fateful day and who argued that the chiefs had not acted with the Oba's authority in attacking Phillips. On 3 September he sentenced three of the chiefs – Uso, Obakhavbaye and Ologbosere – to death, and pardoned another on grounds of youth. Uso and Obakhavbaye were shot by firing squad the next morning and Moor threatened reprisals against other chiefs if they did not help the British to catch Ologbosere, who was still at large. Gallwey wrote that

the chiefs were 'executed in the main market place of the city in the presence of an enormous crowd of their awe-stricken countrymen... the prisoners, with jaunty air, occasionally waved their hands to some friend in the crowd, as if they were going to market for quite another reason. They died without flinching'.[53]

Moor pardoned the Oba, but told him he was no longer king – 'the white man is the only man who is King in this country' – although he would be allowed to serve on the new Native Council set up to advise the British rulers.[54] Moor ordered the Oba to accompany him on a visit to Calabar and Lagos, so he could see how British rule worked in practice. The Oba was suspicious, and did not turn up for a meeting the following day. When soldiers were sent to bring him in, he fled to the forests on the edge of Benin City. According to British officials, 'Captain Roupell and a few men of the force found the king in a bush hut practically alone; as the men entered he darted out at the back door, and eventually ran into the arms of some of the search party.'[55] It was an undignified moment. The Oba was marched back to an irate Moor, who told him, 'you are to be removed from this country for good and you will never come back again'.[56]

The Oba spent four nights in the Forestry Road cell, downcast and refusing to eat. He made a desperate offer to Moor – freedom in return for information on the location of a secret stash of 500 ivory tusks – but was turned down. In the middle of the night of 15 September, Oba Ovonramwen was woken by British soldiers and tied up in a hammock. When he shouted, they stuffed a gag in his mouth and carried him out of Benin City. He was taken down the path towards Ughoton, where a ship was waiting to carry him into exile. The people woke to find their Oba gone. According to Gallwey, 'they had much to think about: their king removed for all time, their fetish chiefs executed, their Ju Ju broken, and their fetish places destroyed.'[57] The Edo historian Egharevba said simply, 'It was a bitterly unhappy day in Benin City which can never be forgotten.'[58]

When the column of British officers and sixteen Hausa soldiers of the NCPF passed through Ugbine the following morning, the people

rushed out to pay homage to their Oba. The British were on their guard, as they'd received intelligence there might be a rescue attempt. There were angry words between soldiers and villagers. The Oba rested under a kola nut tree, but when he asked for drinking water, the British refused him. The Oba turned to the villagers, and said in Edo, 'So you Ugbine people are helpless to rescue me from these foreigners?' The soldiers, not understanding what was being said, drove the villagers away. The site of this final resting point is commemorated today with a small shrine, just a few hundred metres away from the memorial to Phillips and his companions.[59] At Ughoton, the Oba was put on board a canoe and paddled out into the creek to board the *Ivy*. He never saw his homeland again. In Ughoton the elders still lament that day in song:

Àrò gbóbòbo	The eyes are red like crimson.
vbe ọbá mwà tótà ye ùkpókò	When our king sat on the boat.
vbé Ebò sì ẹré rrìé	The British are dragging him to their home.
Ài rù mwọnà	Do not humiliate me.
Ẹ̀dóhìa à wùa ré ná	It is forbidden against all the people of Edo.
Èhékèhé nìyókú ebò rhìrhì ghá yé	Any British army wherever they are.
Èhékèhé nírán rhìrhì mú érhá mwà làó	Wherever they took our father.
Wé nírán mú ẹ̀n wèrrìegbé gùn mwá	They should bring him back to us.
Mà nẹdò í sẹ̀tìn mìamìa ọnà	We the Edo people will never forget.[60]

SEE HOW THEIR FAMILIES FARED

The opening of the 1898 Royal Military Tournament on 31 May was marred by relentless rain and unseasonal cold in London, and the crowd at the Royal Agricultural Hall in Islington was disappointingly small. Nonetheless, the Queen's cousin, the Duke of Cambridge, was joined by a sprinkling of other aristocracy and minor European royalty, as well as Chelsea Pensioners and many ladies in fine dresses. The pageant included cavalry parades and gymnastics. A cycling demonstration by the Middlesex Volunteers was generally felt to have gone on too long and was met with little enthusiasm, but there was a standing ovation for George Findlater, the Piper of the Gordon Highlanders who had received a well-publicised Victoria Cross only weeks earlier. In a recent battle on the North-West Frontier he had played the regimental march even after being shot through both ankles. But the highlight of the Tournament was the final act: a re-enactment of the taking of Benin City, in which British soldiers, in blackface and attired as savage warriors, played the parts of Africans (see illustration section). The Oba, or Savage King, was about to preside over a ritual decapitation when the heroic British stormed in, amid explosions and uproar. 'Such rattling of musketry, and shouting, and promiscuous slaughter as never was seen' was met, newspapers reported, with cheers as the Union Jack was waved over the captured city, 'to end the performance and, most

emphatically, bring the house down'.[1] The defeat of the Oba was a source of pride, but also entertainment.

The 'Capture of Benin' was given an air of authenticity not only by the appearance of a sacrificial sword taken from Benin City, as well as one of Admiral Rawson's Maxim guns, but also the participation of Lieutenant Norman Burrows of the Niger Coast Protectorate Force, a man of imposing physique who had been in the thick of the fighting with the Expedition and afterwards taken some very fine Benin Bronzes, including at least five cast heads, three plaques and an assortment of statues, stools and carved tusks.[2] After the inclement weather of the opening day, the Royal Military Tournament played to several full houses over the following fortnight and extended its run. By then Lieutenant Burrows's finances had received a significant boost, for between April and mid-June he sold ten of his Benin Bronzes to the great collector Lieutenant-General Augustus Pitt Rivers, for a total of £185 (equivalent to about £20,760 today).[3] The advertising of the Tournament played up the Benin connection, and the Prince of Siam, visiting London, made a special point of attending.

This triumphalism did not tell the whole story, for back in West Africa Edo resistance to the British was far from over. To the north-east of Benin City, the elusive Ologbosere fought on for almost another two years, using dense forests and surrounding hills for cover. Rumours that all was not well had reached London, and on 20 April 1899 an opposition MP asked in the Commons if the government knew 'the number of natives who have been killed and the number of villages that have been burnt by British troops since the first march on Benin took place?'[4] Colonial Secretary Joseph Chamberlain said he did not have that information, but on the same day, and with his blessing, Sir Ralph Moor sent sixteen British officers and 250 NCPF soldiers, armed with Maxims and a rocket, to Ologbosere's stronghold of Okemue to put an end to the matter.[5] For six weeks they pursued Ologbosere through the bush, burning villages and enemy war camps. He was finally caught in early June, exhausted, with only a few starving companions, trying to get food from a farm.[6] He was given a second trial in Benin City, presided over again by Moor.

Ologbosere was defiant. He did not deny his part in the attack on Phillips's expedition, but said he'd been sent by the Oba to fight the white men. He poured scorn on those Edo chiefs who had worked with him to defend Benin, but were now part of the court that sat in judgment over him: 'The day I was selected to go from Benin City to meet the white men all the chiefs here present were in the meeting and now they want to put the whole thing on my shoulders.'[7]

Ologbosere Irabor was found guilty, and hanged at 8 a.m. on 28 June 1899 outside the court house. There are photographs of him awaiting execution. He's sitting, hands and ankles in shackles, naked from the waist up, staring calmly at the camera (see illustration section). In one picture, barefoot African soldiers of the NCPF stand to attention on either side, rifles in hand, their faces expressionless.[8] The British saw Ologbosere as treacherous and barbaric, but could not hide their grudging admiration. 'A very fine type of native, proud and arrogant. He met his death with perfect nonchalance,' wrote Gallwey.[9] From the perspective of the early twenty-first century, Ologbosere is more easily understood as a courageous patriot, a hero of the anti-colonial struggle. His death marked the closing scene, as the historian Philip Igbafe wrote, of a bloody drama that began on 4 January 1897.[10] Across the old Benin Empire, the British were finally victorious.

People in Benin City have sometimes suggested to me that if I dig deep, and delve into the careers and families of those who toppled the Oba and took the Benin Bronzes, I may see something of a pattern emerging. You mean a curse, I asked? I get only cryptic responses – 'See how their families fared, see if there are any patterns,' they prompt me – and mysterious smiles in reply.

There is certainly no shortage of tragedy in the subsequent lives of many of those who took part in the 1897 Expedition. Commander Reginald Bacon, who through his book did so much to establish the idea of Benin City as a bloody and savage place, was said to be 'the cleverest officer in the Navy', his self-confidence often irritating to peers. An early convert to submarine warfare and an authority on deep-sea diving, he

became an Admiral during the First World War, but was a victim of naval politics and retired in 1919. By then, both his sons were dead: a soldier, killed in battle, and a sailor, of pneumonia.[11] Bacon was troubled by debilitating 'Benin Fevers' for many years: an attack of malaria which recurred each spring.[12]

The journalist Seppings Wright, whose gruesome pictures and writings from Benin City for the *Illustrated London News* were as influential as Bacon's book, lived until he was almost ninety. Already in his mid-sixties when the First World War began, he sketched and reported energetically from both Western and Eastern Fronts, where he spent a winter with the Tsar's beleaguered army.[13] He returned safely from these adventures, but he too lost both of his sons, killed in France in 1915 and 1916.[14]

Commanders William Stokes Rees and James Startin were both promoted to Captain for their roles in the Benin Expedition.[15] Stokes Rees served on the *St George* and had fought alongside Rawson not just at Benin but at Mweli and Zanzibar.[16] Startin, already a veteran of the Zulu War when he went to Benin, was the man Captain Herbert Walker described chiselling away in search of loot.[17] And, the grim pattern continues, both men also lost sons in the First World War.

Lieutenant Herbert Child, who accompanied the Expedition as a marine and built up a fine collection of Benin Bronzes, was the officer who guarded the Oba on board the *Ivy* during his journey from Ughoton into exile.[18] Child died fighting the Germans in October 1914, not on the Western Front, but drowned in a river in Cameroon while trying to find a safe crossing for his troops.[19] Lieutenant-Colonel Richard Gabbett helped carry the trussed-up Oba out of Benin City, and it was his men who captured Ologbosere and thereby ended opposition to British rule. He was killed in France in May 1915, leading an attack over the top.[20]

This litany of misfortune is perhaps misleading. Many of the officers who took important collections of Benin Bronzes went on to have long and distinguished military careers, and were lauded in the obituaries. Captain George Egerton, Rawson's right-hand man, would become Aide-de-Camp to King Edward VII, a successor to Rawson as

Commander of the Cape Station, and eventually Second Sea Lord of the Admiralty. He died at the age of eighty-seven in 1940, remembered as a man who had assisted Rawson so capably back in their African days when 'operations to repress native outrage succeeded one another rapidly'.[21] Walter Cowan, responsible for the carriers as a Lieutenant in Benin and who also took valuable Bronzes, fought at Jutland in 1916, and, like Gilbert Stephenson, persuaded the Navy to re-employ him in 1939. Captured by the Germans in North Africa in 1942, he was released in 1944, aged seventy-three. He described his three years with Rawson as a 'necklace of small adventures, such a blessed feeling of happy contentment. Although these African "scrambles" were but chicken feed compared to the great wars, they were a long way better than nothing for a young man.' He died as Admiral Sir Walter Cowan in 1956, a 'gallant fighter'.[22]

Stuart Nicholson, who served under Rawson on the *St George*, had the enormous responsibility of supervising water supplies during the attack on Benin. He served at Gallipoli, and was remembered as 'an officer of exceptional talent'.[23] He took one of the most distinctive statues from Benin City, a seventeenth- or eighteenth-century figure of a huntsman, a horned antelope draped over his shoulders and a dog rubbing against his legs. It was the most valuable item at a Sotheby's auction in January 1952, and has been in the British Museum since later that year (where curators judged this untypical piece not to have originated from Benin City itself, but from elsewhere within what is today Southern Nigeria).[24]

The National Maritime Museum in Greenwich has a unique and unsettling item of Benin loot: a 'Flag of the Benin Empire', made of wool and linen. It shows two naked white men – their colour, hair and features all suggestive of Europeans – against a scarlet background. One decapitates the other with a sword.[25] The flag is thought to have been donated by Lieutenant Francis Kennedy of the *Phoebe*. It raises many questions: who does it depict, and, as there are no records of Edo flags, what are its origins? The museum attributes it to the Edo's neighbours, the Itsekiri. Kennedy had joined the navy soon after his thirteenth birthday,

and was one of the last officers to command a ship entirely dependent on sail power. He fought at Jutland with 'great skill and gallantry', and was also promoted to Admiral.[26]

In contrast, the military career of Captain Ernest Roupell, who took the Oba's surrender, ended abruptly just three years later. Fighting at Kumasi in the Fifth Anglo-Ashanti War of 1900, he was shot in both hands after taking over a Maxim gun from a dead colleague. 'He then instructed his black soldiers how to serve the gun, and he himself carried ammunition,' reported the *Daily Mail*. 'Finally he was hit twice in the head, and fell, having been struck by no fewer than seven shots.' West Africa had its revenge. Roupell returned to England 'quite crippled in both hands', according to the *Mail*, whose report was entitled 'Surely the Victoria Cross'.[27] His superiors settled on the lesser Distinguished Service Order and promoted him to Lieutenant-Colonel.

Roupell left the army an invalid to become a clerk in the colonial service, and rose to be Postmaster General of Malta. He makes an unlikely appearance in the memoirs of Mabel Dodge Luhan, a wealthy and sexually liberated American who mixed with some of the early twentieth century's leading artists and writers. From 1905 to 1912, she lived in a lavish villa in Florence, played host to Gertrude Stein, André Gide and others, and summered in the Dolomites. There she met Roupell, recuperating from his African fevers. She fell for the 'lean, brown English soldier, with a beak like a chicken hawk, and…amber eyes'. There was something 'morne and indifferent' in his manner that she found irresistible. With Mabel's unsuspecting husband playing the chauffeur, she and Roupell whispered amorous French words on the back seat as he thrust his bony knee into her skirts.

Roupell was, Mabel thought not inaccurately, the kind of officer who 'stalks through the forests of empire, indomitably certain of his prey'. But, suddenly, she loses interest. There is a humiliating scene in a hotel room near Verona. Roupell, the man who flogged Aisien and made the Oba bow before him, discovers the Buffalo heiress is a conquest too far, and disappears to Venice in shame.[28] He later married in England, and

finished his career in the Ministry of Fisheries. Ernest Roupell, *àmẹ́hịẹn/* Pepper Juice, died in Bedford in 1938, aged sixty-seven, and is buried in the village of Great Barford in Bedfordshire.[29]

Lieutenant-Colonel Bruce Hamilton, who led the soldiers of the Niger Coast Protectorate Force on the Benin Expedition, seemed destined for great heights he never attained. After the success of Benin and his subsequent promotion, he fought in the Boer War of 1899–1902.[30] He returned to Britain as a hero to his fellow soldiers, knighted and the army's youngest Major-General. But some at home wondered whether he had gone too far. The army justified its concentration camps and scorched earth tactics as the only ways to crush the obdurate Boer resistance, but opposition Liberal MPs were not convinced. Hamilton was accused of deliberately leaving Boer women and children to starve after burning the town of Ventersburg in November 1900. He was, said Lloyd George in Parliament, 'a brute, and a disgrace to the uniform he wears'. A young Winston Churchill, in his maiden speech, came to his defence: 'in all His Majesty's Army there are few men with better feeling, more kindness of heart, or with higher courage than General Bruce Hamilton'.[31]

In the years after South Africa, Hamilton, although not yet fifty years old, began to suffer from ill-health. He became increasingly deaf, to the extent that when the First World War began in 1914, he was no longer a candidate for high command. His brother, Hubert, was killed in France in the first weeks of fighting. Hamilton was sent to train the Territorial Army in East Anglia, a humiliating backwater from which he resigned. Retired, and unmarried, he lived on until 1936. 'His growing infirmities had for some time been telling on him, and, to the regret of his many friends, he was not destined to realize the full promise of his South African reputation,' his *Times* obituary read.

And what of Admiral Sir Harry Rawson? He too emerged from Benin very much in favour. When the *St George* returned to Britain in January 1898, Rawson was met by cheering crowds, and Queen Victoria invited the Admiral and his crew to her home at Osborne on the Isle of Wight, an unprecedented honour.[32] The sailors paraded past the seated elderly monarch, saluting one by one, and Her Majesty expressed 'the

deepest interest in the appearance and welfare of the men'.[33] Rawson was invited back to Osborne for dinner later that year, and in 1899, and on both occasions regaled Victoria with tales of Benin. 'A most distinguished officer & a very kind hearted & agreeable man' she wrote in her journal.[34] When Victoria died in 1901, the ships under Rawson's command paid the last honours at Spithead, as her coffin was taken across the Solent by yacht.[35] But Benin had taken its toll. The long marches and stress left Rawson prostrated for weeks afterwards, and his hip caused him excruciating pain for the rest of his life. 'He bore the marks of the Benin campaign to his grave,' according to his biographer. Rawson was a popular Governor of New South Wales from 1902 to 1909, but his time in Australia was overshadowed by the sudden death of Lady Rawson, his wife of thirty-four years, on a steamer on the Red Sea in 1905. Rawson himself died in London in 1910, aged sixty-seven, from complications following an appendicitis operation. He was honoured with a plaque in the crypt of St Paul's Cathedral, only yards from Lord Nelson, and praised as a man of 'tact, kindliness and good sense' who would be missed by many friends. His death spared him future agony; his son, Captain Hubert Rawson, aged just twenty and newly married, died on the Somme in 1916.[36]

And finally, there was Sir Ralph Moor, the British official whose ambition to remove the Oba shaped the events of early 1897, and the man ultimately responsible for the theft of the Benin Bronzes. In the summer of 1909, Moor moved into a delightful Georgian house, the Homestead, on Church Road in Barnes, south-west London. Although he complained about wasp nests in the garden, he gave every indication of enjoying his new home. On the face of it, Moor should have been a content man; still in his forties, with a beautiful wife and young child, lauded for his African achievements.

On closer inspection, his new life was perhaps not so rosy. At the turn of the century Moor's career had been in the ascendancy. In January 1900, the British government ended the charter of the Royal Niger Company, paying a lavish £450,000 compensation to George Goldie (the equivalent of roughly £49 million today).[37] As a result, Moor's fiefdom grew

substantially, for the company's territories were incorporated into those of the Niger Coast Protectorate and he became High Commissioner of the new, expanded Protectorate of Southern Nigeria.[38] But, just as with Hamilton, his methods had not endeared him to everyone. In 1901, as Moor organised an expedition against the Aro Confederacy to the east of the Edo territories, the Liverpool businessman John Holt wrote, 'Moor is at his work again killing people in order to make them more humane and civilized…I consider that the punitive expeditions of Southern Nigeria since the establishment of our government in that district have been a disgrace to our country.'[39] A bishop who toured the Aro region afterwards found that, in village after village, the elderly complained 'that death from the bullets of British soldiers would be preferable to the very miserable life they had been living since the conquest'.[40] By now Moor's health was suffering, but the Colonial Office rejected his requests for a governorship in a more benign climate.[41] In 1903, he resigned and returned to London.

Moor had influential friends, but failed to secure another appointment. He took on the directorships of a number of companies, and accumulated some wealth. He may have reflected that his marriage, in 1898, had not helped his prospects. Adrienne Burns was seventeen years younger than Moor and eager for status and respectability after the scandal of her first marriage. She'd met her husband, Walter Spence Morgan Burns, of the Morgan banking family from America, at a French racecourse in 1895, when she was living under the protection of another man, and passing as 'Mrs Wade'. Walter and Adrienne married secretly weeks later. Walter's father was furious when he discovered, and paid detectives to follow Adrienne to the South of France. The divorce proceedings were reported with relish in the newspapers of February 1897, in the very days the British Expedition was fighting its way to Benin. They quoted eyewitnesses who'd seen Adrienne board a train at Marseilles with 'a dark gentleman with a hook nose, a maid, a dog and a parrot', and cited her adultery with two Frenchmen.[42]

On the evening of Monday 13 September 1909, Moor retired to his bedroom, apparently in good spirits, having transacted some important

business with his solicitor that day. The following morning a servant went up to his room and opened the blinds. An hour later she rang the bell for breakfast but Moor, uncharacteristically, did not come down. Lady Moor, who had taken to sleeping in a different room, went to wake her husband. She found the blinds down again. She opened them and was startled to see Moor lying unconscious, one hand stirring gently. She noticed a strange sweet smell in the room, and found an empty glass on the dresser. By the time Dr G. Hovenden arrived, at 9 a.m., Moor had been dead for fifteen minutes.

He'd drunk potassium cyanide – wasp poison – which he'd bought at a West End chemist. In her evidence to Barnes Coroner's Court, Lady Moor said her husband suffered from recurrent attacks of malaria and blackwater fever, and was 'a martyr to insomnia'. He took drugs to help him sleep. Dr Hovenden testified that the after-effects of tropical diseases 'tend to gradually destroy a man's nerve', and the jury concluded that Moor 'took the poison deliberately while temporarily insane after suffering acutely from insomnia'.[43] The *Telegraph* said Moor's death would be keenly felt in Downing Street, where he was a familiar figure. None of the papers delved further, but Commander Bacon, who'd got to know Moor on the Benin Expedition, wrote cryptically that 'he was a born leader of men...He would without doubt have risen to the highest posts in the Empire if it had not been for one flaw in his character. With men he was steel, with women he was wax. Hence a life in a distant colony and a death deplored by all who knew him.'[44]

Lady Adrienne Moor inherited her husband's Benin loot. This included two of the five ivory masks taken from the Oba's bedchamber and two carved ivory armlets. To Lady Moor these splendid pieces served only as 'painful memories of West Africa as the White Man's Grave'. She took them to a retired merchant navy captain and West End dealer in Japanese and Chinese art, John Sparks. He knew nothing of Benin, but was struck by their beauty. Lady Moor was glad to be rid of them.[45]

And yet, it seems she still dined out on stories of Benin. In Christmas 1914, Lady Moor was in New York. She'd sailed over on the *Lusitania*, braving German U-boats, and, as a 'famous Pekingese authority', was the

star judge of a dog breeders' competition in the Waldorf Astoria hotel. There Lady Moor reminisced to journalists about West Africa. 'During the Benin massacre,' one newspaper wrote, Lady Moor 'established a Red Cross society and did good work at the head of the nurses which attended the British wounded during the war'.[46] Inventive journalism or Lady Moor's fantasies? There were no Red Cross nurses with the Benin Expedition in February 1897, nor was she even married to Sir Ralph at the time. She died at the age of forty-eight in 1919.[47]

10

PURELY AFRICAN, THOROUGHLY AND
EXCLUSIVELY OUT AND OUT AFRICAN

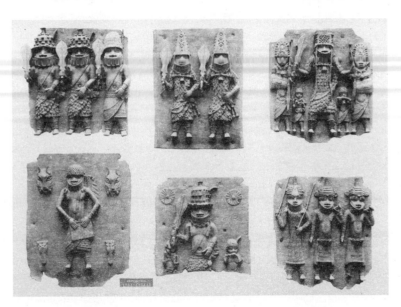

Benin plaques, exhibited in the British Museum, September 1897.

At the end of that Jubilee summer, in September 1897, the British
Museum hosted an unusual exhibition. It was something of a rushed
affair, as the objects on display had only arrived in Britain a few months
earlier. But the museum's ethnographic curator, Charles Hercules Read,

and his assistant, Ormonde Maddock Dalton, had pushed their case enthusiastically. They were excited by the many striking pieces that the Benin Expedition had brought back, and felt they deserved a wider audience.

Read and Dalton had to make do with their exhibition being spread between two rooms some distance apart as colleagues grumbled over a lack of space.[1] The so-called Assyrian Saloon, an 'uncongenial' and cramped space according to newspapers, was in the basement, its gloom somewhat alleviated by a glass roof. This was where some 300 Benin plaques were arranged along two long screens.[2] These were the plaques Sir Ralph Moor had reserved for the Foreign Office during the pillaging of the Oba's palace, and had subsequently shipped home. The museum was hopeful of convincing the government to donate a significant proportion. In the Ethnographic Section on the first floor, meanwhile, Read and Dalton rearranged the African display cases to make room for carved tusks, bronze heads and other items from Benin. These had been brought back by officers and officials; some had been sold to the museum, others loaned for the occasion.

'Surprising', 'remarkable', 'baffled': these are the words that recur throughout the reviews. The *Illustrated London News*, which had made so much mileage from Benin's horrors, now wrote that it 'has proved a mine of ethnographical treasure'. Indeed, its owner, Sir William Ingram, had bought several Benin Bronzes in London auctions that summer.[3] His paper said experts had been taken aback by the number and excellence of carved ivory tusks and castings in bronze and brass that the Expedition had taken; 'they are certainly the most interesting works of art which has ever left the western shores of the Dark Continent'.[4] The *Manchester Courier* said, 'It would seem as reasonable to expect grapes on thorns or figs on thistles as to look for evidences of taste and skill in art in a city that reeked of human blood. Yet here are carvings and castings of figures that would not discredit the skilled artificers of Europe.'[5]

The journalists were confused. Was this exhibition – of what *The Times* called 'an entirely unexpected phase of negro craftsmanship' – a display of exotic war booty or exciting artwork?[6] Or perhaps both? The

auction houses advertised their Benin objects that summer as curiosities and trophies, language that emphasised the exotic rather than the aesthetic.[7] 'Symbolic objects connected with the hideous sacrificial rites of Benin', as one article put it, had an almost titillating value, made more palatable by their association with an emphatic British military victory.[8] Few people were prepared yet to take them seriously on their artistic merits. And just as many of the British officers in Benin City had been more interested in taking ivory than bronze or brass, so too the auction houses gave top billing to their new collections 'of curiously and elaborately-carved Ivory Tusks'.[9] Ivory, after all, had an intrinsic value regardless of whatever was carved upon it. Sir Ralph Moor reported that by the end of February 1897, Benin ivory sales had raised more than £800 for the protectorate.[10] (In June 1898, he wrote that, in total, between £1,200 and £1,500 was raised for the protectorate government by the local sale of Benin loot; most of this would have been from ivory.[11]) Officers and auction dealers assumed – correctly in these early days – that ivory would fetch reliably higher prices than the metal castings.

It was the quality of the Benin castings on display in the British Museum that astonished the critics. The plaque surfaces were clean, the lines sharp and well defined, the use of metal economical and skilled. None of the protruding details, no matter how far they projected, appeared to be additions to the original design. This could only mean they were made using the *cire perdue* method, just like, said *The Times*, 'the finest bronzes of the fifteenth and sixteenth centuries in Europe'.[12] But beyond this, nothing was clear. Some newspapers plumped for the theory that the plaques had been carried to West Africa by Arabs, or the Portuguese when they first explored that coast in the fifteenth century.[13] Others wrote mysteriously of a 'wandering tribe of alien craftsmen'.[14] *The Times* was more generous; the very novelty of the subject matter, it argued, was 'surprising evidence of the skill of the Benin native in the castings of metal'.[15] The confusion was not confined to journalists; the *Courier* published a plaintive plea for any experienced travellers to come forward and help the British Museum to solve the problem of the origin and meaning of the Benin Bronzes.[16]

There had already been rumblings of a deeper appreciation. The Horniman Museum in south London had been displaying a small collection of bronze castings and ivory carvings from Benin City by April 1897, bought from a naval officer who'd taken part in the Expedition, W. J. Hider.[17] He boldly claimed that his objects were the only ones that had survived the sacking of Benin City, and asked the museum for £100.[18] In June 1897, the Royal Colonial Institute advertised a display of 'Some interesting bronzes from Benin City…the precise origin of which is at present unknown.'[19]

This was a big moment for Charles Read and Ormonde Dalton of the British Museum. These two men, so instrumental in shaping British opinion on the Benin Bronzes, could scarcely have been more different in background and temperament. Read, the son of an army sergeant, had joined the British Museum as an eighteen year old in 1874. He was hard-working, blessed with an extraordinary visual memory and by 1896 had risen to the top of his department.[20] Dalton, nine years his junior, had only joined the museum in 1895, but with the more conventional advantages of Harrow, Oxford and a socially connected family. He had a reputation as a brilliant scholar, well travelled and multilingual.[21] Read was genial and sociable, a talented raconteur. He presided over a small daily ritual; at 4 o'clock each afternoon museum colleagues would gather in a backroom round a marble-topped tea table, to be regaled with his amusing stories. 'My dear boy, what I don't know isn't worth knowing,' Read would boast with a smile. In contrast Dalton suffered, in the words of a colleague, from 'distressing states of shyness that sometimes overwhelmed him'.[22] He was happiest walking the Surrey countryside and sleeping alone under the stars on Leith Hill.[23] Dalton examined his shyness, classical mythology and much else in a strange and intimate trilogy of books which he authored under a pseudonym and never acknowledged as his own.[24]

After the positive response to their British Museum exhibition, Read and Dalton presented their findings to the Anthropological Institute at 3 Hanover Square on 9 November. In the late nineteenth century the ethnographic collection was the public face of anthropology, and both

were inextricably linked with imperial expansion. Soldiers, missionaries and civil servants brought back exotic objects from distant colonies, and so ethnographic displays grew. Indeed, there was considerable overlap between the membership of the Anthropological Institute and the ranks of ethnographic curators, and Charles Read was twice its president.[25] The glass cases crammed full of weapons, clothes, tools and ornaments were meant to help the British public understand the newly subjugated peoples of their Empire, even if the voices of those people were unheard and the identity of the actual individuals who made the pieces considered all but irrelevant.[26]

In 1842, the British Museum's guidebook described its ethnographic collection as 'a series of artificial curiosities from the less civilised parts of the world'.[27] In 1859, the guidebook explained that the Ethnographical Room contains objects 'belonging to all nations not of European race'.[28] In 1899, it described ethnography as the scientific study of peoples who were developing 'from savagery towards civilization'.[29] And yet, Read and Dalton told the Anthropological Institute, in their mastery of the *cire perdue* technique, 'we find the Benin savages using with familiarity and success a complicated method which satisfied the fastidious eye of the best artists of the Italian renaissance'.[30] Evidence of the Benin brass casters' ability contradicted the assumptions of the age. The Anthropological Institute had only recently published a detailed paper on the reduced cranial capacity, and by implication mental ability, of African tribes, based on the measurement of twenty-six skulls.[31]

Confronted by the Benin Bronzes, the scholars of late Victorian England had to reconcile what they believed with what they could see. Africans were not supposed to possess the skills to produce pieces of such subtle and varied beauty. Nor, for that matter, were they supposed to possess much history at all. Perhaps the clue lay in those fascinating Portuguese figures, proof of an earlier and more harmonious relationship between the Edo and Europeans. Read and Dalton argued that the detailed and accurate representations of Portuguese soldiers in fifteenth- and sixteenth-century armour were irrefutable evidence that many of the plaques were several hundred years old.[32] *The Times* agreed; it was

'not probable that a figure of a European would be rendered with such an attention to detail at any period very distant from that in which the native artist saw such people'. As the newspaper dated the armour to about 1560, then, evidently, Benin's cultural history had to be older still.[33]

Or was it possible, as some newspapers suggested, that the Portuguese had actually made the Bronzes, or at the very least taught the Edo how to make them? After Read and Dalton had spoken, another member of the Anthropological Institute took the stage. William Gowland had undertaken an analysis of the plaques. His hunch was they had been made by 'the artisans or armourers, who always formed part of the crews of Portuguese ships of sixteenth century, or of natives who were taught by them'.[34] Dalton and Read seemed to go back and forth on this question. In an article Dalton wrote a couple of months after the Anthropological Institute meeting, he tended towards the idea of Portuguese inspiration, and argued that none of the castings pre-dated the arrival of the first Europeans. It was the influence of a superior culture which created what he called 'the Benin Renaissance'. This was, he wrote, a single brilliant period of creativity, a spasm of light, preceded and followed by centuries of darkness and barbarism.[35]

The British Museum's Benin exhibition lasted until January 1898, after which the Foreign Office agreed to donate 203 of the plaques. Read and Dalton made their own selection, judging that the remaining 101, which they wrote would be sold off 'for the benefit of the Protectorate', were essentially duplicates of those they had taken.[36] By now the museum had also received a donation of several pieces from Sir William Ingram of the *Illustrated London News*. These included a great prize; a stunning female head, about life-size, depicted with a tall beaded cap covering a hairstyle that curves forward, in what the Edo call the 'chicken's beak' style. Her features are delicate, her gaze regal, there is a hint of green in her patina, her neck is covered by a beaded collar. Dalton and Read felt it was the most artistically and technically perfect of all the castings; Dalton wrote, 'if a Greek sculptor had been called upon to reproduce the head of a negress, one wonders whether he could have done it much better' (see illustration section).[37] At the time, he and Read described it

as a 'really charming head of a girl'.[38] It was only many years later that the 'girl' would be identified by the Edo historian Jacob Egharevba as a Queen Mother, perhaps Idia herself, the mother of the sixteenth-century Oba Esigie, who is also depicted on the famous ivory masks, and was the first to be given the formal title of Iyoba.

The Bronzes represented, Dalton felt, 'a new "Codex Africanus" not written on fragile papyrus, but in ivory and imperishable brass'.[39] If only the figures on the plaques and the statues could talk, what history they'd tell of the culture that made them and of the visitors who had come to their lands. As rival museums and collectors acquired their own Benin Bronzes, they too grappled with the conundrum of their origins. Henry Forbes was Director of the Liverpool Museums. By 1898, he had a respectable collection that included cast heads, leopard statues and many human figures, although he grumbled that he only had one plaque. 'If these are the work of the Benin people, whence did they derive their instruction?' he asked. Did they really develop their own skills, or were they imitating foreigners whom they'd taken prisoner? Or perhaps the bronzes were entirely the work of foreigners?

Mr Forbes had been impressed with Commander Bacon's depiction in *City of Blood* of the Edo as a decaying race, and he took it as given that the contemporary inhabitants of Benin City were incapable of producing work remotely as fine as the objects the British had taken. He produced a range of imaginative theories on their origins; the 'probability' was the art had been brought to West Africa by a European trader or prisoner, who instructed the natives on how to cast metal. This imported culture flowered briefly, many centuries ago, and then died. Alternatively, it may have come to Benin City via the more noble, horse-riding tribes to the north, influenced as they were by distant Abyssinia or even ancient Egypt. But these equestrian conquerors had bred with the primitive coastal tribes, through which they became 'demoralized and gradually degenerated into their present low civilization. The plaques and statues discovered in the city, may, therefore, be the relics of a former high civilization.' Or, he even suggested, the entire Benin Bronzes may have been the spoils of a successful military campaign over a rival tribe, and

were kept as fetishes. This last idea came to Mr Forbes from Commander Bacon himself. Whatever the truth, his museum had the good fortune, he boasted, of some 'splendid additions to its rapidly growing West African collection'.[40]

As the theories multiplied, Dalton called for what he saw as common sense. 'To implicate the august and venerable civilisations of the Nile, the Mediterranean in the affairs of a negro kingdom' was to take romance too far. Suggested links between the Roman colonies of North Africa and Benin were, he wrote, sensational and bizarre speculation.[41] But the hypothesis of a connection between Egypt and Benin City was not so easily dismissed, not least because in the eyes of many observers the plaques mounted side-by-side on the walls of the British Museum, with their processions of characters and creatures, bore more than a passing resemblance to hieroglyphs. Richard Quick, curator at the Horniman Museum, wrote there was a discernible Egyptian influence on the Benin Bronzes.[42] Dr Robert Allman, who had accompanied the Expedition as Chief Medical Officer, was another proponent of the Egyptian link. He had a more discerning eye than many of the military officers, and spent some time rooting around the Oba's palace and surrounding streets in the aftermath of the British victory. Despite his responsibilities in clearing Benin City of rotting corpses, he found much to admire, such as the cowrie shell inlays of mud seats and couches in the palace. He wrote, 'In my wanderings about the city I came across many bronzes and plaques which were evidently designed, if not executed, by the ancient Egyptians; many others were of more modern times and bore traces of the Portuguese, from whom the art has without doubt descended.'[43]

It wasn't only the British who struggled with the idea that the Benin Bronzes represented the achievements of an indigenous culture. John Payne Jackson was an African nationalist born in Liberia, and as editor of the *Lagos Weekly Record* from 1891 to 1914, a forthright critic of colonial rule. In March 1897, the *Record* carried a passionate denunciation of Cecil Rhodes. He was 'a cool, calculating villain', and it was shameful that the British government appeared to support his project of imperial expansion in Africa. 'Great Britain has demonstrated that

she is champion thief of the world,' said the *Record*.[44] But even this newspaper accepted that a black African kingdom would have needed stimulation and assistance from elsewhere to rise to the unexpected heights of craftsmanship revealed by the Benin Bronzes. It argued that it was an open question as to whether the Egyptians or the Portuguese had inspired the works. 'If they prove to be of Egyptian origin,' wrote the *Record* at the beginning of March 1897, 'the question of the connexion [*sic*] of West African negroes with the ancient Egyptians will be placed beyond all doubt'.[45] By the end of that month the *Record* had made up its mind. The Benin Bronzes bore a striking resemblance to the figures of Egyptian mythology, 'conclusive evidence of the identity of the Negro with the ancient Egyptian'.[46]

It was a curator at the Bankfield Museum in Halifax, northern England, who was prepared to challenge the consensus. Henry Ling Roth was the brother of Felix Norman Roth, the medical doctor and Vice-Consul from Warri who had kept a diary on the Benin Expedition and who had brought back vases, staff heads, rattles and plates. As Henry Ling Roth examined these objects, with their elaborate patterns and representations of Obas, elephants, mudfish and leopards, he wrote of his admiration for the artists' technical skill, variety and clarity of design. Their attention to detail, he felt, 'is worthy of a Japanese'.[47] He also believed he could detect phases in the development of Benin casting, from a realistic representation of animals and people to a more imaginative and stylised one.[48] There was a progression, he argued, styles changed over time and different artists worked in different ways. And if it was the Portuguese who had taught the Edo how to cast metal when they arrived in West Africa, then where were the great contemporary Lusitanian castings? It was an obvious question, but not one which had apparently occurred to anyone else. 'We are still quite in the dark as to any existence of such high-class art in the Iberian Peninsula at the end of the fifteenth century; and we know there was not much of this art in the rest of Europe,' he wrote.[49]

The Portuguese could not communicate a skill they did not possess. Although the Portuguese had clearly made a deep impression on the

Edo people, the art pre-dated their arrival. Outsiders, whether from Europe or from the kingdoms of the African interior, had influenced Edo culture, and this helped to explain the range of motifs and styles, but, Roth argued, that was not the whole story of the Benin Bronzes; 'there is absolutely nothing like them in any part of the world. Commerce and the intercourse of breeds is no doubt responsible for the large variety of forms in the art of the Beni [as the British often called the Edo], but it is hardly sufficient to account for the exceptional bronze plaques. It seems as if the only conclusion we can arrive at is that we have in them a form of real native art.'[50]

With the benefit of hindsight, it seems clear that many of the first British collectors and curators of Benin Bronzes sought overcomplicated and improbable theories as to their origins. If some were baffled by the apparent incongruity of Benin's cruel rituals and the quality of its artistic achievement, they could have taken only a cursory look at similar contradictions within Europe's own history. The truth was not so complex. The Benin Bronzes came from Benin. They were made by the people who lived there, the Edo, whose culture and art had been periodically enriched by influences from abroad. But following the sacking of Benin City, the Edo were scorned and deprived of their culture by the very people who now struggled to interpret it.

Henry Ling Roth outlined his theories in articles in 1898, and then wrote them up into a book, *Great Benin: Its Customs, Art and Horrors*, which remains an important reference source to this day. Many of the photographs he used to illustrate *Great Benin* were of pieces owned by Lieutenant-General Augustus Pitt Rivers. Soldier of the Crimea, amateur archaeologist, compulsive collector and owner of a vast country estate in southern England, Pitt Rivers never visited West Africa but played an important, albeit brief, role in the post-1897 history of the Benin Bronzes.[51] He bought his first Benin pieces only weeks after the Expedition. By the time of his death a mere three years later, at the age of seventy-three in May 1900, his collection of Benin Bronzes was bigger and more varied than any other in Britain, including the British Museum's.[52] 'Money for him being no object, he purchased largely and succeeded in

making a most interesting collection,' wrote Roth.[53] It 'gives at a glance a bird's eye view of the whole field of Benin art'.[54]

Pitt Rivers's Benin Bronzes were housed both in the museum that still bears his name in Oxford and primarily at a private museum on his estate in Dorset. He was sympathetic to Roth's arguments about the Bronzes; in a letter in 1898, he wrote of his new acquisitions: 'It does not follow that because European figures are represented that it all came from Europe. Most of the forms are indigenous, the features are nearly all negro, the weapons are negro.'[55] Pitt Rivers urged critics to look beyond the sensational and violent events of 1897, and appreciate that the Benin Bronzes opened up new frontiers in artistic understanding. And yet even he could not conceive of them as a truly African achievement. Just weeks before his death, he wrote that only European influence, probably that of the Portuguese in the sixteenth century, could explain how the Edo had reached such heights.[56]

In 1898, the number of visitors to the British Museum surged to over 600,000, the highest for fifteen years. Prominent in the museum's annual report's list of acquisitions were the 'most important series of bronze castings from Benin, presented by the Secretary of State for Foreign Affairs, and now incorporated with the ethnographical collections'.[57] Charles Read and Ormonde Dalton ought to have been pleased, but in June Dalton published a report on his recent tour of the ethnographic departments of German museums. He was impressed, but also alarmed, by differences with his own country. Unlike the British, wrote Dalton, Germans of all backgrounds were greatly interested in ethnography.[58] The Kaiser, he argued, supported ethnography and anthropology as disciplines which could strengthen German imperialism.[59] He estimated that the ethnographic collections in Berlin were six or seven times more extensive than those in London.[60] A tour of Berlin's Museum für Völkerkunde (Museum of Ethnology) left him deflated; 'in almost every section…it leaves the Ethnographical Gallery at the British Museum far behind.'[61] He envied his German counterparts for the resources at their disposal; the Museum für Völkerkunde received a generous government grant, but was also supported by a committee of wealthy donors.[62] To

his chagrin, he learnt that it had already spent £1,000, much of it at auctions in London, on acquiring a considerable number of the very Benin Bronzes which the British had brought back from West Africa the previous year.[63]

Dalton, of course, was making the case for more funding for his collection in particular, and for anthropology and ethnography in general. The British Museum's ethnographic collection sat rather awkwardly within the Department of British and Medieval Antiquities and Ethnography, a reflection of its poor sister status. He would have understood that any comparison with Germany, the rising challenger to British supremacy, was bound to be emotive. Benin Bronzes were not quite Dreadnoughts, but they were topical, and it was galling for the British to see the Germans stealing a march. By 1898, notwithstanding the donations from the Foreign Office and Sir William Ingram, the British Museum was complaining of a shortage of funds preventing it from acquiring more Benin pieces.[64]

Dalton's report appears to have hit home; an official history of the British Museum says that it was influential in attracting more money and support for ethnography.[65] He was not alone in his perception that the Germans were one step ahead of the British when it came to an appreciation for, and investment in, cultural treasures coming out of the colonial territories. The anthropologist Northcote Thomas, who worked in Nigeria and Sierra Leone in the early twentieth century, wrote that the Museum für Völkerkunde had ten times more ethnographic items than the British Museum and was a place where 'the work of collection goes on incessantly'. England, he complained, 'with the greatest colonial empire the world has ever seen, lags far behind'.[66] Henry Ling Roth said that a lack of money deprived the British Museum of what he called 'its lawful acquisitions'. (His sympathy for the British Museum only extended so far. In 1897, he sold it six Benin Bronzes – presumably acquired from his brother – for £65, equivalent to about £7,200 today.[67]) Roth lamented that the Foreign Office sold off its remaining Benin Bronzes for a few hundred pounds, when they had cost the British government 'thousands to obtain, as well as much blood of our fellow countrymen'.[68] The British

had plundered Benin; now it was a question of national honour to prevent most of their loot passing to a feared European rival.

German museums had indeed responded with alacrity to the arrival of the Benin Bronzes in Britain. In August 1897, the assistant director of the African section of the Museum für Völkerkunde, Felix von Luschan, heard by chance of an upcoming auction in London, and rushed there to make his first purchases.[69] He was amazed by the quantity and quality of the Benin objects on sale, and was determined to get more. He also sent an instruction to the German Consul in Lagos, Eduard Schmidt, to buy any Benin Bronzes that he came across there.[70] Luschan had the support of Hans Meyer, a Leipzig publisher and patron of German ethnographic studies. Meyer was mystified by those in Britain who saw the Bronzes as little more than war booty, and after a successful buying trip to London, he wrote to Luschan: 'It is actually a riddle to me, that the English let such things go. Either they have too many of them already or they have no idea what these things mean for ethnology, cultural history, and art history…whatever the case may be, the main thing remains, that *we* have these magnificent specimens.'[71]

Over the following years, Felix von Luschan would become a leading scholar on the Benin Bronzes, and his Berlin museum would acquire one of the world's great collections. Luschan was dismissive of the more outlandish theories around their origins. Suggested links with India were 'foolish'; he argued that one might as well trace East Asian china to Germany, or Japanese lacquer-work to the Netherlands.[72] He was in no doubt that the metal casting tradition of Benin City 'was purely African, thoroughly and exclusively out and out African', and yet was also a great and monumental art. Benvenuto Cellini, he wrote, could not have done better.[73]

In 1899, the British Museum released a book by Read and Dalton: *Antiquities from the City of Benin and from Other Parts of West Africa in the British Museum* was a glossy work, with thirty-two large photographic prints of the museum's finest Benin objects. *The Times* said its sumptuous production was indicative of the importance the museum attached to this 'remarkable collection'.[74] Read and Dalton may have had limited

means, but over the following years they steadily acquired more Benin Bronzes. Sir Ralph Moor helped them; in May 1899 he sent Read a gift of another Benin plaque and also four of the venerable cannons with which the Edo had tried to repel the British. One of these guns bore the Portuguese royal coat of arms and the name of an early sixteenth-century Lisbon manufacturer, while another had a Chinese inscription, and has been dated by experts to the eighteenth or early nineteenth century. They are testimony to Benin City's cosmopolitan networks, but the story of how and when they got there is an intriguing mystery.[75]

In 1910, Read and Dalton made their most significant Benin purchase. The anthropologist Charles Seligman sold them the ivory Queen Idia mask with the tiara of Portuguese heads that has been so admired and, in recent decades, contested. It was one of the pair that had belonged to Moor, and which Lady Moor had got rid of after his death in September 1909. Seligman bought both masks as well as Moor's other Benin ivories for £50 from John Sparks, the dealer in Chinese art. He kept one mask for himself, and passed the other to the British Museum, which paid him £37 10 shillings.[76] (Today either mask would be worth countless millions.) Read was overjoyed; the British Museum now possessed, he believed, 'the finest thing that has come from Benin'. The museum's new mask showed conclusively that Edo craftsmen could produce superb work, 'without the aid of European motives, and as far as we can tell, without European suggestion'. He too wrote that to look for links between Benin and ancient Egypt or India was simply a waste of time.[77]

But Luschan in Germany went further. He saw that the Benin Bronzes had a significance that went beyond the academic and artistic worlds. Their existence was a rebuke to the prevailing values of the time. In 1901, in response to reports of Belgian atrocities in the Congo, he wrote, 'Human beings which have brought casting to absolute perfection, human beings to whom with almost absolute certainty the discovery of iron-working may be attributed, human beings about whom we now know that they have stood in reciprocal contact with recognized cultured peoples may not be regarded as half-apes.'[78] Luschan's theories were

inconsistent; he questioned long-held views on 'superior' and 'inferior' races and his work would later be denounced by the Nazis, but he was also a fierce German nationalist and obsessed with skin colour differentiations.[79] Yet when it came to the Benin Bronzes, he understood that they presented Europe with a moral challenge. They could help Europeans to understand 'that the culture of the so called "savages" is not inferior to our own, only different'.[80]

STRANGE HARVESTS COME HOME TO KING STREET

38 King Street, in Covent Garden in the heart of London, is a plain four-storey late-Georgian building. The long dark room on the ground floor was used for auctions since at least 1776, when it belonged to Samuel Paterson, a bibliophile.[1] But the lots became more exotic when J. C. Stevens took over in the early nineteenth century. At one time, Stevens' Auction Rooms was the best place in London to acquire African wildlife: live lions, giraffes, rhinos and elephants were sold (although presumably not exhibited) there, and so too was the zebra-like quagga, soon to be shot to extinction by the insatiable European hunters of the Cape.[2] One of the most celebrated animals to be sold at the Stevens' rostrum was a monkey called General Synam. A hero of the siege of Mafeking, he had been trained by British soldiers to ring a bell whenever he saw Boers starting to shell the town. Covent Garden porters queued to ply him with fruit. General Synam, his cheeks bulging with apples and his arms laden with more, was bought by a Glasgow zoo for forty guineas in the autumn of 1900.[3]

Stevens' was also a place to admire the latest in taxidermy. By 1863, the firm was being run by Henry Stevens, son of J. C. Stevens. He organised the sales of stuffed lions, tigers, gorillas and bears, as well

as birds in abundance, as the trophies of British sportsmen found their way home. In 1877, Colonel Bagot's 'Fine Group of Fighting Tigers' was sold to a Liverpool museum for £200.[4] Henry Stevens didn't stop at wildlife. In the spring of 1898, he caused a sensation with the sale of four Egyptian mummies.[5] In 1902, he sold thirty-three embalmed Maori heads, at between £20 and £40 each.[6] These had belonged to a General Horatio Gordon Ropley, a celebrated collector of the macabre, who had decorated his room with them and was reputed, on sleepless nights, to rise and comb their hair in order to soothe himself. The saying was that if you waited long enough, you could buy anything and everything at 38 King Street.[7]

Henry Stevens worked in a small office to the side of the auction room, surrounded by shells, fossils, photographs and a prized Tiki carving from New Zealand. A sale at Stevens' was rarely dull, but the man himself had an incongruous reputation as a dour workaholic, whose maxims included 'avoid jocularity, it is often misunderstood', 'do not collect the articles you sell, but know all about them' and 'make a hobby of your business and the details will be easy'.[8] Henry Stevens took a photograph of himself in 1903, when he was sixty years old. He is expensively dressed, his gaze haughty and his moustache sharply pointed. He looks like a man who pays attention to detail.[9] Perhaps more than anyone else, he understood the market in the buying and selling of the treasures of the British Empire. It was hardly surprising, then, that he should preside over so many of the most significant sales of Benin Bronzes.

The first sale of Benin objects at Stevens' took place in May 1897: 'Carved Tusks and other trophies from Benin City collected by naval officers in the recent expedition' read the newspaper advertisements.[10] This was where Lieutenant-General Augustus Pitt Rivers bought his first Benin Bronzes, two statues for eight guineas.[11] Later that summer Henry Stevens offered more Benin carved tusks, plaques and metal casts in a sale which also featured spears, temple idols and clubs from the Solomon Islands and stuffed birds from India.[12] He was on to a good thing. Prices, modest to begin with, gradually increased as word spread about the Benin Bronzes.

From 1898 to 1904, Henry Stevens presided over the sale of hundreds more Bronzes. The British had used Benin's gory rituals to justify their invasion; Stevens now exploited them for commercial opportunity. He traded in horror and salaciousness. He sold a plaque at an 1898 auction that he said depicted 'a ju-ju king and executioners going to sacrifice', and had been found 'freely drenched with human blood'. Pitt Rivers bought it for eleven guineas. On the same day Stevens sold what he described as 'Executioners' Bells', which would have 'sent many a tremor through the hearts of the unfortunate natives. No one knew who would next be led to the altar to adorn the arms of the truly awful crucifixion tree.' He did not let his imagination hold him back. Four bronze figures, he wrote, had broken off a frame upon which 'the condemned slave had to lay his head, to be beaten into pulp by the clubs of ju-ju priests, the more blood that was splashed the more pleasure the king and his chiefs enjoyed'. They fetched fifteen guineas.[13] Henry Stevens advised that an object described as a ju-ju nail with the figure of a squat god for its head was 'a truly horrible thing, but it ought to be very valuable'.[14] Unfortunately, it sold for only two guineas. A moment of levity brightened the horror; when 'the keys of the King of Benin's harem' were displayed, they were so large that everyone laughed, even the non-jocular Henry Stevens himself.[15] No wonder an historian of the Stevens' Auction Rooms wrote that 'at the time of the Benin sales an imaginative visitor must have almost beheld the very rostrum in a nimbus of lurid light, and the rooms illuminated with the bloodshot rays of a gory sunset'.[16]

A regular attendee at the King Street sales was a man called William Downing Webster, the son of a Greenwich potato dealer. Webster was twenty-nine years old when the Benin Bronzes arrived in Britain. He had been interested in drawing since a young age, and as a teenager painted fossils in watercolours, and then graduated to stained glass windows. In the early 1890s, Webster moved into collecting and dealing in ethnography. He travelled round Britain, buying at regional auctions but also directly from officials, soldiers and traders who had worked across the British Empire and beyond. He had an eye for the unusual and the valuable, and a flare for publicity. In 1895, Webster published his first

catalogue of 'Ethnographic Objects'. He released thirty more over the next six years, handsomely illustrated with drawings and photographs. Their contents are every bit as colourful as a Stevens' auction list: masks from New Guinea, paddles, spears and sharks' teeth from the South Pacific, shrunken heads from the Jivaro of South America, a club from the North American Indians 'which took part in Custer's massacre', and so on. And just like Henry Stevens, it didn't take Webster long to realise the opportunities offered by the Benin Bronzes.[17]

In November 1897, Webster included his first Benin objects in his catalogue: two large carved tusks on sale at £80 each. By 1901, his catalogue listed a total of 562 Benin objects.[18] Ivory, as elsewhere, got top billing and the highest prices. In 1900, Webster offered a Benin carved tusk for £120 – the most expensive object in any of his catalogues. In the photograph on Webster's *carte de visite* from that year he is framed by four enormous Benin tusks and holds a smaller one in each hand. With his piercing stare and flat cap, bow tie, tweeds and riding boots, he cuts a dashing figure, at the top of his game (see illustration section).[19]

Webster bought many of his Benin Bronzes directly from officers who had been on the Expedition. He boasted that he'd done this early, before the officers knew their true value.[20] He sold them to whomsoever he could: wealthy collectors such as Pitt Rivers in England and Hans Meyer in Germany, and a long list of museums which included Edinburgh, Dublin, Stockholm, Copenhagen, Basel, Leiden, Leipzig, Cologne, Dresden, Stuttgart and Vienna.[21] As such, he played an important role in the great dispersal of Benin Bronzes which had begun in February 1897.

Felix von Luschan, in Berlin, was also a client. Luschan grumbled in his letters about rising prices, but Webster's replies were insouciant. In April 1898, he explained that he was 'perfectly aware that Benin specimens are expensive but everyone wants them so prices have gone up considerably...it is quite impossible to get any more as Benin was cleared out and everything brought to this country'. Webster held all the cards; the quality of the Benin objects, their finite number, the destruction of the city from where they came, and the desire of curators like Luschan to acquire more, made for a seller's market. In May 1898, Webster bought

what he said were the last seventeen plaques still in the possession of the British Government.[22] Two months later, he told Luschan he was 'sorry you think the prices are too high for you to buy – but I am convinced that they will go still higher and that you are making a great mistake in missing anything you have not got.'[23]

In 1899, Luschan returned to England to see for himself the market in Benin Bronzes. After attending an auction, he wrote to a friend in Germany that 'at such prices our current Benin collection would bring well over a Million [marks]!'[24] The prices of statues, cast heads and other metal objects from Benin were indeed increasing, although they still lagged behind ivory. In 1898, Webster offered a Benin head for between £25 and £35, but by 1900 a head was going for £45 and a statue of a Portuguese musketeer for £50.[25] Benin Bronzes had become more expensive than most other artefacts from Africa, South America, Australia and Polynesia, although their prices still appear modest by the standards of the twenty-first century. (£50 in 1900 is worth roughly £5,450 pounds today, and was equivalent to half a year's wages for a skilled tradesman, or the cost of a horse.[26])

The curator of the new ethnographic department in Vienna's Naturhistorisches Hofmuseum, Franz Heger, was in regular contact with Webster. Heger travelled to Berlin at the end of 1897, where, with Luschan's help, he bought a Benin tusk for 500 marks.[27] Such was the speed with which Edo cultural treasures were travelling across the world; a single tusk had been taken from Benin to London, then Berlin, and finally Vienna, all within a year.

Heger begged and cajoled industrialists and aristocrats for support as he sought to build up his collection of Benin Bronzes. Webster, cunningly, played on his insecurities by reminding him that prices were rising, and that rivals already had more; in a letter from May 1898, he says that although Dresden Museum had recently spent £1,000 on Benin Bronzes, Heger still had the opportunity to 'have the finest collection on the continent', but only if he acted swiftly.[28] Heger, like Luschan, felt he might have better results by building ties with the Niger coast itself. The German Consul in Lagos, Schmidt, had managed to buy some

eighty Benin Bronzes for Luschan, which at least proved that the British had not taken everything with them. Heger worked through Captain Albert Maschmann of Hamburg, who had good contacts in Lagos. But by 1899, Maschmann's letters suggest the supply of Benin Bronzes was drying up. In June, he quoted from his agent in Lagos, who said 'there is none at all to be got after the latest expedition after the King of Benin's fighting man [the British campaign against Ologbosere]...I sent a man up to the Benin country, but he came back empty handed.'[29] (The odd Benin masterpiece would still pop up in the region. In November 1899, a British steamship engineer donated a sixteenth-century Benin Bronze Queen Mother head – as splendid as that which Sir William Ingram had given the British Museum in 1897 – to the Liverpool Museum. He had acquired it only weeks earlier, somewhere in West Africa.[30])

Within a few short years many of the museums and collectors of Europe had what they wanted. In any case, the supply of objects taken by the Benin Expedition had been largely exhausted. And as the Edo had been judged a degenerate people with a decaying civilisation, the assumption was they had little new to offer. In 1910, Charles Read wrote that it is 'not to be expected that the city of Benin itself will for the present continue to supply any great number of works of art...[it is] improbable that any great surprises are in store'.[31] Or, in the words of an historian of German museums, 'Benin had been consumed'; the frenzy was over and it was time to move on to the next big thing.[32]

The Edo themselves were not so much mere bystanders in this process, as excluded from it altogether. Their Benin Bronzes, laden with spiritual meaning, had been forcibly taken from them to a new continent, where, over time, they would acquire a different significance. With hindsight, that first exhibition in the British Museum in September 1897, despite the contradictory responses, marked the beginning of a transformation. Under a European gaze, the Benin Bronzes would be discussed, sometimes denigrated and often admired, all in ways that those who made them could never have conceived of or intended. In Britain, Germany and elsewhere, they would come to be seen not as objects of religion, but as objects of art.

William Buller Fagg joined the British Museum in 1938 straight out of Cambridge, as an assistant keeper of ethnography. He stayed in, and eventually ran, the department until his retirement in 1975. Photographs from his later years show Fagg as a short, bald man, rather rotund and gnomic, an Englishman abroad. 'Bumbling, always on a bicycle, often in a sling because he kept on falling off it,' recalls a colleague.[33] But in the world of ethnographic art Fagg was a giant. The son of an antiquarian bookseller, a Catholic who never married, he was a keen rower in his youth, and later a lover of music, parties and good food. He was humorous, but also shy and not one for small talk, especially after he suffered a stroke in 1967. 'Disconcertingly phlegmatic' is the description of another colleague.[34] He is still spoken of with reverence by those who worked with him, and indeed some who didn't. Julie Hudson joined the British Museum years after William Fagg left, and yet she feels his forthright presence and intellect, lurking in the museum's archives and stores. 'I never knew Bill, but I have conversations with Bill,' she admits. 'Like out-of-body experiences. His feelings and perceptions come through his notes.'

African, and above all Nigerian, art was the passion of Fagg's life. Nigeria, he wrote in late 1947, was Britain's 'greatest colony', a distinction, in his mind, derived primarily from its cultural wealth.[35] In the middle and later parts of the twentieth century, Fagg probably knew more about the Benin Bronzes than any person outside Nigeria itself. Their arrival in Europe in the spring of 1897 was, he felt, of profound cultural significance. This was the moment, he believed, that 'African art suddenly acquired a real presence in the civilized world'. Bronze sculpture had been accepted as among the highest manifestations of art for centuries, and it was simply impossible to dismiss those from Benin as mere ethnographic curiosities or cultural artefacts. Not that Fagg was an uncritical admirer. He believed Europe was so dazzled by the sheer mass and richness of the Bronzes, and the superlative quality of a few, that 'the artistic sterility of the majority of them escaped notice'. And yet despite these reservations, he went further. Not only had the Bronzes changed European attitudes to what Africans could do, but they also

changed European art itself. What he called the 'historical accident' of the Benin Expedition was the catalyst which enabled ideas from 'the 'primitive' world to penetrate the European art world, 'with incalculable effect in the experimental beginnings of modern art'. To Fagg, it was no coincidence that a mere decade after Rawson's troops looted the Oba's palace 'the great artistic innovators of Paris and Munich found in the direct and poetic dynamism of tribal art the sanction for their rejection of imitative in favour of conceptual art'.[36]

To portray the Benin Bronzes as the inspiration for the eruption of European avant-garde art at the beginning of the twentieth century is quite a claim. In Germany, expressionist artists in Munich, Berlin and Dresden were certainly stimulated by the new ethnographic museum collections. But Benin Bronzes appear in their words and pictures only in passing. In 1910, Ernst Ludwig Kirchner wrote of his joy that the Museum für Völkerkunde in Dresden had reopened: 'how relieving and enjoyable are the famous bronzes from Benin,' he told a friend. In Berlin, Emil Nolde made about 100 sketches in the ethnography department between 1910 and 1912, but only one is arguably derived from a Benin Bronze. Max Pechstein made a woodcut of a hunting scene in 1912 that was based on a Benin plaque that he saw in Berlin. But Benin was one of a multitude of influences for these men. August Macke wrote that the 'Negro Bronzes from West African Benin (discovered in 1889) [*sic*], the Easter Island idols from the Pacific, the chief's collar from Alaska and the wooden masks from New Caledonia are equally expressive as the Notre Dame chimeras and the tombs in the Frankfurt cathedral.' The German expressionists did not elevate the Benin Bronzes to a special rank. Rather, they saw them as part of the great range of ethnographic objects which provided such an exciting contrast to the traditional and the classical and thereby inspired them. To that extent, they too 'consumed' Benin.[37]

But what of France? Already in the nineteenth century – from Japonisme to the paintings of Paul Gaugin – public and artists were showing an appreciation for new aesthetics. At the beginning of the twentieth century Pablo Picasso and others were also looking to break free of the realistic tradition in Western art. In 1905, Maurice de Vlaminck

said that Picasso was the first artist to appreciate 'what one could gain from African and Oceanic art'.[38] In 1907, Picasso visited the Musée d'Ethnographie du Trocadéro, a seminal moment in the European perception of non-European culture.[39] Through Picasso's eyes, the abstract wooden sculptures and masks of Africa and the Pacific were more than curios or scientific specimens; they were 'Primitive Art', an inspiration for new aesthetic ideals and forms of expression. Later that year Picasso painted the famous *Les Demoiselles d'Avignon* in which two of the prostitutes appear to be wearing African masks.

Any link between the French avant-garde and the Benin Bronzes seems tenuous, however. Excitement about the Bronzes was initially concentrated around the museums of Britain and Germany, and very few Benin objects went to France in those early years. Picasso and his friends could only be moved by what they saw, and in Paris it was predominantly wooden sculpture from French and Belgian colonies in Africa, as well as the South Pacific. The Musée d'Ethnographie du Trocadéro would not hold a major exhibition of Benin Bronzes until 1932.[40] Picasso and his circle were surely aware of them, however. His friend Guillaume Apollinaire published an autobiographical fantasy, *Le Poète assassiné*, in 1916. Picasso appears in the book under the guise of 'the Benin Bird', named after a distinctive long-beaked bronze bird in Apollinaire's collection.[41] Picasso did eventually buy a Benin Bronze, but only in 1944.[42]

In the mid-1950s it emerged that at least one great French artist had nurtured a deeper passion for Benin Bronzes. André Derain, friend of Henri Matisse and co-founder of the Fauvist movement, was seventy-four years old in March 1954, and suffering from a persistent eye infection. He decided to auction his sculpture collection in Paris. The record prices came on the third day, when the Musée de l'Homme (the successor to the Musée d'Ethnographie) found itself outbid time and again by private collectors, including from Switzerland. The prized items were six Benin Bronzes, advertised as 'brought back by Admiral Rawson' in 1897. They included statues, a plaque, a cockerel, a leopard and a leopard mask that was said to have come from Pitt Rivers's collection. The Bronzes fetched a combined price of some 5 million francs (equivalent to about £140,000

today), far more than Derain's other sculptures.[43] Derain had visited the British Museum back in 1906, and presumably that was when he first saw Benin Bronzes.[44] He died in a car accident only six months after the sale, in September 1954.

To the artists of the avant-garde, African art was a resource, to be used just as Europeans have used so many African resources. Hilary Spurling, biographer of Matisse, says that at the beginning of the twentieth century neither he nor Derain 'seem to have known or cared where those first African pieces came from…they simply provided aid and support in the titanic struggle to cut free from the academic past and break through to some form of contemporary i.e. Modern art'.[45]

Perhaps the most compelling evidence that the Benin Bronzes were of only peripheral significance in the development of twentieth-century European art comes from the appearance of the objects themselves. There was a good reason why Luschan sought to compare the Benin Bronzes to the works of Cellini, while Read and Dalton evoked the sculptures of ancient Greece and the Italian Renaissance.[46] The Bronzes are peculiarly 'un-African' in their representational character. They invariably depict very recognisable people and animals, even if their proportions are not always precise. They are figurative and descriptive. The distinction, for example, between an African and a European face on a Benin Bronze, is obvious in the details of features, hair and clothes. This made them instantly accessible to many Europeans. They appeared to be related to the Western tradition of art, stretching back to antiquity. Philip Dark, an historian of the Benin Bronzes, wrote that 'Of the many art-forms of Africa, Benin art was one of the least exotic and closest in style to those appreciated in Europe at the time of its discovery.'[47]

Art dealers today still speak of the Bronzes as having a paradoxical allure, of appealing to people who don't generally appreciate African art. The converse is also true, that the Benin Bronzes are sometimes dismissed by those interested in African art as somehow not 'truly African'. Carl Einstein's 1921 book *Afrikanische Plastik (African Sculpture)* was important in helping bring African art to a wider audience. But Einstein, who had embraced Cubism and was searching for traces of it in African art, gave

short shrift to the Benin Bronzes. Though 'highly esteemed', he considered them 'of no decisive significance'. It was precisely their 'affinity with European common taste' that, in his eyes, damned the Bronzes as technical achievements of little stylistic importance.[48] Whereas many art experts immediately after 1897 had decided the Bronzes were so fine they could only have been made with the help of Europeans, those at the cutting edge of European art in the 1920s were disappointed they did not conform to the Africa of their imaginations. Carl Einstein believed that the Bronzes represented the old idioms that the artists of Paris, Berlin and Munich were seeking to destroy, not the new ones they were striving to create.

The reactions were contradictory, and said more about Europe than Benin. Felix von Luschan, at least, saw that the Benin Bronzes, even in disarray and out of context as they had arrived in Europe, nonetheless represented a civilisation. In that case, they needed a history. He – and a colleague and disciple, Professor Bernhard Struck of Dresden – thus set about doing what no other European had yet even tried to achieve.[49] They tried to place them in chronological order.

Luschan had the written accounts of European explorers and traders to help him. But these raised as many questions as they answered. If Dapper, for example, mentioned plaques as being on palace pillars in the mid-seventeenth century, but Van Nyendael did not at the beginning of the eighteenth, did that mean that all plaques could be dated to before Dapper's visit, and they were taken down after? He also had the writings of British officers who took part in the Expedition. But, as we've seen, their interest in Benin Bronzes was derived largely from profit and proof of conquest, not the quest for knowledge. They were neither anthropologists nor art historians.

Luschan's theory was that art and technique in Benin City peaked in the sixteenth century, and steadily declined thereafter.[50] This could be seen as consistent with British justifications for the 1897 Expedition: Benin had 'degenerated' and needed to be saved from its own barbarity. Luschan's work was taken up and developed by William Fagg and others. Fagg also believed that Benin taste and craftsmanship steadily

deteriorated over the course of four and a half centuries prior to 1897, from what he called 'the subtle and sensitive creativity of the early period to the empty formalism of the late'.[51] He used the great variety of Benin heads, commemorative of deceased Obas, to form a timeline. Fagg believed that the more naturalistic heads, delicately cast in thin metal, were from the fifteenth century, or the 'earlier' period. This fitted with the theory that Benin City's metal casting tradition originated in Ife, where cast heads were also naturalistic in style. Over time the heads became heavier and more stylised, Fagg argued, taking us right up to the end of the nineteenth century.[52]

The contrast between 'early' and 'late' heads is striking. It was the 'early' heads which evoked comparisons between the Benin Bronzes and the art of ancient Greece and the Renaissance. They resemble the European classical tradition, and yet even they are not completely lifelike. They depict faces which tend to resemble each other, and their features are not entirely realistic. Fagg argues that each one was intended to represent an 'ideal portrait' of kingship, rather than be a likeness of a particular king.[53] They have a beaded collar that ends under the chin, and their hair is often uncovered. Over time, according to Fagg's chronology, the collar creeps higher and higher, so that by the eighteenth century it forms a choking cylinder, the head above apparently gasping uncomfortably for breath. Finally, the heads he designated to the nineteenth century are tall and monumental, with a flanged base, long braided hair and an ever more elaborate headdress that has by now developed wings.[54] These heads often served as mounts for the tusks which fitted through the hole in their crowns, hence they had to be heavy. The faces of the royal family, according to this chronology, morph over the centuries, from the serene beauty of the supposed sixteenth-century Queen Mother, the Iyoba, which Ormonde Dalton exulted over, to the exaggerated features of the 'late' heads, with their menacing fish-like eyes and swollen cheeks. These changes reflect, Fagg argued, the increasing pomp and ceremonial flamboyance of the late Obas' courts. 'Yet even in the days of decadence,' he writes, 'a certain savage grandeur subsists in these relics of a despotism in which religious feeling and tradition still played a paramount role.'[55]

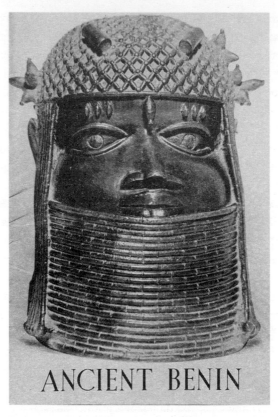

ANCIENT BENIN

Benin's treasures, exhibition at Berkeley Galleries, London, 1949.

In 1936, the Edo, at last, got to tell their story to the outside world with the publication of Jacob Egharevba's *Short History of Benin* (the Edo language original, *Ekhere Vb'Itan Edo*, had appeared in 1933).[56] Egharevba, of noble descent, was three years old when the British overthrew the Oba. He grew up determined to give his people back their voice. In the 1920s, writing in the Edo language, he speculated that with only a few more brave commanders in 1897, the Edo could have kept the invaders at bay for much longer.[57] Egharevba was both a dogged compiler of oral histories and an astute analyst of early European accounts. The process of blending two very different sensibilities of the past was difficult, as he complained:

'how great and tedious the task has been of reducing to comprehensive facts the stories which were told by superstitious native historians in peculiar ways blended with myths, miracles and fables'![58] The Edo understood the heads and plaques as the archives of their past. Egharevba translated the oral memories of those archives to be read within the framework of a Western calendar. He compiled a lineage of the Obas, and their approximate dates, which stretched all the way back to the Ogisos and the thirteenth century. This was, some historians argue, an overly ambitious undertaking; there are many reasons to doubt the reliability of both Egharveba's European and Edo sources.[59] And yet every scholar of Benin and the Bronzes has leaned on his pioneering achievement ever since.

As early as 1897, members of the Anthropological Institute in London attempted to analyse the Benin Bronzes' metallic composition. A basic hypothesis, beset by numerous anomalies but borne out by some of the evidence, is that the 'early' Bronzes have more tin in them, and the 'later' ones have more zinc, marking a transition from predominantly bronze to brass.[60] This complements the theory that the Portuguese, with their brass manillas, provided Benin City's metal casters with new material from the late fifteenth century onwards. An abundance of a previously scarce resource could also explain why the 'early' heads are so thin and the 'later' ones are thicker. One complication is the presence of other metals in the Bronzes, including lead, silver, antimony, nickel, arsenic and bismuth.

Thermoluminescent, or TL, dating gives an indication of when an object was heated, based on the radiation exposure which has occurred since. Since the 1960s museum curators in Europe and the United States have applied it to the Benin Bronzes. The results, unfortunately, have been a disappointing collection of variable and imprecise dates.[61] The fire which swept through the Oba's palace in 1897 may be partially to blame, as the Benin Bronzes exposed to it may have effectively had their TL clock reset to zero.[62]

Science has provided no magic method to crack the code of the Benin Bronzes. In the frustrated words of a Berlin museum curator, 'the age determination of Benin art is to this day based upon hypothesis,

conjectures and, at best, approximations'.[63] Fagg's chronology has many potential flaws. It implies the Edo were dependent on Ife for artistic inspiration at the beginning of the Oba dynasty, which is contentious. In recent decades some experts on Edo history have argued that the 'early' heads do not in fact depict Obas, but are 'trophy heads' of defeated enemies that could have been cast across a longer period of Edo history.[64] Fagg argued that what he called the 'tribal artist' was more than a mere copyist, and that his or her work was the result of a fusion between 'tradition and the individual genius of the artist, and in both the relative strength of these two forces may vary almost infinitely'.[65] It was an appeal for the makers of the Benin Bronzes to be treated to the same standards as European artists. But the ages of the Bronzes remain elusive, and the identities and stories of the individuals who cast them even more so.

Scholarly disputes on chronology and the evolution of style were of little concern to William Webster or Henry Stevens, looking only to sell their Bronzes as profitably as possible. The two men had a symbiotic relationship. For Webster, the King Street auction house was a useful source of Benin Bronzes and other artefacts. In July 1901, he wrote to the Museum Volkenkunde in the Netherlands, chasing money owed to him for Benin Bronzes, which he needed because of his impending move 'to a large house in London.'[66] By 1904, Webster appeared to run into financial difficulties. In November that year he chose Stevens' as the place to sell off his personal collection. The bidding went on for five days; Stevens' advertised the collection as 'probably the finest outside any museum'.[67]

Webster's career had been intricately linked to the sale of the Benin Bronzes, and it declined as the frenzy around them subsided. His wife Agnes filed for divorce in 1906 on grounds of cruelty, abuse and adultery. In 1907 Webster married Miss Eva Cutter, who lived opposite the British Museum and who came from a family of natural history and ethnography dealers.[68] Webster died in an alcoholic coma in January 1913, in the nondescript London suburb of Pinner. He and Eva, who lived until 1945, are buried in a forlorn corner of the Islington & St Pancras Cemetery, their grave enveloped by brambles and ivy.[69]

Henry Stevens died in his early eighties in 1925. The intensity of the initial excitement around the Benin Bronzes at Stevens' would never be replicated, and yet its part in their story was not quite over. In the 1920s and '30s, many of the officers who'd taken part in the Benin Expedition were dying, and their private collections were up for auction. 38 King Street remained a favoured location. The remaining Benin Bronzes of Colonel Norman Burrows, star performer of that 1898 Royal Military Tournament re-enactment and later the Governor of Wakefield Prison, were sold there in April 1923.[70] In January 1928, there was another intriguing sale. *The Times* wrote that the vendor, Ralph Locke, 'was Divisional Commissioner of South Nigeria, and is said to be the only survivor of the Benin City massacre of January, 1897'.[71]

Leaving aside the fate of the ever-neglected carriers, Locke was indeed the last survivor of the attack on Vice-Consul James Phillips's expedition. His companion on the traumatic escape from Ughine, Captain Alan Boisragon of the Niger Coast Protection Force, had died in March 1922. Boisragon's life turned on those events. He came from an Indian Army family, where his father and uncle were British heroes in the suppression of the 1857 Uprising and his cousin was awarded a VC.[72] Boisragon was the most senior soldier to accompany Phillips, and there were calls in the British press for him to be court-martialled after his fortunate reappearance. He tried to join Rawson's Expedition weeks later, but was unceremoniously sent back to England after a few days, admitting 'neither nerves nor physical condition being in a fit enough state to allow me to go on'.[73] He rushed out a book about his experiences, *The Benin Massacre* – published in September 1897 – but if this was an attempt to clear his name, it did not stop the downward trajectory of his career.[74] He became Superintendent of Police in Shanghai in 1900, but was considered a disappointment and moved aside.[75] When he died in Earl's Court he left his long-suffering wife, Ethel, a mere £190 in his will.[76] She lived on, alone, until 1956.[77]

Ralph Locke, younger son of a landed Kent family, fared better. He appears to have accrued no blame for the events of January 1897. He was greeted in his home village of Hartlip a few weeks later with a torchlight

procession and the ringing of church bells.[78] In April that year he was promoted to Vice-Consul in the Niger Coast Protectorate.[79] He stayed on in Nigeria until 1903, and was later a prison governor and JP.[80] His life was not without further setbacks; one brother was killed in the Boer War and another in the First World War.[81] The 1928 sale of his Benin Bronzes at Stevens' raised £432 (worth about £26,200 today), including a handsome statue of a Portuguese soldier in late-medieval armour carrying a musket.[82] Some years earlier, in 1915, he had donated a fine example of a Benin 'late' head to the Royal Albert Memorial Museum in Exeter.[83] A romantic interpretation of Locke's interest in Benin's art would be that such was its seductive power he was prepared to put to one side his traumatic memories. More likely he saw his collection as trophies, mementoes of a vanquished foe. Locke died in 1933, at the age of sixty-eight.[84]

J. C. Stevens' Auction Rooms went out of business in the early 1940s, during the difficult war years.[85] Many years after its closure, the association between 38 King Street and Africa would be revived, yet could scarcely have been more different. In the 1960s, the Catholic Church donated the building to 'the people of Africa', and it was formally opened by the President of newly independent Zambia, Kenneth Kaunda, as the Africa Centre. It became the political and cultural hub in London for the African diaspora, a place where exiles planned for freedom from colonialism and apartheid, plotted coups against former friends, and celebrated the food and music of their beloved continent. 'When you were feeling a little low and homesick,' said Archbishop Desmond Tutu, 'and everything seemed so foreign, you'd have this place, it was so heart-warming.'[86]

The journalist Richard Dowden recalls the Africa Centre's glory days: 'You could find everything African there, from Ghanaian food to fierce debates and fantastic parties. Sometimes all three at the same time on a Saturday night; a High Life or Congolese band playing to a crammed floor of dancers while below in the basement radicals and reactionaries sipped pepper soup and argued about evolutionary versus revolutionary change.'[87] I can recall the exuberant parties of the BBC's African Service

in the early 1990s, sweaty bodies and soukous music in what I now realise had been the Stevens' main auction room. For a one time emporium of imperial loot, it was a rather wonderful afterlife. Sadly, the Africa Centre went into decline around the turn of the millennium, and in 2012, 38 King Street was sold to a property developer.

LIKE RIPPING PAGES
OUT OF OUR HISTORY

In 1903 and 1904, a British anthropologist called Richard Dennett visited Benin City. 'The people still dig amongst the ruins of the palace for the bronzes the Oba and his followers valued so much,' he wrote. The Edo were defeated and scrabbling in the dirt for remnants of their stolen heritage. With their patron gone, the brass casters were in disarray; what little they produced was 'rough and crude'. In a pathetic scene, Dennett shows Edo chiefs Lieutenant-General Pitt Rivers's book *Antiquities of Benin*, which included photos of his Benin Bronzes. 'Their surprise and satisfaction was very great, and they were glad to think that most of their ancient works of art still exist.' Even in sympathy, Dennett reveals the vast gulf between colonial master and colonised. He urges collectors in Britain to bequeath their Benin Bronzes to the British Museum, which he believes should also display photographs of the Bronzes in German museums. The educated Edo of the future 'as a British subject has a right to expect to find as full a collection of these bronzes, etc in this Imperial Museum'.[1]

One man's family history captures some of the contradictions thrown up by that epic defeat. Dr Ekhaguosa Aisien's grandfather was the Edo soldier who fought the British invaders, who then captured and flogged

him, but Ekhaguosa is an Anglophile, deeply influenced by years of study in London. In Benin City today, he lives in an imposing house, surrounded by a high wall. When I met him there he was in his late eighties, tall and slim, an energetic talker. He received me in a palatial room with a high ceiling, windows of church-height and a gallery above. We sat on the heavy furniture around the sides, facing a table with a plastic bowl of fruit, talking loudly to make ourselves heard over electric fans. Ekhaguosa used a bell to summon a boy in a faded Manchester United shirt, who was sent off to bring cold cans of Malt drink and a bottle of rosé wine. The boy would be called back sporadically throughout our conversation, and instructed to rummage through an adjacent library for copies of the eight books on Edo history that Ekhaguosa has written.

He told me how he went to London in 1957, in his mid-twenties, to study medicine at King's College. Although Ekhaguosa came from an eminent Edo family, this was an extraordinary opportunity for a young man from the hinterland of one of Britain's African colonies. 'We had a feeling of Empire pride. Going to London in those days, unlike now, was a prestigious fit,' he recalls.[2] 'Very few black people in those days, and we were admired as colonials, we were British subjects, we were to be looked after and cared for.' He was thrilled to be allocated a 'palatial slot' in Halliday Hall, a five-storey halls of residence overlooking Clapham Common. Halliday Hall had been built in the 1930s as a hotel, and almost every room had its own bathroom. Ekhaguosa stayed there for four years – 'positive discrimination' for African students, he says, as their British counterparts had to move out after two – and never lost the sense of wonder that he didn't have to cook, clean his room or do his own laundry. He loved London as a city which venerated its history, and he wanted Benin City to do the same.

'It is my great regret of 1897,' Ekhaguosa told me, 'that we have no neutral accounts. Even the British journalists got here too late. We had no literate people, so we only have the British officers' accounts. And in the years after, our own people were too intimidated or reserved about giving their side of the story, as they didn't want to offend their new British masters.' But his grandfather must have been an embittered man?

Ekhaguosa doubted this. The Edo had never believed Benin City would be conquered, but neither had they imagined the sort of weaponry Admiral Rawson had at his disposal. 'We should say my grandfather was reconciled. The whole of the kingdom was reconciled. This was something you couldn't fight against. Such a big, enormous power,' he said. This sense of fatalism, Ekhaguosa was told as a child, was shared by even Oba Ovonramwen himself. 'He just could not believe his ears and eyes that there was a force on earth that had come to Benin to remove him. This was something that could never have entered his consciousness. So he thought, "This is God's doing," he accepted the whole thing.'[3]

The capture of the Oba of Benin was a propaganda coup the British were determined to exploit. Dr Felix Norman Roth and Reginald Granville, an official at the Warri Consulate later posted to Benin City, wrote that the neighbouring Itsekiri people said Ovonramwen 'could not possibly be caught as he would turn himself into a horse, dog, or bird, etc., and so escape. When they heard the king had given himself into the British they said: "White man be god man, we no savey them white man; white man pass all other man, palaver set" (i.e., it is no use arguing anymore).' After he was taken away from Benin City the Oba was paraded by the British before Urhobo chiefs at Warri, who had not believed reports of his capture. 'They shook their heads and said nothing – it was all beyond them. Both Jekris [Itsekiris] and Sobos [Urhobos] now acknowledge that the king's juju is finished,' wrote Roth and Granville with satisfaction.[4] The Oba was taken on the *Ivy* into exile at Calabar, the capital of the Niger Coast Protectorate. The boat took several detours up and down the rivers of the Niger Delta, its captor on display. At Brass, where the British had put down a rebellion in 1895, they invited chiefs on board to see with their own eyes the fallen king.[5] Just like the Bronzes, he too had become a trophy of Benin.

There are several photographs of Oba Ovonramwen on board the *Ivy* on that journey to Calabar. In two of these his feet are shackled together in chains, and he is guarded by the African soldiers of the Niger Coast Protectorate Force (see illustration section). He stares at the camera in

cold fury and contempt. In a third picture, perhaps at a later stage in the journey, he is seated alone and wears a wry smile. British officers who met him on the journey described him as 'a man of exceedingly fine physique, of commanding presence'.[6]

Was that smile the beginning of the acceptance that Ekhaguosa spoke of? Oba Ovonramwen would have plenty of time to reflect on his fate. His Calabar exile lasted seventeen years, until his death in 1914. His conditions gradually improved, as he was moved from prison to a guarded cell in Government House, and in 1898 to a private house provided by a prominent man of the local Efik people. Etinyin Essien Etim Offiong III had no connection to Benin City, but he was a wealthy trader on good terms with the British and thus able to shield the Oba from the worst inequities of exile. They had no language in common, at least initially, but developed an understanding. According to Offiong family legend, their house guest behaved as if he was still a ruling monarch. He dressed in his regalia each morning, received dignitaries from his throne, and there was no question of his helping on nearby farms. In the evenings, he strolled along the streets of Calabar.[7]

The Oba spent much of his time with a favourite and senior wife, Queen Egbe. He had lost the harem and retinues of his palace, but his Calabar household gradually expanded over the years. British documents show that by 1908 the Oba had four wives, one daughter with child, one son, one interpreter, three houseboys, one market boy, three small boys, two cooks and two cooks' mates attending to his needs, and a further ten maidservants assisting his wives. In October that year the Oba's request for two more wives was denied by the British, although they agreed to send him four hammock boys.[8] That same month, in London, a backbench MP, Cathcart Wason, argued in the House of Commons that the Oba, 'who has been in banishment from his country and people for nearly ten years', should finally be allowed home. But the Liberal government was as inflexible as its Conservative predecessor. The Under-Secretary of State for the Colonies, Colonel John Seely, replied that the events of 1897 had been 'shocking' and 'I regret to say that I cannot hold out any hope of its being possible to agree to the return of Overiami [*sic*]'.[9]

A surviving letter from the Oba to a British official in Calabar in March 1910 gives a tantalising insight into his character. The handwriting is cursive, the English language formal and polite. They may not be his own, but the sentiments are. He explains that three of the four hammock boys are unhappy in Calabar, and wish to return to Benin City. One is even threatening to kill himself. They are spreading rancour among other servants, encouraging a cook to run away. The Oba urges the British to allow the hammock boys to go home as soon as possible. The man once portrayed to the world as a bloodthirsty tyrant was immersed in domestic minutiae, and comes across as a humane head of household.[10]

Diminished as he was, the Oba was still a figure of enduring fascination for the British. One man who saw him regularly in Calabar was Henry Gallwey, who had begun to rise up the colonial ranks and was the Acting High Commissioner for Southern Nigeria from 1900.[11] He seems to have enjoyed his conversations with the Oba, but also took pleasure in reminding him how the tables had turned. He remembered how the Oba had kept him waiting for days in Benin City in 1892. 'I often used to see him at Calabar, and had many talks with him. On more than one occasion, when I consented to see him at a certain hour and he turned up ten minutes or so late, I refused to see him. My turn had come!'[12]

The Oba was a political prisoner, under surveillance, yet he managed to maintain surreptitious contact with his homeland. His visitors included emissaries from Benin City, disguised as farmers and traders, who brought him the regalia he required to observe Edo festivals and sacrifice animals in a nearby forest.[13] His supporters in Benin kept him informed of political developments. They sent him a wooden stool, carved with imagery that he would understand. The so-called Benin Telegraphic Royal Stool depicted a crowded kingdom, in which royal swords are held by imposters, snakes lurk in corners and women frolic with sexual abandon. The Oba would thus have understood there was no peace in Benin, that usurpers sought his powers, and that British officials and their collaborators were breaking taboos.[14] The Edo's culture was diminished, yet they could still use it to outsmart the British.

In Benin City today, the elders who guard their people's history struggle to convey the full impact of the British invasion. It was Patrick Oronsaye who'd told me that 1897 was Year Zero for the Edo, the moment everything changed. I went to see Prince Gregory Akenzua – the brother of Edun Akenzua and great-grandson of Oba Ovonramwen – who had visited the British Museum in 2017. He was resting on his shaded front porch, by a driveway crowded with vehicles. He fanned himself, and apologised for the lack of electricity. His conversation was quiet and thoughtful, occasionally interrupted by the queries of servants. A doctor appeared at the gate, accompanying Prince Akenzua's driver, who had a black eye and looked angry. The driver had been punched by another motorist, and the doctor had treated him. Prince Akenzua majestically produced a few banknotes from within his robes, and resumed his conversation. He spoke of how Vice-Consul James Phillips had always intended to overthrow the Oba, of how he forcibly tried to enter another man's country without permission. Did anything good come out of the British invasion, I asked? He cast me a withering look, and then, as he often does, reached for a suitable quotation. 'Ruskin said that great nations write their biographies in three manuscripts: their words, their deeds and their arts. That artwork can be said to represent the history of the Benin people for centuries. It was taken from us. It was like ripping pages out of our history.'[15]

British rule brought great changes. The Oba was gone and horizons were expanding; his territories were swallowed into the Niger Coast Protectorate, which became the Protectorate of Southern Nigeria in 1900. In 1914, the British amalgamated the protectorates of Southern and Northern Nigeria into a single unit, Nigeria itself. The Edo were now only one ethnicity among hundreds, in an emerging country with only the most tenuous sense of unity. The wider world was getting closer. Benin City got a post office, and in 1905, its first bicycles. Motor cars arrived in the following years, as did a government hospital and pipe-borne water.[16]

This was the time for British commerce to take advantage of the riches that Sir Ralph Moor had spoken of: the 'extensive rubber forests, valuable gums, the usual products of palm oil and kernels, and possibly many

other valuable economic products'.[17] The British built roads through the forests and Glasgow and Liverpool firms moved in, eager to exploit Benin's reputed wealth in timber as well as palm oil. By 1903, the British were so concerned by the destruction of Edo forests that they put restrictions on the extraction of timber.[18] In the 1910s they started to establish forest reserves with the intention of more sustainable exploitation.[19]

Rubber was a new attraction, regarded by colonial officials as a raw material with commercial potential. A Scottish surgeon, John Boyd Dunlop, had patented the pneumatic rubber tyre in 1888. In the Belgian Congo the greed for rubber would bring cruelty and suffering on a vast scale. The Edo lands experienced their own rubber boom after the Oba's overthrow, with hundreds of rubber-tappers arriving from Lagos. Their methods were often reckless; trees were killed by dry season tapping and excessive bleeding, to the extent that Benin's first Political Resident, Captain Alfred Turner, complained of the 'wholescale murder of rubber trees by Lagos and Accra men'.[20] But the Edo themselves were quick to grasp the new opportunities. In 1916, the Acting Conservator of Forests, T. H. Espley, wrote that there 'was hardly any village in Benin…which had not a commercial rubber plantation'.[21]

This reflected a wider social change. The old Benin Empire was not cut off from the rest of the world, but the Obas had always sought to control interactions with outsiders. Trade with Europeans, conducted in the currencies of manillas, cowries and brass rods, was inaccessible to most. The new coins introduced by the British opened the door to economic involvement for a much wider segment of the population. They bore the name of King Edward VII and were struck with a hole in the middle, so as to enable even people without clothes to carry them on a string round their necks. By 1907, cash was accepted as the principal mode of exchange across the lands the Oba had once ruled.[22]

Christianity, first introduced by the Portuguese all those centuries ago, returned, and with greater success. Many of the first conversions – including that of Jacob Egharevba and a prominent wife of the Oba – were the work of Bishop James 'Holy' Johnson, who arrived in Benin City in July 1901 with a very personal motivation to spread the faith. His

father, a Yoruba, had been enslaved by the Edo in the inter-ethnic wars of the nineteenth century. They sold him to European traders and he was en route to America when he was rescued by the Royal Navy. He was dropped off in Sierra Leone, where he married another freed Yoruba slave and where Johnson was born. Puritan and evangelical, Johnson said his 'desire to Christianise the Edo…had consumed him since boyhood when his father related to him the cruelties and sufferings he had experienced as a slave in Benin City'.[23]

Johnson was an outspoken critic of colonialism. He said the British invasion of Benin had been 'vengeful, destructive and desolating', and Oba Ovonramwen's exile amounted to 'unlawful detention'.[24] And yet he and the British were united in their determination to end human sacrifice and slavery in Benin. Johnson denounced many traditional Edo spiritual practices; the human sacrifices carried out before the British invasion were, he wrote, 'cruel and abominable'.[25] Mission schools and government schools opened up, their teaching bringing an irreversible rupture with the past. For Ekhaguosa Aisien, this was an unequivocal good. 'We were completely benighted,' he says of the Edo before 1897. 'No literacy at all. Not a single Benin man could read or write. Well, the conquest of Benin made the building of schools possible; the flame of literacy came to us. We became more and more citizens of the outside world. We could trade, we could read and write, speak English.'[26]

Just days after Oba Ovonramwen was overthrown, Captain Turner announced that any slave who returned to the deserted city before their master would be free. It marked the beginning of what historian Philip Igbafe says was 'a systematic assault on the institution of slavery'.[27] When it was finally abolished in 1915, thousands of slaves travelled to Benin City from throughout the Edo lands and danced around a pole before formally winning their freedom.[28]

Patrick Oronsaye says that for those at the bottom of the social structure, British rule brought obvious benefits. And even for those higher up, the fear of arbitrary punishment had lifted. No longer would the Edo use the curse *Ọbá ghá gbùà*; 'The Oba will kill you'. 'In those days,' Patrick says, 'the Oba could instruct any chief, no matter how great: "Commit

Suicide" and he had to commit suicide before the next month.'[29] Jacob
Egharevba wrote that 'the old Benin, with its barbarities and horrors,
had to fall before the new Benin could rise and take its place'. He says the
Edo were allowed to keep their laws and customs, except those that were
inhuman. In this way, the Punitive Expedition 'has been a source of real
blessing...[and]...we owe much to the British Government for improve-
ments in the country'.[30] To a twenty-first-century reader Egharevba's
tone is ingratiating. He may have been trying to curry favour with the
British rulers, yet he also voices some of the complex emotions about
the momentous changes his people were living through.

The British had banished the Oba, and yet they struggled to govern
the Edo without him. They tried their own political structures. Edo chiefs
perceived as loyal were rewarded with seats on the new Native Council
or turned into Paramount Chiefs. These were often resented for their
ability to enrich themselves through contracts with British companies.
The Native Courts were full of cases of 'refusal to obey Paramount
Chiefs'.[31] In the countryside, all was not peaceful, even after the capture
and execution of Ologbosere in 1899. In June 1906, a British Assistant
District Commissioner, Oswald Crewe Read – reputed to be disdainful of
traditional chiefs and their shrines – and several policemen were killed in
Owa, forty kilometres east of Benin City.[32] The British sent 200 soldiers to
put down the disturbance, and newspapers reported heavy fighting and
the death of a Paramount Chief.[33] In the House of Commons Winston
Churchill, by now Under-Secretary of State for the Colonies, was asked
whether Crewe Read's death was caused by British officials extracting
forced and unpaid labour.[34]

In August 1906, rumours swept across the Edo lands that chiefs loyal
to the exiled Oba were planning an uprising. The plotters were betrayed
by Chief Agho Obaseki, who had built up great wealth and influence
since 1897. He told British officials that the plotters had sworn oaths to
their cause and were raising money and weapons. The British responded
to what they called the 'Benin Scare' by arresting the Oba's eldest son,
Prince Aiguobasimwin, reinforcing the Benin City garrison and sending
patrols into the villages. The Prince was released after a search of his

house produced no weapons.[35] This was the unease the Edo people had secretly conveyed in their carvings on the wooden stool they sent to the Oba in Calabar.

One evening in late December 1913 a telegram arrived in Benin City.[36] It was addressed to Prince Aiguobasimwin. He could not read it, but showed it to his son, who was attending one of the new British-run schools. The telegram said the Oba was gravely ill. Prince Aiguobasimwin prepared for a journey of several days, and left Benin City for Calabar. He travelled by foot, then canoe, and eventually river steamer. He got as far as the port of Forcados, where there was another telegram waiting for him. Oba Ovonramwen, the last independent king of the Benin Empire, had died in hospital in Calabar on 14 January 1914. There is no record of Ovonramwen's exact age, but as elders recalled that he was already alive when his father Adolo became Oba, around 1850, he is thought to have been about seventy years old.[37]

Prince Aiguobasimwin travelled on to Calabar, and asked the British for permission to take his father's corpse back to Benin City for a royal burial. The British refused, on the grounds that the Oba had already been buried days previously.[38] But they were more sympathetic to the calls from Benin City for a new Oba to take the throne. Frederick Lugard was the British Governor who had just presided over the amalgamation of Northern and Southern Nigeria. A restoration of the Obaship fitted his concept of 'indirect rule', which co-opted the authority of traditional chiefs and kings in support of British colonialism. Prince Aiguobasimwin was the heir apparent, but he had a rival in Agho Obaseki. He petitioned King George V in support of a resumption of the previous line of succession.[39] Primogeniture, after all, was something the British understood, and they decided in the Prince's favour. After a seventeen-year interregnum the Edo awaited the return of an Oba to the palace.

The District Officer in Benin City, W. B. Rumann, left an account of the funeral ceremonies for Oba Ovonramwen in May 1914. They went on for weeks. The Edo, he said, 'were overjoyed and full of gratitude' at the restoration, and a feeling of celebration permeated the city. There was no corpse, but chiefs paraded through the streets with a coffin covered

in scarlet cloth. They fired guns in salute each morning and evening, and sacrificed oxen, sheep, goats and dogs at a rate of fifty to sixty per day. (The dogs, according to Rumann, took 'the place of the slaves who were always sacrificed at an Oba's funeral in olden times before the British occupation'.) The chiefs caught the blood in calabashes, and smeared it on their foreheads and big toes. In the *Olodo* dance, mourners shuffled back and forth and raised both hands to the ground, chanting in honour of the late Oba. Life-size effigies of the Oba, one covered in coral, the other made from chalk, were buried in the palace grounds.[40]

Aiguobasimwin's coronation, two months later, was just as elaborate. The Edo travelled to Benin City from across their kingdom, carrying yams and other presents. Aiguobasimwin took the title of Eweka II, a reference to the very first Oba and thus a name that evoked both continuity and a new beginning.[41] Rumann reflected warmly on those weeks; he believed the Edo had shown themselves to be not a bloodthirsty nation 'but on the contrary a courteous and friendly people'. He thought the restoration would bring better relations with the British. It also, he felt, could mean a 'revival of those arts for which the Bini [Edo] were justly celebrated more than three hundred years ago and which can be seen and admired by anyone visiting the British Museum'.[42] The ceremonies concluded on 28 July 1914. On that same day Austria-Hungary declared war on Serbia, and Britain's government had more pressing concerns than Benin. But in one remote corner of an empire sliding into war, there was a feeling that a dark chapter was ending.

Oba Eweka II's first task was to restore the derelict palace grounds. These were much reduced; the British had built government offices, courts, a prison, post office and hospital within the old compound. He needed to refurbish the palace shrines, and this brought renewed demand for brass casters with memories and skills from the old days. Eweka II himself was known as a fine carver of ivory and wood as well as a metal caster, but was in no position to be the munificent patron of the guilds that his forefathers had been. Philip Igbafe says the restored Oba was a caricature of the old, a 'glorified puppet', who'd lost his rights and authority over land and power to impose taxes, but instead resembled

a British constitutional monarch.[43] He lacked the means to feed, house and supply a stable of artists. In any case Benin City's new social and economic circumstances made it impossible to turn the clock back. A new, looser relationship between Oba and brass casters was inevitable. Eweka II gave them permission to create and sell their work wherever they could, and in 1926 the colonial government sponsored the opening of an 'Arts and Craft School'.[44] In order to survive, the royal guilds had become commercial industries.

The British, meanwhile, kept a watchful eye. When one of the Oba's wives disappeared, there were rumours that he'd had her sacrificed. A policeman was ordered to dig for her remains, but she was found a short time later living quietly with a lover in the town of Warri, and the man who had written the libellous letter which prompted the investigation was fined £50.[45]

In 1934, a celebrated American film-maker and collector of traditional music visited Benin City. Her name was Laura Boulton, and she described a peaceful and quiet town where she was treated with great courtesy. She went to the Oba's palace, where 'the altars are again filled with ceremonial objects...Some made since the capture [1897], some hidden in the forest and now brought forth.' The carved tusks, life-size bronze heads and smaller figures were of excellent quality, as were the sweet-toned bells rung by palace chiefs to summon the spirits. Benin City's artistic heritage, she felt, was very much alive, its best metal casting still defined by 'grave simplicity, the beautiful proportions, the strength, vigor, and boldness of the modeling, and the feeling for design'.[46]

Laura Boulton met the new Oba, Akenzua II, the son of Eweka II who had died in 1933. Born after the British invasion, educated at the best colonial schools, trained as a civil servant, Akenzua II was at the apex of Edo traditional power yet embodied many of the changes in its society. He disbanded the palace harem and kept only eight wives.[47] He took an interest in all his children's education, and allowed some daughters to choose their own husbands.[48] Some years later, in 1950, he became the first Oba of Benin to leave the shores of West Africa, when he and a wife took a six-week tour of Britain as guests of the British Council,

including a stop at Cambridge, where his son was reading law at the university.[49] Laura Boulton had been told the Oba was an intelligent and well-educated man, but was nonetheless surprised to find him reading a copy of Lord Chesterfield's *Letters to His Son*, an eighteenth-century guide to English social etiquette.[50]

Raymond Tong was a British official with the Colonial Education Service who lived in Benin City from 1949 to 1953, and wrote a colourful book about his time there. Benin City still felt enclosed by thick forests, in which giant trees had 'the air of dim columns in some vast cathedral'.[51] The journey through the forests from Lagos – today a drive of about three hours – lasted an entire day on dirt roads. Tong's first impression was that Benin did not resemble the capital of a once-powerful empire. 'Its crumbling walls were overgrown with bush; there were no great gates' and it had 'a strangely depressing and desolate air'.[52] The houses were built of mud, thatch and corrugated iron, just like in any Southern Nigerian town of that time. But Tong warmed to Benin City, a place where strangers were treated with generosity, where drums beat every night with 'a primeval throbbing, timelessly vibrating above the surrounding palms', where women walked to market carrying small crocodiles on their heads, and where crowds flocked to traditional wrestling but also the new cinema, 'a link with the great, fascinating world which exists beyond their own mud walls'.[53]

Christianity – Anglican, Catholic, Baptist – flourished in Benin City, and Christmas was celebrated with riotous exuberance, yet Tong felt the Edo had not cast off 'the shadow of their ancient gods'.[54] When he was invited to their homes, he saw shrines bedecked with feathers and the bones of animals from recent offerings. Tong did not doubt British motives in 1897, yet he was troubled by the past. He paid his respects at the stone cross for James Phillips and his companions in Ugbine, 'a sad little memorial' in a clearing beneath the trees.[55] He travelled on to Ughoton, the river port, which was small and desolate, a ghost of its former self. He was well received by Oba Akenzua II, now fifty years old, 'a soft-spoken, tall and rather dignified man' who insisted they share a warm beer.[56]

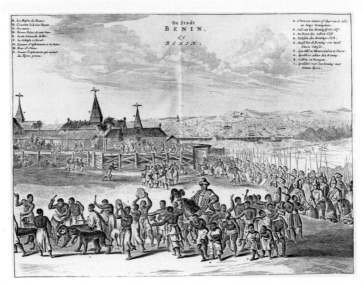

The glory of ancient Benin. From Olfert Dapper's *Naukeurige Beschrijvinge der Afrikaensche Gewesten*, Amsterdam 1668.

Men of War. Leaders of the Punitive Expedition sail to Benin. Consul-General Ralph Moor (seated), Captain Herbert Walker (behind Moor), Major Frederick Landon (fifth from right), Lt Colonel Bruce Hamilton (third from right).

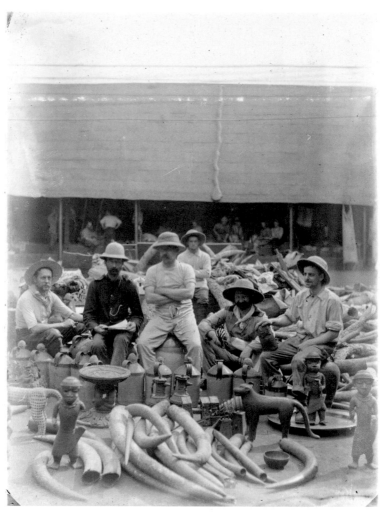

'A regular harvest of loot!' The British in the Oba's palace, February 1897.

The British called Benin 'the City of Blood'. Removing the victims of human sacrifice. From Herbert Walker's diary.

'The king's house is rather a marvel.' The British take their pick, *The Graphic*.

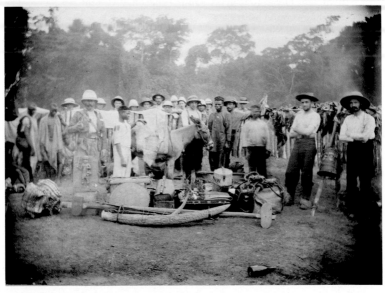

Loading the spoils. A British officer wrote of 'carrier after carrier bearing tusks, carved and uncarved, bronzes, panels, and all sorts of loot'.

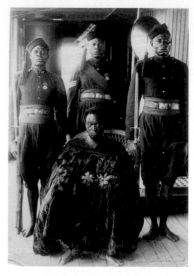

Above Left: The man who took Benin. Admiral Harry Rawson, sketched by *Vanity Fair*.

Above Right: Oba Ovonramwen taken into exile. On board the *Ivy*, September 1897. Note chains round his ankles.

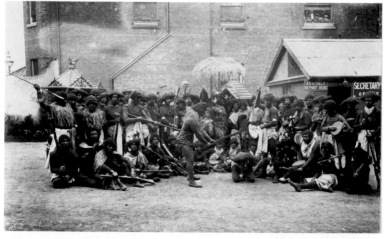

The conquest of Benin as morbid entertainment, Royal Military Tournament, London 1898. British soldiers in blackface and costume re-enact 'hideous sacrificial rites'.

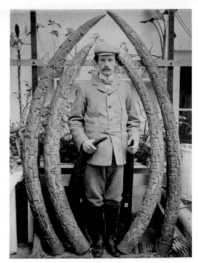

Above Left: Chief Ologbosere, moments before his execution, 28 June 1899. He resisted the British to the end. 'He met his death with perfect nonchalance.'

Above Right: William Downing Webster, dealer in Benin Bronzes, 1900. He told a museum 'sorry you think the prices are too high – but I am convinced that they will go still higher.'

Below: Oba Ovonramwen with his family in exile. He spent 17 years in Calabar, and never saw his kingdom again.

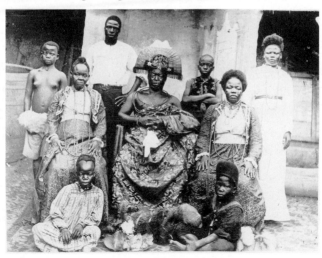

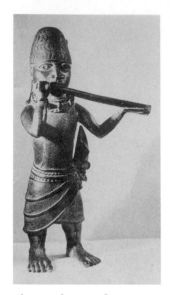

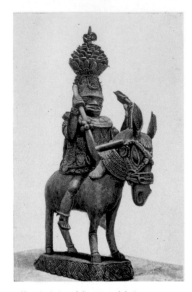

Above Left: Benin fluteman, or Herbert Walker's 'Toochly-Poochly'.

Above Right: The Swainson Horseman, a Benin Bronze with a happier provenance.

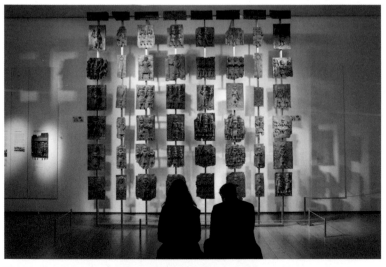

The Benin plaques on display in the British Museum.

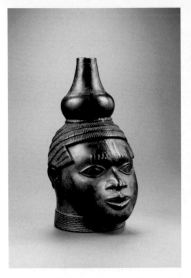 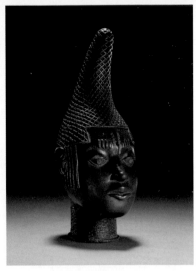

Above Left: The Ohly Head, the £10 million Benin Bronze.

Above Right: Queen Idia, early sixteenth century. As if from ancient Greece, said British Museum curators.

Mark Walker hands over his Bronzes. With Prince Edun Akenzua, Benin City 20 June 2014.

Enotie Ogbebor, Benin artist and campaigner for return of the Bronzes.

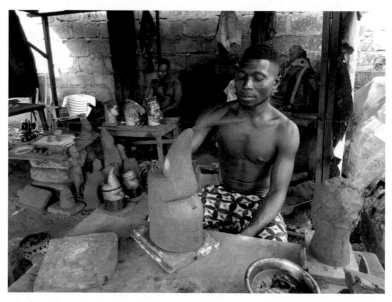

The brass casters today. Igun Street, Benin City.

In the 'rambling, ramshackle' palace Tong saw reconstituted shrines to previous Obas, and admired ivory carvings and brass heads.[57] 'It is often thought that the best examples of Benin art have all left West Africa, and can only be seen in museums in England and in Germany,' writes Tong. 'I can say that this is not quite true. Benin has managed to retain at least a few fine examples of its ancient arts.'[58] Tong felt these objects had more relevance in Benin – on shrines still wet with the blood of recent sacrifices, surrounded by empty beer bottles, cowries, bones and feathers – than they could ever have behind cold glass in a European museum. When he visited the brass casters on Igun Street, he admired them as 'a living embodiment of one of Africa's oldest arts, producing both form and meaning which have real significance in relation to their surroundings'.[59] In an elderly chief's house, Tong was taken to the shrine in a central courtyard, where he saw a line of old bronze and wooden heads. 'It is to be hoped,' he wrote, 'that they will never become alien curiosities in some distant museum, but that they will remain where they are, in a house which is…a memorial of Benin culture.'[60]

The brass casters Tong met on Igun Street in the 1950s were using the same materials and tools as their predecessors in Benin's days of glory. The tradition never died. But brass casting was only one of Benin City's two great artistic legacies. The other, ivory carving, has surely gone forever. The elephant herds of West Africa have all but disappeared, as have their forests, and with what is left of them hemmed in by vastly increased numbers of people, it's difficult to imagine they can ever recover their numbers. And yet for the Europeans, ivory was the first prize. When James Phillips and others imagined Benin's wealth before the invasion, they talked of its ivory. When the British officers grabbed what they could from the Oba's palace, they reached for ivory, and above all the ornate tusks, some almost two metres long and entirely covered in fine carvings of human and animal figures. When Sir Ralph Moor wanted to realise a quick return for his government from the Benin loot, he sold tusks. And, as we've seen, for years after 1897, the auction houses in London, and dealers like Webster, sold ivory at higher prices than Benin's brass castings.

Elephants – *èní* – and ivory had been part of Edo culture since long before the Portuguese arrived. Patrick Oronsaye says the legend is that the guild of elephant hunters was formed during the time of the Ogisos, before the Oba dynasty. That was when elephant calves were said to have been brought to a place near Benin City, Oregbeni, where they were trained as military cavalry. 'It was easy for the elephants to cross a moat or bulldoze a way through the forest, and the army follows,' says Patrick.[61] Today Oregbeni – which means 'the open space of the elephant hunters' – is a teeming market, flanked by a road of choking traffic and blaring car horns. There is another village near Benin City, Ugoneki, which was renowned for magical powers to turn young men into elephants at times of war.

The Portuguese found that ivory carving was an established art at the court of the fifteenth- and sixteenth-century Obas, practised under royal patronage by the *Igbesanmwan* guild. In the seventeenth century, European visitors described for the first time the display of tusks on ancestral altars.[62] The Obas decreed that wherever an elephant was killed in their kingdom, that tusk which touched the ground first belonged to them, and they retained the prerogative of buying the other one. Hence the Edo saying *Ì má mi ighó yà gú ọgbèní dúẹkì*; 'I am not rich enough to trade in elephant tusks.' Elephant hunting was difficult and dangerous; hunters perched in trees above forest paths, waiting for them to pass. Even if they succeeded in hitting an elephant with poisoned arrows or spears, it might not die for another four or five days, during which time they pursued the irate animal through the forest.[63]

The Europeans wanted more ivory than the Edo had hitherto needed, and their guns made it easier to kill elephants. Edo hunters learnt to use Dane guns, firing poisoned darts which penetrated further into the elephant's hide than arrows or spears. In the late nineteenth century, the British trader Cyril Punch met an Edo man who boasted of killing 200 elephants during his career.[64] But West Africa's ivory trade peaked in the late seventeenth and early eighteenth centuries, driven by Dutch, and to a lesser extent, British, demand. Dutch records from that time show it was not unusual for a ship returning from the West African coast to carry

15,000 pounds – about 6,800 kilograms – of ivory.[65] American scholars who've studied the trade calculate that just in the years from 1699 to 1725, a minimum of 5 million pounds – about 2.27 million kilograms – of ivory left West Africa on Dutch and English ships alone.[66]

These figures need to be put into perspective. An average adult elephant at the time was thought to carry some seventy pounds of ivory, so 5 million pounds would represent more than 71,000 elephants.[67] Nigeria's entire surviving elephant population, in the first years of the twenty-first century, is about 300, and carries considerably less ivory than just one Dutch ship sailing down the Benin River in the early eighteenth century.[68] In London and Amsterdam, West African tusks were turned into cruci-fixes, plaques, chests, mirror frames, cutlery, chess pieces and whatever else took the fancy of aristocratic and trading families. And for Benin's Obas, ivory, not slaves, was the principal means to buy European imports.

The French trader and captain J. F. Landolphe, who visited Benin City in the 1780s, sent home some 20,000 pounds (9,000 kilograms) of ivory, and wrote of how the Oba had 3,000 tusks piled up in a palace courtyard.[69] The Scottish explorer Mungo Park travelled through West Africa in the 1790s and observed that 'nothing creates a greater surprise among the negroes on the sea-coast than the eagerness displayed by the European traders to procure elephant's teeth...they cannot, they say, easily persuade themselves, that ships would be built and voyages undertaken, to procure an article which had no other value than that of furnishing handles to knives etc. when pieces of wood would answer the purpose equally well.'[70] By then the ivory trade complemented what had become the more lucrative slave trade. Mungo Park describes how Europeans swapped guns and ammunition for ivory, and that 'a great quantity of ivory is...brought from the interior by the slave coffles'.[71]

Inevitably, the slaughter had an impact. Mungo Park observed that by the end of the eighteenth century 'the quantity of ivory collected in this part of Africa is not so great, nor are the teeth so large, as in the countries nearer the line [Equator]; few of them weigh more than eighty or one hundred pounds'.[72] Again some perspective is needed. By the impoverished standards of the twenty-first century, an elephant

carrying a pair of 100 pound – about forty-five kilogram – tusks is defined in conservation circles as a 'super-tusker'; there are perhaps thirty such magnificent animals left on the whole African continent.[73]

Between the 1780s and 1830s, the price of ivory rose tenfold in Europe. According to an historian who has studied the trade, 'ivory became the plastic of the era', turned into piano keys, billiard balls, combs and other luxury items.[74] The hunters had wiped out most of West Africa's coastal populations of elephants. Now they moved into the interior. In the first decades of the nineteenth century most ivory imported into Britain still came from West Africa, but East Africa became steadily more important thereafter. By 1891, three-quarters of the world's ivory was traded through the island of Zanzibar.[75] Although the Royal Niger Company was still buying up large quantities of tusks in the 1870s, West Africa's elephants had largely disappeared.[76] When Henry Ling Roth ran his hands wistfully up and down the majestic carved tusks that the British took from Benin City in 1897, he could only wonder at the 'pacific life elephants must have lived in former times to have enabled them to live long enough to produce such splendid ivory'.[77]

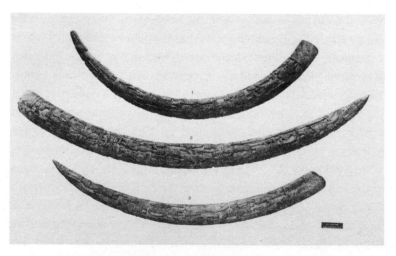

Carved tusks from Benin – from the vanished elephants of West Africa.

Too late, the British tried to repair the damage. Their first directives in 1897 included prohibitions on elephant hunting, not just immediately around Benin City, but also in the Edo traditional hunting grounds of Owo and Akure to the north-west.[78] In 1932, the colonial administration commissioned a retired soldier, Colonel Austin Haywood, to survey Nigeria's wildlife. He estimated the country's population of elephants at just 2,000. The nature reserves close to Benin City were, he wrote, in a parlous state: 'the native does as he pleases' and British officials had little interest.[79]

When I mentioned to people in Benin City that a handful of elephants are still thought to survive in a fragment of forest only one hour's drive away, I was met with incredulity. Almost everybody – historians, palace officials, visiting European scholars of art – doubted my information. 'No, no, no, they are extinct!' I was told again and again.

In truth, a visit to Okomu Forest National Park is not for the light-hearted. I was taken there by the senior park official, Abdullahi Ahmed, a softly spoken, nervous man. On our drive through undulating rubber plantations and cocoa farms he said the park was under pressure from loggers and oil smugglers armed with automatic weapons, and his men had only a few double-barrelled shotguns with which to respond. 'Don't worry,' he reassured me, 'we will only take you to the safe parts.' Trucks laden with timber, going the other way, drove past at regular intervals. 'You see, we don't even know if this is legal or not, but we can't stop them,' Ahmed complained. At the park entrance I couldn't help notice I was the first foreigner to have signed the visitor's book in more than a year. I later learnt from a well-informed friend that a South African woman who ran the park accommodation had been kidnapped a few years earlier. She was held captive for three nights in a hut, surviving on noodles and water, before escaping from her drunken guards. Since when, the trickle of foreign visitors to Okomu has all but dried up.

And yet, the elephants are still there, although the rangers scoffed at my hopes of seeing one during a two-day visit. Even they, living there, go months without encountering the elusive animals. But they were proud of the progress they've made. No elephants in Okomu had

been killed for years, they said, and the population had recovered from less than ten to a still precarious thirty animals.[80] The rangers took me on an evening walk through the forest. We could see almost nothing except dense vegetation, but we could hear parrots, turacos and hornbills squawking overhead, antelopes crashing through the undergrowth, and monkeys fleeing through the tree tops. We climbed a ladder, 140 unnerving steps high, to a wooden platform which looked down on the canopy and swamps. It was a step back in time to the old Benin, the legendary forest kingdom.

The rangers leave hidden cameras on the forest paths. That evening, huddled round the glow of a laptop, they showed me the footage, grainy pictures of a group of elephants, young and old, walking silently through the forest. I counted fourteen animals, their tusks not much bigger than pencils. They moved swiftly, not looking back, and then they were gone. The ghostly remnants of Benin's past, not quite extinct after all.[81]

FAMILY SECRETS

The British Empire whose armies swaggered across the world stealing what took their fancy, and the African kingdom where human sacrifice and slavery was commonplace; 1897 can read like ancient history. And yet the fates and fortunes of the families of some of those involved in the overthrow of the Benin Kingdom are still shaped by the events of that year.

Florence Swainson worked in the Liverpool Post Office as a telephone operator all her adult life. She lived across the Mersey in New Brighton, in a rented ground-floor flat in an Edwardian semi-detached house. Her flat was in poor condition, dark and shabby according to the few visitors, but Florence had had a difficult life. She never met her father. He died abroad in 1897, less than a year after her birth. His name was John Swainson, the Liverpool trader who'd accompanied Henry Gallwey to Benin City in 1892. Swainson already knew Oba Ovonramwen, so Gallwey would have hoped his presence would have increased the chances of securing a treaty. For all his long absences and African adventures John Swainson left his widow, Eleanor, less than £100, and so Florence, the only child, had to make her own way in the world. She joined the post office when she was sixteen and eventually rose to be a Chief Supervisor of Liverpool's telephone operators.[1]

Florence never married, but one of her closest companions was a

cousin of a similar age, whose descendants became in effect surrogate children and grandchildren. Florence was the poor relation, and they were a source of comfort. She rarely spoke about herself, but when prompted had a repertoire of well-trodden but unlikely stories about her father; how he had been the friend of a great West African king called the Oba, how this Oba was so amused by her father's red hair that he asked if his wives could touch it, how he had given her father a bronze sculpture of a royal ancestor riding a horse as a wedding present, and so on. She had learnt these tales from her mother. Florence inherited the red hair, but otherwise it was difficult to connect this lonely woman and her ordinary life with her father, the West African trader.

In 1974, Florence's cousin's grandson, a man called Peter Karpinski, was an undergraduate studying art history at Leeds University. He borrowed Florence's copy of Captain Boisragon's 1897 book *The Benin Massacre* (she'd inherited it from her grandfather David, John Swainson's father) and it piqued his interest in Benin. Dropping her at home after one of her visits to his grandmother, he asked to see the horseman sculpture, the purported wedding gift from the Oba. Florence was only too pleased. She kept it outside on her porch, where she used it as a doorstop. Almost half a metre tall, it was easily visible from the street. Decades of exposure to the Wirral's salty winds had turned it green. Peter knew little about African art, let alone Benin, but had a feeling he was looking at something unusual. Florence explained that somebody had offered her £50 for it a few years earlier, but she had turned him down. But when Peter asked if he could photograph it, Florence said if he was really interested, he might as well take it away.[2]

The horseman sat in Peter's bedroom, on top of a chest of drawers, for another four years. Then, one day, his brother bumped into an old school friend on a London bus who had found a job in the Tribal Art department at Christie's. 'Tribal art? My brother's got an African sculpture, you might want to take a look.' One thing led to another, and William Fagg, working at Christie's in his retirement, was bowled over the moment he saw it. There were perhaps a dozen equestrian statues taken from Benin in 1897, but Fagg believed this one to be as

fine and old as any of them. The rider – perhaps an Oba himself – wears a headdress that resembles an upside-down pine cone, topped with a crown of feathers. He has a wide and intricately decorated collar. His coat, embossed with ovals, is pulled up to his hip, revealing a leopard-skin garment underneath. In one hand he holds a decorated spear, in the other a rein and some arrows. He has a patterned shield over his shoulder, a sheathed dagger and spurs. The horse's neck is decorated with ropework and a bell. He stands on an ornate rectangular base. It is a work of astonishing detail (see illustration section). The history of horses in the Benin Empire is rather mysterious. Dutch and Spanish visitors in the seventeenth century saw the Edo using them, but they seemed to disappear during the nineteenth century, and there were none by the time the British invaded. Fagg believed the sculpture was from the sixteenth century, and a laboratory at Oxford University, using thermoluminescence, came up with an approximate date of 1560.[3]

If Florence's story was correct, that 'the Swainson Horseman' was a wedding present to her father in 1892, then it might have been the first Benin Bronze to arrive in Britain, and with a happier provenance than the thousands which came five years later. Swainson did indeed get married, on Merseyside, a few months after returning from Benin in 1892, and the evidence that his horseman was in Britain before any of the looted objects is incontrovertible. It was written about and photographed in the Liverpool newspapers of January and February 1897, when there was the flurry of interest in Benin before the invasion. The *Liverpool Daily Post* reported on a 20 January meeting of the Liverpool Geographical Society on 'The City of Benin: the country, customs and inhabitants', addressed by Swainson's employer, James Pinnock, who showed the audience 'an exceedingly quaint and well modelled equestrian statuette, made in Benin'.[4] The *Liverpool Graphic* said it had been given to Swainson by the Oba.[5] It would have been a generous gift, but Oba Ovonramwen was known to exchange presents with the other trader, Cyril Punch, and he also gave Gallwey a tusk. Perhaps the Oba wanted to thank Swainson for brokering the 1892 treaty, before he came to appreciate its dire consequences.

There does seem to have been some sort of a relationship between the Oba and John Swainson. Captain Boisragon lamented that Swainson had not been able to join him, James Phillips and the others in January 1897, as his experience and contacts in Benin City would have been invaluable.[6] More tellingly, when the captured Oba was being taken to Calabar later that year, British newspapers reported that he specifically asked after his two 'friends', Mr Swainson and Mr Punch.[7] That was when the Oba was told the sad news: Swainson had died. The Oba could have been forgiven for being preoccupied by his own problems at this stage, yet is said to have reacted with 'much concern'.[8]

So what had happened to Swainson, and why didn't he go with Phillips and the others in January 1897? The traders who did, Thomas Gordon and Harry Powis, were both killed, of course. Swainson had told Boisragon he couldn't join them because, much to his regret, he was suffering from rheumatism.[9] Was he looking for any excuse to back out of what he realised was an ill-conceived mission? Perhaps, because at least one newspaper subsequently reported a completely different reason for his absence: the sudden death of one of his clerks.[10] When Boisragon and Locke made their escape after the ambush, and came across the protectorate steamer, *Primrose*, Swainson was on board, and, Boisragon wrote, wept tears of joy.[11] Yet he was not well. By 10 February, he was in Lagos, en route to England for health reasons. He never made it. John Swainson died on board the SS *Cabenda*, sailing from Lagos, on 21 March 1897.[12]

At the beginning of June 1978, Christie's was preparing to sell the Swainson Horseman. There was much excitement; British and American newspapers flagged up the impending sale and predicted a six-figure sum. *The Times* described the Swainson Horseman as 'the only important work of art to have come out of Benin City between the sixteenth century and the Benin massacre of 1897'.[13] Then, after the catalogue was printed – 'Important Tribal Art', with eight pages dedicated to photos and the unusual history of the Swainson Horseman – the horseman was suddenly withdrawn from auction.[14] Peter Karpinski, with Florence's consent, had been in secret negotiations with the Merseyside County Museum

(its ethnographic collection is now the Liverpool World Museum). It expressed an interest, launched a hurried search for funds and, with the support of an arts charity, made its own offer. 'Museum to pay £60,000 for a doorstop,' reported the *Guardian*.[15] Peter and Florence wanted the sculpture to be on public display, and felt the museum made a fitting home for an artwork which spoke of Liverpool's historic ties with West Africa. Christie's lost out on a twenty per cent commission, and faced legal threats from American dealers who'd travelled across the Atlantic to bid for the Swainson Horseman. 'We had a man staying at the Ritz shouting down the phone he wanted all his costs reimbursed,' says Christie's Hermione Waterfield.[16]

Peter Karpinski, who had done the research which confirmed the horseman was not looted in 1897, says he kept Christie's in the dark because he didn't want them to sabotage the sale to the Merseyside County Museum. Christie's had put much time and effort into the same research. It also arranged for the British Museum to clean the horseman, because, according to Hermione, 'it was completely green when it arrived, it had been by the seaside'.[17] More than forty years later, the emotions around this affair are still extremely tender.

In Benin City, John Swainson's role may not appear so benign. When Peter Karpinski followed in the footsteps of his relative and made his own visit there in the early 1980s, the then Oba, Erediauwa, pointedly asked him, 'Was it right for your ancestor to advise my ancestor to sign the 1892 treaty?'[18] And yet the Swainson Horseman, today one of the star pieces of the seventy Benin objects in Liverpool's World Museum, is a Benin Bronze with a uniquely uncontested past. 'I felt very strongly that if any Benin Bronze deserved to stay in this country, this was it. The others have a dodgy provenance, but this one is in a different league,' argues Peter Karpinski.[19]

For Florence, there was a happy ending. With the proceeds of the sale, she was able to move out of her grim flat, and buy a bright new one in a purpose-built block on the other side of the Wirral. It was a gift from beyond the grave from John Swainson. In the final years of her life, she would look across the River Dee, all the way to the Welsh hills,

still wondering about the father she never knew and his friendship with an African king. Florence died in April 1980.[20]

One morning in late April 2016, the art dealer Lance Entwistle walked south from his Bond Street office for a few blocks across Mayfair. When he reached Berkeley Square, he stopped at the Lansdowne Club, which calls itself a 'noble Mayfair club…a haven of civilised calm'.[21] There he had coffee with two art experts, Will Hobbs and John Axford, from the Salisbury auction house Woolley & Wallis. Then the three of them walked a short distance past Arab embassies and hedge-fund offices, until they came to Park Lane. Stanhope House, next to the Dorchester Hotel, is an ornate, neo-Gothic affair with bay windows and parapets, a playful suggestion of a medieval castle. Built by a soap mogul at the turn of the previous century, it's owned by a company based in the Turks and Caicos and is a branch of Barclays Bank. 'I was always intrigued by that branch of Barclays,' recalls Lance, 'it's rather swish, and, at least in the good old days, with a swish branch comes safe deposit boxes. They are curiously lacking in this country, whereas in continental Europe, perhaps it has to do with wars and occupations, a lot of people keep their valuables in safe boxes in banks. I've been into many bank vaults in France, in Belgium, in Switzerland.'[22]

I had my expectations of what a high-end Bond Street art dealer should look like, and Lance Entwistle conformed to them. We met in the summer of 2019, in his library lined with rare and interesting books on African sculpture. He was wearing a burgundy blazer with a hand-kerchief showing from his breast pocket, and his blue shirt matched his piercing eyes. I'd guess he was a well-preserved mid-sixties, charming and debonair. The phone rang from Paris, where he keeps his showroom, and his French was elegant and precise. His website says his company, simply called Entwistle, has been 'leading tribal art dealers for over forty years', working with private collectors and many of the world's most famous museums.[23]

'Tribal Art' is a term that Western museums now avoid, but is still common in the world of auctions and private sales. Lance Entwistle has

rarely been to Africa, and never to Nigeria, but he's well connected. The British Museum, the Tate, the Musée du Quai Branly-Jacques Chirac in Paris, the Metropolitan in New York and the Field Museum in Chicago have all bought pieces from Lance. He started his career on a Portobello Road market stall, hawking ancient Egyptian beads and scraps of Roman glass, much of it bought at Sotheby's auctions and then resold at profit. From those humble beginnings, he has worked his way up. I suspect that beneath the velvet there may be some steel.

Lance took that walk across Mayfair in a state of expectation. He had been contacted some weeks earlier by a woman he knew called Frieda Leithman,[24] daughter of the late art dealer Ernest Ohly. Ernest's father, William, was a prominent figure in the mid-twentieth-century London art scene. William Ohly lived, in Lance's words, 'at the centre of a cultural hub, a nexus of culture, society and artists. It was a milieu in the late 1940s and early '50s that doesn't exist any more.'

William Ohly collected a range of modern, classical and ethnographic art, including from the Himalayas, India, Oceania and Africa. He'd borrow and loan pieces for his exhibitions of 'Primitive Art' at his Berkeley Galleries, just off Berkeley Square. These attracted collectors and socialites, but also artists such as Jacob Epstein, Lucian Freud, Henry Moore, Francis Bacon, Duncan Grant and Vanessa Bell. The first was held in the bomb-scarred London of June 1945, just weeks after Germany's surrender.[25] In the snow and cold of January 1947, they crowded into Berkeley Galleries again to admire an ivory mask from Benin.[26] In December that year, William Ohly dedicated a whole exhibition to the Benin Bronzes. 'A remarkable collection…splendidly ornamented,' wrote *The Times*.[27] William Fagg, in the foreword to the programme, wrote that with the exception of the British Museum's exhibits, 'it is to Mr Ohly's shows almost alone in London that we now look for the material without which a British taste for African and other primitive art cannot adequately develop.'[28]

William Ohly had fled from Nazi Germany in 1934. His mother was Jewish, and he married a Jewish woman, Gertrude, the daughter of a prominent professor of ceramics. Their son, Ernest, was sent to

boarding school in Switzerland, but later joined William in London, and became involved in the family business. Ernest's love and knowledge of art came from his father, but he was a very different character. William, who died in 1955, was a man of charisma and tact whereas Ernest was often uncommunicative and closed.[29] 'A very, very difficult man to know. He didn't let anything out. You did not know what he was thinking,' said Lance. Under Ernest, Berkeley Galleries began to lose its allure. 'When I got to know it in the early 1970s it was a gallery without life,' says Lance, 'musty and undynamic. Its glory days had gone.' It closed in 1977 and Ernest, divorced, became increasingly reclusive. 'He would have been a difficult man to live with,' says Lance. 'He never complained about anything. You'd say "How are you?", he'd say "Fine", but he wouldn't converse.'

Ernest Ohly's death, at the age of eighty-seven in 2008, provoked a ripple of excitement among those in the know at the now lucrative top end of ethnographic art. He had not been an active dealer for years, but was rumoured to have an extensive collection. His children, Frieda and a brother in Germany, gave Christie's permission to auction one of his prize pieces, a Polynesian wooden statue, almost two and a half metres tall. 'The Ohly Figure', as it became known, was sold in Paris for almost €1 million in 2011. Woolley & Wallis sold another thirty-six of Ernest Ohly's pieces in January 2013, for more than £100,000. These included masks from the Yaure and Baule peoples of Ivory Coast, statues from the Kuba of Congo and the Fang of Gabon, as well as figures from the Solomon Islands and North America.[30]

The sale by Woolley & Wallis was assumed by art dealers to mark the end of Ernest Ohly's collection. Frieda and her brother knew otherwise. In old age, Ernest had told them he had another important sculpture, sitting in a Barclays safe deposit box. Frieda had a suspicion it was a Benin Bronze. It was not to be sold, Ernest specified, unless there was another Holocaust. By the beginning of 2016 that second Holocaust had thankfully not yet come, but matters had been taken out of the children's hands. Barclays had written to say it was closing its safe-box facility; customers had to collect their belongings. That was why Lance

Entwistle, John Axford and Will Hobbs walked so purposefully that April morning. They were on their way to meet Frieda Leithman. Together, they were going to retrieve the mysterious piece from Ernest Ohly's box in the vaults of Barclays on Park Lane. Then, Lance's job would be to sell it.

In the event, only Frieda was allowed downstairs, accompanied by representatives of the bank. Lance, Will Hobbs and John Axford waited upstairs. For twenty minutes they perched on an uncomfortable Chesterfield sofa in the corner of the bank and watched customers go about their daily business. Frieda returned, carrying a head-size object, covered in an old dishcloth. She unwrapped the cloth, and everyone gasped. A youthful face cast in bronze or brass stared out at them. He had a beaded collar running halfway up his neck and a small gourd or calabash balanced on the crown of his head. Lance recognised it as an 'early' Benin Bronze head, he thought an Oba from the sixteenth century. He suspected it was worth millions of pounds, and wanted a private space to examine it further. The bank staff led them into a panelled room, where they laid the head on a table.

'I was mightily impressed,' said Lance, 'bowled over. It was beautiful, moving, and its emergence from obscurity was in itself so exciting.' The head was in near-immaculate condition (see illustration section). It had the dark grey patina of old bronze, much like a contemporary piece from the Italian Renaissance. 'I'm very used to being told about a Benin head, a Benin plaque, a Benin horse and rider. Generally I'm not excited because ninety-nine times out of one hundred they are fake, and very often the remaining one per cent has been stolen,' said Lance. Provenance is everything in his world. This time, thanks to the Ernest Ohly connection, he was confident he was dealing with a bona fide Benin Bronze. Will Hobbs, from Woolley & Wallis, said, 'Just to hold something like that in your hands. In this job we see beautiful things all the time, but that was a special moment.' They told Frieda it was an amazing find, a significant and unusual piece, and convinced her to take it home in a taxi, all the way to her terraced house in Tooting.[31]

*

The 'Ohly Head', as Lance and Woolley & Wallis would call it, is not the only Benin Bronze to have surfaced dramatically after decades of obscurity. In 1948, Mr C. H. Joyce of Luton spotted something unusual poking out of a local rubbish dump. It turned out to be the upper part of a Benin Bronze ceremonial staff: an intricately cast piece of metal more than a metre long, a column of human figures, wriggling snakes, monkeys and leopards. He sold it to the British Museum for £20.[32] In 1961, Mr L. Hope of Croydon was showing his neighbour, a policeman, around his greenhouse. 'I think you might want to get this checked out,' said the policeman, holding up an unusual cast metal head with a plant stuck on top of it. It dated from the late sixteenth or early seventeenth century. It's not clear how long it had been in Mr Hope's greenhouse, but it did not seem to have done it any harm. It was sold at Christie's a few months later, lauded as a superb piece, and briefly became the most expensive Benin Bronze in history. Today it is in Boston's Museum of Fine Arts.[33] 'Of course there are many Benin pieces that can be traced back to the Expedition,' says Lance, 'and many that can't. Those that were collected by senior officers are likely to be traceable, but there were disposals, things sold for widows and so on.'

In 1972, Dale Idiens, ethnography curator of the National Museum of Scotland in Edinburgh, was visiting the McLean Museum, in the town of Greenock, where one of the staff casually mentioned that some African statues were kept in a cleaning cupboard. Almost fifty years later, she recalls what happened next as if it were yesterday. 'He opened it for me, and there, behind the mops and brooms, were these Benin Bronze statues. I nearly fell over,' she said. 'That sort of thing does not happen very often in a curator's career.'[34] The McLean Museum, once informed they were 'extremely valuable and extremely rare', agreed to hand them over. The four figures, including a flute man and royal messenger from the seventeenth or eighteenth century, are now some of the National Museum's most precious exhibits, and have been displayed across Europe and the United States. Their journey from Benin to a Clydeside broom cupboard had taken a spectacular detour, via the high society of colonial Kenya. They had been donated to the McLean Museum in the 1920s

by the widow of Sir William Northrup McMillan, a wealthy American of Scottish descent who lived in Kenya. McMillan had no connection to Nigeria, and little interest in art, so his ownership of these precious Bronzes is, at first glance, mysterious.[35]

The explanation lies in McMillan's close friendship with Major Charles Ringer, who fought with the Niger Coast Protectorate Force on the Benin Expedition in 1897. There are photographs of Ringer posing in the Oba's palace (p. 88), and he donated a carved tusk to the East Lancashire Regiment Officers' Mess.[36] He was invalided for months afterwards, weakened by gonorrhoea, headaches and swollen legs.[37] He recovered to take part in the operations against Ologbosere in 1899, fought the Boers in South Africa, and then travelled to Kenya on a hunting trip. He liked it so much he decided to stay. He bought a ranch outside Nairobi, on Ol Donyo Sabuk mountain, which he called 'Long Juju', and which he later sold to McMillan. Perhaps the Benin Bronzes were thrown into the sale, although they weren't worth much in those early years. Ringer had lived a spartan existence on the ranch, on one occasion allowing his horse to sleep in his hut-like dwelling while he stood guard outside against prowling lions, but McMillan built a luxurious estate for hunting safaris where he hosted Teddy Roosevelt and a series of aristocratic guests.[38]

Ringer used his ranch money to build a hotel in Nairobi, the Norfolk, which opened on Christmas Day 1904 and quickly established itself as the colony's finest. Ringer, with a reputation for gruesome stories of cannibalism and witch-doctors from his West African days, as well as tales of adventures from South Africa to the Caribbean, would have made an entertaining host. Teddy Roosevelt called him 'the Juju major'. When Ringer and McMillan went on holiday together to the United States in 1911, Roosevelt insisted they visit him on his Long Island estate.[39] By now Ringer was living back in Britain, in Cornwall. On 18 September 1912, with a strong east wind driving the waves onshore, he fell from his yacht off the rugged coast around Nare Head. His body was never recovered. Thus another Benin veteran met a tragic end.[40]

Sir William McMillan loaned his Benin Bronzes, along with some of his vast collection of hunting trophies, to the McLean Museum in

1919 (he had a friend who was a prominent Greenock shipbuilder). In March 1925, McMillan, hugely overweight, was travelling to England to see his doctors when he fell ill. He died in Nice, in an English nursing home. His body was returned to Kenya, and was buried on the slopes of Ol Donyo Sabuk. His widow, Lucie, had never much approved of Major Ringer, whom she saw as a bad influence on her husband. A few months after Sir William's death she turned the loan to the McLean Museum into a donation.[41]

Benin Bronzes were probably not to Lady McMillan's artistic taste, but she could scarcely have anticipated how, in the second half of the twentieth century, their value would appreciate. As their prices rose, at first gradually and then steeply, they evolved into prestige investments. Dealers like Lance Entwistle have been instrumental in this process. And while many of the finest Benin Bronzes remain on display in museums, an important proportion have slipped into the private collections of the wealthy and reclusive, and have disappeared from public view.

The London auction sales tell the story. In December 1953, a Benin Bronze head, part of Dr Robert Allman's collection, sold for £5,500 at Sotheby's, amid stiff competition between dealers. The price raised eyebrows; the previous record for a Benin head was a mere £780.[42] By the mid-1960s British newspapers were regularly reporting new record prices for Benin Bronzes.[43] In June 1968, a Benin Bronze plaque sold at Sotheby's for £11,000, an unprecedented price for a piece of African art. It had belonged to a Major W. K. Findlay, whose father had brought it back from West Africa after the 1897 Expedition.[44] But that record was shattered by Christie's a few months later, with the sale for £21,000 of the head that had been so fortuitously discovered in Mr Hope's Croydon greenhouse. It was sold to a dealer, who sold it on to Robin Lehman, the collector, artist and film-maker from the banking family.[45] In the early 1970s, prices soared of all types of so-called tribal art, and Benin Bronzes led the way. Geraldine Norman, art critic at *The Times*, speculated in 1973 that 'discontent with advanced industrial society is presumably creating collector interest in the products of vanishing primitive societies'.[46]

The finite supply of pre-1897 Benin Bronzes added to their cachet. One new source, however, was the great collection of Augustus Pitt Rivers, most of which had been in his Dorset museum. There, according to one romantic description, the ill-fated recruits of the First World War had contemplated their meaning:

> In 1914–16, when soldiers were stationed in the camp above Blandford, many a soldier, sometimes a London lad, or a lad from the North seeing for the first time the warm valleys of the southern shires, walking or cycling in the lonely lanes, came upon what he least expected to find – a museum. At Farnham, deep in the dreamy heart of Dorset, remote from cities and from noise, is the museum that holds the collection of General Pitt Rivers, and there the bronzes that he bought have come – far, far removed from the old scenes of blood. There in the still, cool rooms, like strange forms of dead sins, many a lad saw them, before he went out to face crimes not yet outlived, and the devilries of modern war.[47]

Pitt Rivers's collection was inherited by his grandson George Pitt-Rivers (the descendants used the hyphen) in 1927. George, a First World War hero and with a reputation as irresistible to women, was also a supporter of Adolf Hitler. He was locked up in Brixton Prison in 1939, but released on condition he stay at least ten miles from the Dorset coast. He struggled with the finances of the museum from the beginning, and sold off a few of his most precious Benin Bronzes after the war. He died in 1966, and the museum finally closed. George's children – he had three sons from two marriages – did not inherit its contents. Instead, they went to his partner, Stella Pitt-Rivers (they never married but she changed her name by deed poll), who, to the distress of other family members, allowed the break-up of the collection. Some pieces were auctioned at Sotheby's in the 1970s.[48] A group of London dealers – 'devious old coves', according to someone close to the process – also helped Stella, often

sadly incapacitated by drink, to sell some of the finest Benin Bronzes directly to leading international collectors such as Robin Lehman and George Ortiz.

The consequences of increased demand were predictable. Hermione Waterfield worked at Christie's for over forty years, mostly in the Tribal Art Department. She recalls that in the early 1970s 'suddenly all sort of Oba's heads and flute players popped up, and there were leopards everywhere'.[49] Benin Bronzes had become so valuable there was a thriving market in fakes. The process may have begun as early as the late 1950s. William Fagg, who said that 'fakes are the work of the devil and a sin against art', blamed American and French dealers who had visited Benin City around that time.[50] He complained they had shown brass casters photographs of Benin Bronzes from Europe and the United States, and asked whether they could make more of the same.[51]

This raises the question of what a 'fake' Benin Bronze is, and who has the right to define one. The brass casters of Igun Street could hardly be blamed for practising their historic craft, or responding to market demand. One expert defines a fake as a copy of an older piece, artificially aged and made for sale to outsiders.[52] By these criteria, there are many fake Benin Bronzes, faithfully resembling their prototypes and often objects of great beauty. 'As anyone knows who has worked for some time in Benin City, there are local bronze-casters and ivory carvers who are capable of producing remarkable "antiquities",' wrote Barbara Blackmun, an American expert on Benin City's art, in 2003.[53] Brass casters, and unethical dealers, have mastered the tricks of artificial ageing: distressing pieces by rubbing in dirt or burnishing. The sales of fraudulent antiques probably bring big profits to middlemen, rather than casters themselves. And just as Benin City lost its original masterpieces, it has no monopoly on the creation of imitations. Art dealers complain that casters in South Africa, Ghana and Cameroon are all notorious for the production of 'Benin Bronzes'.[54] Science has proven no more helpful here than in the dating of the great museum collections. 'Problematic Benin bronzes are often accompanied by unjustifiable laboratory certifications,' according to Blackmun, who writes that with microscopic analysis of the patina 'a good laboratory

may be able to ascertain that an artwork is not old. Proof of genuine antiquity is much more difficult to establish.'[55] And as scrupulous dealers acknowledge, a provenance is easier to fake than the art itself.

None of this chicanery stopped the relentless rise in the prices of Benin Bronzes. In 1982, Philip Dark worried at the values of a crass world where Benin Bronzes 'cease to be art but become symbols of economic ability and power'. William Fagg was less concerned; he argued it was a good thing if the 'new ethnographical arts' were finally 'in the same league as the long established arts, e.g. Greek, Roman…etc.'[56] In 1986, a Benin messenger figure was bought by a European collector at Sotheby's in New York for just over £500,000.[57] In 1989, Christie's sold a Benin Bronze head from one anonymous Swiss collector to another for £1.32 million, three times its pre-sale estimate.[58] In 2007, the world record fell again. Sotheby's in New York sold a late sixteenth-century or early seventeenth-century Benin head, on behalf of the Albright-Knox Museum. It was expected to reach more than $1 million, but eventually went for $4.7 million.[59] It was sold, via a Paris dealer, to yet another European collector.

Lance Entwistle had kept a close eye on that 2007 sale. The buyer was not publicly disclosed, but Lance knew who he was; he happened to be a trusted client. Nine years later, faced with the challenge of trying to sell the head retrieved from Ernest Ohly's safe box, he knew where to turn. 'You have a feel for your clients, and what they're prepared to pay. It was the first client I offered it to, which is what you want, there was no need to shop around,' he said. There was only a minor haggle over price. The client, Lance insisted, was not interested in the head as an investment opportunity, but out of his love for African art. 'He will never sell, in my view. He does not have a lot of other Benin Bronzes, he doesn't have plaques, he's more interested in three-dimensionality.' Whoever he is, whatever his motivation, he paid another world record fee, more than three times what he paid for the Benin Bronze head in 2007. The Ohly Head was sold in 2016, I have learnt, for a publicly undisclosed price of £10 million.[60]

*

If you envisaged the woman who sold the world's most expensive Benin Bronze, you might not come up with Frieda Leithman. We met in the Members' Room at Tate Modern, overlooking the Thames. She'd travelled up from Tooting by tube. She was in her mid-sixties, a mother of five and grandmother of seven, with grey close-cropped hair and glasses, wearing a red-striped top and blue Capri trousers. She worked for many years as a nurse in children's nurseries but is now retired. There's a little bit of London's flattened vowels in her voice. 'I'm curious about where that head came from, but I'm not going to find out. My family is riddled with secrets. My father refused to speak about his Jewish ancestry, we were never to talk about it.'

Frieda had to do her own research to find out what happened to Ernest Ohly's family during the Second World War. Several relatives on Gertrude's – his mother's – side died in Nazi concentration camps. Ernest's character was shaped in those years, alone in his Swiss boarding school, and then making his way in post-war London. He was haunted, 'paranoid' says Frieda, by the idea of another catastrophe engulfing the Jews. He distrusted Arabs, he lived in a bygone world of cash and secret objects. He literally kept his money in a suitcase under the bed, full of £50 notes. 'He was always smuggling things to Switzerland or New York. My father, I hate to say this, was a great schemer at avoiding taxes. They were a little collection of Jewish dealers, squirrelling away money. And they were highly suspicious of any authority.'

'Ernie the Dealer' was the family nickname. His children joked that he wore the same clothes for years and mended everything. 'Fifty ways Ernie would use a chicken – dry out the skin to wear as underwear.' He lived in Blackheath, south-east London, for his last fifty years. The children grew up surrounded by artworks and artefacts. It was a modernist, Span house, but by the end it was chaotic and cluttered. Ernie, in his late eighties, was tired of life. His once-valuable Persian rugs were infested with moths. When the family found the suitcase of banknotes under his bed and took them to the bank, they discovered they were no longer legal tender. The house 'was packed with artefacts, you didn't dare throw anything away when he died, but it was no longer organised, broken bits

falling apart. We got two fellow dealers to help clear out the house – we had to watch them closely.'

Ernest Ohly may have let things slide, but he was a formidable collector in earlier years. 'He and my grandfather loved the art, but they needed to make a living. They used to watch the market closely, they weren't going to be hoodwinked. They never went to Africa or the South Pacific, but they got their knowledge from being around these objects. There was a whole group of these European dealers in London, in the forties through to the seventies.' The British Empire was ending, and the demise of a final generation of administrators and soldiers brought rich pickings. 'I never understood why my father was so interested in reading the obituary pages. The *Telegraph*, *The Times*, really studying them. And if they were anything to do with Foreign Office, armed forces, anything to do with the Empire, he would write to the widows.'

Ernest listed his buys in meticulous handwriting in ledger books. That's how Lance found the entry he was looking for: *Benin Bronze Head, December 1951, 230 pounds, Glendining's*, the Mayfair auctioneers where Ernest often bought coins and stamps for his own collection.[61] In today's money, that is the equivalent of a little over £7,000.[62] In other words, a substantial purchase, and a lot more than the £34 Ernest paid for a pair of Benin Bronze leopards on the same day. But he knew what he was doing. In the long run, he had a steal. Ernest put the head in the safe box in 1953, and never touched it again. It stayed there for sixty-three years.

'We always knew that there was a special box, in case there's a Holocaust again. It was like a lump of gold,' said Frieda. The windfall was not quite as large as it might have been. Ernest had left his affairs in bit of a mess, and the tax man took a substantial amount. 'We didn't want any underhand business – I don't like to live like my father, and there were fines to pay for nondisclosure at the point of death.' Still, Frieda says, she can sleep easy now. The money bought care for her family, and property for her children.

Frieda is married to a Jamaican, and her son Brian is a journalist.[63] At the beginning of his career, in December 2010, he wrote an article

about how Nigerians in London were campaigning to stop the sale at Sotheby's by Henry Gallwey's family of a Benin ivory mask he had taken in 1897. In fact, although Brian would not have known this, it was the same mask his great-grandfather, William Ohly, had displayed at Berkeley Galleries in 1947. The article, entitled 'Stolen Out of Africa', described the outrage of Edo people in Britain that Gallwey's family might profit from what they considered a war crime.[64]

Frieda is too intelligent and sensitive a person not to appreciate the layers of irony behind her family story. Naturally, she'd followed the long-running arguments about whether the Benin Bronzes should be returned to Nigeria. 'Part of me will always feel guilty for not giving it to the Nigerians…It's a murky past, tied up with colonialism and exploitation.' Her voice trailed off. 'But that's in the past, lots of governments aren't that stable and things have been destroyed. I'm afraid I took the decision to sell. I stand by my decision. I wanted my family to be secure.'

We were walking along the South Bank now, making small talk, about children and the weather. She would catch her train at Waterloo. I was about to say goodbye. Unprompted, she brought everything up again. Sometimes, she said, she just wished her father had sold that head when he was still alive, and then he wouldn't have worn the same clothes for all those years. And, by implication, a dilemma would have been taken out of her hands. 'It was a difficult decision for me,' she said again. 'Part of me felt we should have given it back.' Then she was gone.

Henry Gallwey's heirs faced their own quandary in 2010. They had every legal right to sell their ivory mask, but in the process discovered how ethical judgements about the past had changed. It is part of the celebrated series of five Queen Idia masks, which includes the one in the British Museum which came from Sir Ralph Moor's collection. (The others are in the Metropolitan Museum in New York, in the Seattle Art Museum, and – sold from the Pitt Rivers collection – in the Linden Museum in Stuttgart.[65])

Henry Gallwey was a pivotal figure in the story of Britain and Benin. Perhaps a conflict in the 1890s was inevitable, but if he had not persuaded

the Oba into, if not quite signing, at least consenting to the treaty of 1892, the story of subsequent years might have been very different. After leaving Nigeria in 1902, Gallwey became a Governor of St Helena, The Gambia and finally South Australia. He was knighted, and in 1913 married Marie Carola, an aristocratic woman of formidable intellect and energy. When, in old age, he looked back on his career, he said that of forty-two years spent in the colonial service the twelve in Nigeria were 'by far the most interesting and intriguing'.[66] West Africa had him hooked. 'Once a man has tasted the fetish water, he finds it hard to stay away.'[67] Marie said that after marrying him she had to drastically revise her own 'primitive ideas about the Dark Continent'. She had always thought of the Bight of Benin as a sinister place, but her husband insisted it was 'a portal to Elysium'.[68]

And yet the death of James Phillips and his companions troubled Gallwey until the end. 'I have neither the intention nor the wish to judge Phillips' action in visiting Benin City,' Gallwey wrote in 1942. 'He was a great friend of mine, a charming companion, a very able officer and a man of high courage.' He described three of those who died with Phillips – Copland-Crawford, Arthur Maling and Kenneth Campbell – as 'full of the *joie de vivre*, good to look at, boon companions, and devoid of fear.'[69] 1897 cast its long shadow. Gallwey died in 1949, aged eighty-nine.[70]

Six decades would pass before his family decided to part with their ivory mask. They had kept its very existence a secret; it had not been displayed in public since that appearance at William Ohly's gallery back in 1947. Jacob Epstein saw it there, and after Gallwey's death he wrote to the widowed Marie Carola to tell her he had been 'much impressed' by the mask. 'I would not insult you by asking you to sell it to me,' he wrote, but offered instead a swap with any sculpture of his that she desired. She declined his offer, and was similarly unimpressed by letters from the art dealer Sydney Burney, offering 'a very substantial price'.[71] Marie Carola had children from a first marriage, but none with Henry Gallwey, and when she died in 1963, the mask passed on through the step-family. In 1977, according to a British Museum curator, the owners were 'extremely prickly' about any publicity.[72] In

2010, they contacted Sotheby's. They had decided to sell. A source at Sotheby's said the auctioneers then 'went the extra mile to make the Nigerian government aware' of the re-emergence of the mask, with a view to exploring ways in which it could be returned. They received no response. In December 2010, Sotheby's announced it would sell the mask at auction in London, alongside several other Benin pieces, in February 2011.

Sotheby's marketed the mask, not unreasonably, as 'amongst the most iconic works of art to have been created in Africa'.[73] Its head of African and Oceanic Art, Jean Fritts, described it as having 'an amazing untouched surface which collectors love…Its honey colour attests to years of rubbing with palm oil.'[74] Sotheby's estimated it would fetch as

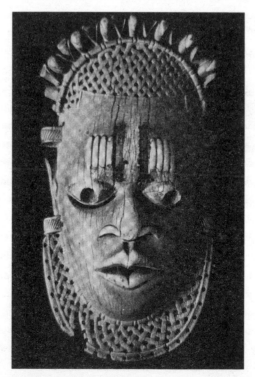

The Gallwey Mask in 1947 at Berkeley Galleries, London, its last public appearance.

much as £4.5 million, although Benin's treasures have frequently proven more valuable than auctioneers anticipate. All was expected to proceed smoothly. In 2004, after all, Sotheby's and Christie's had competed to sell the loot of another Benin Expedition officer, Surgeon Edgar Dimsey, on behalf of his descendants. Christie's sold Dimsey's treasures – which included a plaque and wooden throne – for more than €600,000 at an auction in Paris, without a murmur of public condemnation.[75] But this time was different. Days after announcing the Gallwey sale, Sotheby's cancelled it.[76] A gathering furore – including an online petition and criticism from the Edo State government in Nigeria – was too much for Gallwey's heirs. 'As soon as there was a public reaction, they didn't want that, they didn't want the spotlight,' Jean Fritts told me, 'we never heard from them again.' Queen Idia retreated back into the shadows.[77]

On a November morning, I took the tube to west London, and walked to an imposing Victorian mansion block. I've come across a handful of people who are descendants of British officers from the 1897 Expedition, and are still in possession of Benin Bronzes passed down within their families. As recently as 2010, or even 2015, I don't think it would have been too difficult to get individuals in their situation to come forward. Since then, however, the voices calling for the return of imperial loot have become more prevalent and the fear of attracting opprobrium more pervasive. I was on my way to meet a woman in her late seventies who owns Benin Bronzes taken by her grandfather, who'd agreed to speak to me on condition of anonymity.[78]

She welcomed me into her flat – a gloomy place of long corridors – and gave me coffee and chocolate biscuits. Her walls were decorated with old maps of Mesopotamia and Turkey, wall hangings from Mosul, Chinese statues, Indian bric-a-brac, mixed in with collections of Staffordshire pottery, oil paintings of British naval scenes, sketches of birds, antique clocks. It was remarkable to know there still were flats like this in London. She'd been born in India during the Second World War. 'I inherited almost everything here,' she said. 'Most of the best stuff went to the V&A when Father died.' When she spoke about her nephew,

she pronounced the word 'nev-view', which reminded me of how my grandparents talked. She had books and books, neatly categorised with labels stuck onto the shelves: Syria and the Levant, Egypt, Arabia, Africa and, near the bottom of one bookcase, a small subsection: Benin.

We sat in the living room, where a pale winter sun filtered through the window. 'You came to see my birds,' she said and retired to her study before returning with two brass Oro birds with curved beaks and outspread wings, mounted on hollow staffs, which she lay down on a Turkish kilim. Each was some thirty centimetres long. The Oro: a prophetic bird resembling an ibis which is said to have flown above Oba Esigie's army in the Idah War of 1515, shrieking a warning of disaster and sending his soldiers into panic. The bird he ordered the Portuguese to shoot, so as to show his supremacy over supernatural forces. The bird commemorated in Edo culture ever since. The Edo say *Ènọ̀ ghá yìn ágbọ̀n i dànmwẹ̀ èhọ́ áhíanmwẹ̀ nútìoyà*; 'He who most succeeds in life ignores the bird that cries doom.'

I picked them up. In the context of all the Benin Bronzes, these were mere trinkets, and yet this was the first time I had actually held an object that had been taken in 1897. They were cold and heavy. She would not allow me to photograph them. I wondered how they had come into her grandfather's possession. Had he rifled through the Oba's palace in the first chaotic hours after the British victory? Sent his 'boy' in with instructions to take whatever he could find? Or, more likely, had his pick of the pile of loot laid out the following morning, the officers taking turns as they worked their way through it. Or even on the boat home, perhaps he'd swapped these for others with a fellow officer, or won them in a game of cards. We would never know, and she was not going to humour me in my conjectures.

'They are precious to me,' she said, 'as family heirlooms are.' I offered that given the direct and proven link to the events of 1897, these Oro birds might be of some value. Their provenance gave them distinction; they had a back story. Was she tempted to sell them? After all, she had told me they were usually in a drawer, and had been brought out for my benefit. 'No, not at all. That will be up to my heirs. I'm on

the threshold of the great beyond. They'll inherit them.' A younger generation, I suggested, might feel the right thing to do would be to return them to Benin City. She thought about this. 'If they want to do that, that's fine. I can't impose conditions on my descendants.' She paused again. 'I suspect they are detached from them, they don't feel close to them like I do.'

She'd never been to Sub-Saharan Africa. 'There's nothing to draw me into their cultures,' she said. Did she feel uncomfortable about the history? 'I've felt misgivings, considerations that crossed my mind and were then dismissed.' Then she corrected herself. 'Maybe misgivings is too strong a word, on reflection. I don't feel like giving them anything. It's not secure.' There was a long silence. 'You know,' she said, 'one bumbles along for seventy-seven years, and suddenly this has become a *sensitive* subject. It never was before.'

Outside, the winter sun had disappeared behind clouds, and London was returning to a more familiar grey. The room grew darker. Before me was a small old lady, sitting in her living room, clutching her birds.

TOOCHLY-POOCHLY

Museums have talked for years about whether or how the Benin Bronzes could be returned to Nigeria. One person, however, has not waited for the tortuous debates about morality and practicalities to reach a conclusion. In 2014, Mark Walker, a retired doctor from Wales who owned a pair of Benin Bronzes, felt that something was not right. He took a bold and simple initiative. He got on an aeroplane, flew to Nigeria and gave his Benin Bronzes back to the Oba.

Mark lives on the island of Anglesey, beyond the mountains of Snowdonia. He's a quiet, practical man, in his early seventies, who likes to build things and loves to sail. When he suggested we meet at the Royal Welsh Yacht Club, I was expecting a stuffy sort of place, befitting its advertised status as 'the oldest yacht club premises in the world'. In fact, the club is a series of appealingly scruffy and draughty rooms built into Caernarfon's thirteenth-century walls. There, overlooking the windswept Menai Straits, on a bleak winter day, he told me his story.

Mark's family history is steeped in empire and military. There was a great-uncle with a farm in the Kenyan highlands, another who was a Major-General and won a Victoria Cross in Somaliland, and a third who was a First World War fighter pilot and played a vital role in preparing the Royal Air Force for the Second World War. There was a great-grand-mother born in Ceylon, and long associations with South Africa and

Herbert Sutherland Walker, CBE.

India. And then there was his grandfather, Captain Herbert Walker, the intelligence officer with the Benin Expedition, whose diary I had found so useful for my own understanding of 1897. The same Captain Walker who'd travelled from Liverpool by ship with Ralph Moor, who'd dined with Admiral Rawson, who'd kept photographs of piles of 'loot' taken by his fellow officers.

Herbert Sutherland Walker, CBE, died in 1932, before Mark was born. He was a wealthy man, and left a generous estate to his widow, Josephine. They had, by today's standards, an unconventional marriage. Josephine was the daughter of Herbert's first cousin. So they were closely related, yet a generation apart. Josephine, who was a young woman of quite bewitching beauty, went on to live until 1963. The young Mark regarded his grandmother as a second mother. When he was one year

old, his parents set off by road to build a new life in South Africa. Mark and an elder brother were left with Josephine, and travelled down by ship several months later, once his parents had established themselves. When he was twelve, Mark lived with his grandmother in London for a year. His yacht, on which he spends several weeks every summer, is called *Josephine*.[1]

It was during that year in London that Mark learnt about the family Benin Bronzes. Josephine kept them in her Chelsea home: an Oro bird broken from its staff, and a bell that would once have decorated shrines and been rung to summon ancestors to share offerings or hear petitions from the living. 'They were treated just like any other bits of bric-a-brac around the house,' Mark remembers. He read his grandfather's diary from Benin, and had a strong feeling; he wanted those Bronzes. They connected him to Herbert and Josephine. But he didn't inherit them until many years later, when his own parents died.

Then a strange thing happened. Mark had coveted the Bronzes for so long, and yet now they were finally his, he felt uneasy. In part, the reasons were practical. Mark and his wife had moved into a smaller house. They didn't want too many little objects lying around, gathering dust. But Mark's outlook was beginning to change in more fundamental ways. He felt he was moving into a new stage of life, where it was less important to own stuff than to experience things. His own children made it clear they had no interest in inheriting the Bronzes when their turn came. 'It struck me that if I wanted to assure the future of these objects I needed to make sure they came into the ownership of someone who had an interest in their future, beyond that of decorative knick-knacks around the home,' he said. The answer dawned on him; he had to take his Benin Bronzes back to Benin City.

Mark had never been to Nigeria, knew nobody there and didn't know where to start. He had a sense of the country's menacing repu-tation, and worried that, if he went there with his Bronzes, he could be arrested for being in possession of stolen artefacts. There was also a discouraging family precedent. Josephine had been in possession of a carved tusk which Herbert had also taken from Benin. She used it as a

mount for a lampshade in the Chelsea dining room, and her grandchildren used to joke that its dark cracks took their colour from bloodstains. In the late 1950s, Josephine sold the tusk to the Jos Museum in central Nigeria, one of the first the British had established in the colony at the time.[2] According to Walker family legend, the tusk was stolen from the museum after Nigeria's independence in 1960, during a break-in in which several other artefacts went missing. So when Mark told relatives about his plan to take back his two Bronzes, they thought he was 'nuts', and warned that anything he gave back would be bound to reappear on the international art market.

Mark turned to an unlikely source for help. In 2013, he contacted Steve Dunstone, a retired policeman in his sixties, who lives in a wooden cabin on the edge of an Essex golf course. Steve's a self-deprecating man. He worries about his weight and how to best care for his ageing parents. But he's also big-hearted and courageous, qualities which have served him well in Nigeria, and given him extraordinary access to that country.

Steve was working as a Royal Protection Officer at Buckingham Palace when he first travelled to Nigeria. He had become intrigued by the story of Richard Lander, a Cornish explorer born above a Truro pub in 1804, who made his first trip to Africa as a teenager. In 1830, he returned with his brother John, and they became the first Europeans to travel down the River Niger. He was shot on a subsequent expedition on the Niger and died when his wounds turned gangrenous. He was twenty-nine. Today he is commemorated by a statue in Truro and an eponymous school in that town, but is otherwise largely forgotten. Steve decided, somewhat impulsively, to mark the bicentenary in 2004 of Lander's birth by repeating his 700-kilometre journey down the Niger.[3]

Steve soon found himself confronting a legion of logistical and bureaucratic problems, not least the opposition of his superiors at Buckingham Palace to what they saw as a highly dangerous venture. But he had a colleague and friend, Timothy Awoyemi, who was brought up in Nigeria and had invaluable contacts on the ground and a better sense

of the challenges ahead. The Palace relented, and the expedition was a triumph. Steve and Timothy arranged for a twenty-four-foot Cornish-built canoe, the *Goodwill*, to be shipped to West Africa and then transported overland to New Bussa, the town in north-west Nigeria where Richard Lander began his river journey. As the crew paddled the *Goodwill* down the Niger, they were fêted in every town, hailed by emirs, chiefs and governors. Farmers and journalists crowded the riverbank to cheer them on. 'It became like a travelling circus,' remembers Steve, 'there were TV cameras everywhere.' The Nigerian press reported 'attacks by men of the underworld…[and] careless accidents on the road', but Steve, Timothy and the others had armed protection, and reached the Atlantic coast without major mishap.[4] They distributed piles of books and educational material to schools en route, and, they hoped, rescued Richard Lander from undeserved obscurity.

Steve had also learnt about the Benin Bronzes. In a riverside village, on the eastern borders of Edo land, he was clambering back onto the *Goodwill* when a man thrust a letter into his hands. He put it in his rucksack, and only looked at it later. It said, 'Help us get back the Benin Bronzes.' Steve didn't know what these were, but when he returned to England he started to read. He was enthralled, but also fired up by a sense of injustice. 'I just felt, the people I'd met out there, a part of their culture was missing.' He added a Benin Bronze page to his Richard Lander website, in which he argued the return of at least some of them would be an historic act of goodwill from Britain, and unite Nigerians. Rather optimistically, Steve and Timothy wrote to the British and Nigerian governments, asking to be appointed as official envoys to negotiate the repatriation of the Bronzes from British museums. That never happened, and several years passed, before, out of the blue, Steve got an email from Mark Walker. He had two Benin Bronzes. Could they help him take them back? Steve did not hesitate. 'This was huge,' he remembers feeling, 'a gesture that would reverberate around Britain, and all the museums that have Benin Bronzes.'

On 20 June 2014, Mark Walker, dressed in a linen suit, stood respect-fully before the elderly Oba Erediauwa in his palace in Benin City. The

Oba, in a glistening white robe, sat on an elevated golden throne. Mark handed over his Bronzes, presented on a red cloth. It was a moment of symbolism; the grandson of the British officer who took the Bronzes, returning them to the great-grandson of the Oba from whom they were taken. The chamber was packed, a crowd of people at the door, straining to get a glimpse. Mark stumbled out of the air-conditioned room, into the fierce heat of the palace courtyard, which was lined with marquees and festooned with banners that read 'The return of the Oro and the Bell, After 117 Years'. At that point he was more or less mobbed. Small children and old women thronged around him, saying 'thank you, thank you'. It was a moment of vindication. Steve, standing by Mark's side, remembers 'the shine in people's eyes as the Bronzes were handed round'.

Mark spent a happy week in Benin City, a guest of honour driven around at speed with a police escort. A grandson of the Oba was getting married, and so the celebrations went on. But the trip had been almost derailed by a political row before Mark had even left Britain. He had been invited to the Nigerian High Commission in London to discuss his

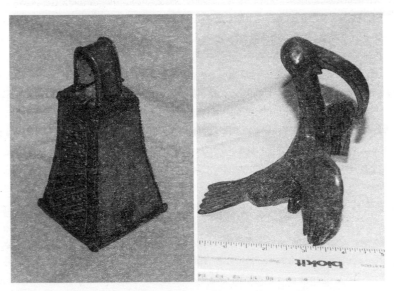

Mark Walker's bell and Oro bird. Returned to Oba Erediauwa, 20 June 2014.

plans. The High Commissioner made an offer: his government would fly Mark to the capital, Abuja, so he could hand over the Bronzes to the Minister of Arts and Culture. Mark, to Steve and Timothy's embarrassment, replied that if he could not give them directly to the Oba the trip was off. The Oba's palace was furious at what it saw as the federal government hijacking an event of specific and immense importance to the Edo people. Prince Edun Akenzua, by this time brother to the Oba, accused the government of sabotage and disrespect.[5] In the event, the Oba paid for Mark, Steve and Timothy to come directly to Benin City, and they never visited Abuja. Nigeria's disunity, briefly on display, was smoothed over, but the dispute was an insight into the rivalries that could easily erupt should a more substantial return of the Benin Bronzes ever occur.

Three months after he came home from Benin City, Mark was invited to the British Museum for what was called a 'VIP World Premiere' of a Nigerian feature film, *Invasion 1897*. It was directed by an Edo film-maker, Lancelot Oduwa Imasuen. Lancelot is a bombastic, animated man, who works out of a bungalow in Surulere, the Lagos neighbourhood that is the historic centre of Nigeria's film industry, Nollywood. Many of his productions, he bashfully admits, are the traditional Nollywood fare of quick turnaround 'chop money films' – a romantic comedy, *ATM*, was about a Nigerian who lures a white woman online as a ruse to escape the country, while *Enogie London* follows the adventures of a Nigerian fraudster in the UK – but *Invasion 1897* was something more ambitious and closer to his heart. Lancelot simply wanted his own people to give their account of the disaster which befall them in that year.[6]

His inspiration came, in part, from a play, *Ovonramwen Nogbaisi*, by the Nigerian playwright Ola Rotimi, which describes the British invasion in lyrical and eloquent language. Rotimi's play was first performed in 1971. Lancelot, like many West African children from the 1970s through to the 1990s, grew up reading it as a set text at school. 'That play was so popular,' says Lancelot, 'anyone who is an adult over forty has read it.' In both *Ovonramwen Nogbaisi* and *Invasion 1897*, the Oba resembles the hero of a Shakespearean tragedy. Noble and wise, he knows the British

are not to be trusted – 'White one, your face shows love, but does your heart?' he asks of Gallwey in the play – and yet, even as he senses his power slipping away, he urges his chiefs not to attack the foreigners.[7]

The languages spoken in *Invasion 1897* are Edo and English, and if the special effects – plenty of decapitations and spurting blood – are crude, Lancelot went to great lengths to capture the atmosphere and rites of the Oba's court. The Edo warriors fight heroically – 'These guys are something else,' mutters an injured British soldier – before inevitable defeat. In Rotimi's play the British are ruthless and greedy – 'Commerce, gentlemen! Commerce brought us to Africa; commerce determines our actions in Africa!' proclaims Vice-Consul James Phillips – but in *Invasion 1897* they become cartoon villains.[8] Many of the white actors speak with incongruous German or Dutch accents, and they rape and loot with evil chuckles. After they capture Benin City, they perform a victory dance with looted Bronzes on their heads, while singing 'Rule, Britannia!' They resemble football hooligans who have put their opponents to flight.[9]

Invasion 1897 opens and closes with a contemporary storyline shot in London, in which a young Nigerian, fired up by historical injustice, is arrested after trying to steal, or liberate, the Benin Bronzes from the British Museum. In court, he is defiant – 'the real thief here is the British Empire, which unjustly invaded my people in the year 1897!' – and is acquitted amid whoops and tears from the public gallery. I wondered whether the British Museum – which for many Edo people is synonymous with a painful sense of loss – had felt awkward about hosting the premiere of *Invasion 1897*. Africa curator Julie Hudson gave me a very proper answer: the museum had a discussion, agreed to allow the screening, but she did not attend herself.[10] Lance remembers it as an evening 'that evoked emotion never compared. The future Oba, the Crown Prince, was there, and the hall was full. And some British couldn't stand the reality! They ran out. When they saw the massacre they ran out of the hall, they couldn't sit.' An elderly white British woman who was there told me, 'We felt rather invaded by all the Nigerians. The film was a disaster. I was full of shock. We were stunned.'[11] But Mark's recollections

are warmer. Lancelot mentioned him in his opening speech as the man who'd returned his Bronzes, which won a standing ovation from the audience. Mark was touched. 'I rather enjoyed the film,' he said, 'it was surprisingly even-handed, given Lancelot's rhetoric. I had already met him in Nigeria. We hit it off.'[12]

Since 2014, Mark has thought a lot about what he did. He doesn't regret it. His Bronzes, like those I had seen in the elderly lady's flat in London, were unexceptional. He could have sold them for several thousand pounds. But he would have lost the opportunity to perform a symbolic act he felt was of far greater value. In Nigeria, he had discussed with Edun Akenzua whether historic artefacts could be properly looked after in that country or were bound to be neglected and stolen. 'He said to me, "If you come and steal my car, and I ask you for its return, and you reply that you've housed my car in a very smart air-conditioned garage, and you can't give it back until I show I've built a garage at least as good as yours, that does not make your theft any less a theft".' This argument impressed Mark. He felt the moral case for returning the Benin Bronzes was strong. 'A lot of time and legal effort has been spent on returning goods looted by the Nazis in Germany and Austria, and the law has no trouble in suggesting these were improperly acquired,' he points out, 'so how is it the Benin Bronzes were properly acquired?'

When Mark made his speech in the Oba's palace, he tried to explain his grandfather's motivations to an Edo audience. Herbert Walker, Mark told the people of Benin City, was 'an imperialist but not a racist'. For one as astute as Mark, this seems a curiously unperceptive remark. Herbert Walker was a man of his time. In his diary from 1897, he refers to his servant or 'boy' as a 'perfect fool', the carriers are worthy of contempt and when the enemy are killed, they are 'bagged', like wild game.[13] A chief, whom Herbert only calls 'Bull-necked', is taken as hostage, in the hope he'll lead the British to the fugitive Oba. When 'Bull-necked' fails to deliver, Herbert writes that he was 'severely flogged…which rather surprised him and had an excellent effect'.[14] It would be miraculous if a Victorian army officer fighting at the sharp end of imperial expansion didn't appear racist to the modern reader. Herbert Walker lived – and

succeeded – in a world defined by rigid racial hierarchies. To try to condone – or condemn – his actions seems ahistorical. We can only try to understand.

Mark learnt from Josephine that Herbert was a severe man, private and undemonstrative. He had joined the Cameroonian Regiment aged twenty in 1884, and was based in India for ten years. He was promoted to Major for his good work in Benin, and thereafter seems to have been typecast as an African specialist; he served in the northern territories of the Gold Coast, compiled a report on the Mashona and Matabele rebellions in Rhodesia, and worked in the Intelligence Division for the Secret Services during the Boer War.[15] In 1903, he retired from the army and became the Chief Constable of Worcestershire. At the outbreak of the First World War, he offered his services to the War Office and went back into intelligence work. It was a successful, but by its very nature somewhat shadowy, career. In 1918, he returned to the Worcestershire Constabulary, where he remained until his retirement in 1931.[16] He and Josephine, whom he'd married in 1908, lived at Cross House, in Powick, a handsome building dating from the seventeenth century, today sadly exposed to a busy road. They raised two children, one of whom, Richard, was Mark's father. Herbert owned the first motor car registered in the county and, according to the obituaries, was a policeman respected by all ranks, awarded the King's Medal for 'prolonged service distinguished by exceptional ability and merit'. Herbert and Josephine enjoyed travelling until the end. In March 1932, they went on a cruise down the Nile. Herbert died a fortnight after their return from Egypt, of an intestinal perforation. It may have been amoebic dysentery. He was sixty-seven years old. So Africa – or, who knows, perhaps the curse of Benin? – got him in the end.[17]

I felt there was something in Herbert's story that was missing. In his Benin diary, once the fighting is over, loot appears to be one of his main preoccupations. He was irritated that Admiral Rawson and his staff were 'safeguarding' the bulk of the Oba's treasures, and was a keen observer of who else was taking what.[18] And then there was that brief entry on his last day in Benin City, 14 March: 'busy packing loot!', and

the observation, the following day, that the Hausa soldiers were carrying great quantities on their heads for the march down to the boats.[19] 'Busy packing loot' did not tally with the two small objects Mark had returned, or even the handful of similarly modest pieces that I knew had been inherited by other relatives.

Buried in the footnotes of a 1953 article by William Fagg in an anthropological journal, I found a clue which led me, and the surprised Mark Walker, to a more complete picture. Captain Herbert Walker, I would learn, had helped himself to a large number of very fine Benin Bronzes and pieces of ivory in 1897. Some of these are now in the world's greatest museums, and one, which is in private hands and has not been seen in public for almost fifty years, became the most expensive piece of African art in the world.

Fagg's passing reference was to a sale by Captain Walker of a pair of matching Benin Bronze water vessels or aquamaniles, shaped as rams, which took place at Foster's auction house on 16 July 1931.[20] Foster's, at the St James's Palace end of Pall Mall, is another of London's forgotten auction houses. It closed in 1940, but for a brief period from 1930 to 1934 played host to a series of sales of Benin Bronzes. It was a natural choice for Herbert Walker; several Benin Expedition colleagues' collections were sold at Foster's in the months before July 1931, and several more appeared there in the months that followed.[21] More officers were dying, or retiring, or had fallen on hard times during the Depression, and so their collections saw daylight after thirty years in the shadows. I tracked down the Foster's catalogues, and found that Fagg's footnote was accurate; there was indeed a sale, at 2 p.m. on Thursday 16 July 1931, of 'Fine Bronzes Ivory and Wood Carvings From The Walled City of Benin, West Africa'.[22] It was advertised in the newspapers: 'AN IMPORTANT COLLECTION OF BENIN BRONZES, the property of a field officer who removed them himself at the time of the Expedition.'[23]

Perhaps Herbert Walker did not die of dysentery, but had a slower, terminal disease, and was planning ahead during the summer of 1931. He certainly looks tired and aged in the last photo Mark has of him, from 1930. He may have wanted money to help Josephine buy the

Chelsea house, or to help Richard through Cambridge. The catalogue from the July 1931 sale lists more than forty objects taken from Benin City by the officer who took part in the Expedition, including plaques, statues, swords, masks, carved tusks, ivory horns and armlets. Several are described as being 'in perfect preservation'. We can't be sure how much they fetched in total, but newspaper reports, and handwritten annotations on a programme, show that just six of the lots – admittedly the most expensive items – raised £748, or about £50,000 in today's money.[24] These included the matching aquamanile rams (sold for 180 guineas), one of which would find its way to the British Museum some twenty years later, and also a 'magnificent old Benin ivory tusk…carved in relief in numerous figures of chiefs, warriors, alligators, cat fish etc. six feet high' (seventy-five guineas). At least three of Walker's Bronzes sold that day were bought by a man called Harry Beasley, owner of the North Kent Brewery, which funded his passion for ethnographic collecting. (Beasley had his own ethnographic museum in Chislehurst in Kent, and, following his death in 1939, much of its contents were divided between leading British museums.)[25]

Two Frenchmen travelled together to London for the sale. One of them, Georges-Henri Rivière of the Musée d'Ethnographie du Trocadéro, bought a 'very fine plaque…of a chief and four attendants' (130 guineas). This plaque would become a prized item at the Trocadéro, celebrated on postcards, and its successors the Musée de l'Homme and the Musée du Quai Branly, where it remains on display to this day.[26] But it was Rivière's young friend, a dealer called Charles Ratton, who bought the most expensive piece of the sale, what Foster's called 'a highly important standing figure of a chief blowing a war horn' (210 guineas).[27]

There is an intriguing folk memory of such a Benin Bronze in the Walker family; one of Mark's cousins recalls how Josephine and her children used to refer to it fondly as 'Toochly-Poochly'.[28] Was the musician blowing a war horn? Or a flute? Critics tended to go for the latter. In Edo the instrument is known as *Àkọnhẹ̀n*, and the player is called *Ọ̀kpàkọnhẹ̀n*.[29] The statue is as wonderfully intricate as many of the other great Benin Bronzes, but standing at a height of some sixty-five centimetres, and

weighing twenty-seven kilograms, it is grander and more imposing than most.[30] (It is in fact one of a small group of almost identical flute man statues looted in 1897, which includes one of the Charles Ringer statues rescued from the Greenock broom cupboard and now in the National Museum of Scotland, and the British Museum has another.) The musician has a leopard-tooth necklace and is cast so delicately that his robes and muscles seem to ripple. The statue would have stood on an Oba's shrine, and probably dates from the late sixteenth century. Its undignified Toochly-Poochly years – as a soldier's memento or children's plaything – were always an aberration. Following the sale in London, it was destined to return to greater things. It was now a much admired work of art.

Charles Ratton sold the flute man on to his friend and fellow Parisian dealer, Louis Carré. In the summer of 1932 the Benin Bronzes finally burst onto the French art scene, with Ratton and Carré helping Rivière at the Trocadéro to put on the *Exposition de bronzes et ivoires du royaume de Bénin*. The flute man was one of the stars of the show, prominently displayed and photographed in the art magazines (see illustration section).[31] Its next appearance was in New York, at the Museum of Modern Art's 1935 exhibition of 'African Negro Art'. In 1953, it was bought by a Philadelphia collector, Sturgis Ingersoll, from whom it acquired a new moniker, the 'Ingersoll Flute Man'. Ingersoll died in 1973, and the Flute Man went on sale at Sotheby's in London in July 1974. The bidding started at £15,000 and eventually reached £185,000, an astonishing price at the time.[32] It was more than six times what anyone had previously paid for a Benin Bronze at auction and the first time, *The Times* reported, 'the art of primitive peoples, in any form, has passed £100,000'.[33] Hermione Waterfield, of Christie's, recalls it as '*the* moment that alerted people across the world to just how much money could be made through Benin Bronzes'.[34]

From 1974, the trail goes cold. The mystery buyer was listed as M. Baile.[35] The dealer Lance Entwistle believes that may have been a false name, to cover the traces of the purchaser. There's a rumour that it might be owned by a Swiss Italian, and is somewhere in Switzerland.

'It's a great mystery…Nobody knows,' says Lance. He smiles. 'Someday it will pop up, out of nowhere. Somebody dies…somebody needs the money. That's how it goes.'[36] Until such a time, we can only imagine. But for now *Òkpàkọ̀nhẹ̀n* / Toochly-Poochly / Ingersoll Flute Man stands lonely in a glass cabinet, perhaps in a château overlooking Lake Lugano, awaiting the next stage in a journey that began when Captain Herbert Sutherland Walker scooped up his generous share of the treasures laid out in the courtyard of the Oba's palace in February 1897.

15

ALL DONE FOR THE SAKE OF NIGERIA

Kenneth Murray (right) and colleagues at the opening of the Jos Museum, 1952.

On Saturday 22 April 1972, an Englishman called Kenneth Murray was being driven from Lagos to Benin City in a Volkswagen bus. He was carrying a valuable consignment of Benin's art, which he had taken from Nigeria's National Museum in Lagos to install in the new government-run museum in Benin City. It was typical of Murray, sixty-nine years old, that

he was so involved in Nigeria's museums years after his notional retirement, and that he chose to travel with the exhibits in person. He had been working on the accompanying photographs and panels for months.[1]

The Ijebu to Benin City section of the road has always been dangerous, even by Nigerian standards. Drivers pick up too much speed on the long, straight stretches and oncoming traffic is obscured by a series of rolling dips. But in April 1972, Nigeria's roads were especially perilous. At the beginning of that month drivers were ordered, by military decree, to switch from the left to the right side of the road. The cars had changed sides, but the steering wheels had not, and when Murray's driver pulled out to overtake a truck on a bend, he had no idea what was coming towards him. Many years earlier, Murray had written that the least stressful way to travel on Nigerian roads was to lie on a mattress in the back of a lorry, looking up at the sky: 'It is much more restful not to see the coming road.'[2] This time, though, he was in the front passenger seat. He would have seen the oncoming car before his driver, but it was too late.[3]

Kenneth Murray was the creator of Nigeria's museum system. He had also done more than anyone to bring back its art from abroad. He spent forty-five years in Nigeria and spoke many of its languages. The Yoruba knew him as *Baba oni wahala*, the Old Man Who Never Rests, and *Oyinbo Alwaron*, the White Artist.[4] Physically brave and scornful of danger, Murray was a striking man, tall, slim and muscular, with a mop of blond hair, gleaming eyes and an aquiline nose, 'in profile almost hawk-like' according to a colleague.[5]

His funeral, paid for by the Nigerian government, was extraordinary. He lay in state in the National Museum, as *egungun* masquerades performed rituals and danced around his body. Forty Fanti fishermen – he had lived alongside them for years and, in the words of a friend, was 'one of the very few Europeans, perhaps the only one, who had travelled several times between Ghana and Nigeria by open canoe' – carried his coffin at the front of the procession to St Saviour's Church, which was packed with all ethnicities and races.[6] He had lived his life, said friends, as if it were a *Boy's Own* adventure, sleeping on the beach, fishing on

canoes and riding a motorbike down bush paths in pursuit of a rumoured sculpture or mask. To that extent, there was consolation in his sudden death; Kenneth, they said, had lived a life of 'almost boyish happiness' and had died in the country he loved, among people he loved.[7] Others, even as they voiced admiration, remembered him as a difficult character with an acid tongue; a perfectionist fiercely critical of himself but also those who worked with him. One colleague said he could be 'horrible and abrasive...towards anyone who didn't perform up to the standards he had set, although he didn't tell you what they were'.[8]

Kenneth Murray, a dropout from Balliol College, Oxford, travelled to Nigeria as an art teacher in 1927. On the boat journey, his fellow British passengers were incredulous that anyone would go to West Africa to teach art.[9] But when he arrived, it was Murray's turn to be astonished, by the rich variety of Nigerian culture, both historic and contemporary. He lobbied the colonial authorities to establish a museum.[10] He complained that it was easier to study Nigerian art in Europe than in Nigeria itself, and wondered at the absurdity that there were some 2,000 Benin Bronzes in Europe, while in Benin there were 'only a dozen indifferent ones'. In Europe, he argued, they served a mainly academic purpose, but in Nigeria they were necessary for 'the cultural life of the country itself'.[11]

Kenneth Murray's dreams began to take shape in 1943. He narrowly avoided being shipped off to Burma with thousands of West African soldiers to fight the Japanese (his brother Donald, a soldier, was killed in the unsuccessful defence of Hong Kong in December 1941) and was instead appointed Nigeria's first Surveyor of Antiquities.[12] His priority was to preserve the great art and cultural works still within Nigeria. He was dismayed to see them, as he put it, 'rotting away in huts', being consumed by termites and deteriorating in the rain.[13] But he also worried about the haemorrhaging of artworks out of the country, and sought to control the process through new restrictions which prohibited the export of antiquities without the Governor's permission.[14] He travelled tirelessly across Nigeria, photographing and cataloguing cultural artefacts. But over time, Murray's ambition expanded. For Nigeria to preserve what it

still had was a good start, but it was not enough. He started to work to repatriate many of the treasures which the country had already lost.[15]

In 1946, Kenneth Murray became Nigeria's Director of Antiquities.[16] That same year, the British colonial administration set aside £25,000 (worth more than £1 million today) 'for the purchase of Nigerian antiquities abroad'.[17] Murray had something to work with. The authorities in Lagos assumed he would spend most of his money in defeated Germany, buying back Benin Bronzes from its museums, but the occupying American and British administrations blocked this idea.[18] Instead, Murray turned to London, where he had an important ally: William Fagg of the British Museum. The relationship was cemented by William's brother Bernard, who was Murray's deputy in Nigeria, and who would emerge as the twin driving force in the establishment of Nigeria's museums. Murray and Bernard Fagg were chalk and cheese. Bernard Fagg was an extrovert, a 'tycoon-like figure' according to the museum curator John Picton, who worked in Nigeria's museums from 1961 to 1970. Whereas a setback would anger Murray, Bernard Fagg would be inclined to find a joke. 'And yet they got on well in a relationship of mutual antipathy,' says Picton.[19]

In the auction rooms of London, meanwhile, William Fagg was Murray's informal agent. Although William Fagg's first loyalty was to the British Museum, he worked diligently to help Murray build up his collection in Lagos.[20] Angela Rackham, Bernard Fagg's daughter, who worked in Nigeria's museums from 1967 to 1976, says her uncle William was indispensable to Murray, as 'he knew the collectors, was friendly with them, and persuaded them to sell at reasonable prices. All done for the sake of Nigeria.'[21] They were intellectual sparring partners until the end; shortly before setting out on that final journey to Benin, Kenneth Murray wrote William Fagg a long letter, with his latest thoughts on the chronology and origin of the Benin plaques.[22]

In 1948, Murray made his first significant purchases for Nigeria, giving £2,000 to Admiral Rawson's daughter-in-law for forty-six Benin Bronzes as well as the Admiral's diary. Many of these objects had been on display at the December 1947 exhibition at William Ohly's Berkeley

Galleries, which had opened with a speech by the Governor of Nigeria, Arthur Richards, who appealed to British owners of Nigerian art 'to make arrangements wherever possible for the return of these works to Nigeria'.[23] Murray doubted the Governor's supportive words would have much impact. He felt he had to move swiftly, as he'd caught wind of William Ohly's own interest, and worried he could not compete with him if it came to a bidding war.[24]

In 1949, the British Museum bought more than 800 items from Dorothy Oldman, the widow of William Oldman, a prolific London collector whose cluttered house near Clapham Common was a treasure trove of Pacific and African artefacts.[25] William Fagg said it was one of the most valuable additions ever made to the museum's African collection.[26] It included twenty-nine Benin Bronzes. But when Fagg saw that among Oldman's superb Benin statues were two very similar Portuguese cross-bowmen, he kept one and ensured the other went to Murray in Nigeria.[27]

On 7 December 1953, at Sotheby's in London, another extraordinary haul of Benin Bronzes came up for sale. They had belonged to Dr Robert Allman, Chief Medical Officer in 1897. Whether Dr Allman took all his Bronzes from Benin in February 1897, or his collection was 'formed' – to use William Fagg's word – over a longer period of time, is not clear, as he lived in Southern Nigeria for several years afterwards.[28] Dr Allman died in Dublin in 1917, and left a large estate to his family, including his Benin Bronzes.[29] They sold dozens of pieces at Foster's in 1931 and 1932, but the bulk of Dr Allman's Benin treasures only came before curators, collectors and dealers at the Sotheby's sale in 1953.[30]

In the event, it was William Fagg who bought the entire collection for £10,395 – worth roughly £292,400 today – resisting what *The Times* called 'keen competition' from London dealers.[31] But Fagg was not spending the British Museum's money, but that of the Nigerian Department of Antiquities, and he had confidential instructions from Murray to go over £10,000 if necessary.[32] Fagg shipped to Lagos everything he had bought. This included a splendid Benin horseman, leopards, a cockerel, and three swords, one of which came with an explanatory note from Dr Allman that he had found it covered with human blood, 'amongst upwards of

sixty recently decapitated human sacrifices. So there can be no doubt as to the use it was intended for.'[33]

The most valuable of Dr Allman's Benin treasures had no such gruesome associations. This was a Queen Mother head with a forward-curving 'chicken beak' headdress, mounted on a delicate patterned base but in every other way remarkably similar to the Queen Mother head, believed to depict Idia, that Sir William Ingram gave to the British Museum in 1897. Indeed, such is the resemblance of these two beautiful sisters that Fagg believed they had been cast by the same artist, probably in the mid- to late sixteenth century. Fagg wrote that it was 'the finest Benin bronze ever offered for sale, and one of exceedingly few Benin pieces in which rarity is combined with the highest artistic sensibility and imagination'.[34] He made other purchases at the same auction on behalf of Kenneth Murray and Nigeria, including one of the ram aquamaniles that had originally belonged to Herbert Walker.

It was no coincidence that in that same month, December 1953, the British colonial administration finally approved Kenneth Murray's plans for a National Museum in Lagos.[35] The extent of Murray's ambition is clear; he had initially been allocated a paltry £5,000 for the construction of the entire museum, and yet Fagg had spent twice that amount on his behalf at a single auction of Benin Bronzes.[36] In the event, the museum ended up costing the colonial administration some £100,000.[37]

In April 1954, Fagg returned to Sotheby's, and again spent several thousand pounds on Benin Bronzes for the nascent Nigerian collection.[38] Murray, meanwhile, had also been working the private market, and searching beyond Britain. In 1952, he made his most expensive purchase, from Louis Carré's gallery in New York, of two Benin leopards, considered by some experts to be the finest of all the cast metal leopards, on a par with the ivory pair taken by Admiral Rawson for Queen Victoria which are now in the British Museum. The colonial authorities, on Murray's behalf, paid £7,133 for the pair.[39]

The British Museum, normally so possessive of its own collection, was, surprisingly, another source of Benin Bronzes for Nigeria. In 1950 and 1951, the museum sold or donated twenty-three Benin plaques to

Murray for a total of £2,525.⁴⁰ Murray let it be known that if the museum
gave him more Benin Bronzes, then it 'might confidently expect a recip-
rocal gift of equal value', and when he offered some objects from the
Lagos collection, along with a payment of £25, he received a further two
plaques in exchange.⁴¹

Kenneth Murray was on a mission to acquire the very best for his
new museum, but money was tight and some purchases were beyond
him. He was constantly looking for funds, begging and cajoling the
colonial government, foreign companies in Lagos and local businessmen.
His letters reflect his frustrations, as he complains that prices of Benin
Bronzes had shot up, and that American rivals had greater resources than
he did.⁴² In August 1948, he wrote to Bernard Fagg, with a plan to raise
money to buy one of the five famous Queen Idia ivory masks. This was
the second of the magnificent pair that had belonged to Sir Ralph Moor,
and which had been kept by the anthropologist Charles Seligman when
he sold the other to the British Museum in 1910. Following Seligman's
death in 1940, it passed to his widow Brenda, an eminent anthropologist
in her own right. Fagg described the mask as the 'most valuable Benin –
or indeed West African antiquity – still in private hands in the world'.⁴³
Murray plotted how to convince Mrs Seligman to sell. His first idea
was that wealthy Nigerians would donate some £40 each – he believed
he had forty potential candidates – and this would raise the £1,000 or
more that he hoped would persuade Mrs Seligman 'to let Nigeria have
her ivory Benin mask'.⁴⁴ Later, he turned to the Shell oil company, and
in 1954 wrote that he had been nearly successful in brokering a deal.⁴⁵

Unfortunately, by 1958 Mrs Seligman, aware she was in possession
of a much coveted treasure, had raised her price to a formidable £20,000.
Petitions were circulated in Benin City and the authorities in Lagos
asked the British government for help. Alas, none was forthcoming, and
Mrs Seligman sold the mask to the American billionaire and future US
Vice-President Nelson Rockefeller. The master-dealer Charles Ratton
brokered the sale, but asked that his role not be publicised. A powerful
Edo politician, Chief Humphrey Omo Osagie, reacted angrily to this
missed opportunity: 'I accuse the British of stealing and in order to

redeem the good name of the only nation which is fair and just, they must repurchase the mask,' he said.[46]

Mrs Seligman donated the money to a grateful Royal Anthropological Institute, which used a photograph of the mask as its Christmas card.[47] On the evening of 24 January 1958, she threw a party, a sort of farewell ceremony for the mask that had graced her home for almost fifty years. Over a sherry toast, she joked as to whether it had been 'collected' or 'liberated' by Sir Ralph Moor. She hoped that in New York it would 'be appreciated as much as it was when in Benin, though in a different way, and by a wider public'.[48] And yet Kenneth Murray had still not given up. To the embarrassment of the Royal Anthropological Institute, he promptly wrote to Nelson Rockefeller, appealing that he donate his newly acquired mask to Nigeria.[49] Rockefeller was unmoved. He had bought the mask as a star exhibit for the New York Museum of Primitive Art, which he had founded in 1954. (When the museum closed in 1976 its collection was transferred to the Metropolitan Museum.)[50]

The British Museum says that by 1958, the Lagos Museum had ninety Benin works of art, and that fifty-five of these had come through its 'good offices', essentially meaning the Murray/Fagg partnership.[51] This was only a small proportion of everything the British took in 1897, but given the care and expertise with which Murray and Fagg bought the very best pieces, a significant collection nonetheless. Murray believed it included 'several masterpieces': above all the Queen Mother head and the pair of bronze leopards, but also 'one of the best' castings of a horseman, several fine plaques and a carved ivory tusk which he considered 'probably the finest Benin tusk in any collection'.[52]

What can we make of Kenneth Murray's and William Fagg's motivations? It is tempting, from today's perspective, to believe they were driven in some way by a desire to atone for the original sin of 1897. But even though they went some way to repairing the damage inflicted by the Benin Expedition, such thoughts seem never to have crossed their minds. Indeed, towards the end of his life, Fagg provocatively queried whether there even was such a sin. In a paper entitled 'Benin: The Sack that Never Was', he argued that as the fire in the Oba's palace had been

accidental, there was 'no evidence of significant looting' beyond the palace itself and, he said, no indiscriminate slaughter; it was wrong to describe Benin as having been 'sacked'.[53] Kenneth Murray, for his part, admired the British Museum; he wanted his new museum in Lagos to be like it, and he considered it a valuable partner in his objective. Moreover, he thought of Nigeria as a whole, not the Edo nation within it. That Nigeria had to buy treasures from the same institution that held so many of those that had been taken from its territory might appear like a glaring injustice today, but it was not one that occurred to Murray.

He too, after all, was, in his own idiosyncratic way, a product of Empire. At times, he appears curiously tin-eared to the spiritual beliefs of the Nigerians he lived and worked among. He was horrified to see wooden statues and masks slowly disintegrating in the villages, but their owners did not always share his concern. He wanted to protect objects in a museum, while they may have wondered, and felt offended, at the suggestion that ancestral objects should be entrusted to a colonial government and displayed as exhibits.[54] In one letter, he describes a visit to Eastern Nigeria where his car was hemmed in by furious villagers, some lying across the bonnet, as they tried to stop him from removing a wooden carving, which, he complained, had been left to rot on a rubbish tip.[55] A colleague, looking back at that period, admits, 'We were rescuing objects everywhere and putting them in museums, but many of them just ended up as dead objects, out of context.'[56] And yet, Kenneth Murray, grandson of Sir James Murray, the first editor of the *Oxford English Dictionary*, was also a Nigerian patriot. 'He spoke endlessly of Nigeria, lovingly, impatiently, hopefully, despairingly,' according to a friend.[57] When Murray wrote in 1942, 'In a Museum can be gathered together the evidence of past civilisations and achievements in art that will help the Nigerian to have pride and confidence in himself', he sounds very like the Nigerians of the twenty-first century who are campaigning for the return of the remainder of the Benin Bronzes.[58] In hindsight, there is a poignancy around his death beyond the tragedy of the accident itself.

When the National Museum finally opened in Lagos's King George V Memorial Park in March 1957, it was thronged by enthusiastic crowds.[59]

Murray, ever the perfectionist, was not entirely pleased. He complained he had fought a lonely battle against 'a reluctant and uninterested succession of officials…I asked for the bare minimum and the Government would offer less.' As a result, he grumbled, his museum was too small, had poor security and a number of other design faults. 'The museum is much finer than was first envisaged, but is less than it should be,' he wrote.[60] But a colonial government report that year praised Kenneth Murray for the single-mindedness and sense of purpose which 'has resulted in the finest collection of Nigeria Art in the world being housed and displayed in the Federal Capital of Nigeria'.[61] The nucleus of the new museum's exhibits came from Murray himself; he donated his private collection wholescale.

In the weeks before Nigeria's Independence Day, 1 October 1960, the excitement about Murray's museum reached fever pitch. On 15 September he wrote that 'the crowds were so great…that no one could get in or out and all the flowers were trampled and the stairs almost broken'. People waited outside for hours to enter, and the police were almost overwhelmed. Murray says there were 17,000 visitors that day. The following day he 'could hardly get in and had to go upstairs by a ladder since the staircase was jammed by a struggling crowd'. On 28 September he wrote, 'the museum all the week has been inundated with visitors, 30,000 on one day'.[62]

Murray's figures are scarcely credible, but on the morning following Independence Day another eye-witness described 'a very long queue of Nigerians, many of them dressed in their national costumes', waiting to enter the museum and enjoy their heritage.[63] By the entrance they admired a contemporary bronze by the acclaimed sculptor Ben Enwonwu, a former pupil of Murray's.[64] This graceful female figure, *Anyanwu*, dressed in Edo royal regalia, was a symbol of Nigeria arising into the modern world. Murray was frantically busy; he was also organising a fishermen's regatta and musical arrangements for the celebrations. But he was in the crowd at the racecourse to see Prime Minister Tafewa Balewa make his Independence Day speech. Balewa spoke, Murray felt, very well about Nigeria's bright prospects, although he did 'perhaps over-do his flattering references to the British'.[65]

Kenneth Murray and Bernard Fagg's museum system was still thriving in the early 1970s. Their successor, the first Nigerian Director of the Department of Antiquities, Professor Ekpo Eyo, had an inheritance to build on. He said Bernard Fagg 'was sent out to Nigeria to project the image and power of the British empire but reversed all expectations and projected the image and past of the Africans'.[66] Eyo, a widely admired academic, increased the number of government museums from fewer than a dozen to the fifty which exist today. And yet these museums are now sadly neglected, the object of both scorn and pity from many of the leading figures in Nigeria's abundant artistic community. Tellingly, the leading European museums that have now agreed, in principle, to lend back hundreds of Benin Bronzes feel confident enough to do so precisely because these objects will not go to Nigerian government museums. All of which begs the question: what went wrong? And more specifically, what happened to the Benin Bronzes that were returned to Nigeria in the 1940s and '50s?

In 2019, the Nigerian writer Chimamanda Ngozi Adichie wrote in *Esquire* magazine of the National Museum in Lagos 'with its carefully tended flowers outside the building and inside an air of exquisite abandon'.[67] When I visited that year, the front lawn was strewn with litter.[68] The car park was well swept but empty, save for a lone policeman sleeping on a bench. Another sleeping man, topless, lay on the table of what had once been the museum café but now seemed to be a makeshift staff kitchen. The main building, hailed as a fine example of modernist architecture, now looks every one of its sixty-plus years. It was a Saturday, but I wandered alone through dank and dingy rooms. The electricity was off and the museum generator was not working. By the time I left, an hour later, I'd encountered a school party and six other visitors. There was a small but important selection of Nigeria's culture on display, including the terracottas of ancient Ife and Nok culture, and the soap stones of Esie. The handful of Benin pieces included a pair of carved tusks, ivory carvings and some plaques depicting Portuguese soldiers.

The school children looked on dutifully, before heading to the more exciting Modern Nigeria exhibit in an outbuilding. Its morbid centrepiece

is the black Mercedes limousine in which the military ruler General Murtala Muhammed was assassinated in a Lagos traffic jam, or 'go slow', in 1976, its windscreen punctured for eternity by three bullet holes. Muhammed had already decided to move Nigeria's capital away from congested, unruly Lagos. His death concentrated his successors' minds and gave added impetus to the process. Abuja, ethnically neutral and in the centre of the country, became the new capital in 1991, and the federal government buildings that remain in Lagos have progressively deteriorated over the years. The National Museum certainly fits that category, but the problems of Nigeria's museums run far deeper. Indeed, a long promised replacement museum in Abuja has yet to materialise.

John Picton remembers the National Museum in the 1960s bustling with visitors, and staff who took pride in their connoisseurship. It had an entire gallery dedicated to Benin with about 100 objects on display; a good representation of all the main styles in bronze and ivory. He returned in 1995 to find the museum with much less exhibition space and, in his view, no sense of purpose. On his most recent visit to Nigeria, in 2002, he decided not to go to the museum. 'It was too heart-breaking,' he says.[69] Anna Craven went from Cambridge University to work as an archaeologist at the Jos Museum in central Nigeria – the country's first when it opened back in 1952 under Bernard Fagg – in the 1960s and early 1970s. Jos only ever had a small collection of Benin Bronzes, but in its heyday was one of the most innovative museums in Africa, with a famous collection of pottery, Nok terracottas, traditional architecture, a zoo, an African restaurant ('The Bight of Benin') and much more. When Anna returned in 2013 she found the pottery collection to be 'a wreck, a complete tragedy'. Photographic and manuscript archives had disappeared and the storeroom was chaotic and dusty. When Anna asked the staff about missing collections, nobody even knew what she was talking about. 'There was no continuity, no clue of what had happened before,' she said.[70]

It's easy to dismiss these as the nostalgic laments of elderly Brits, pining for the good old days. Unfortunately, many of the Nigerians who followed in their footsteps share their sadness. Professor Ekpo Eyo

remained in charge until 1986, overseeing the transformation of the Department of Antiquities into the National Commission for Museums and Monuments (NCMM), which survives to this day. He continued the campaign for the return of Nigerian antiquities from abroad, but was aware of the growing weaknesses of his own museums. Nigeria's economy went into a prolonged downturn in the late 1970s, corruption worsened and government funding grew more erratic. Ekpo Eyo left to teach in the United States in 1986, where he died in 2011. 'He was worn out,' says Angela Rackham, 'and leapt at the chance of being a professor in Maryland.'[71] His son, Etim Eyo, says his father did his best to leave the museums 'in a condition under which they could continue. A certain amount of money in the accounts, etc. But all of that money was eroded...He was very, very upset.'[72]

Helen Kerri worked for Nigeria's museums from 1972 and was Director of Museums from 1995 until 2004. She's a petite, sprightly lady in her mid-seventies, with a no-nonsense stare but a twinkle in her eyes. She keeps busy in her retirement by running a charity for unemployed youths in the Niger Delta. If Ekpo Eyo could see Nigeria's museums today, she says, 'he would not be proud. We have so much in the store-rooms, but we don't have the ability to present it. Museums are money intensive. Conservation is not cheap. Collecting – they don't do it any more, they have no money – it's not cheap. Training is not cheap. The government is not interested.' From the United States, Ekpo Eyo had looked on in despair as the National Museum leased a chunk of its land to a shopping mall. 'We had no money to build on that land,' says Helen. 'The government was not funding us. And we couldn't get money from the Ford Foundation or UNESCO; they didn't trust Nigerians to give us that money.'[73]

By the 1980s and 1990s, trust, or the lack of it, was a critical issue. Nigeria's museum staff had gained a reputation for not just incompetence, but also dishonesty. Treasured artefacts were disappearing from the institutions that had been built to protect them. Extracting the truth from all the hearsay and rumours is difficult, not least because some have a vested interest in exaggerating them, but it was undoubtedly a

dark period. Etim recalls his father saying he 'had to be careful of his colleagues, there were ones that needed to be watched'.

In 1980–81, the Nigerian government, burning up the last money of the 1970s oil boom, bought what Ekpo Eyo called 'half a dozen quality Benin pieces' to supplement the national collection. This included a spending spree at Sotheby's in London on 16 June 1980, at the sale of the collection of Adolph Schwarz, an Amsterdam businessman. Ekpo Eyo watched on in excitement as Nigerian diplomats, with instructions from the government in Lagos to bid high if necessary, bought four Benin Bronzes for a combined total of £532,000, including a Benin head which cost £200,000 (the same head had passed through Sotheby's for £320 in 1954).[74] 'I accept of course that Nigerian art is part of world art,' said Eyo afterwards. 'But it is not unreasonable to ask that some be sent back...This is a matter of national honour.'[75]

They were the first major purchases by Nigeria of Benin Bronzes since the Kenneth Murray era. But shortly afterwards, according to Eyo, 'a tragedy struck the National Museum in Lagos'.[76] Some of the Benin pieces which Nigeria had just bought were stolen, and appeared on sale in New York. Helen Kerri remembers it well, with a rueful laugh. 'We went into the storeroom one morning and found holes in the ceiling. The security men who were supposed to be taking care of the objects at night were the ones stealing them.'[77] With the help of the FBI and the Pace gallery in New York, most of the pieces were returned, again, to Lagos.

A European museum curator told me that at least three of the plaques which the British Museum sold or donated to Lagos in 1950–51 were illegally taken out of Nigeria and sold to collectors in the United States.[78] Shockingly, two were in the Metropolitan Museum of Art in New York from 1991 to 2021. The Met ignored my repeated enquiries about these plaques, but after the publication of the first edition of this book, suddenly announced it was returning them to Nigeria, and said it was 'greatly appreciative' of 'new information' I had provided, which 'precipitated an extensive provenance review, which led to this action.'[79] A third plaque was put up for auction in Virginia in 2016, with an estimated price of up to $1.2 million. The Nigerian authorities, tipped off by a European museum,

alerted their embassy in Washington, and the sale was stopped.[80] (The auctioneers have not responded to my many messages.) An art expert told me she had seen another former British Museum plaque in a private collection in Europe. The owner, who had bought it from a European dealer, was unaware it had been stolen from Nigeria.[81]

In January 1987, the Jos Museum suffered a major theft, including a rare early Benin head, which later turned up in Switzerland, where it was offered to collectors for 500,000 Swiss francs. It was due to be sold at a Zurich auction but American and Swiss museum curators intervened and the head returned to Nigeria in 1991. Angela Rackham, who visited the Jos Museum shortly after the theft, believed it could only have occurred with the connivance of people working there.[82]

The list of thefts from the 1990s is numbing. The Kwara Museum, home to the famous Esie stone carvings, was robbed at least twice. Security guards were beaten and, on one occasion, drugged with laced soft drinks, as thieves made off with at least thirty-four statues.[83] During a robbery at the Owo Museum, close to Benin City, a security guard was murdered and others severely injured.[84] The Ife Museum was repeatedly robbed between April 1993 and November 1994 and dozens of pieces taken.[85] On the most notorious occasion, thieves smashed open eleven display cases, and made off with several of the treasured life-size bronze and terracotta heads. Frank Willett, a protégé of the Faggs and Kenneth Murray who was Curator of the Ife Museum from 1958 to 1963 and a world authority on Ife art, said he had reliable information that this was also an inside job.[86] Three of the heads were recovered in Paris in 1996, and returned to Nigeria.[87]

In 1996, the NCMM said fourteen of its museums had lost major items in the previous three years, and Nigeria's Minister of Culture, Walter Ofonagoro, admitted, 'we are losing our cultural heritage at such an alarming rate that unless the trend is arrested soon, we may have no cultural artefacts to bequeath to our progeny'.[88] In that same year, Ibrahim Coomassie, Nigeria's Chief of Police, said that 103 'precious artefacts' had been stolen from museums, and 88 of these were on sale in Spain and the Netherlands.[89] In 2014 Boston's Museum of Fine Arts

returned eight objects to Nigeria – including a statue and head from Benin City – which it said had been stolen from Nigerian museums or otherwise taken out of the country illegally between 1970 and 2000.[90] At least some record was kept of thefts from museums, but looting from archaeological sites, particularly terracotta figurines of the ancient Nok culture in central Nigeria, did not enjoy even that minimal oversight.

Nigeria's rulers have set a poor example. In 1961, one year after independence, Prime Minister Balewa took a Benin carved tusk from the National Museum, which he gave as a gift to President John F. Kennedy in Washington; it still resides in the JFK Presidential Library in Boston.[91] Curators in Lagos were appalled and Bernard Fagg pleaded in vain with Balewa not to take the tusk.[92] But Fagg had already faced similar frustrations when he was in charge of the Jos Museum. Angela Rackham recalls government officials coming to the museum and picking objects for VIP visits, much to her father's fury. 'Father had no choice but to accept,' she says.[93]

One Saturday morning in Lagos in 1973, Ekpo Eyo received a telephone call at home. This was surprising, as his phone had not worked for months and engineers had ignored his pleas to fix it. The identity of the caller may have had something to do with the unexpected repair. Nigeria's head of state, General Yakubu Gowon, told Eyo that he'd be round at the National Museum in a couple of hours, to choose a present for the Queen for his forthcoming state visit to London. Eyo rushed to the museum, and hurriedly hid those objects he considered irreplaceable. When Gowon arrived, he chose a mid-period Benin head, of which several examples survive. This was a small relief to Eyo, who was nonetheless horrified by the incident, which he felt undermined Nigeria's case for the return of objects in Britain.[94] (Declassified documents confirm Eyo's fears; in 1976 the British Museum, fending off Foreign Office pressure to lend Benin treasures to Lagos, cited Gowon's 'plundering' as an example of how the Nigerians could not be trusted with their own patrimony.[95]) Helen Kerri says, 'It shows the level of ignorance of our rulers. You can't give away a nation's treasure to make yourself look good before another ruler.'[96]

Thirty years later it emerged that not only had the British government known that Gowon's gift was a genuine Benin Bronze (a British art expert wrote to the Foreign Office in 1974 explaining that it 'was a sixteenth-century piece worth up to £30,000'), but also that this head was one of those that had been bought in London in the 1950s and returned to Nigeria, thanks to Kenneth Murray and William Fagg.[97] Now part of the Royal Collection, the much travelled head – looted first by the British military and then by a Nigerian military ruler – is on display in Windsor Castle.[98]

In 1999, Frank Willett delivered an excoriating paper on the state of Nigeria's museums. He could not, he said, recommend that any artefacts be returned from British collections to Nigeria. He was proud to have worked in that country, but depressed that 'those who hold the titles we once did are not only not taking care of their heritage but are exploiting this irreplaceable material'. And yet, he asked himself, would he behave any better with a salary that 'even when it turned up, was totally inadequate to feed my family and when I was regularly reading headlines in the Nigerian press about the ridiculous prices Benin pieces fetch at auction'?[99] John Picton wrote in 2000 that recent thefts and illegal excavations from Nigeria 'constitute at least as serious a tragedy as the looting of the art of Benin City by British forces in 1897'.[100] Helen Kerri agrees that 'we had dishonest people who would do whatever they could to steal from the museums'. But she argues that they were encouraged by outsiders. 'These thefts were commissioned. We suspected Americans, Europeans. Art dealers. They tempted them with money,' she says, which was not difficult given their pitiful salaries.[101] The demand for Nigeria's culture came from the dealers, collectors and museums of the West. In that way, the pillage of the 1990s bore some similarities to that of the 1890s.

These days, a popular Lagos newspaper reports, the National Museum 'may well be mistaken for a graveyard'.[102] The curator, Mrs Omotayo Adeboye, says it receives between 10,000 and 12,000 visitors per year, or about thirty each day, the majority being children on school trips.[103] A leading figure in the Lagos art world, who asked for anonymity, told me

the museum was an 'absolute joke, it suffered many years of outright theft, and still today it has a basement crammed full of valuable objects covered in dust and cobwebs, that they have no capacity to show'.[104] Giles Peppiatt is head of African art at Bonhams, the London auctioneers that describe themselves as 'the world leader in all matters relating to the art of Africa'.[105] He visits Nigeria on average four times each year. He told me its public museums are 'a disgrace. No big collector in Lagos – and there are some very serious ones – would give their art to a public museum – it won't be looked after, it might be pinched. That's why they're setting up all these private institutions. No one wants anything to do with the national museums.'[106] Even Helen Kerri, in charge of Nigeria's museums until 2004, told me the Benin Bronzes in European museums were 'being taken care of a lot more than they would be taken care of in Nigeria'.[107] She says her government's neglect of the arts is compounded by popular indifference to history; the subject was not even taught in Nigerian schools for many years, although the government announced its reintroduction in 2019. The National Museum's librarian, Taye Pedro, said religion was also to blame for public apathy towards museums, with many people associating traditional artefacts with 'fetish' worship. 'Religion has blindfolded us...if your family knows that you work in a museum, they will ask you to resign because they think it is a shrine.'[108]

It would take a brave soul to look for signs of hope in this bleak situation. But in the twenty-first century Nigerian museum officials insist that the rampant theft of the 1980s and '90s is over, and European curators who work with them agree that security is much improved. 'Thefts took place in a certain period – not now,' an official at the British Museum told me. The National Museum in Lagos only has the means to exhibit some 300 of the objects in its collection. The remaining tens of thousands are in storage; statues, masks and other carvings poorly labelled and often chaotically crammed together. But crucially, the most highly prized objects, the treasures of Benin and Ife, are kept in a secure room, and access to them is carefully monitored with strict protocols. And yet the unhappy experience of the recent past shows that metal

cages, padlocks and alarm systems offer little protection once the culture of an organisation has turned rotten.[109]

In 1982, the British academic Philip Dark attempted to catalogue the whereabouts of all the Benin Bronzes in the world. This was an ambitious undertaking, given the secrecy with which some are held, the existence of fakes and his inclusion of some important items made after 1897. Nonetheless, he recorded some 500 Benin Bronzes in Nigerian museums, including more than 270 in the Lagos National Museum.[110] This is consistent with John Picton's recollection from the 1960s, that it had the third largest collection of Benin Bronzes in the world, after the British Museum and the Ethnologisches Museum in Berlin. Many of the most valuable of these are the ones that Murray and Fagg bought before independence.

In recent years, as the debate over the return of objects has become more heated, European curators have pressed their Nigerian counterparts at the NCMM to divulge exactly how many Benin Bronzes they have. The NCMM has struggled to do this, but perhaps more as a result of administrative confusion than anything else. A British Museum official who has worked closely with the NCMM said that frequent changes in management and documentation systems had resulted in the organisation simply losing track of what it has, rather than losing objects altogether. 'Dark's figures are still plausible. Sometimes it appears objects are not there, but they are actually there. Or stolen objects have been returned, but given new numbers. And there is no monitoring of loans between Nigeria's museums.'[111] Dr Barbara Plankensteiner, a worldwide authority on the Benin Bronzes, describes those held by Nigerian museums 'as a remarkable collection that today stands amongst the finest worldwide'.[112] Helen Kerri, for all her criticisms of the organisation where she spent her professional life, concurred. 'We have a very good collection. We're proud of it...thank god the artefacts are not deteriorating. They are not badly kept – they are surviving.'[113]

PLEASE, SIR, WHEN WILL BRITAIN GIVE BACK THE BENIN BRONZES?

Joseph Alufa, cheated by Nigeria.

Joseph Alufa, seventy years old, lives on a quiet dirt street in the Upper Sakpoba neighbourhood on the edge of Benin City, in a house that is testimony both to his imagination and his poverty. The entrance is

guarded by stone statues: of warriors holding a sword aloft, of Edo women and a bust of Joseph in his prime. When I visited, a young man was busy in the front porch, putting the final touches to a decorated wooden throne. Much of the rambling structure behind him was in ruins. Walls had tumbled down, roofs fallen in or never built, and a pawpaw tree protruded from the top of what looked like an abandoned castle turret.

Joseph Alufa was wearing a long brown robe and flip-flops. He is a wiry old man, with thick, black-framed glasses, one eye badly clouded by cataract. He is hard of hearing, and so I had to shout, and he shouted back. 'Stress has made me deaf,' he shouted. 'I am frustrated. Nigeria frustrates me, that's why my house is in ruins.' He led me along a dark corridor to his bedroom. The room was shabby and threadbare, but the bed itself was a thing of wonder, a massive cement structure with an exuberant headrest of arches and waves, crowned by an angel with spread wings, flanked by cherubs and mermaids and lions in bas-relief, fleur-de-lis and star motifs, all decorated with rows of cowrie shells. It was as if Gaudí had met the Benin tradition, and thrown in a bit of Baroque. But Joseph was too angry to notice my admiration. 'I'm a hero, but I'm a poor hero,' he said. He showed me a certificate, in a stained and peeling plastic cover. It was from General Olusegun Obasanjo, Nigeria's military ruler in the late 1970s, appointing him a Member of the Order of Nigeria. It was an honour, but not one that he could eat, or educate his children with, or use to finish building his house. 'Would you treat a hero like this in UK?' he demanded to know. 'A national hero…it's a disgrace.'[1]

In the mid-1970s, Nigeria was on a high. The civil war was over, oil money flowed in, and Nigeria spoke for all black Africa in the struggle against the white regimes of the South. Nigerians look back on those days as a time of ambition, hope, folly and exuberance. If there's one event which encapsulates that era, it is FESTAC, the Black and African Festival of Arts and Culture, which took place in Lagos in early 1977 and was, according to Nigerian state radio, 'the effort of the black man to tell the world he has a heritage to be proud of'.[2] There was a regatta and a

durbar; Stevie Wonder, Miriam Makeba and other artists from forty-eight countries performed; and the exhibitions, concerts and plays went on for a whole month. The organisation was chaotic, and Lagos's streets were often at a standstill, but Kaye Whiteman, a distinguished journalist of post-independence Nigeria, remembers it as 'a magnificent moment', as the organisers tried to evoke the glories of pre-colonial history to create a sorely needed sense of national unity.[3]

In 1974, the Nigerian government – prompted by the Edo artist Erhabor Emokpae – decided that the Queen Idia ivory mask in the British Museum should be the emblem of FESTAC. What better symbol of African creativity than the splendour of ancient Benin? In the British Museum, according to Emokpae, Queen Idia was 'in prison'.[4] It was time to free her. There was just one problem. Everything depended on the co-operation of the British Museum, but nobody had checked whether that would be forthcoming. Emokpae hoped that 'global pan-African solidarity' would force it to give ground.[5] He would be disappointed. The British Museum rejected Nigeria's request to borrow the Queen Idia mask, in its words, 'on conservation grounds – the great delicacy, fragility and instability of the object...would have put the mask too much at risk if it were allowed to travel'.[6] John Picton, who by the 1970s had left Nigeria and was working for the British Museum, supported the decision. The mask was already fractured, both on the surface and the inside. He said, 'The fear was not that we'd never get it back, but that it would be subject to different climatic conditions and much greater humidity and the ivory would shift and the surface would crack.'[7]

For many Nigerians, the request to borrow back a treasure from the colonial power that had looted it in the first place was demeaning enough. But for the British Museum to argue that the Queen Idia mask would break up in the very climate where it had been made some 400 years earlier added insult to injury. This was, said the *Daily Times* of Lagos, a 'tragi-comedy'.[8] What followed, in the obtuse words of the Director of the British Museum, David Wilson, who took over in 1977, was 'an extraordinary outburst of anti-colonial feeling'.[9] The Nigerian government said the museum had agreed to lend the mask on condition

the Nigerians pay an insurance bill of £1.8 million. The museum says there is no evidence such an offer was ever made – and there is nothing in its internal papers to suggest it was even considered – but it was prepared to make a replica and discuss alternative loans, including Benin plaques, if it could be assured of their safety.[10] The replica mask, made of resin and valued by the British Museum at £6,000 (equivalent to about £37,500 today), sat unclaimed in its vaults for many years.[11] The Nigerian government made it clear they would regard it as an insulting gift, and in 1977 the Foreign Secretary, David Owen, warned the British Museum not to even try to hand it over.[12]

Nigerian politicians piled in, African artists in London voiced outrage, and Nigerian newspapers were full of 'the crisis of the FESTAC symbol'. Britain, said one, was not showing 'the correct attitude of a father to a son'. Other papers were less charitable: the British had shown 'insolence, spite, contempt', they should be brought before the International Court of Justice on charges of robbery, they had 'a diabolic plan' to ruin FESTAC, and their refusal to lend the mask was another example of 'poor, small Britain's history of international brigandry and thieving, in the tradition of Drake and Rhodes'.[13] A Nigerian movie of the time, *The Mask*, a precursor to Lancelot Imasuen's *Invasion 1897*, featured a James Bond-like character, Major Obi, played by the director Eddie Ugbomah, who travelled to London to retrieve the mask.[14] 'Since the mask was stolen, let us go to their museum and steal the thing back,' said Ugbomah many years later, 'and you know what my film achieved for this country? Respect!' More than at any time since 1897 Britain's invasion and plunder of Benin was a source of public controversy and debate in Nigeria and, to a much lesser extent, in Britain too.

British Museum and declassified Foreign Office documents that chart this long-running row make for fascinating reading. On the one hand the museum is every bit as dismissive of Nigerian sensibilities as its fiercest critics might imagine. But the misapprehension, often shared by those same critics, that the museum is in some way subservient to the British government could not be further from the truth. As early as September

1974, the museum Director, John Pope-Hennessy, tells the Trustees – a sprinkling of Lords, Sirs, Professors and a single Dame – that 'the agitation' for the return of the mask is 'artificial', and they firmly support his recommendation to resist it.[15] In 1975, the Director and Trustees acknowledge that an upcoming UNESCO conference on restitution addressed 'a matter of great importance which could not be expected to die away but would have to be met'.[16] Yet they are both 'strongly of the opinion' the Director should not attend.

For the Foreign Office, this 'unpleasant tiff' could not have been more inopportune.[17] In 1976, Anglo Nigerian relations were in crisis. On 13 February, shortly after General Murtala Muhammed's assassination, the would-be coup leader, Brigadier Bukar Dimka, and a pair of armed soldiers strolled into the British High Commission in central Lagos. Dimka demanded to make a phone call to Nigeria's previous ruler, General Yakubu Gowon, who had been overthrown by Muhammed in 1975, and was now living in the UK, studying at the University of Warwick. (Presumably Dimka wanted Gowon to return to Nigeria and resume his rule.) The British High Commissioner, Sir Martin Le Quesne, refused to help Dimka, but Muhammed's surviving colleagues on the Supreme Military Council – swiftly back in control – were furious he'd been allowed into the building at all. Their anger was exacerbated by Britain's refusal to extradite Gowon. There was a riot outside the High Commission, Dimka was executed and Sir Martin expelled.[18] For the remainder of 1976 the British worried the Nigerians were playing 'a cat and mouse game', refusing to accept a new High Commissioner until the Queen Idia mask was sent to Nigeria.[19]

There was a lot at stake. Britain was in a balance of payments crisis, and Nigeria was its largest export market in the developing world. British diplomats fretted that arms deals, major railway contracts and the oil company British Petroleum would all be adversely affected by the British Museum's refusal to lend the mask. 'The affair is bound to damage our relations in almost every sphere,' warned British diplomats.[20] Ted Rowlands, Minister of State in the Foreign Office, wrote, 'we must press the museum to be as forthcoming as possible'.[21]

The Foreign Office explained its concerns about 'our Nigerian difficulties' to the British Museum in October 1976, and confessed it felt 'under increasing pressure on this issue'.[22] The Trustees, a diplomat suggests, need to understand the political context. Perhaps they'd like to hear from a government minister directly? But throughout, the museum gives no ground; the mask was not up for negotiation. Although its curators proudly – but privately – believed they were in possession of 'the finest' of the five Queen Idia ivory masks taken from Benin, they also suggested the Foreign Office assuage the Nigerians by buying the Gallwey family's mask and offering that one to Lagos instead.[23]

Some British diplomats wondered whether British Museum curators were using their mask's fragility as a convenient excuse. 'I cannot suppress the unworthy thought that the museum may be hiding behind the conservation argument,' wrote Patrick Roberts on the West Africa Desk.[24] In January 1976, he visited Malcolm McLeod, Keeper of the museum's ethnography collection. Roberts says McLeod told him there was a risk the Nigerians might simply refuse to return the mask after FESTAC (although Nigeria always promised it would).[25] In November 1976, another British diplomat wrote that McLeod had told him the Nigerians 'had no conscience insofar as the giving of guarantees was concerned'.[26] Speaking in 2020, the long-retired McLeod said – understandably – he could not recall details of these specific conversations, but he did remember the 'conservation of the mask was a serious concern'.[27]

The row continued into 1977. FESTAC had come and gone, but David Owen tried to revisit the issue of the mask. 'Its return would undoubtedly contribute more than any other gesture in improving Anglo-Nigerian relations', according to his briefing notes.[28] In May 1977, he invited the British Museum's Chairman of Trustees, Lord Humphrey Trevelyan, for a chat. Malcolm McLeod was also there, and told me that Lord Trevelyan (himself a seasoned diplomat and veteran of Suez and other crises, and for whom the Benin mask was surely small beer) politely explained that the British Museum never took orders from a Foreign Secretary. 'A badly briefed minister thought he could put pressure on the museum,' said

McLeod.[29] Writing in 1992, McLeod was less circumspect. He recalled that Lord Humphrey had been asked to see David Owen because of 'foreign office cowardice...[Owen] wanted to know why the British Museum couldn't be nice to Lagos. Humphrey T, bless his heart, sticked the b up so he couldn't breathe let alone move'.[30]

Giving up on the unhelpful British, Nigeria's government asked Edo artists to replicate the mask themselves, working from photographs. They would display the replica at the new National Arts Theatre, on posters and stamps, and knock off more copies for visiting heads of state and dignitaries. Queen Idia's mournful face was ubiquitous throughout Nigeria during FESTAC and remains synonymous with it to this day, commemorated in thousands of imitations on sale in hotel lobbies and airports. It is still known, in Nigerian parlance, as the 'FESTAC mask', with a dual identity as symbol of colonial injustice and post-colonial pride.

Joseph Alufa was one of five Benin artists commissioned to make the replica, but his moment of glory was a prelude to decades of frustration. The exact terms of what was agreed between Joseph and the long-departed military government are not clear, but more than forty years later, he is still waiting for money he says he was promised.[31] His lawyer has pursued the case through the courts since 1989 in an increasingly forlorn process. Alufa is consumed by anger. He twists his bed sheets around his fist, and gestures at his falling-down house. 'My case is uncompleted. I'm a poor man. If they'd paid me,' he shouted, 'I could have finished my home. It's a disgrace!'

Today the National Arts Theatre which hosted FESTAC is a decrepit hulk of a building, dark and humid inside, and barely used. FESTAC Town, the estate built for visiting artists, is a place of potholed streets, the original houses squeezed between many illegal structures which have sprung up. Successive Nigerian governments – always more interested in the next contract – have barely bothered to maintain what they've already built. Similarly, they have taken advantage of their people's talents and enthusiasm, and left them destitute. 'It is very sad that our country only recognises its heroes after they are dead,' says Joseph Alufa.

'That's when people shed crocodile tears and heap accolades on them and name streets after them.' But when I asked him whether he thought the Benin Bronzes in Europe and the United States should be returned, he instantly redirected his outrage from Nigeria's kleptocratic rulers to the old colonial power. 'They were stolen, they must give those things back. They belong to Benin, not the British government. They came here to thieve. Armed robbers! They took so much,' he clapped his hands for emphasis, 'and they must pay for retention. For retention!'

For decades, the Edo have dreamt of the Benin Bronzes coming home. In the 1930s, Oba Akenzua II sought to turn the dream into reality. His strategy, rather than ask British officials for the return of everything, appears to have been to request specific items that had been part of the Oba's personal regalia. His charm and gravitas appealed to the upper echelons of British society; a senior colonial official described him as 'an

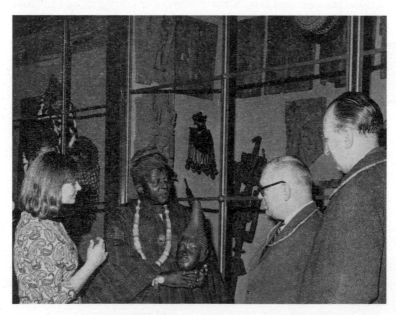

Can we have it back? The Edo chief Usman Lawal Osula cradling Queen Idia, on a 1965 visit to the British Museum, with William Fagg.

extremely able and cultured man'.[32] In 1935, the Under-Secretary of State for the Colonies, the Earl of Plymouth, Ivor Windsor-Clive, visited Benin City, and befriended Akenzua II, who asked him to assist in the return of two brass stools, believed to have served as thrones for Obas before 1897 (one can be seen in a photograph of British looting of the palace – see illustration section). The Earl and his officials pursued the request with some persistence; a long trail led them from London dealers and the Sotheby's and Stevens' auction houses to the Museum für Völkerkunde in Berlin. In 1936, Akenzua II received a predictable reply; the General Director of German State Museums 'was not prepared to give back or sell chairs of such high cultural value'.[33] Nazi Germany was not fertile ground for a restitution claim, but nor was anywhere else in 1930s Europe. Nonetheless, Akenzua II had more luck, in 1937, when G. M. Miller, son of a member of the Benin Expedition, gave him a pair of coral bead crowns and a tunic that had been part of Ovonramwen's royal costume.[34]

In 1944, Akenzua II began assembling what objects he had within the palace, under the care of the historian Jacob Egharevba, who was a member of the *Iwebo* society of palace officials, responsible for the Oba's wardrobe and regalia.[35] In 1946, Kenneth Murray and Egharevba moved the collection to a small room in Benin City's police station, so the public could admire it, although the exhibits were poorly displayed behind glass panels in heavy wooden frames. In 1956, Queen Elizabeth II and the Duke of Edinburgh paid a passing visit to Benin City; Oba Akenzua II came to the airfield and, in an unusual show of humility, bowed and shook the Queen's hand. The collection of Benin objects was moved to a 'temporary museum' at the airfield, where the Queen received a lecture on Benin Bronzes from Murray and Egharevba.[36] In about 1960, the collection moved again, to larger premises in the colonial Post Office building.[37]

But what did the Edo actually have to display? William Fagg said the Benin City collection had an importance disproportionate to its size and was 'of exceptional interest' because it included many objects dug up by archaeologists in more recent years which were untypical of those Admiral Rawson and his men had taken in 1897.[38] Frank Willett agreed;

'the Royal Navy did not find everything,' he wrote, describing unusual
discoveries excavated in the 1960s such as ram-head pendants and masks
with snakes emerging from nostrils.[39]

Professor Ekpo Eyo did not share their excitement. He described the
contents of the Post Office museum as 'only a few third-rate objects left
in the minor shrines of the Benin chieftains'.[40] In 1973, he presided over
the opening of the much grander National Museum in Benin City, a
circular three-storey terracotta-coloured building. This was the museum
Kenneth Murray had been working on when he was killed the previous
year. Eyo saw its opening as an opportunity to ask Western countries to
give back more Benin Bronzes. Jacob Egharevba prayed these 'may be
returned to the proposed Benin Museum in order to stimulate design
and execution' among contemporary casters.[41] The Nigerian government
wrote to embassies and high commissions of countries known to have
large Benin holdings, and appealed to museums directly through the
International Council of Museums, but did not receive a single response.
Even after the transfer of some objects from Lagos, Eyo felt the new
museum looked inadequate and 'empty'.[42] 'Consequently,' he wrote
angrily some twenty years later, 'the National Museum in Benin City
opened to the public with photographs and replicas of the art objects
that have become the pride of other nations and institutions'.[43]

Usman Lawal Osula was a wealthy Edo businessman and member
of the royal family, known as the Arala of Benin. In 1965, the British
government invited him to London and laid on a hectic itinerary of
political, cultural and business meetings. Osula enjoyed himself; 'my only
criticism of the tour was the British climate'. Edinburgh was a highlight,
its buildings and traditions, he wrote, 'reminded me so much of the
equally ancient history of my own country, the old Empire of Benin'.[44]

Osula used his visit to appeal for the return of the Benin Bronzes. He
had already enjoyed a small breakthrough in this regard some years earlier,
befriending a colonial official in Northern Nigeria, Gilbert Stephenson,
who revealed himself to be the son of the Gilbert Stephenson who had
taken part in the 1897 Expedition. At Osula's instigation, Stephenson
junior brought back to Nigeria the sword his father had taken from

the palace, and presented it to Akenzua II. But in London itself, Osula found that doors were closed politely in his face. Stephenson senior, now a retired Vice-Admiral, regretted he was indisposed to meet him. Osula went twice to the British Museum and made his case to William Fagg, but to no avail. Fagg could have pointed out that he had played an important role over the previous twenty years in ensuring the return of at least some Benin Bronzes to Nigeria. But rather insensitively, he said that if Nigerians were still interested in those held by the British Museum, they could commission replicas. Osula returned to Nigeria with a vague promise that Fagg would 'in due course' send a photo album of the museum's Benin collection.[45]

In 1975, a comparatively young David Attenborough travelled to Benin City to make a BBC documentary, *The Kingdom of Bronze*. Attenborough crouched at the feet of the now venerable Akenzua II, resplendent on his golden throne, and although the broadcaster's tone is respectful, unctuous even, he does not make a single mention in a fifty-minute film dedicated to Edo culture of any dispute about the Bronzes' whereabouts.[46] Akenzua II died in 1978. His son, Oba Erediauwa, continued to raise the cause of the Benin Bronzes, but in vain. In the 1980s and '90s, Western governments and museums paid little attention to claims for the return of objects taken under colonial rule. Indeed, the British Museum was still acquiring Benin Bronzes taken in 1897 as recently as 1986.[47] Nigeria's economic decline, a series of oppressive and corrupt military governments and the plummeting reputation of its museums did not help the Edo cause.

In the mid-1990s, it was the Labour MP for Tottenham, Bernie Grant, who took up the cause of the Benin Bronzes. 'Barmy Bernie' to enemies on the right, British Guiana-born Grant was an unstinting campaigner for racial equality. The actor Rudolph Walker, who many years later appeared in Lancelot Imasuen's *Invasion 1897*, said 'for black Britons of his day, he was our voice, our Rosa Parks, our Martin Luther King'.[48] In 1987, Grant was elected to Parliament. He arrived at Westminster in West African robes, and sought to build links between Britain's black community and Africa.[49] In 1993, he travelled to Nigeria for a conference on reparations

for slavery.[50] That may have been when the Benin Bronzes came to his attention, for in July 1994 he organised a series of protests outside the Museum of Mankind, at Burlington Gardens off Regent Street. (The British Museum's Ethnography Department, including many of the Benin Bronzes, moved to the new location in 1970, as the Museum of Mankind. In 1997, it merged again with the British Museum, and returned to Bloomsbury.) The Museum of Mankind was hosting an exhibition on Benin art that summer, and Bernie Grant and some twenty supporters – 'good natured and peaceful' according to museum security – occupied the steps on four successive Saturdays, holding placards saying 'African Treasures Belong in Africa' and 'Give Back Our Culture, Our History and Our Inheritance'.[51] A fellow Labour MP, Tam Dalyell, wrote to Grant in support: 'Bernie, I think this question of Benin Bronzes etc. is increasingly urgent – and I like your pose!'[52]

In 1997, Benin City hosted a centenary commemoration of the British invasion. It was a bleak period in Nigeria, the country suffering under the dictator General Sani Abacha, its international reputation in the doldrums following the execution of the environmental activist and writer Ken Saro-Wiwa in 1995. Benin City wore a suitably down-at-heel look, coated in harmattan dust and, following the accidental burning down of the telephone exchange, with little communication with the outside world.

The commemoration began with speeches from Oba Erediauwa and the British High Commissioner, Thorold Masefield. These two Cambridge graduates had very different interpretations of what had happened 100 years earlier.[53] The Oba sought to correct what he called an Anglocentric version of history. The British, he said, had launched a premeditated war on his people. The trial of his great-grandfather, Ovonramwen, had been a mockery of justice as the British were simultaneously 'the complainant, the prosecutor, the judge, and the jury, in utter violation of the rule of natural justice known very well to the English Common Law; *nemo judex in causa sua.*' Mr Masefield said the British had faced a 'dilemma…They wished to put an end to slavery and to human sacrifices, as well as to open up what they perceived had become a shrunken, inward looking

empire to the benefits of contact with a wider world.' If only, he argued, the two sides had understood each other better, then Benin's art could have come to the world's attention without bloodshed and agony. The Oba urged caution to those who wished to take the Benin Bronzes issue to the International Court of Justice. He was, he said, 'in contact with some eminent people in London who are supportive to our cause and seriously helping'.[54]

Presumably these included Bernie Grant, for the planning around the centenary had provoked a flurry of contact between the Oba's palace and the MP for Tottenham. The British Museum was bracing for a storm. In February 1996, the head of ethnography wrote to the Director, Dr Robert Anderson, to warn him that 'this is going to be a difficult period'.[55] Bernie Grant met the Oba's brother, Prince Edun Akenzua, in London in November 1996 and became, in his own words, 'an agent of the Oba' in the quest for the return of the Bronzes. Grant promised to take up the issue with the Commonwealth's potentially sympathetic Nigerian Secretary-General, Chief Emeka Anyaoku, as well as the Foreign Secretary, Malcolm Rifkind.

He also wrote to museums across Britain, but concentrated his efforts on Glasgow's Kelvingrove Art Gallery and Museum, where he felt he had political support and the legal challenges to breaking up collections were least problematic. Several Glasgow Labour councillors agreed in principle that the twenty or so Benin pieces in the museum should be returned to Nigeria, but felt this could only happen after General Abacha's junta had stepped aside.

Bernie Grant travelled to Glasgow to make his case. Standing in front of the museum's display of Benin Bronzes, he had an animated exchange with a curator, Mark O'Neill. Scotland, Grant pointed out, had recently celebrated the return of the Stone of Scone after 700 years as an English spoil of war. It would now be 'two-faced' if it did not return its Benin Bronzes, which 'belong to a living culture and have a deep historic and social value which goes far beyond the aesthetic and monetary value which they hold in exile'. Mr O'Neill replied that his museum had a 'moral imperative' to inform Scottish people about Benin through its

collection. 'The bottom line is that we're not in the business of addressing historical wrongs,' he said.[56]

In March 1997, Grant organised another protest, this time at the British Museum itself.[57] He arrived on a Sunday morning accompanied by drummers, some supporters and a bevy of journalists. The museum was closed but a duty officer decided to allow the crowd through the front gates and as far as the colonnade steps. There, with a character-istic flourish, Bernie Grant signalled for the drums to fall silent, and handed over a Repossession Notice for the Benin Bronzes, addressed to Dr Robert Anderson: 'Acting Under the Authority of the Oba of Benin. You are hereby ordered to return the goods. Bailiff's Name: Bernie Grant MP. Monetary Value: Priceless. Payment Must be Made now to the COUNTRIES OF ORIGIN.'[58]

All of these efforts were appreciated in Benin City and when Labour's wilderness years ended with Tony Blair's victory in the May 1997 election, Oba Erediauwa wrote to Bernie Grant, 'I pray and hope that with your Party now in Government your hands will be strengthened to assist me in the matter of the recovery of our Benin works of art.' Edun Akenzua returned to London in June, encouraged that whereas 'previously we had a friend in Parliament, now we have a friend in Government'.[59] The Benin royal family was not in a position to pick and choose its allies in Britain, but perhaps overestimated Bernie Grant's influence. He was certainly committed, but, unfortunately for Benin, not a central figure in the New Labour project. Indeed, he fought an often lonely struggle to force the British establishment to re-evaluate the past.

In any case, Bernie Grant's position may have been more nuanced than was suggested by his public reputation as a rabble-rouser. Privately, he expressed concern to Edun Akenzua about the safety of the Benin Bronzes should they return to Nigeria. His correspondence with Dr Anderson at the British Museum is good humoured and scrupulously polite. A forthcoming demonstration, Grant informs Dr Anderson, will be a rather small event, a vigil really, and it would it be most helpful if Dr Anderson could attend in order to receive a petition.[60] John Picton shared a stage with Grant at a London event to discuss the Benin centenary, and

recalls the evening: 'Bernie Grant got up and said, "Send all the African art back to Africa! If you want to see it, go to Africa." Everyone cheers. Then I got up and said, "Hang on, if we send all the Chinese art to China, all the ancient Indian art back to India, all the ancient African art back to Africa, all we'll have is the ancient art of the British Islanders. But they didn't have any. They ran around naked, staining their bodies blue with indigo." I said, "There has to be a compromise." Quietly he leaned over to me and muttered, "I agree."'[61]

Nigeria returned to civilian rule in 1999, which brought an improvement in political ties with Britain. In March of that year, the Foreign Secretary, Robin Cook, paid a goodwill visit. I was the youthful BBC Lagos correspondent, and happened to attend his question and answer session with children at King's College. 'The Eton of Nigeria' – a school of long verandas, cricket whites and Latin mottos – was a pale shadow of its colonial glory days, but the teenage pupils, especially from the sister Queen's College, were as sharp as anything. Mr Cook had already been – forgivably – caught off-balance by a question about the 'disgraceful conduct of British holidaymakers on the island of Ibiza', when a girl raised her hand at the back of the class with a simple question: 'Please, sir, when will Britain give back the Benin Bronzes?' Robin Cook, normally no fool, looked blank. He conferred in hurried whispers with his High Commissioner, before giving a waffling answer with words to the effect that Britain had always been a worthy custodian of treasures that had come into its possession throughout its long imperial history, etc., etc. I still recall the sense of embarrassment in the room; it appeared the British Foreign Secretary did not even know what the Benin Bronzes were, let alone had bothered to rehearse a convincing response before visiting Nigeria.

In early 2000, Bernie Grant was still writing to Glasgow's councillors about the future of that city's Benin Bronzes. By then, however, his health was failing. In March 2000, Edun Akenzua submitted a memorandum to the British Parliament, as Chairman of the Benin Centenary Committee. The Bronzes, he wrote, 'have been referred to as primitive art, or simply, artefacts of African origin. But Benin did not produce their works only

for aesthetics or for galleries and museums…Taking away those items is taking away our records, or our Soul.'[62] Akenzua demanded the British government take full responsibility for returning the remaining objects, or else pay the Oba compensation for them at current market prices. It was an optimistic plea, and a reflection of Edo frustration. The centenary had come and gone, democracy had been restored, and yet nothing had changed. Bernie Grant died of a heart attack days later, and the Edo cause seemed as forlorn as ever.

The Benin National Museum, the one which opened in 1973, sits in the middle of a giant roundabout in front of the Oba's palace. Modern-day Benin City hurtles around it, and fruit bats screech and flap in the trees above. Like many Nigerian government buildings, it seems to have more than enough staff, and a fair amount of listlessness and sleeping at desks. But the curator, Theophilus Umogbai, has a busy manner, and the museum, given an extensive refurbishment by the Smithsonian Institution in 2017, is in better condition than any other I've seen in Nigeria. Of course, the collection of Benin Bronzes pales beside that of the British Museum – there are only a handful of plaques on display and they are torn and incomplete – but is more imaginatively presented than in its fusty counterpart in Lagos, and the staff in the galleries are informative and helpful.

Theophilus bristles at suggestions that his museum is not a safe place for Benin's cultural treasures. He took over in 2012, but says he's scoured the files for records of past wrongdoings. 'We've never had a break-in or burglary here,' he said. 'Nothing has been stolen here. Ever!' He thumped his desk. It was a categorical answer, which contradicted what I'd been told by two European museum curators who work closely with Nigeria's NCMM but wanted to remain anonymous. One allegation that is on the record came from Frank Willett; he wrote that in the early 1980s 'an employee of the Benin Museum sold a couple of bronze heads from a reconstructed royal ancestral altar, reshuffling the other objects to cover the gap'.[63] They were apparently recovered in the United States. But Theophilus was adamant: 'those allegations they

made in the past were all false'. He blamed 'certain interest groups', but wouldn't be drawn on who these were. The problem, he said, was that people don't understand how museums work. Objects were taken away for exhibitions abroad, and when they returned to Nigeria would disappear into Lagos storage. 'And then we're accused of looting and stealing them,' he said.[64]

European museums, it must be said, are hardly immune to theft. In 2012, for example, thieves broke into Cambridge's Fitzwilliam Museum and took £57 million worth of Chinese artefacts. The gang stole from other British museums and auction houses, and although several members were convicted, many of the objects were not recovered.[65] Europe's violent twentieth-century history also resulted in the destruction and loss of Benin Bronzes that would never have occurred had they remained in Africa. The Liverpool Blitz was in May 1941. On the night of 3 May, a bomb crashed through the roof of the Liverpool Museum on William Brown Street, setting off a fire which raged through the galleries for hours. Some 3,000 objects were destroyed, from stuffed elephants to New Zealand carvings, but also some of the rich collection of Benin Bronzes. A cast leopard – sold to the museum in 1897 by Dr Felix Norman Roth – lost its head and front legs, and its tail was severed. Other pieces, including a Queen Mother head, were reduced to melted fragments.[66] One of the destroyed objects, a shield-shaped plaque or aegis decorated with elephants, rams, mudfish, a human face and snakes in interwoven patterns in bas-relief, tantalisingly survives only as a black and white photograph in Henry Ling Roth's book from 1903.[67]

The fear of aerial bombardment, but also staff shortages and lack of funds, caused major disruption to the British Museum even in the First World War. Exhibition galleries were closed to the public in March 1916, and most did not reopen until 1919. The museum was better prepared next time around. With admirable prescience it began contingency planning for a new conflict in 1933. Director Sir John Forsdyke ordered the packing up of exhibits the day after the signing of the Nazi–Soviet Pact in August 1939.[68] This was done, according to the museum's official history, 'with

a sense of urgency, but also with a sense of order and calm'. The ethnographic collection was divided between the depths of Aldwych tube and the Baroque splendour of Drayton House, Northamptonshire, where it was troubled by moths and damp, but not the Luftwaffe.[69] The museum buildings themselves, however, were severely damaged in May 1941.

The Benin Bronzes in Berlin, meanwhile, survived the Allied bombing, but some 400 Benin objects from the reserve collection were seized by the Soviet army in 1945 and taken to the Ethnographic Museum in Leningrad. In the late 1970s, the USSR gave them to the Leipzig Museum in East Germany, to show 'friendship between communist peoples'. When the Berlin Wall fell, West German curators, who had feared the worst, were delighted by the 'sensational discovery' of the recovered Benin objects.[70] But the collection was not complete; sixty-five objects had gone missing, perhaps stolen or destroyed, or maybe still sitting forgotten in a Russian museum vault.[71]

For all this, it is surprisingly easy to encounter influential people in Benin City who have reservations about the return of Benin Bronzes from European to Nigerian museums. Patrick Oronsaye, great-grandson of Oba Ovonramwen, member of the *Iwebo* palace society and my informative guide to Edo history, worked as an artist in the Benin National Museum for six years. 'If you send these things back, I'm sorry to say, they'd take them to Igun Street [where the casters still work], they'd recast them and fake them, give them the colour and patina of the original – and sell the original pieces.' Theophilus Umogbai would dispute this, but I heard similar reservations from Ivie Uwa-Igbinoba, also of royal descent, who writes about the Edo language and works for Nigeria's National Council for Arts and Culture. At university, she studied Benin's history under Philip Igbafe, and felt the humiliation of 1897. 'The pain is still there; the pain is there. I go to the UK often. I went to the British Museum. I saw our Bronzes. I had a heavy heart,' she told me. So I was not expecting what she said next. 'If they bring them here, can we take care of them? We have robbers all over the place. Are they safe in our museums? Can we really maintain them? It's been over 100 years they've been away.'[72]

The most conservative, if that's the right word, point of view came from the octogenarian Ekhaguosa Aisien, historian and grandson of Aisien, the warrior who fought the British in 1897. He too likes to describe himself as 'a palace man', yet, by his own admission, often finds himself disagreeing with his fellow palace chiefs on the future of the Bronzes. He loves to tell the story of how he first saw the Benin Bronzes in the British Museum, as a young student from the colonies, more than sixty years ago. 'As I entered the foyer there was one big hall on the right and another on the left. So I turned into the big hall by the right. That hall was all Benin artefacts. All from Benin! From Benin, from Benin,' he said, still shaking his head in wonder after all these years. When he saw those Bronzes in London Ekhaguosa didn't feel anger or sadness. He felt pride. And not the pride of defiance borne through pain that other Edo who've been to the British Museum have described to me, but one that came from a sense of acknowledgement and recognition.

As a schoolboy, Ekhaguosa had read in a British encyclopaedia about 'Antique Works from Benin City', and had scarcely believed this could be a reference to his home town. 'I remember thinking, "Are there two Benin Cities in the world?"' He had even walked down Igun Street and seen the brass casters, but still the penny had not dropped. Now, standing in the British Museum gazing at the Benin Bronzes, everything fell into place. 'To imagine that the things my forefathers made with their own hands are what the white man now cherishes and treasures so that they spend so much on their maintenance.' He looked at the museum guards, in smart green uniforms with yellow braid. 'You dare not touch anything. When I saw the outside world, the developed world, the more aware world, regarding these things as important, I felt an enormous pride, which still remains with me. The Indians, the Japanese, the Chinese, going to the British Museum and saying "Oh, these are from Africa." You know people say the black man has contributed nothing to the history of humanity. Now they would say "something good has come out of Africa."'

Ekhaguosa's experience in the British Museum awakened his interest in his people's past. 'I began to say, "OK, probably there is something

important about Benin – and therefore about its history."' When he got home from London, he sat down with his father, a man steeped in the legends of old Benin, to learn more. His father told him story after story. 'I began to feel I must write about Benin, so that was what really set me off writing about our history.'

Ekhaguosa gives another, more startling, opinion: that the carting away of the Benin Bronzes was one of the 'advantages' of the 1897 British invasion. 'If those artefacts had remained in Benin they would probably all be in the Oba's palace, mildewed and nobody looking after them.' In 2018, he went to Chicago's Field Museum, and when he saw Benin Bronzes there, his reaction was very similar. 'I stopped in my tracks when I saw a Benin head. To think our bronze casters in Igun Street 400 years ago made such an exquisite, lifelike object of such artistry; those things there do a lot of good to us in Africa,' he said.

Ekhaguosa was philosophical about the ebb and flow of history. 'We were conquerors once, we cut the heads off other tribes, brought them back and cast them in bronze,' he said, 'and now they are also part of the history of Britain, acquired through the sacrifices of their citizens who came here, for all their superiority. They didn't steal, they conquered and took our treasury, as has happened in every epoch of war. I don't call it loot. I call it war booty!'

Ekhaguosa is a respected elder and intellectual in Benin City, the authentic voice of a different era. I suspect his untypical opinions are not just a reflection of his age but also his privileged position within Edo society. Ekhaguosa's children live in Chicago, Memphis and California. Visits to London or Chicago are something that most people in Benin City can only – and in fact often do – dream of. But Ekhaguosa is hardly alone in arguing that Nigeria has a wretched record in conserving its heritage. 'Look at our moat. A few years ago a group of Chinese visitors came to see it, as they'd heard it was longer than their Wall, but they were appalled. People here need some filling for their houses, so they just excavate from the moat, which is 500 or 700 years old.' It was true. Reading Bernie Grant's 1990s correspondence, I'd noticed that palace officials told him of their ambitious plans to clean up Benin's wall and

moat. Nothing, it seems, had come of these. 'If we treat it like that, will we look after other objects properly?' asked Ekhaguosa.[73]

I was hearing almost the same diversity of opinions about the return of the Benin Bronzes in Benin City itself as I might have heard in far-off London. And after a few days trawling around the city, I began to feel that Nigeria's demons were closing in on me. Joseph Alufa, consumed with anger at his betrayal as he lay on his surreal bed in his tumbledown house. The strong voices of scepticism, countered by Theophilus, with his indignant protestations of his museum's integrity. I returned to the palace. I had an appointment with Frank Irabor, secretary to the Oba. He sits in a small office up a flight of stairs next to the palace gates, smiling eyes peeking over piles of files stacked on his desk. His walls are plastered with photographs of the current Oba, Ewuare II, the son of Erediauwa who died in 2016.[74]

The Oba, Frank regretted to tell me, was not receiving visitors. Frank, however, was happy to answer all my questions in his stead. He wanted to emphasise that the Oba's position is more nuanced than sometimes understood. Ewuare II, Frank explained, is a man of the world, educated in Britain and the United States, a diplomat who worked at the United Nations and was Nigeria's ambassador to Angola and Sweden. He was not asking for the return of all the Benin Bronzes. 'It's logical that some of these artefacts should be in Europe and elsewhere in Africa,' said Frank. 'They are our cultural ambassadors, they showcase our ancestry.' It was quite an Ekhaguosa-like remark. Perhaps Benin City could speak with one voice after all. But I should be in no doubt, Frank said, that 'any returned items will be cherished, just like when your compatriot Mark Walker brought back his. We welcomed him as to his home. And anybody else who returns artefacts will also receive a rousing reception.'

A LOT OF HISTORY WE JUST NEVER HEARD ABOUT

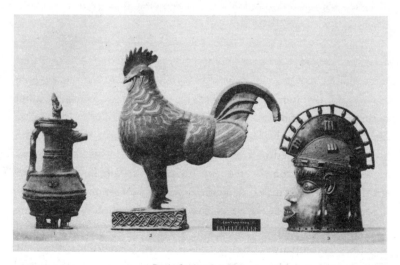

Benin Cockerel, centre.

On a November evening in 2015, two Cambridge University students shared a cab back to Jesus College. Amatey Doku, in his third year, and Ọrẹ Ogunbiyi, in her first, among the few black students at the university, were returning from a meeting of the African-Caribbean Society. They chatted away, and the conversation continued when they got back

to Jesus. Amatey mentioned the Benin Bronze cockerel, prominent on a wooden plinth at one end of the college dining hall. It had been there since 1905, a handsome bird, slightly larger than life, with a plume of tail feathers. The Edo call it *Ọkpà*, and it is a common symbol in Benin art and on ancestral altars commemorating queen mothers, while the Oba's most senior wife, the *Ésọ̀ọ̀n*, is sometimes called 'the Cock that Crows the Loudest'.[1] The British probably took more than twenty such cockerels from Benin City in 1897.[2] Jesus's had a plaque in Latin explaining it was a gift from George William Neville, whose son was a student at the college. The 1905 college annual report describes 'the bronze cock of native workmanship [as] a most appropriate and interesting present', given that Jesus's coat of arms depicts three cockerels, in honour of its fifteenth-century founder, John Alcock, the Bishop of Ely.[3]

George William Neville was a man of contradictions. When he died, aged seventy-seven in 1929, *The Times* wrote, 'West Africa loses one of its Grand Old Men'.[4] It was probably true that of all the British who took part in the Expedition of 1897, none knew West Africa better. He was not, as often described, a soldier or colonial administrator, but a shipping agent and a banker, born in London but living in West Africa since 1874, where he became a pillar of Lagos society.[5] In truth, his claim to have accompanied the Expedition was something of an exaggeration. Admiral Rawson rejected his request to join it on the unsurprising grounds that the assault on Benin City was no place for non-combatants. Undeterred, Neville found a boat to take him to Ughoton, from where he travelled to Benin City – just like Seppings Wright – on the back of a donkey, accompanying Henry Gallwey and Captain Ernest Roupell. They arrived on 1 March 1897, several days after Admiral Rawson and the bulk of the British force had left.[6] He brought supplies to the grateful remaining British soldiers who were by this stage, according to Herbert Walker, 'almost in rags'.[7]

George Neville helped himself to a generous share of Benin's treasures. When he arrived home in Lagos on 14 March, the *Lagos Weekly Record* wrote that his 'valuable specimens of antique carvings and bronze sculptures' included three 'huge' carved tusks depicting hunters in armour

similar to that of ancient Greeks or Romans, two 'perfect' bronze leopards, a cast head and a full figure of a man that bore 'a striking resemblance to the figures of Egyptian mythology'. The cockerel, in other words, was the tip of the iceberg. Lieutenant-Colonel Bruce Hamilton gave Neville a guard of twenty Niger Coast Protectorate Force soldiers for the march back to Ughoton. Hamilton, according to Neville, had told him, 'I should advise you to push on as quickly as possible, as the fact of so many ancient heirlooms leaving the city may attract attention and possibly lead to molestation.' Neville agreed this was 'sage advice'.[8] One throwaway exchange, it is as damning as anything said or written by the British invaders of Benin City; they felt entitled to take whatever they wanted, yet they clearly understood what anguish this caused.

Neville was proud of his Benin Bronzes. They formed an important part of the first exhibitions in London in 1897. In 1908, Neville, by now living back in Britain, lent them for display at that summer's popular Franco-Britain Exhibition, which was visited twice in a week by Queen Alexandra, and her daughter Victoria.[9] Visitors to Neville's house in Weybridge found the Benin tusks, leopards, plaques and more arranged as trophies around his imposing fireplace.[10] A friend, Captain F. Shelford wrote, 'Neville was peculiarly sagacious in business, with a quick sense for the good and the bad.'[11] Posthumous proof of this assessment came in 1930, when Neville's Benin Bronzes were sold at Foster's on Pall Mall. *The Times* wrote they were a 'treasure-trove…the Neville collection is probably the most extensive and important of its kind to come up for sale in London'.[12] It sold for £5,600 (roughly equivalent to £356,700 today), the 'exceptional prices' including the pair of leopards going for £787 (approximately £49,000).[13] These were bought by Charles Ratton who took them to Paris. They at least would, in a roundabout way, find their way home to Nigeria; this is the very same pair that Louis Carré sold in New York to Kenneth Murray of the Lagos National Museum in 1952.[14]

For all this, George Neville does not fit our stereotypical image of the nineteenth-century imperial looter. In retirement he looked back on his career: 'After my long association with Africa, and the Africans, I should like to record my admiration and, I may add, my affection for

this remarkable people...The cultured class are able, broadminded and gentlemen in the true sense of the world.'[15] Neville was known as a man who stood up for his African friends – 'welcome guests at our table', he called them – even when this put him at odds with British officials. The *Lagos Weekly Record* said he was unusual in that he 'conceived and strove to carry into effect the idea that the interests of the natives and the Europeans were identical'.[16] In 1894, when the Royal Navy turned its guns on Benin's neighbour Chief Nana, and blasted his home town of Brohimi to bits, the wounded Nana escaped and made his way to Lagos, where he sought refuge at Neville's house.[17] Neville considered Nana 'an enlightened and humane ruler', but could not prevent his decade-long exile to the Gold Coast. During his absence, Neville complained to the *Weekly Record*, Chief Nana's people were 'like sheep without a shepherd'.[18] When Nana was eventually allowed home he commemorated the date as 'Neville Day' in honour of the friend who had lobbied on his behalf.[19]

George Neville also held unconventional views about Benin City and the overthrow of the Oba. In disapproval of James Phillips's determination to proceed there in January 1897, he wrote that 'we have no more right to ride roughshod over the susceptibilities of subject races than we have to storm the tabernacles and tear down the banners of the Salvation Army'. When it came to human sacrifice, Neville had his own take; it was motivated not by 'blood lust but a deep-seated belief in the principle of propitiation, for which authority is not wanting in the Old Testament'.[20] He appealed to his compatriots not to rush to condemn: 'let us not forget that, almost within living memory, we Englishmen hanged men for sheep-stealing and exhibited heads on Temple Bar; and I question whether any atrocities in Africa...have ever approached in magnitude the massacres under Cross and Crescent in modern times'.[21]

The story of the Benin Bronzes, let alone the intriguing career of George William Neville, was not something that Amatey knew anything about when he arrived at Cambridge in 2013. But growing up in Britain in a family of Ghanaian origin, he had a nagging feeling at school that there 'was a lot of history we just never heard about'. At Jesus, he soon

heard the rumours: the cockerel was stolen from some African tribe who were asking for it back. Encouraged by his tutors, some of whom told him they didn't want to 'kick up a fuss' themselves, he read up on Edo history and the events of 1897. Now, he told Ọrẹ, he wanted to start a campaign to have the cockerel returned to Nigeria. Ọrẹ, who spent much of her childhood in Nigeria, needed no convincing. She is a forthright and determined person and instantly felt this was an important opportunity to right the wrongs of the past. The Benin Expedition, she told me, 'had very real effects in terms of self-esteem and conscious-ness for the victims, and we have to make corrections where we can'. If anything, she was embarrassed she had not noticed Neville's trophy during her first weeks at the college. 'I was in so much shock, we were laughing. I was very, very upset. I felt it was ridiculous, we had to do something about it.'[22]

At a meeting in February 2016, Jesus's students voted for the cockerel to be returned to Benin City. The meeting lasted three hours, and grew very heated, but not in the way Ọrẹ and Amatey had anticipated. There was little resistance to the idea of returning the cockerel but several black students felt that Ọrẹ and Amatey's approach, which emphasised working with the college authorities, was much too conciliatory. Amatey says, 'They would have preferred something more like "we're outraged you've got stolen property and we demand you return it".'[23]

Two articulate and politically conscious students, Amatey and Ọrẹ were in the right place at the right time. Jesus College, Cambridge, with its beguiling medieval buildings, generous grounds and alumni ranging from Thomas Cranmer to Samuel Taylor Coleridge, is not an obvious hotbed of radicalism. But something was stirring that winter. A version of the Cambridge cockerel row was simultaneously being played out at Oxford University, where students demanded Oriel College take down a statue of Cecil Rhodes. The two campaigns attracted national media attention, and put college authorities under an awkward spotlight. There were differences between the root grievances, but both campaigns were driven by changing attitudes towards Britain's imperial legacy which extended beyond the country's most ancient universities.

The Oxford students' cry of 'Rhodes Must Fall' failed in 2016, in part because benefactors threatened to cut off funding to Oriel to the tune of £100 million if the statue came down.[24] (The 'Rhodes Must Fall' campaign was revived in June 2020, as the Black Lives Matter protests spread across the world, and Oriel said it did want to take down the statue.) In Cambridge the Jesus authorities, although initially unsympathetic to the students' demands, were not presented with a similar dilemma. They agreed to hold consultations over the cockerel's future. Amatey, who was by now the President of Cambridge University Students' Union, and Ọrẹ wanted to keep up the momentum. They invited Mark Walker to a college dinner, in recognition of his returning his own Benin Bronzes two years earlier. The plan was that they would sit in the college hall, underneath Neville's cockerel. The dinner happened, but there was no cockerel for Mark to see; the college authorities took it down just hours before he arrived. The *Ọkpà* had stood in Jesus hall for 111 years. It would never be seen there again.

There was only a splutter of opposition, at least in public. Francis Bown, an expert on etiquette and men's dress who was at Jesus College from 1968 to 1972, wrote to the *Daily Telegraph*, berating the silliness of undergraduates and 'supine appeasement' of the college authorities.[25] He said that unless 'the African cock' was returned to the hall where he once dined, there would be no mention of Jesus College in his will. I met Mr Bown at Claridge's Hotel – his choice, not mine – and found his bark to be worse than his bite. He was immaculately turned-out in an expensive three-piece suit and drives a 1963 Rolls-Royce, but endearingly confessed that his threat of disinheritance did not amount to much. 'But you must be rich to drive such a beautiful car?' I protested. 'On the contrary, I'm not rich because I drive such a beautiful car,' he said, before going into a long lament on garage bills. Despite his fury with his 'feeble, pathetic college, giving in to PC nonsense', he had not attempted to mobilise any likeminded alumni. Mr Bown, I learnt, has spent a lifetime swimming against the tide. In his youth he campaigned to keep women out of men's colleges at Cambridge, and then resigned from the Anglican Church over the ordination of women. By his own admission, he is 'a prince of

lost causes', and, regarding the fate of the cockerel, he already seemed resigned to his next defeat.[26]

It was another conversation that gave me more insight into how the consensus has changed in recent years. Professor Colin Renfrew was Master of Jesus College from 1986 to 1997. A celebrated archaeologist of the Cyclades, he's also a devoted campaigner against what he warns is the looting of the world's cultural heritage, meaning theft of artefacts from archaeological sites for the gratification of private collectors and museums.[27] In other words, he has an area of expertise not directly related to the Benin Bronzes, but not entirely unrelated either. Indeed, in more recent years he has been involved in some of the discussions between Nigerians and European museums, and in 2020 he told me he thought it 'perfectly reasonable' that the cockerel should be returned to Benin City. When I asked him why he had not taken any action to make this happen during the eleven years he was in charge of Jesus College, he was briefly lost for words, before giving a candid answer: 'The issue didn't arise. Nobody asked for the return of it...I was very much aware of it, it's a wonderful object, but twenty years ago it was not discussed. Benin Bronzes were seen as curiosities except by enthusiasts.'[28] And twenty years ago, students of African descent were even thinner on the ground at Cambridge University than they are today, and Bernie Grant, MP, struggled to elicit any responses from British museums on even the simple question of how many Benin Bronzes they had in their possession.

At midday on 27 November 2019, Jesus College students and alumni – Ọrẹ, Amatey, Francis Bown *et al* – received an email. It was from Sonita Alleyne, the new Master, and the first black person to lead a college at either Cambridge or Oxford. She wrote that a group of academics and students had been examining the extent to which Jesus had profited from the slave trade, as well as trying to decide the future of the Benin cockerel. This had been cast centuries ago, she wrote, most likely to commemorate a member of the Oba's family, and had been looted in 1897 at the time of the Expedition. Although in 1905 Jesus had described it as a present from Neville, Sonita Alleyne was unequivocal: 'It is not,

and never has been, owned by the College.' Consequently, the decision had been taken to return it to the Oba's court in Benin City. This was being done, she wrote, 'not in a bid to erase history, but in the honest spirit of acknowledging the past and shaping our future'.[29]

It was a stunning victory for Ọrẹ, Amatey and other students who worked with them. The cockerel would be one of very few Benin Bronzes to return to Nigeria for many decades. More importantly, Jesus College was making it clear, just as Mark Walker had done, that it was giving it back to whom it considered the rightful owners. Such an act of penance raised ethical questions about the future of other Benin Bronzes. Amatey, by now a management consultant in London, was astonished when he heard the news and said he had never expected things to go that far.[30] Ọrẹ, working back in Nigeria as a speechwriter for the Vice-President, was jubilant. It was a reminder, she wrote, that 'sometimes, just sometimes, if we fight hard enough, we can win. This is a win for black students, a win for Benin and its people, and a win for the college…It's taken our new Master…two months to give us an answer that everyone was too scared to give us for three years.'[31]

The student campaign was a catalyst that set in motion a much bigger process. One man who had followed the row at Jesus with interest was based up the road, at Cambridge's Museum of Archaeology and Anthropology. Professor Nicholas Thomas, the museum's Australian Director, had spent his career grappling with the legacy of colonialism and museum artefacts, mainly in the South Pacific. Since taking over at Cambridge in 2006, he had also been thinking about the future of the Benin Bronzes. His museum has 415 Benin objects, although, unusually, most of these were not taken during the 1897 Expedition but were collected by a British anthropologist, Northcote Thomas, in the early years of the twentieth century.[32]

The Cambridge museum looks like the ethnography museum of one's imagination; all the bounty of Empire – totem poles, canoes, Buddha statues and wooden masks – brought home by missionaries, colonial officials and sailors, housed together in a grand old Edwardian building. On closer inspection, it's apparent that Professor Thomas is

trying to distinguish his museum from its own past. 'The museum is working to decolonise its collections', I read on one panel. The display of Benin Bronzes was accompanied not only by a photo of George Neville's exotically decorated Weybridge living room, but also a quote from the Nigerian writer Wole Soyinka: 'When I see a Benin Bronze... the mastery of technology and art...We forget that we were once a functioning people before the negative incursion of foreign powers. The looted objects are still today politically loaded.' And behind Soyinka's incriminating words, the looted objects themselves: a case full of late period Oba and Queen Mother heads. 'Decolonising a collection' seems to mean many things, but displaying one's dirty laundry in public – in curator parlance 'addressing the invisibility of colonial violence' – is one of the more obvious.[33]

'The context has changed and we have to act,' Professor Thomas told me in his study, just off the museum's hall of wonders. He has a bit of the wild professor about him, scruffy hair and glasses, and a deep passion for the subject. 'It's not right that we just have a stand-off over the decades. Museums can't just say "we can't do that" or "we don't want to do it".' This is a moral issue, he argues; just like Mark Walker, he said that if we agree that material taken by the Nazis should be returned to individuals or their descendants, we have to acknowledge similarities with, say, the Benin Bronzes.

For all this, Professor Thomas baulks at the idea of the immediate return of all objects that can be shown to have been taken by force. 'It should be a more nuanced discussion. What do people in a specific country actually want?' Do they really want everything to be returned? Do they have a clear idea of what they'd do with it? What capacity do their museums have? Professor Thomas wanted a conversation that was less political, and more practical. When the Jesus College cockerel row blew up, he sensed opportunity.[34] He invited representatives from ten European museums, the Oba's palace and Nigeria's National Commission for Museums and Monuments for a meeting in Cambridge in March 2017. It took place in Trinity, the university's grandest college; 'we wanted to give it a sense of distinction,' he said.[35] The opening discussions were

about the cockerel, but the talk soon broadened out. The meeting marked a revival of the Benin Dialogue Group, an originally hopeful initiative that had been at a standstill for the previous three years.

The Benin Dialogue Group had been formed off the back of a notable Benin Bronze exhibition that opened in Vienna in 2007 and moved across Europe to the United States. Oba Erediauwa had written a pointed preface in the exhibition catalogue. Just as his brother Prince Edun Akenzua had argued to the British Parliament in 2000, he said the Benin Bronzes were not meant to be 'mere museum pieces for art lovers to admire' but 'were objects with religious and archival value to my people'. He appealed to Austria to 'show humanness and magnanimity' and return at least some Bronzes to the Edo.[36] His eloquent plea fell on deaf ears. But the organiser of the exhibition, Barbara Plankensteiner of Vienna's Museum für Völkerkunde, had formed close ties with officials in the Oba's court and Nigeria's NCMM, and all sides wanted at least to keep a conversation going.

The Benin Dialogue Group met in Austria, Germany and Nigeria between 2010 and 2013. It was a breakthrough; just to have the Nigerians, both from the Oba's palace and the NCMM, sit down alongside curators with the biggest collections of Benin Bronzes – the British Museum and the Ethnologisches Museum in Berlin – as well as a host of smaller museums from Germany, Britain, Sweden and Austria. There was much talk of trust and collaboration, and the Nigerians got a better understanding of where in Europe the Bronzes were, and the political and legal situations of the various institutions that held them.

Nigerian impotence, however, was cruelly exposed in 2012, when Robin Lehman gave thirty-two Benin Bronzes and ivories to the Museum of Fine Arts in Boston. This was no ordinary bequest; Lehman, as we've seen, had bought many of the finest Bronzes from the Pitt Rivers collection and others between the 1950s and 1970s. The head of Nigeria's NCMM, Dr Yusuf Abdallah Usman, appealed for their return. 'Without mincing words, these artworks are heirlooms of the great people of the Benin Kingdom and Nigeria,' said Dr Usman. 'They form part of the history of the people. The gap created by this senseless exploitation is

causing our people untold anguish, discomfort and disillusionment.'[37] The Museum of Fine Arts ignored Dr Usman's appeal and proudly announced that it had acquired the 'single greatest private holding of objects from Benin'.[38]

By 2013, Nigerian frustration was spilling over into the Benin Dialogue Group. Discussions about digital co-operation and curatorial training were all very well, but fell distinctly short of the ultimate prize. Professor Folarin Shyllon, a Nigerian legal scholar involved in the group, complained that 'return or restitution has been relegated to the background'.[39] The British Museum did not attend the 2013 meeting, which took place in Benin City; it says it intended to, but its representative did not receive a Nigerian visa in time. Afterwards, Prince Edun Akenzua, representing the Oba, said 'we have had enough of these meetings which only end as an academic exercise'.[40] Most members of the group believed the British Museum was due to host the following meeting. In the words of one leading European curator, 'for all kinds of reasons they postponed and postponed. They had changes in leadership, there was a big gap. The British Museum was the issue.'[41] The museum says it never offered to host a meeting, although its failure to do so caused heated internal debate. Either way, it was not clear whether the Benin Dialogue Group was entering a hiatus or was dying a slow death. Then came its unexpected Cambridge revival. 'It was those students,' Professor Shyllon said, 'they rescued the whole endeavour.'[42]

By 2017, the Nigerian context had changed. Oba Ewuare II had taken the throne. He replaced one uncle, Prince Edun Akenzua, with another, Prince Gregory Akenzua, as his representative at the Benin Dialogue Group. It was an astute choice; Gregory had a powerful blend of moral authority and dignity, but was more diplomatic than his brother. The beleaguered NCMM was also coming under new leadership. Meanwhile, Edo State had elected Godwin Obaseki as Governor in 2016. A scion of a powerful family, an art enthusiast and urbane and persuasive man, Obaseki spoke with passion about the Benin Bronzes. 'We can't change the past, so what can we do? I want to bring back as much as possible, but it has to be done through negotiation,' he said.[43]

In Cambridge, Prince Gregory Akenzua made an unexpected announcement to the Benin Dialogue Group on behalf of Ewuare II. He told them the new Oba had decided to establish a Royal Museum in Benin City. It had the support of Governor Obaseki, and would not be under the control of the NCMM. Moreover, although the palace was careful to state it would never waive its claim to a permanent return of the Benin Bronzes, it was prepared to talk about alternative interim solutions. That meant loans, something the European museum curators felt empowered to discuss. 'There are so many complexities within our group as to who makes decisions on permanent returns,' said Professor Thomas, 'cities, governments, trustees, university authorities. In some cases it would take ten years to get an answer... So we thought, "why don't we commit to what we can commit to?"'[44] The group announced it had agreed on 'the establishment of a permanent display in Benin City of rotating material from a consortium of European museums'.[45] At a reception afterwards, Prince Akenzua thanked Ọrẹ and Amatey, and presented them with a modern wooden Edo sculpture. 'We were reanimated,' felt Barbara Plankensteiner.[46] Julie Hudson of the British Museum said 'there was a new dynamic'.[47]

The momentum was carried over into October 2018, when the Benin Dialogue Group met at Leiden, in the Netherlands. This time, Governor Obaseki attended. He struck a positive and businesslike tone, and the Europeans were impressed. They felt they were listening to a man who controlled the purse strings and had more freedom to act than a civil servant or junior minister in Nigeria's federal government. Theophilus Umogbai of the Benin National Museum and the NCMM, who was in Leiden, said the Governor 'spoke not as a politician but as an art lover'.[48] The plans for the Royal Museum began to appear more tangible; the Governor would find the funds and promised it would have an autonomous management. The European museums agreed to lend their Benin Bronzes, including their most iconic pieces.[49]

HOW DO YOU THINK YOUR ANCESTORS GOT THESE?

In the spring of 2018, the Benin Bronzes made a fleeting return to the cinema screens. Only this time, not even the most ambitious Nollywood director could have dreamt of such an impact. *Black Panther* was a Hollywood production that became a global hit, earning hundreds of millions of pounds within days and eventually becoming the ninth-highest-grossing film of all time.[1] The black director, Ryan Coogler, and mainly black cast were acclaimed for their roles in a superhero film laden with political undertones. At no point was the message more pointed than in a compelling scene near the beginning, set in a 'Museum of Great Britain'.

Killmonger, from the fictitious African state of Wakanda, is wandering through the museum, admiring artefacts from his home continent. A curator, a white British woman, offers to help. She explains the origins of various objects, including what she says is a sixteenth-century mask from the Edo people of Benin, which bears a respectable resemblance to the real thing. Another item, she says, is also from Benin. Killmonger knows better. It's originally from Wakanda, he corrects her, even though British soldiers took it from Benin. Now, he's going to take it back. The curator haughtily informs him the objects are not for sale. 'How do you

think your ancestors got these?' asks Killmonger. 'Do you think they paid a fair price? Or did they take it, like they took everything else?' At which point the curator collapses, poisoned by Killmonger. He and his associates then kill the museum's hapless security guards and make off with the precious artefact.[2]

In this brief exchange, *Black Panther* condemns colonialism and the museum collections which came from it. The Museum of Great Britain, to all intents and purposes the British Museum, seems to condescend to the very people whose culture it profits from. And the objects which the film's makers chose to exemplify this iniquitous relationship are the Benin Bronzes. The scene resonated for the descendants of colonised people around the world. I imagined the staff at the British Museum, and perhaps especially those responsible for the Benin Bronzes, squirming in their seats as they watched. In fact, had they watched? I got a rather deadpan reaction from Dr Sam Nixon, one of the Africa curators. 'It was a useful critique we could respond to. It was an opportunity to engage with new audiences,' he told me.[3] What else could he say? In the weeks after *Black Panther* was released, one of his colleagues received a series of anonymous phone calls, in which men threatened to poison British Museum staff. They were wearily philosophical: 'We're there to be kicked, that feels like our role.'[4]

By the end of 2019, the British Museum was feeling more kicked than usual. Of course, the museum has confronted arguments over provenance – above all over the Parthenon Marbles – for decades. 'We lived in fear of Melina Mercouri,' said Professor John Mack, who was in charge of the museum's African collection until 2004, referring to Greece's charismatic culture minister of the 1980s.[5] UNESCO has been calling for the return of colonial-era collections since the mid-1970s. Much of the clamour for return, or, more pointedly, restitution – giving back to the legitimate owner – comes from Africa, the Pacific Islands and Asia, but it was recent developments elsewhere in Europe which had left the museum badly exposed.

On 28 November 2017, France's new President Emmanuel Macron gave a speech in Ouagadougou, the capital of the West African former

French colony of Burkina Faso. 'I cannot accept that a large part of cultural heritage from several African countries is in France,' he told a rapt audience of university students. 'I want to see within five years that the conditions are met for the temporary or permanent restitution of African heritage to Africa.' To underline his point, he tweeted shortly afterwards, 'African heritage cannot be a prisoner of European museums.'[6] President Macron appeared determined not just to draw a line between his administration and the paternalistic traditions of *la Francophonie*, but to force European museums as a whole to a day of reckoning. They had been talking about giving objects back for decades, but now would they walk the talk?

President Macron asked two academics, Felwine Sarr of Senegal and Bénédicte Savoy of France, to recommend how to realise his announcement. The Sarr-Savoy Report, published in November 2018, is both a searing indictment of the history of Europe's museums – 'born from an era of violence' – and a radical blueprint for change.[7] Sarr and Savoy concentrated exclusively on Sub-Saharan Africa, which they argued has retained 'almost nothing' of its cultural and artistic heritage.[8] France, they said, should give back 'any objects taken by force or presumed to be acquired through inequitable conditions'.[9] They gave short shrift to concerns over conditions in African museums or the idea of loans rather than permanent returns. The consequences of implementing the Sarr-Savoy Report for the Musée du Quai Branly-Jacques Chirac in Paris, with its 70,000 African objects, would be dramatic. President Macron announced a symbolic beginning in December 2018: the return of twenty-six objects from the museum – including statues, thrones and doors – looted by French soldiers in 1892 from the Kingdom of Abomey, in the present-day Republic of Benin, neighbouring Nigeria.

The Sarr-Savoy Report raised a host of complex questions, not least in relation to French law, which deems national collections to be 'inalienable'. Indeed it wasn't until three years later, after the French parliament had passed a special law, that the twenty-six Abomey objects were returned.[10] The president of the Quai Branly, Emmanuel Kasarhérou, of Melanesian descent, said the 'very militant' report 'cannot be a blueprint

for policy'.[11] Even Felwine Sarr and Bénédicte Savoy appeared to row back from their own conclusions, blaming the media for misrepresenting their report, and explaining they did not envisage the emptying of European museums.[12] By then, however, they had succeeded in accelerating a process of change that had already been under way. In May 2018, the German government presented new guidelines for museums to return objects taken as colonial loot.[13] In March 2019, the Nationaal Museum van Wereldculturen in the Netherlands – a member of the Benin Dialogue Group and which has the overwhelming majority of Dutch colonial objects – did the same, broadening the criteria under which these could be returned. Its chief curator, Dr Henrietta Lidchi, said 'the accusation in the past is that ethnographic museums were handmaidens of colonialism, they colluded in the colonial narrative. This is how to make them post-colonial.'[14]

It wasn't all rhetoric and new guidelines. During 2018–19, European museums and governments returned a number of objects; from Germany to Namibia a fifteenth-century stone cross and twenty-five human remains, including skulls, of victims of the Herero genocide; from France to Senegal a nineteenth-century sword; and from Norway to Chile's Easter Island thousands of artefacts and human bones.[15] In Britain the Manchester Museum returned forty-three sacred and ceremonial objects, including musical instruments, body ornaments, spiritual statues and an emu feather headdress, to indigenous Australians, and the National Army Museum in London gave Ethiopia two locks of Emperor Tewodros's hair, cut from his body after he killed himself as British soldiers seized Maqdala in 1868.[16] At the beginning of 2020, the UK's Arts Council, following the Dutch and German examples, announced it would produce new guidelines for museums on returning cultural objects from former colonies.[17]

The Horniman Museum in London said it would hold consultations with the Nigerian diaspora in London, before coming to a decision about the future of its fifty Benin Bronzes. Most of these were bought by the museum's founder, the tea trader and Liberal MP Frederick Horniman, between 1897 and 1899, including the collection he acquired from the

sailor W. J. Hider. A curator at the Horniman told me the museum needed to think more ethically about its history and future purpose.[18] The Bristol Museum, presented with an appeal from Prince Edun Akenzua for the return of its Benin Bronze head, said it wanted to work alongside the Benin Dialogue Group to 'be part of the solution'.[19] Professor Dan Hicks, of the Pitt Rivers Museum in Oxford, said Britain had reached a tipping point in its national dialogue over the restitution of looted objects.[20]

If so, it wasn't a dialogue that the country's national museum appeared to be leading. In July 2019, the Egyptian writer Ahdaf Soueif resigned from the British Museum's Board of Trustees. She said she'd felt compelled to do so because of several issues: the museum's willingness to take sponsorship from BP despite the worries of many – especially young – people about climate change, its poor treatment of cleaners, but also its refusal to engage in discussions around colonial legacies. The Sarr-Savoy Report, she said, had burst open this debate, and yet, the British Museum, 'born and bred in empire and colonial practice…hardly speaks'. The irony, she argued, was that it was in a unique position to lead the conversation and demonstrate the usefulness of museums, and thereby could help make the case for collections to stay in London.[21]

I spoke to a fellow British Museum Trustee, an eminent person with an interest in the issues around colonial collections, who wished to remain anonymous but expressed sadness at Soueif's resignation. This Trustee agreed the museum had not communicated enough on an issue which deeply troubled its board, and thereby did itself a disservice. They described the British Museum, and indeed many other museums in Britain, as being in a bind. Government funding has been cut, but alternative sources of funds – such as oil companies – are coming under ever more critical scrutiny. Then, the future of colonial-era collections had blown up – 'a really hot topic' – and the museum's instinct was to 'batten down the hatches and put out bland statements from the press office'.[22]

If the British Museum won't address the issue, its many critics will. Two weeks after Soueif's resignation, I paid £11 to take an 'Uncomfortable Art Tour' around the galleries. These are led by Alice Procter, an Australian

art historian in her mid-twenties. She is tolerated rather than welcomed by the British Museum. 'We are aware of her and we allow her in,' one curator told me sniffily, and pointed out that 'you pay her to enter a free museum'. Alice was not allowed to hold a placard to identify herself, so I and my fellow tour members – about twenty people, cosmopolitan, mainly youthful – gathered rather subversively by the entrance at the designated time, trying to work out if we were with the right crowd and, if so, which one of us was Alice. Her red badge, 'Display It Like You Stole It', was a clue.[23]

Alice also gives tours of other leading London museums – the V&A and the National Gallery, for example – with the goal of 'providing conversational space to promote thinking about empire and colonialism'. This space has limits. As we set out, she explained that she has a 'no devil's advocate rule', because she wants an empathetic conversation. 'So don't be a dick,' she warned. 'This tour might be an echo chamber, but that's not a bad thing.'

Our compact group weaved through the late-afternoon crowds. The British Museum is full of exhibits with, in the phrase now piously adopted by curators, 'uncomfortable histories', and we only had time to see a handful. These included statues from the South Pacific believed by those who made them to contain spirits of ancestors and an Aboriginal bark shield punctured by an apparent bullet hole, an all too characteristic greeting from British explorers of Australia (the mealy-mouthed accompanying label said 'first encounters in the Pacific were often tense and violent'). Alice was sceptical of the British Museum's ability to address the demands for restitution. White supremacy and the urge for acquisition, she argued, were part of its DNA, and could be traced back to its origins in the seventeenth- and eighteenth-century collections of Sir Hans Sloane. An Enlightenment thinker, Sloane was dedicated to placing plants, animals and finally people within a hierarchy. Look, she pointed out, how the African Gallery is the only one we physically descend to, how it has no chronology within it as if Africans have no history, and how Ancient Greece and Rome are given more gallery space than Africa, Oceania and the Americas combined.

The seizure of the Benin Bronzes, Alice said, was the most bloody and explicit example of colonial theft in the entire British Museum. And yet the information panels around the exhibits – full of euphemisms and half-truths, in the words of the lawyer Geoffrey Robertson – made no attempt to place the Benin Expedition within the tradition of nineteenth-century imperial looting, or give any indication of how many people it killed.[24] The panel to the side of the plaques, which explained the events of 1897, was entitled 'The discovery of Benin art by the West'. All of this, Alice argued, was 'incredibly dismissive and disrespectful'.

To its detractors the British Museum is an institution that expresses no regrets and offers no apologies. It seems curiously immune from doubt, even as debates rage around it over the definition, even the future, of museums. Ahdaf Soueif's resignation, Alice said, was 'too little, too late' to provoke fundamental change. My own conversations with British Museum curators and Trustees gave me a different impression, of an institution whose silence was symptomatic of defensiveness and doubt, not blithe self-confidence. Other museums seemed more fleet-footed, more adept at anticipating their critics and acknowledging those 'uncomfortable histories'. In 2018, when the V&A hosted an exhibition of the Maqdala treasures, the ugly story of how they had come to Britain, one in many ways analogous to that of the Benin Bronzes, was laid out for all to see. The panels, written in consultation with Ethiopian scholars, described the slaughter caused by British weaponry, the glee with which soldiers looted, and contemporary expressions of grief and shame. Rather like Professor Thomas's Cambridge museum, they were, to borrow Alice's phrase, displaying it like they stole it.

The other museums within the Benin Dialogue Group like to portray the British Museum as the most conservative, even recalcitrant; it can't be bypassed because it has the biggest Benin Bronze collection, but has been the least willing to take bold measures to return any to Nigeria. But the museum is bound by legal constraints that are especially restrictive. The 1963 British Museum Act forbids it from disposing of – or de-accessioning – any part of its collection, with a few limited exceptions,

such as if the museum holds duplicates, or an object has been damaged. Put simply, neither the Director nor the Board of Trustees could return the Benin Bronzes to Nigeria, or for that matter the Parthenon Marbles to Greece, without Parliament voting to change the law.

My anonymous Trustee said the British Museum is forced to operate within a statutory framework it did not choose. 'On the one hand the Trustees don't want to be seen – which they often are – as hiding behind the British Museum Act. On the other hand, the British Museum Act is a reality. We have a lot of discretion about loans. But not returns.'[25] And yet the accusation of 'hiding behind the Act' is a common one. It wasn't until 2002 that the *Art Newspaper* revealed that the British Museum had not only sold those Benin Bronze plaques to Kenneth Murray's fledgling Nigerian museums in the 1950s, but indeed had also sold or exchanged another dozen to private dealers and collectors in Britain and America, including a couple to Robin Lehman – in return for a Benin horseman – as recently as 1972.[26] Even if the Nigerian sales can be put down to altruism, the others are embarrassing. The British Museum had argued it was getting rid of 'duplicates', but Benin Bronzes, individually modelled and cast through the *cire perdue* method, are by definition unique. The Trustees flouted the law, or were ignorant of it. Either way, their case to keep the remaining Benin Bronzes was undermined.

In any case, laws can change. In 1998, forty-four countries met in Washington DC to discuss what is known as the *Raubkunst*, the theft by Nazi Germany – mainly from Jewish families – of an estimated one-fifth of Europe's cultural treasures. In 2009, the British government introduced the Holocaust (Return of Cultural Objects) Act, giving the British Museum, the National Gallery and fifteen other national institutions the power to return items to their original owners or their descendants.[27] The United States passed similar legislation in 2016. Many people felt it had taken the law too long to catch up with ethics, yet catch up it had. Likewise, in 2004, the British government changed the law to give museums the powers to return human body parts, since when the British Museum has given cremation ashes to Tasmania and bone fragments to New Zealand.[28]

There are differences between Nazi and British colonial crimes, but I wanted to know where the British Museum drew the line between them. After all, both Professor Nicholas Thomas and Mark Walker had suggested it was difficult to justify keeping Benin Bronzes if the ethical consensus is that Nazi loot should be returned. Was it a question of scale, or date? The passage of time brings purity, but is it right that we feel more compelled to address an injustice from the first half of the twentieth century than one from the late nineteenth? Would the museum dare to accept that geography and race are factors? The curators in charge of the African collection would not answer my questions about this. The Trustee I spoke to felt it was about practicality. 'With the Nazis, there are people alive who owned that stuff, or their children or grandchildren... Before 1900, it is much further back in time to trace ownership, but you're also talking about things which weren't owned by individuals or political communities.'[29] They were addressing the question in general terms, but in Benin City there is no dispute over whom the Benin Bronzes belonged to. And 1897 is awfully close to 1900.

Even in the recent past, the British Museum defended itself with a swagger and an insensitivity that jars today. In 1983, the then Director, David Wilson, accused Greece's Melina Mercouri of 'cultural fascism' for saying the Marbles should go back to Athens.[30] In a subsequent book, Wilson explained the philosophical reasons why the British Museum opposed the return of any part of its collection to a country of origin. The British Museum was a universal museum with a duty 'to present as complete and integrated a picture as possible of the development of different but related cultures through the ages'. The Trustees had to remain above political, emotional, nationalistic and sentimental influences, not for Britain's sake, but for the whole world's. To dismantle the collection, Wilson argued, 'would be to start a process of cultural vandalism which would make the politicisation of art in the 1930s in Germany look like a petulant child's destruction of its dinner'.[31]

A more recent Director, Neil MacGregor, presented the same argument more skilfully. The millions of people who visit the museum for free each year and admire marvellous objects such as the Benin Bronzes

'will see that there are many good ways of organising the world'.[32] The British Museum was founded, he argued, not to reinforce the dominance of one race or nation, but for the benefit of all people in the quest for truth, 'And not one perpetual truth, but truth as a living, changing thing, constantly remade as hierarchies are subverted, new information comes, and new understandings of societies emerge. Such emerging truth, it was believed, would result in greater tolerance of others and of difference itself.'[33] So while the Benin Bronzes were brought to London as trophies of imperial conquest, in the long run their presence in the British Museum serves to undermine the very hierarchy that made their seizure possible. A collection that spans the world shows the oneness of humanity, and promotes understanding between peoples and cultures.

Within the European museums that belong to the Benin Dialogue Group, I heard horrified reactions to the Sarr-Savoy Report. Barbara Plankensteiner, the driving force behind the group, was the most diplomatic. 'It's not a guideline, it's a political statement. Sometimes you need something like this to raise awareness, and in this regard it was very successful,' she told me, although she felt it did not convey an understanding of practicalities: of who would pay for returns, or of how long African museums would need to prepare for them.[34] Professor Nicholas Thomas of Cambridge told me he was 'shocked' by its blanket prescription of return, which, he argued, might bring a symbolic moral victory but which ignored the capacity, or even the desire, of African authorities to take back what had been stolen in colonial times. He said it did 'violence' to museum collections through its indifference to their varied history.[35]

The British Museum, not surprisingly, was similarly unimpressed. Hartwig Fischer, who'd taken over as Director in 2016, maintained a diplomatic silence in public but, according to a Director of another museum, was 'really rattled' by the Sarr-Savoy Report.[36] When I asked Julie Hudson at the British Museum what she made of it, one year after its release, she simply said, 'We've seen where it's gone,' the implication being not very far, and that the French government would have to row back.[37] The Trustee I spoke to was scathing: 'I don't think France will ever act on it.

I thought it was ridiculous, super-irritating. It was just rhetorical, and a bit disingenuous. They're not people who've had to run museums.'

This person also had philosophical objections, about the Sarr-Savoy Report in particular, but the clamour for objects to be returned in general. It was as if, they said, museums were being asked to bear the entire moral weight of colonialism. The objects themselves had become 'fetishised' as symbols of injustice, yet they were 'a drop in the ocean to the harms colonialism did. If we want to wipe the slate clean, and deal with countries and people we've treated very badly in the past on a more egalitarian basis, that can't just be left to museums.'[38]

Such arguments don't only come from Europe, nor are they new. In 1998, the Nigerian artist and academic Moyo Okediji, who studied in Benin City, wrote a compelling article questioning what would be achieved by returning objects such as the Benin Bronzes. To do so, he wrote, 'is to pretend that such a reparation fully atones for or even partially indemnifies the timeless African tragedy'. Besides, Okediji felt it was already too late, that the Benin Bronzes and others had lost their innate Africanness. They had been 'caged, displayed on blocks and pedestals, or auctioned from hand to hand like the human cargoes which they followed across the Atlantic Ocean'. Benin City, in the meantime, had changed in ways that a nineteenth-century Oba could never have dreamt of. 'The meanings of the objects are lost and more interesting to scholars and politicians than to the average inhabitants of present-day Benin City – I was once one – who excruciatingly measure their survival on a daily basis,' Okediji wrote. If the Bronzes returned, they would sit 'within mediocre imitations of Western museums'. The fate of those which did go back to Nigeria in the 1950s would appear to bear him out. And if the Obas were asking for reparations from Britain, would they in turn consider paying reparations to the descendants of slaves they sold to the New World, not least as these slaves were sometimes bartered for the Portuguese manillas that provided the metal for the Benin Bronzes?[39]

Ahdaf Soueif argues that the British Museum has no god-given right to keep its collection just because it already has it. 'The collection is a starting point, an opportunity, an instrument,' she wrote. 'Will the

museum use it to influence the future of the planet and its peoples? Or will it continue to project the power of colonial gain and corporate indemnity?'[40] She and other Trustees and curators feel the museum does a bad job of promoting all the excellent work it does in partnership with museums in poorer parts of the world. Julie Hudson, for example, has worked for years with Nigeria's museums, but also with the even more neglected ones of small and war-torn countries like Sierra Leone and Guinea Bissau. 'We give them confidence and guidance, and we learn so much from them about objects and history,' she said.[41] The other museums in the Benin Dialogue Group may like to grumble about the British Museum, but they also acknowledge it has built up an enormous amount of goodwill and connections within Nigeria. Helen Kerri, former Director of Museums in Nigeria, told me she'd always be grateful for the training she received in London, and the expertise and support of British Museum staff on their frequent trips to Nigeria.[42]

By 2019, there was a perception within the Benin Dialogue Group that the British Museum's attitude had changed. 'They understood that it helped their image to work with the Benin Dialogue Group and they needed to do something about it,' one European curator told me.[43] The Nigerians also noticed a change. The Edo artist Enotie Ogbebor, adviser to Governor Obaseki and son-in-law to Prince Gregory Akenzua, told me that the British Museum had 'started to participate in a more pronounced manner. I think they're keen – from their body language, from the enthusiasm they've shown so far – to engage, to interact, and to find a joint resolution'.[44] Enotie was in a good position to judge; in September 2018, he helped host Director Hartwig Fischer, Keeper of the Africa Department, Dr Lissant Bolton and Julie Hudson on a visit to Benin City. Enotie's studio, an entire floor of an otherwise derelict high-rise building in the middle of the city, is lined with enormous canvasses of vivid colours and sculptures in various states of creation. Hartwig Fischer loved it there, and returned several times. He bought two pieces from the young artists whom Enotie mentors, which he donated to the British Museum's collection. Governor Obaseki echoed Enotie's judgement. He told me the museum had been 'very very forthcoming, we believe

they should provide leadership amongst the European museums and I see them doing that'.[45]

The European museums had not agreed between them who would lend what or exactly how many of a proposed total of 300 Benin Bronzes, but the British Museum had said it would contribute a substantial number.[46] 'We have about 950 Benin objects. Other museums in the group have thirty. We have different challenges, but we will be as open and helpful as possible,' Julie Hudson told me.[47] In a sign of a changed approach, the British Museum said in 2019 that it would lend what it called 'twelve iconic items' to a major new museum in Lagos, the John Randle Centre for Yoruba Culture and History, for a minimum of three years. These included a carved wooden stool known as the Lander Stool, after the nineteenth-century explorer Richard Lander whose descent of the River Niger was celebrated by Steve Dunstone, and which the Lagos State authorities intended to make a centrepiece of the opening exhibition. The John Randle Centre is effusive in its praise for the support it has received from Hartwig Fischer and the British Museum.[48]

When the Benin Dialogue Group met in Benin City in July 2019, Governor Obaseki announced something of a coup. He'd commissioned the architect Sir David Adjaye – designer of the acclaimed Smithsonian National Museum of African American History and Culture in Washington DC – to work on the plan for the new Benin Royal Museum. Sir David – British with Ghanaian parents – flew to Benin City and spoke to the assembled European curators. 'This was major, the best that could happen for the project,' said Barbara Plankensteiner.[49] Sir David's African American Museum was praised for conveying both the tragedy and the unbreakable spirit of the black American experience. He'd felt an enormous privilege at the opportunity to turn 'a yearning within a society' into a building that could help people understand the past in a new way. From the Mall in Washington to the Oba's palace in Benin – from slavery to colonialism – he now had a second chance to make a statement that would resonate across the world.

Governor Obaseki had been connected to Sir David Adjaye by a mutual friend, Phillip Ihenacho, reputed to be one of the richest men

in Nigeria. An Igbo, from eastern Nigeria, Ihenacho grew up in the centre of the country and calls himself 'detribalised'. In fact, he moves easily across the entire world; educated at Yale and Harvard, married to a Norwegian, with a home in London, he spoke to me on Zoom from his ranch in the foothills of Mount Kenya. He and Governor Obaseki go back a long way. 'Godwin and I were business partners, I was best man at his wedding, I've known him forever, he's a very, very good friend.' The Governor asked him to help raise the money to turn the Benin Royal Museum into reality.[50]

Phillip Ihenacho is an engagingly plain speaker. 'There's no point in agitating for the return of something when you don't have the capacity to preserve what you're asking for,' he says. He wanted Sir David Adjaye on board – 'I've known him twenty-plus years, he designed my first office in London' – because his 'superstar status' would send a signal that the project was serious. Phillip Ihenacho and Sir David Adjaye's involvement reassured the Europeans in the Benin Dialogue Group, but also put them under the spotlight. Sir David was impressed by the commitment of the European curators he met in Benin City, yet also picked up on a certain tension. He told me he felt 'a sense of engagement but definitely nervousness about what this is going to entail. I think they're all wrestling with Trustees who are really struggling with the idea of some kind of return.'

The irony, Sir David argued, is that the British Museum and others 'store ninety-five per cent of the collection – it's kind of ridiculous this hoarding. There's no more space.'[51] If anything, he may have underestimated the share of the British Museum's collection that is hidden from the general public; others have suggested ninety-nine per cent is in the storerooms.[52] As long ago as the aftermath of the First World War, British Museum curators were complaining of 'intolerable congestion' in the ethnography storerooms. In 1953, the Keeper of Ethnography, Hermann Braunholtz, wrote that the ratio of stored to exhibited items was 'constantly rising, and is already probably of the order of twelve or fifteen to one. As with an iceberg only a small fraction of the mass, spectacular though it be, is visible above the surface.'[53] The museum points out that anybody can request individual items be brought up to study

rooms, which have more space and better lighting than the storerooms. (While writing this book I was able, in this way, to see several Benin Bronzes that are not on public display.) Sir David Adjaye argues that it is the sanctity of the storerooms themselves which is being fetishised by the British Museum. 'You're at capacity and you have ninety-five per cent in the vault. What's it doing there? You want to build bigger and bigger vaults?'[54]

The critics of the British Museum are loud and eloquent. They found their voice again, and with renewed vigour, during the Black Lives Matter protests in the summer of 2020. If the authorities were so worried about looting, well, what about the history of the great Western museums? So when Hartwig Fischer released a statement expressing the British Museum's solidarity with black people across the world, he was met with a storm of digital derision. The many hundreds of responses on Twitter were scathing: 'the audacity!', 'awkwardly delivered in front of piles of stolen art and relics', 'um who's going to tell them?', 'Are you joking?? you are the most blatant symbol of colonial looting in the world.'[55] Was this an online echo chamber or a new moral consensus? There seemed to be an immediacy and passion to the charge of hypocrisy, and much of it came from Africans.

By then, however, I sensed that for the British Museum, and perhaps many other museums, voices of condemnation from outside were only part of the reason why the Benin Bronzes had become so important. 'From a general ethical point of view, and for the morale of the British Museum too,' my Trustee told me, 'people at museums are troubled by these issues and want, deeply, to have a consensual resolution.' For the British Museum, and others, the fear of precedent is powerful. If we give back the Benin Bronzes, then why not everything else? But there was another, competing fear: that of being caught out of time, of losing public support and sympathy. The composition and backgrounds of the crowds who walk the streets of London is very different to that of forty years ago, and the values of many of those who work at and visit the museum have also changed. 'World Museum' is another term commonly used for 'Universal Museum'. 'But if that's what they call themselves,'

argues Alexander Herman, an expert on art and law, 'they must engage with the world of today – not the world of the past, otherwise they forfeit the title.'[56]

The British Museum was closed for almost six months in 2020, because of Covid-19. When it reopened in the autumn, visitors found some small but highly symbolic changes. A bust of Sir Hans Sloane, whose collection formed the basis of the museum's, had been moved from a plinth to a display case, where he was labelled a 'slave owner'. Ahdaf Soueif said it was an 'excellent' move.[57] The information panels next to the Benin Bronzes, now entitled 'Benin: colonial conquest and military looting', had been comprehensively rewritten. Benin City, the museum said, suffered 'a violent and devastating occupation with many casualties', while Phillips's expedition had been 'highly provocative'.[58] A curator in the African collection told me that colleagues were determined the museum should be more transparent, and the changes represented 'significant progress'.[59] But in the same week the British Museum reopened, Prime Minister Boris Johnson complained of 'an orgy of national embarrassment' about Britain's history. The museum, accustomed to being the focus of disputes around restitution, was now caught up in a wider cultural war. This time it was conservative critics who were angry and accused it of a new-found 'wokeness' and reacting 'in panic clothed as principle'.[60]

Changes in attitudes had filtered through to the parallel world of auctions, private sales and collectors. In that same summer of 2020, Christie's auctioned a pair of Benin Bronzes in Paris, but the European Head of African Art, Bruno Claessens, insisted they could not be traced to the plunder of 1897. He said: 'We no longer sell Benin Bronzes which we know came from the Punitive Expedition, and have not done so since at least 2016.'[61] Sotheby's, who have also sold Benin Bronzes since the release of the Sarr-Savoy Report, were less cautious. 'Just two weeks ago someone asked me, "Can you find me a Benin plaque?"' Jean Fritts told me in June 2020, at the height of the Black Lives Matter protests. But she admitted the report, and accompanying furore, had made some

collectors nervous, if only for a while. 'They asked, "What does this mean for me?"' Sotheby's, she said, 'was very cautious about the PR' of selling Benin Bronzes.[62]

I asked Lance Entwistle, a pivotal figure in the sale of many important Benin Bronzes in recent years, whether he saw an impact on prices and demand. 'I think the committed buyers who are already in the market are not affected. It may be that buyers who were considering getting into the market are more cautious, less quick to get involved,' he told me. 'But if I was asked by a client, "Is there a problem in buying a Benin Bronze that's in circulation, and been passed from hand to hand?", I would say "no". There couldn't possibly be any legal grounds for forfeiture of an expensive piece of Benin art that someone has invested in.'[63]

A short walk up Bond Street I met Giles Peppiatt, in charge of African art at Bonhams. He is every bit as suave and accommodating as Lance, but strikes a different tone. Somebody offered him a Benin Bronze in 2018. The provenance was solid, the piece worth an estimated £185,000, but Giles passed. Why? Because provenance is no longer enough once ethics have changed. 'If I told my press office we were selling a Benin Bronze, they'd throw their hands up. It's like rhino horn or ivory now. The '70s, '80s, '90s were a very different time for dealers. They were operating within the law but there were not the same moral qualms about what was sold.' In the past five years, according to Peppiatt, because of 'Macron, changes at the British Museum, Jesus College, social media, everything has changed so much'. Private sales might continue, he believed, but 'no reputable international auction house would put its head over the parapet'.[64] If auctioneers decide that Benin Bronzes have become too hot to handle, then museums, in turn, are likely to become more nervous about the possibility of future litigation, or queasiness among their donors.

All of this creates an opportunity for the Oba, for the Edo people, and for Nigerians who want the Benin Bronzes to come back, that their predecessors did not enjoy. The power dynamic has shifted. The European museums are not merely playing for time, but feel they have a vested interest in a successful conclusion. An ally of Governor Godwin

Obaseki who has been negotiating with the Europeans felt that, if any-thing, the pendulum may have swung too far. 'Quite frankly, if Godwin put up a shed at the back of his house some European museums would still hand things over. They are under huge pressure domestically and just want to get rid of these embarrassing objects.' Professor Thomas of Cambridge said, 'We have a feeling that we've got to do something, we just can't be in the same situation in twenty years' time, with our museum successors and Prince Gregory Akenzua's descendants having the same old discussions.'[65]

WE CAN MAKE IT WIN-WIN

In Benin City I met a slight man full of nervous energy called Nosa Okundia, who told me a tale of cruelty and suffering. Nosa, aged thirty-seven, had been tracking me down for days, and eventually found me in my hotel lobby. My time in Benin City was limited, there were lots of people I wanted to meet, and I could not see what he had to do with the Benin Bronzes. Only later did I understand.

Nosa is the founder and leader of the Greater Returnees Foundation, which he says has 1,600 members in Benin City. It promotes the interests and welfare of people who embarked on the journey across the Sahara to Europe and have now come home. Nosa told me his life was in danger. 'Me alone, I've brought eighteen criminal traffickers to book,' he said. He receives threatening phone calls, and leads a peripatetic existence, rarely sleeping at home. But he's driven on by the memories of his experience.[1]

Nosa, born and raised in Benin City, was working as a carpenter in Lagos when he first heard of opportunities to travel to Europe as a stowaway on board a ship. If you paid a boatman $100, he'd take you out at night to the container ships anchored in deep water. The objective was to wait until a ship was leaving, then leap onto its side and climb in through a porthole. 'If you get inside you survive, if you don't you fall into the water. They say "we've lost a spanner."' Three of his friends drowned. Nosa also fell in, but a boy fished him out. He got as far as Freetown,

Sierra Leone, hidden in a ship's hold, but when he was discovered by the crew they sent him back to Lagos.

In late 2015, he decided to try again. He wanted to be the family breadwinner. This time he'd go by land. He had an Edo friend who had reached Germany, who told him on Facebook to try the Libya journey. 'It's nothing,' said the friend, and gave him a number for Moses, a Nigerian trafficker. Moses wanted $1,000, which Nosa borrowed from his parents on the understanding that he would pay them back once he got to Europe. He crossed the border to Niger at night, crammed into an old vehicle with other young men and women. The traffickers took all their money. On the desert journey across northern Niger they joined an enormous convoy of Toyota Hiluxes, with fellow travellers from Eritrea, Senegal, Ghana, The Gambia and elsewhere. In Nosa's car, there were thirty-four people. They bribed soldiers to pass. They saw many bodies by the road. At one point Nosa realised the person jammed in next to him was dead. They stopped briefly, to unload the body and put sand and three stones on top of it. Many people were crying in the car, but when a woman shouted, 'My leg, my leg, I can't find my leg,' the driver spat at her. At night he warned the women, 'If you don't allow me to sleep with you I will leave you in the desert.' They stopped at a well to drink. There was a dead body in it, but they drank the water anyway.

At the Libyan border, soldiers beat them, robbed them of their remaining possessions and raped the girls anally. They slept in a goat farm for two days, until the road was clear. While they were there a woman with a swollen leg died. An Arab man with a pistol told them to dispose of the body. At the town of Brak, Nosa met Moses the trafficker. Moses had a list of who had paid or not. Those who had not paid were kidnapped, and Moses phoned their families to warn of worse to come. Nosa had paid, but the Nigerian gangs beat him anyway, with a metal pipe. Others were shot dead.

It took eight days to reach Tripoli, as the gangs negotiated security on the roads ahead. When they arrived, they were sent to a seaside ghetto. There, Libyans were in charge, but Nigerians did the beating. Nosa, black

and blue with bruises, called his parents and begged for more money. They scraped together $120 which they sent to him. The migrants spent days waiting for the sea to calm, during which more people died. Then, one night, they were ordered into a van and driven to the beach. 'If you have money, bring it out,' said the traffickers. They also took phones, and thrust their hands into the women's private parts to check they weren't concealing anything. They were loaded onto a ribbed dinghy, and a Gambian man was given a compass and a satellite phone, with instructions to ring a certain number after eight hours at sea.

At daybreak, they tried ringing the phone, but no one answered. Nosa counted 246 of them aboard. The dinghy was taking in water, and they were baling it out. People started panicking. They saw a boat coming towards them. Somebody shouted it was a German rescue boat, but it was the Libyan coastguard. 'They are dangerous,' someone else warned.

'Put your heads down,' shouted the coastguards. One man panicked and jumped into the sea, and the coastguards shot him. They removed the pregnant women, and one of them helped drive the dinghy back to the Libyan coast.

After that, Nosa spent a total of six months in three different Libyan prisons. He learnt Arabic, and became a spokesperson for the prisoners. When UN officials visited, Nosa was delegated to speak to them and the guards behaved well. Afterwards they would stab him in the hands and cut his arms, and fire their guns near him, to find out what he had told the UN. Nosa converted to Islam and became Mohammed Musa in an attempt to garner favour, although it didn't make much difference. But one day the Nigerian ambassador visited the prison, and promised to take them home. On 23 August 2016, Nosa flew back to Lagos.

Nosa has been a spokesperson for returnees ever since. He goes to schools and churches, and warns people not to travel to Europe. Often, they reply 'you are telling us not to go, but what can you give us?' Despite Nosa's best efforts, many returnees go into crime. And people are still leaving Benin City, although the most popular journey in recent months had been to work in the mines and sex trade in Mali. 'In Mali they are killing Nigerians seriously right now,' said Nosa.

Nosa's story was numbing in its cumulative brutality, but – full of locations, logistics and telling details – it rang true to me. Not least because I've heard it, or versions of it, before. In 2015, when Nosa set out from Benin City, I spent a week on a rescue boat off the Libyan coast and a further fortnight on Sicily, listening to the stories of Africans picked up at sea. Every single Nigerian woman I met came from Edo State or, just occasionally, the neighbouring Delta State. The following winter, on an industrial estate in Abruzzo, central Italy, I found teenage girls and young women in skimpy underwear huddled by roadside fires, waiting for punters. They were all from Benin City.

Depressingly, I'd even heard this story twenty years ago. In a village outside Benin City in 2000, I met a teenager who'd been trafficked into prostitution in Italy. She thought she was going to be a hairdresser. I went to a secondary school where children were being lectured on the dangers of travelling to Europe. Already back then, Edo State, and Benin City in particular, was the epicentre of Nigerian people trafficking, especially to Italy. The women were regularly flown home by the Italian authorities and paraded in disgrace on the Nigerian evening television news. Criminal gangs, their authority reinforced by spiritual rituals, had a grip on Edo society. Successive Obas, and Edo State Governors, have railed against their activities – back in 2000 the then Governor, Lucky Igbinedion, told me he would stop at nothing to catch traditional priests involved in trafficking – but none have defeated them. The trade brings Benin City international notoriety, just as the Bronzes have brought it distinction. The paradox is that Europe covets Benin's artistic masterpieces, but doesn't want its people. We deport Nigerians, but have spent decades agonising about the idea of sending any Bronzes back to Nigeria.

The brass caster Phil Omodamwen told me three members of his extended family had been killed trying to reach Europe. He says that in 2018, when Hartwig Fischer and his British Museum colleagues were in Benin City, they came to see him and asked if he'd like to cast a brass piece depicting an overcrowded boat of migrants crossing the Mediterranean. It was a perhaps clumsy but well-intentioned request. The museum would have the opportunity to exhibit a Benin Bronze

with a very contemporary relevance, and Phil's expertise would be on display to a huge international audience. But the subject matter made him uncomfortable. 'I don't want to be linked to that misery, I was troubled,' he said. It felt exploitative. But over time he felt differently and decided to put his reservations aside. 'This could be a good, good thing for me, I'd be happy for all that exposure,' he told me in 2020. Besides, just maybe, he thought, his sculpture would make people in London think differently about their relationship with Africa.[2] (The British Museum says the idea of a brass boat was one of several they discussed with Phil in 2018, but no agreement was reached.)

I went to see Enotie Ogbebor in his studio in the derelict building, the one where he'd played host to the delegation from the British Museum. I could see why Hartwig Fischer liked coming here. Enotie strode across the expanse, pointing to his favourite pictures stacked up against the surrounding walls. Some of the canvasses were huge – six metres by three – and garish to my eyes: an African Mona Lisa, or a glamorous

Phil Omodamwen, brass caster.

couple drinking champagne on a balcony. Others were wonderful, like the market scene he was working on, a composite of oil paint, glass and fabric. The studio was busy; young artists dropped by for advice, or just to work in peace. It overlooks the entrance to Igun Street, but if Benin City's brass casting tradition can sometimes appear tired and unimaginative, this was a place of vibrant creativity. For Enotie, the past is not something to be preserved in aspic, but a source of inspiration for a better future. The significance of the Benin Bronzes was not so much that they were old and beautiful objects, but that their return offered an opportunity for Edo renewal.

'Now more than ever, we need these works to come back so that our people can behold them,' said Enotie. If only the Edo could compare their past achievements with where they were today, he argued, they'd see how fundamentally wrong they've gone. They would understand what hard work and dedication bring, they would learn that what came from their own culture was not automatically inferior to that which came from abroad. If only, Enotie said, Benin City was like Athens or Cairo, where you can climb the Acropolis or ascend into a Pyramid, and feel a sense of inner awe and wonder and pride at what your people have done. 'We were speaking our language, we had a culture, we respected ourselves, even as we interacted with the Portuguese. Four hundred years ago, 600 years ago, 800 years ago!' He was in full flow now, eloquent and persuasive. 'Today we disrespect ourselves so much that we want to take the risk of walking through the desert, throwing ourselves in the sea, to reach Europe to do anything – no matter how menial, no matter how dangerous, no matter how illicit and illegal – then, where's our sense of inner pride?'[3]

I've lived much of my life in Africa and know how, in conversations and friendships, it is rare to feel truly free of the suffocating weight of colonialism. Perhaps especially so in eastern and southern Africa, where its racial characteristics are most deeply imprinted. But at that moment, sitting in Enotie's studio, a full sixty years after Nigeria's independence, its whole wretched legacy, its humiliations, felt more acute and relevant than ever.

One evening, Enotie took me to meet the Edo State Governor, Godwin Obaseki. The guards at the gate saluted and waved us through, but Enotie stopped anyway to give them some money. 'Oiling the cogs of the machine,' he explained. The Governor was outside, on the terrace of his expansive mansion, reclined on a sofa, surrounded by twelve of his aides and advisers, all men. They were deferential to him but not sycophantic, I noticed, and we were warmly welcomed. The Governor was relaxed and gracious, the whisky and champagne flowed, and so did the jokes and laughter. The previous day's local election results were starting to ping on the smartphones, and Obaseki's appointees had done well, making everyone even more cheerful.

Governor Obaseki likes to talk about the Benin Bronzes, about how moved he was when he visited the British Museum – 'I was so emotional, I did not know we had treasures like that' – and his vision for the new Benin Royal Museum. He'd allocated it some £1 million in his latest budget, a statement of intent to get the project started. Already, I knew, some people in Edo State were grumbling about this. They couldn't eat Benin Bronzes, after all, and what about the bad schools and hospitals, the lack of jobs? Weren't these what people really cared about, and the reasons young people were running away? 'It's all linked up,' insisted the Governor. 'Why are people going across the Sahara? It's 1897, we are dislocated, and this project can get us out of the maze.'[4]

Nigeria has no shortage of soaring rhetoricians, and I was in danger of succumbing. Parts of the Governor's and Enotie's vision seemed very ambitious. The new museum would be at the cutting edge of modern technology, with the latest in computer-generated images and artificial intelligence. There would be a cultural quarter, with an institute that would become the best place to research not just Edo, but all of Africa's, cultures and traditions. And one day, the museum would be loaning its works back to Europe, and in turn receiving the best Europe had to offer. 'If I was to display Benin ivory, wood or bronze works, and juxtapose them against the works of Michelangelo, Van Gogh, Picasso or Renoir,' imagined Enotie, 'what a show! People would want to come here, the centre of arts and culture and tourism in West Africa.' He pointed out

that when I had arrived by plane in Benin City a few days earlier, I was the only white person on board. 'But we can have them flocking here.'

I admired Enotie and the extent of his vision, even if I was sceptical, at least in the short term, of Benin City's prospects as an international tourism destination. Nigeria's reputation as a violent and badly governed country is sometimes exaggerated, but nor is it entirely undeserved. It seems cruel but relevant to say here that the first time I visited Benin City, in 1999, a would-be thief almost killed me. I was on the road from Lagos, sitting next to my driver, and we were going over 120 kilometres per hour through the forests approaching Benin City. There was a blur of movement from the embankment high to our right. A hand hurled a large rock out of the undergrowth, downwards and straight into our windscreen. It was a favourite tactic at the time; the windscreen smashes, the stunned driver (who may also have been hit by the rock) loses control of the careering car, and the bandits emerge from the bushes to plunder from the wreckage. In our case, the rock sent cracks juddering across the windscreen, but bounced away to our left. We sped on.

The reputation of particular Nigerian roads ebbs and flows, and I'm told that the Lagos–Benin City route is now safer. A more recent danger comes from the lucrative kidnapping industry. Friends and relatives are forced to cough up thousands of dollars for the release of their loved ones. Enotie, driving a good car and with wealthy connections, was aware of the risks in Benin City. He told me how he deliberately varies his hours at his studio, sometimes leaving at 2 a.m., sometimes arriving at 2 a.m. and working until dawn. 'I'm always unpredictable,' he said.

The Benin Royal Museum would also have to survive the vicissitudes of Nigerian politics. Nigeria is littered with the ruins of prestige projects associated with one politician but abandoned by an indifferent successor. When I met Governor Obaseki in 2019 he seemed a shoo-in for a second four-year term, but over subsequent months a rift within Nigeria's ruling APC party threatened his ambitions. Disqualified from standing for the APC in the September 2020 election, Obaseki was forced to switch to the main opposition party, the PDP. The APC was determined to unseat him, and the election was fiercely contested. The

repercussions for the Benin Dialogue Group were potentially serious. Before the vote, the Director of a European museum in the group was circumspect: 'It's obviously not our business whom Edo State elects. But this has been an Obaseki project. He's been a great partner. If it's somebody else I'm concerned we'd lose momentum.'[5] Phillip Ihenacho told me he was 'acutely conscious' the new museum had 'to be set up in such a way that withstands the various changes politically in Nigeria, and if we don't do that it will be destroyed as soon as Godwin's successor comes in'. But he added bluntly, 'If Godwin is not re-elected, I have no interest in this project. I know it will be very, very difficult to get something like this organised under someone who's not committed'.[6] In the event, Obaseki won comfortably. Enotie, who had been in the thick of the campaign, was exultant. He sent me a message saying the result was 'a great fillip' to Edo efforts to return the Benin Bronzes.[7] For their part, the European museums in the Benin Dialogue Group breathed a sigh of relief. Obaseki would now be their partner until 2024.

At Benin City's National Museum, where the curator Theophilus Umogbai had assured me no theft had ever occurred, I wanted to know what he thought of the Benin Royal Museum. On the face of it, the idea amounted to a searing indictment of his organisation, Nigeria's National Commission for Museums and Monuments, and by extension the federal government itself. The Europeans were on board precisely because the Bronzes would not be coming back to government museums. Barbara Plankensteiner told me, 'The NCMM needs a new structure and philosophy. People within it think this. It needs an overhaul. There are many professionals and good people, but the whole hiring structure, how they work, has to be rethought.'[8] The Oba's palace and Governor Obaseki concurred: the Bronzes had to come back, but specifically to their new museum. Their motivation was in part a reflection of ethnic loyalty over national identity – they wanted Edo treasures to be displayed in an indigenous Edo museum – but I heard the same sentiments from Helen Kerri. She is not Edo, and she ran Nigeria's government museums for almost a decade, and yet even she told me she was 'extremely happy' that the NCMM would not control the Royal Museum, such are its weaknesses.[9]

Theophilus, it was evident, felt hurt. 'Personally I would have wished that my museum would be the final place for these objects when they come back,' he admitted. He was tired of hearing from Western museums that his lacked security and expertise. If so, could they not do more to help him? But he was prepared to swallow his pride for a greater good, now that the prize was finally in sight. 'For any Nigerian to see these objects now, he or she has to get a visa, get a ticket – maybe pay as much as £1,000 for that ticket – just to go to the British Museum for one hour. But when these objects come to the Benin Royal Museum, I'll just walk out of my house, get on a bus and go see them.' If that's what the Europeans were insisting on, why rock the boat? Besides, he said, defying his Oba was never a possibility. 'You don't go to a meeting where the Oba sends his own reps, and as an Edo man, get up and say, "No, don't give the Bronzes to the Royal Museum." No! I can't do that.' The association with royalty, he felt, would also bring a degree of protection that Nigerian government museums could never enjoy. To steal from the Oba carried a terrible stigma; 'instant doom for that person and his family, for generations'.[10]

Some Nigerians felt uneasy at the perception that the Oba and the Governor had made concessions. Professor Folarin Shyllon was unhappy that the Benin Dialogue Group seemed at this stage to have abandoned talk of permanent returns. 'Half a loaf is better than no loaf, so reluctantly I go along with them,' he said to me.[11] Passing through Lagos, I'd caught up with Victor Ehikhamenor, the Edo artist who had been so pained by his visit to see the Benin Bronzes in the British Museum. After Jesus College announced it was going to return Neville's cockerel, Victor told newspapers that it was a huge step towards restitution, and other British institutions should follow, 'without any excuses or delay'.[12]

Victor's studio was a clutter of bronze castings, abstract oils on canvasses and the figures made from rosary beads that have become one of his trademarks. He sat in a small office at the back. Victor is also a successful writer, and his desk was piled high with novels. The shelves were heaving with more books, and wooden sculptures lined the walls. He was busy preparing for a Lagos exhibition and a possible return to

London. A woman called Blessing, in a stylish black and white chequered dress, tapped away at a laptop on a sofa in the corner. Another acclaimed Nigerian author, a Harvard graduate and medical doctor, had just flown in from New York and dropped by to say hello.

Victor told me that he, like Professor Shyllon, remained troubled that the Benin Dialogue Group were still talking about the Benin Bronzes being loaned from European museums. 'The word "lend" makes me uncomfortable. It makes me question who is the owner,' he said. He saw an ominous precedent in Edo history. In 1892, Henry Gallwey tricked Oba Ovonramwen. Were the Edo, once again, committing themselves to an agreement not in their best interests? Victor had raised his concerns with Governor Obaseki, who had told him this was 'a conversation starter'

Victor Ehikhamenor in his Lagos studio.

with the European museums. But still, Victor worried, an important moral point over ownership had already been conceded. Things were getting off on the wrong foot. 'Do we learn to walk wrongly so that we can correct that walk later, or do we learn to walk well?'[13]

For Prince Gregory Akenzua, Governor Obaseki, Enotie Ogbebor and Theophilus Umogbai, the Nigerians doing the actual negotiating, the risk was worth it. 'We're called names, that we've sold out and so on,' said Theophilus. He shrugged his shoulders. He agreed with Professor Nicholas Thomas of the Cambridge Museum of Archaeology and Anthropology; the talking had gone on too long, it was the time for action. 'I'm about to turn fifty-five years old. We've not had much success for fifty-five years. I will be grey soon – that's where I'm going. People are born and pass on without seeing these objects. So much talk, we just want them back.'

Enotie, too, felt the passing of the years. 'Since the age of ten, I've always prayed I could be involved in this restitution matter, I've had such a keen interest, since the age of ten!' Now, at last, they were almost there, and it was important to be realistic, not emotional. 'Sometimes the emotions do overwhelm you, when you see the sheer amount of our objects in vaults that will never be displayed,' he said. 'But the people who call us sell-outs don't know about the nitty-gritty details of the talks, that the British government does not run the British Museum, that the museum's Trustees cannot go against their own policies.' Governor Obaseki said the same. And if the European museums wanted reassurances, then he would work with them to ensure the Benin Bronzes were coming back to an institution that matched their standards. And, just like the Oba, he saw them as ambassadors of the Edo people. He didn't want them all to come back. 'We can make it win-win,' he said.

In April 2020, while the world was shut down because of the Covid-19 pandemic, I spoke via Zoom with Sir David Adjaye in Ghana. He was running his global architecture firm – Adjaye Associates – from there. 'I've left London, Accra is now my home. I'm very invested in West Africa', he said.[14] The internet connection was poor, Sir David's face something of a blur, but what came down the line clearly was the sense that he, like Enotie

and the Governor, was thinking big. 'Benin needs to find its identity again, it needs to move from becoming another satellite city to something that stands for something'. He too spoke of its potential to be a new Athens, of building a monument that would start an artistic renaissance across Africa. The cultural quarter would incorporate the walls, the palace, Igun Street and much more. These would form the ring, with the new museum the jewel at its centre. 'It's an enormous plan,' he admitted. Fundraising alone would take two to three years, the whole project twice as long. And even that timeframe, developed before the pandemic, seemed optimistic.

Sir David's message to the European museums was conciliatory. 'When I was asked to make this commission I wasn't interested in an "us and them". That's not interesting, the past is past.' Surely, he argued, those museums would welcome the birth of new cultural institutions in West Africa, with which they could engage and share. Besides, his ideas for the Benin Royal Museum were very different from the traditional European concept. 'It cannot happen as a kind of Western glass box, a vitrine, it would mean nothing, it would be totally disregarded by the community.' Instead, he wanted to reconstruct, at full-scale, the chambers and palaces and rooms and shrines, which would bring the old Edo civilisation to life, from the Obas to the clerks, to the concubines, with the Benin Bronzes, or replicas, placed in their midst. 'Because what is missing in Edo culture,' he said, 'is an understanding of how those bronzes, ivories and corals were operating within their societies.'

Implicitly, this was a criticism of the Kenneth Murray legacy, of colonial museums that lacked indigenous roots but sought to imitate those of the mother country, and which have now withered and all but died. But Sir David was also reaching out to the Nosa Okundias, to the millions of Nigerians casting around for an identity. 'West Africa,' he said, 'is an oral knowledge culture and a secret knowledge culture and the problem is that we have population explosions, the elite hold the information and young people don't know.' His museum, he hoped, could reconnect Africans to the history they had lost.

On my last day in Benin City, I drove back to Prince Gregory Akenzua's house. We were passing through the southern parts of the city, along the

route Admiral Harry Rawson marched in conquest in February 1897. He and his men stayed only a few days, but they took so much away with them, and the damage has endured. And yet, as an outsider, one of my strongest impressions of Benin City was just how much Edo culture remained intact. I'd struggled to get hold of Prince Akenzua, because as an *Enogie*, a Duke, he'd been mediating in land disputes between communities, representing the Oba in the traditional way. He was back on his terrace, catching the evening breeze. When I'd spoken to Victor Ehikhamenor, he'd told me of another issue that irritated him. What right did the British have to say that the Benin Bronzes, once returned, should go into a museum, even if it was one as sympathetically designed as Sir David Adjaye's? That was not their original purpose, he said. 'The thief cannot prescribe to the rightful owner how they should be used,' said Victor. But Prince Akenzua brushed that argument aside. He accepted that the Benin Bronzes had acquired a different culture. Some of those which Rawson took have now been sitting in European museums longer than they were originally in the Oba's palace. The clock could not be turned back, the past could not be undone.

'We've seen the advantage of other people seeing our work,' said the Prince. 'Wounds heal over time. When we see people who fought each other 100 years ago, working together now and admiring the same objects, and sharing, I think that is good for human development.' He turned to Shakespeare. '*Sweet are the uses of adversity*. That event, bad as it was, brought Benin to the limelight of the world.'[15]

Afterword

MAY ITS JOURNEY BE SUCCESSFUL

Six years after they launched their quixotic campaign, Ọrẹ Ogunbiyi and Amatey Doku went back to Jesus College, Cambridge, to see its successful conclusion. The handover ceremony of the Benin cockerel – part of George William Neville's haul – to the Nigerian government and Oba's representatives took place in October 2021. Jesus proclaimed itself to be 'the first institution in the world to return a Benin Bronze'. Strictly speaking, this was not true. The British Museum, as we've seen, sold or donated more than twenty plaques to Nigeria in the early 1950s. But, unlike the museum, Jesus had made what it saw as a purely ethical decision. It was returning its cockerel not because the law compelled it to, but because it was the right thing to do, and this gave the event its significance.

The Master of Jesus, Sonita Alleyne, tall and black, born in Barbados, her hair in tumbling dreadlocks, presided over the ceremony, her position in itself evidence of change in British institutions. Her clear words cut through history and decades of arguments. 'When one sees a wrong that is so egregious' she said, 'the only institutional question one can ask is how to right that wrong... It's a simple, moral question. It must be answered with no caveats, with no conditions.' She gestured to the cockerel, which sat on a plinth at the front of the stage. 'This Benin Bronze does not belong to us.'

Oba Ewuare II was represented by his younger brother, Prince Aghatise Erediauwa, who wore white robes and an orange-red coral necklace and bracelets. He spoke with dignity and restrained emotion. How far, he asked, had those British men gone into the inner chambers of the palace to ransack the sacred shrines? 'We still don't see these things as loot, as spoils of war. We still have ceremonies for certain objects that are not with us but which we know exist, they are indestructible.' His grandfather, Akenzua II, had seen the cockerel in Cambridge, and had promised it would go home. At last that day had come.[1]

There was music, Nigerian and Classical, gifts exchanged and documents signed. Finally Sonita Alleyne said the cockerel 'leaves with the love of Jesus. May its journey be successful. We hope a ten-year-old boy or girl in Benin City will gaze upon it and feel proud of their own heritage. It is done.' At dinner that evening the guests sat beneath a projected image of the cockerel and feasted, appropriately, on hazelnut and tarragon stuffed roulade of corn-fed chicken. Amatey gave a speech, thanking the Nigerian delegation for the graciousness with which they had received their stolen loot. The whole day, he felt, had been 'surreal', a befitting conclusion to a long struggle. 'At Jesus,' he reflected later with satisfaction, 'I always felt I belonged, but for all sorts of reasons didn't quite belong. That Benin Bronze being on display was at odds with my heritage. Now, when I see my college face up to its difficult past, it is a place I'm more comfortable with.'[2]

George Neville – plunderer par excellence but also unlikely racial progressive – was not mentioned by name once during the ceremony. 'The person who gifted it' was as close as a Jesus academic came to identifying him. My old Claridge's acquaintance, Francis Bown, wrote another letter of futile protest to the *Daily Telegraph*. The cockerel had been 'much loved by us Jesuans,' he lamented, and suggested a sign be erected in its place in the college hall, 'with the words "Benefactions not welcome."'[3]

Jesus College had gone first, but change was sweeping across Western academia and the museum world. Assumptions about race, history and empire were being turned upside down. New technology was a part of

the process. It wasn't just that social media empowered the previously voiceless (as well as the stridently certain) but also that more and more museums chose, or felt compelled, to produce detailed online provenance information for their collections. Those sometimes embarrassing backstories, once jealously guarded, were now widely available. Perhaps the Covid-19 pandemic accelerated the changes, its upheavals undermining old certainties. 'After times of great turmoil,' argued the expert on art and law, Alexander Herman, 'societies often proceed towards a wholesale settling of accounts, of a grand attempt at making right the injustices of the past, of drawing a line between then and now.'[4]

The new direction had been clear ever since the speech by French President Emmanuel Macron in Burkina Faso in 2017. In November 2021, amid much fanfare, he presided over the handover of the twenty-six Abomey objects, which included a throne and ornate palace doors, from the Musée du Quai Branly – Jacques Chirac to the Republic of Benin, neighbouring Nigeria. Bénédicte Savoy, co-author of the Sarr-Savoy report, said this event was 'comparable to the fall of the Berlin Wall. There will be a before and an after.'[5] Hyperbole, surely, but the French parliament had voted unanimously in favour of the return, and President Macron promised further returns to other former French African colonies. The Dutch and Belgian governments also agreed in principle that objects taken by force should be returned to their former colonies.[6]

Germany, meanwhile, had made a startling announcement earlier in 2021, when the Culture Minister Monika Grütters said that leading museums had agreed collectively to 'make substantial returns of Benin Bronzes', beginning in 2022. She said they had reached this decision because of the 'historical and moral responsibility to bring Germany's colonial past to light and to come to terms with it'. German museums, of course, had been assiduous collectors of Benin Bronzes in the very first weeks after the Benin Expedition returned to London and in the years that followed, and are thought to hold more than 1,150, far more than any other European country except Britain itself.[7]

Germany's announcement had consequences for all museums and countries in possession of 1897 loot. It both reflected but also helped

shape the perception that the Benin Bronzes had become emblematic of the debate about colonial-looted objects. As Monika Grütters put it, the Bronzes were 'the touchstone'.[8] It was easy to see why the Benin Bronzes had acquired this special status. Not only are they amongst Africa's greatest cultural treasures, but they are scattered through so many Western cities and museums, from Seattle to Stockholm, that they feature prominently in many different national discussions. Moreover, as I have tried to show, the manner in which they were taken, so well documented and even photographed, and right at the very end of the Scramble for Africa, was particularly shocking.

In Germany the government and museums appeared to be more or less in harmony, allowing them to present a coherent, national approach to the Benin Bronzes. This was never likely in Britain, where the degree of government support, and freedom of trustees and curators to take the initiative on restitution, varies widely between museums. Nonetheless, there was a discernible shift. At the Cambridge Museum of Archaeology and Anthropology, Professor Nicholas Thomas told me 'in principle the decision has been taken, and the direction of travel is clear.'[9] The Benin Dialogue Group met at the British Museum in late 2021, the first in-person meeting since the pandemic. (It was also the first meeting attended by the National Museums of Scotland, which has some eighty Benin Bronzes.) Governor Godwin Obaseki and Phillip Ihenacho were there, and Phillip told me afterwards, 'the tide has turned on restitution, the issue is settled, it's not whether, but how.' Significantly, the original consensus within the Benin Dialogue Group, that they would be *lending* their Bronzes back to a new museum in Benin City, had been abandoned. Permanent returns, once Nigeria's unrealistic ambition, were now the imperative. 'Virtually all the museums are exploring ways of returning their Bronzes,' Phillip said.[10]

Virtually all? The exception, of course, was the most important one of all. When Germany made its announcement, I called a contact at the British Museum. Germany's new position, they agreed, was 'very significant, on a gigantic scale'.[11] One result, instantly apparent and increasingly pronounced in the months that followed, was that the British Museum

was more isolated than ever. Monika Grütters said Germany was acting out of a sense of 'moral responsibility'. So where did that leave the museum with the national collection of the country responsible for the Benin Expedition, and with by far the most Benin Bronzes in the world?

Professor Abba Tijani, Director-General of Nigeria's National Commission for Museums and Monuments (NCMM), arrived at the meeting at the British Museum carrying a gift of a folding wooden stool, but more importantly, a letter from his government. This, at long last, was a formal demand for 'the return of Nigerian antiquities' many of which had been acquired 'through circumstances that cannot be described as desirable'.[12] Thus one of the British Museum's more disingenuous arguments – that it had never received an appropriate diplomatic request for the return of the Benin Bronzes – was finally demolished (although more cynical observers might query the letter's claim that Nigerian museums are 'empty' only as a result of imperial plunder). Professor Tijani travelled on to Cambridge, thanked Jesus College for the example it had set, and rammed the point home. 'Of course the mighty British Museum is waiting and looking,' Professor Tijani said, but 'they have nowhere to go.' The audience murmured in agreement. It would surely 'succumb to this trend that is prevailing now'.

But would it? Undoubtedly, some people at the British Museum were increasingly unhappy and desperate for change, or at least more communication and a sense of clarity from the Trustees. 'We see the abyss, we need change from the top, burying our head in the sand is not good enough,' one person told me.[13] An all too foreseeable diplomatic train crash loomed, whereby every other museum in the Benin Dialogue Group gave back their Benin Bronzes, while the British Museum alone lent theirs, with all the opprobrium that would follow.

At the heart of the issue is the British Museum's relationship with the British government. In the 1970s, when the Foreign Office pleaded with the British Museum to return the Queen Idia mask to Nigeria, the museum gave it short shrift. Looking back from the perspective of 2022, the insouciance the museum showed in the face of political pressure is striking. But so too is the image of a government which backs off

meekly when it meets resistance. After the Black Lives Matter protests of 2020, Boris Johnson's government wrote to the British Museum and other national collections, and said they should not remove objects with 'difficult and contentious' histories, or 'take actions motivated by activism or politics'. National collections, the letter said, were dependent on government money, the spending of which was 'rightly scrutinised'.[14] This thinly veiled threat resonated in the British Museum, as well as at London's Horniman Museum, which also receives government money, and where some felt trapped 'between the desire to do the right thing with the Benin Bronzes, and not to provoke the government'.[15] Museums all over Europe and the United States were facing demands for restitution, but few governments appeared as unsympathetic to these as Britain's.

Professor Tijani of Nigeria's NCMM argued that the well-trodden legal arguments around the 1963 British Museum Act were merely an 'excuse. If the British Museum would advise the government to change it, then the government will accommodate it.'[16] Or, as Nigeria's letter to the museum put it, 'Where there is a will, there is a way. Please create the will!' But at least some British Museum curators and Trustees felt themselves to be hostages of rules they did not create, and were powerless to change. Moreover, the Covid-19 pandemic and the resultant prolonged closures accentuated the power of the government relative to the museum. The British Museum's annual report for 2021 recorded a 97 per cent fall in both visitor numbers and trading income compared to the previous year. The government provided emergency funding to mitigate the losses, for which the Trustees expressed gratitude.[17] Given this context, it would be surprising if the British Museum's appetite for battles with the government were not diminished.

All of this meant that by 2022 the fate of the Benin Bronzes in the British Museum was more at the whim of British politicians than it had been before. By then the museum had a new Chairman of the Board of Trustees. George Osborne was a former Conservative Chancellor of the Exchequer but more liberal on cultural issues than some in Boris Johnson's government. Was he the man to take the government on and try and pull off a dramatic volte-face on the Benin Bronzes, or, for that matter,

the Parthenon Marbles? Initial evidence suggested not. As he assumed his position, Osborne made a robust defence of the global museum. It would be easy, he argued, to 'hide behind' the British Museum Act. 'The harder approach is to stop being defensive and instead make the case for this incredible display of civilisations… in an age that is pulling us apart, the British Museum is best equipped in the whole world to tell the story of our common humanity.'[18] Or, more intriguingly, could a mercurial Prime Minister decide that sending the Bronzes home was a price worth paying to give 'Global Britain' a much-needed image boost in the emerging markets of Nigeria and beyond? Unlikely, but not inconceivable. After all, many things have changed very quickly in the history of the Benin Bronzes.

In the summer of 2021 a South African woman, Ngaire Blankenberg, was appointed Director of the Smithsonian's National Museum of African Art in Washington DC. I had met Ngaire when I lived in Johannesburg some fifteen years earlier, where we had friends in common. Throughout her career she had been driven by the desire to change museums and make them what she saw as more inclusive and diverse places. She arrived in Washington with the Smithsonian's collection of Benin Bronzes firmly in her sights. Within days she ordered that ten pieces explicitly linked to the 1897 Expedition be removed from display and that curators research the provenance of all of the museum's some forty Benin objects. In place of the removed objects, the museum put up a noticeboard which read, 'We recognise the trauma, violence and loss such displays of stolen artistic and cultural heritage can inflict on the victims of those crimes, their descendants and broader communities.' Ngaire told me she was 'more than 100 per cent committed to giving the Bronzes back… I'm extremely impatient.' She said 'having and displaying collections that [cause] harm stands directly in the way of my commitment to making [the museum] a place where racialised peoples feel they belong.'[19]

As I listened to Ngaire, I couldn't help thinking of Ekhaguosa Aisien, whom I'd met in Benin City, and who felt such pride when he saw the recognition given by the British Museum to the Benin Bronzes in the 1950s. Ekhaguosa, who sadly died at the age of ninety-one shortly after

the first edition of this book came out, belonged to a different era. Ngaire is representative of a new generation of museum curators, who see the world, and its great cultural institutions, in very different ways to their predecessors. But as the momentum for Western museums to return their Benin Bronzes grew stronger, I felt that the Edo themselves were ill prepared to take advantage of the situation. Ignored for so long, they were suddenly knocking on an open door. As they struggled to adjust, it was not surprising that cracks began to appear between the various Nigerian and Edo institutions with a vested interest in the return of the Bronzes.

In July 2021, Oba Ewuare II summoned 'all well-meaning people' to an emergency meeting at the palace in Benin City. Hundreds answered his call and came in handsome robes, singing his praises. Ewuare II warned them of an attempt by what he called an 'artificial group' to 'divert' the return of the Bronzes.[20] He was referring to the Legacy Restoration Trust (LRT), a new body which had the backing of Governor Godwin Obaseki and whose trustees and advisors included Phillip Ihenacho, the artists Enotie Ogbebor and Victor Ehikhamenor, the architect Sir David Adjaye, the Oba's son and Crown Prince Ezelekhae Ewuare, as well as a representative of the Nigerian government's NCMM. Together they were committed to making the new museum in Benin City – which they were now calling the Edo Museum of West African Art (EMOWAA) – 'home to the world's most comprehensive collection of Benin Bronzes'.[21]

To many European curators within the Benin Dialogue Group, EMOWAA had evolved smoothly from the original concept of the Benin Royal Museum as an independent institution with the backing of the different Nigerian interests. Indeed, the British Museum signed a contract with LRT to conduct archaeology in Benin City and the German government also agreed to fund it – support worth millions of pounds – precisely because they believed that it and the Oba were working together.[22] And yet now the Oba told his followers that he had only recently learnt of the LRT, and that anybody who dealt with it did so 'at their own risk and against the will of the people of the Benin Kingdom'. He said that he was 'the custodian of all the cultural heritage of the Benin Kingdom'

and the 'only legitimate destination' for the Bronzes would be a Benin Royal Museum administered by his own Oba Ewuare II Foundation.

The Oba's announcement caused consternation amongst European museums. Here was the great-great grandson of Oba Ovonramwen, a man with unparalleled moral authority in any discussion on the future of the Benin Bronzes, rejecting the process they had embraced. Simmering distrust between Governor Obaseki and Oba Ewuare II had burst into the open. An Edo historian involved in the discussions about the return of the Bronzes said the rift 'has sent a chill through us all.'[23] The rival camps traded ugly accusations. The Oba's supporters and some close relatives said the Governor was surreptitiously taking control of the return process, and had 'lured' the Crown Prince into his schemes. (The venerable Prince Gregory Akenzua had withdrawn from the fray by this stage.) In private, both sides said the other was more interested in financial gain, either from the Bronzes themselves or the contracts from a new museum, than in rectifying an historical injustice. 'Treachery', 'lies', 'greed', 'it's like the loot of 1897 all over again'; I heard it all.[24]

The divisions were exacerbated by the sense that so much was at stake. The Benin Bronzes had become a global story, their cultural and monetary value reported across the world. Nigeria's fragile political structures were always going to be tested by the hype. The federal government also sensed an opportunity, and insisted that all repatriations go through the previously somnolent NCMM. The Oba was happy to accept this, although his supporters said they would never concede on the ultimate question of ownership. Most Western museum curators were ill-equipped to understand the political dynamics, their introspections on the legacy of colonialism woefully detached from modern Nigerian power struggles. 'There is a bewildering array of vested interests and personal power grabbing,' fretted one European curator.[25] For some, this was reason to pause. A museum director with a large collection of Benin Bronzes told me, 'Our policy is that if claimants are in dispute amongst themselves we wait until they resolve it.'[26] But Ngaire Blankenberg bristled when I asked her if disagreements in Nigeria influenced her thinking on what to do with the Benin Bronzes in the Smithsonian. 'That's a disturbing

narrative,' she told me, 'I'm not the guardian of these objects and have no moral authority over them. The Nigerian political situation is in no way a factor in my decision. My objective is to return them. ASAP.'[27]

Some European curators blamed the Germans for pushing ahead with bold announcements about returns before they had confirmed everyone in Nigeria was aligned on such a sensitive issue. 'The Germans really fucked up,' said one. A key German official admitted that he had moved quickly because he wanted to secure an agreement before his own country's election in the autumn of 2021. But more importantly, he said, he wanted to do what was right. 'Something is going to go wrong,' he said, 'but how do we bring change? At some point we had to take risks. If you don't start you will fail, because German and Nigerian politics are too complex.'[28]

By the end of 2021, the row between Oba and Governor rumbled on, and yet the outline of a messy compromise was also visible. The Benin Dialogue Group no longer talked of a new museum, but instead 'the museum landscape in Benin City'.[29] Enotie Ogbebor struck an emollient tone, saying Legacy Restoration Trust had never planned to take possession of the Benin Bronzes, but instead wanted to raise money for Benin City's planned cultural quarter. He and Professor Tijani told me that three museums – the existing National Museum of the NCMM, as well as a new Benin Royal Museum and EMOWAA – could co-exist side-by-side in Benin City, each with different functions. If that is the solution, it seemed to be shaped more by political exigency than public demand. But Phillip Ihenacho told me he never expected a smooth ride. 'Any project in Nigeria comes with this sort of noise,' he said. 'I don't lie awake at night worrying about this. This is a lifetime project. The cause is a great cause. No one will give up.'[30] Victor Ehikhamenor concurred. 'We didn't expect this process to be a cakewalk,' he said. 'Colonialism yoked us together. We just need to speak with one voice.'[31]

After the handover and celebrations at Jesus College, Cambridge, the Nigerian delegation rose long before dawn the following morning, to catch a London flight to Scotland, where they were to receive a second

Benin Bronze from Aberdeen University. I had been invited to the ceremony in Aberdeen, and made the same journey by train. Whizzing across the Lincolnshire flats, I felt that history, which often moves so slowly, had suddenly speeded up. Britain had resisted returning any Benin Bronzes for 124 years; now it was giving two back in as many days.

Aberdeen was under steady drizzle when I arrived, a grey city that felt a long way from Nigeria. But as the Nigerians walked into the university theatre, there was an evening burst of sunshine, and the mood inside the theatre was warm and welcoming to the visitors. Aberdeen University Museum had bought its one and only Bronze, a cast of an Oba's head dating from perhaps the late eighteenth century and which had once belonged to the collector Sydney Burney, at a Sotheby's auction in 1957 for £750.[32] But in early 2021, it announced that it would return it, 'unconditionally', given the 'reprehensible circumstances' in which it had left Benin.[33]

The Oba's head sat on a blue cloth on a table in front of us, a squat, powerful object with a coral necklace up to its mouth, large eyes gazing blankly out, and a bouquet of flowers behind. I listened to the chatter in the audience; 'a great day, pity Cambridge beat us to it,' said an elderly lady. 'I'll be sorry to see him go, I've looked after him for so long,' a curator told me, 'but I'm also glad he's going.' The Principal of Aberdeen University, George Boyne, said the handover 'was not a moment of celebration, but it is very significant, and we hope others will follow'. Just like Jesus College, Aberdeen University had made 'a simple decision'. It too had concluded it had legal, but not moral, title to its Benin Bronze. It too transferred ownership to Nigeria's National Commission for Museums and Monuments, with the Oba's representatives signing as witnesses.

Prince Erediauwa responded. He said he and his people had grown up with a sense of injustice, and now felt 'great gratitude to trailblazers like Aberdeen'. The person who had taken that Oba's head could never have understood 'the void he had left behind'. Now the void was being filled, and he said the Oba and the Edo State and Nigerian governments would work together to make these returns a success.

The university choir, dressed in purple robes, sang an uplifting South African hymn, 'Come Walk With Me For The Journey Is Long'. We spilled out into the damp Aberdonian night, and it felt inevitable that more and more Benin Bronzes would soon be making that same long journey home.

ACKNOWLEDGEMENTS

I could not have written this book without the insights and introductions that Enotie Ogbebor generously provided in Benin City. From the other side of the Atlantic, Uyilawa Usuanlele steered me through the intricacies of Edo culture and history, corrected errors in my manuscript and gave me insights and leads. Thank you, Uyi, for also connecting me with so many knowledgeable and helpful people in Benin City, not least Godfrey Ekhator, whose energy, wisdom and humour make him the perfect travel companion and historical guide.

Isaac Emokpae helped me with the history of FESTAC 77 and Gabriel Obazee assisted with translations from the Edo language.

In Lagos, I am indebted, again, to Robin and Hugh Campbell for hospitality, memorable evenings and many connections. Thank you to Ayoola Kassim for insights, friendship and Yoruba translations. My understanding of Nigeria's past has been enhanced by the scholar, musician, film-maker, *oga* of Nigerian history enthusiasts and friend, Ed Keazor.

The 'Nigeria Nostalgia Project', a Facebook group established by Etim Eyo, is a brains trust and source of collective wisdom which I often turned to while writing *Loot*. Etim, Kehinde Thompson, Uyi, Ed and others always came to my rescue with their wealth of knowledge and sources.

Staffan Lundén in Sweden is an expert on the post-1897 history of the Benin Bronzes, and has been extremely helpful and generous. So has Professor Robert Home, whose *City of Blood Revisited* is still a refreshing and balanced read forty years on.

Mark Walker gave me lots of time as well as his grandfather's diary and dealt graciously and patiently with many enquiries. I hope that he and his relatives feel I have been fair to the family history.

Thank you also to John Adeleke, Sir David Adjaye, Prince Gregory Akenzua, Femi Akinsanya, Polly Alakija, Judy Aldrick, Joseph Alufa, Ngaire Blankenberg, Roger Blench, Felicity Bodenstein, Francis Bown, Eric Brassem, Tim Chappel, Bruno Claessens, Annie Coombes, the late Anna Craven, Kathy Curnow, Neil Curtis, Amatey Doku, Steve Dunstone, Victor Ehikhamenor, Lance Entwistle, Prince Aghatise Erediauwa, Jean Fritts, Amanda Hellman, Will Hobbs, Dale Idiens, Phillip Ihenacho, Lancelot Oduwa Imasuen, Frank Irabor, Mayeni Jones, Peter Karpinski, Helen Kerri, Zachary Kingdon, Tunde Morakinyo, John Murray, Oswyn Murray, Aiko Obabaifo, the late Irene Ododo Odaro, Ọrẹ Ogunbiyi, Nosa Okundia, Phil Omodamwen, Patrick Oronsaye, Giles Peppiatt, John Picton, Sue Picton, Barbara Plankensteiner, Angela Rackham, Colin Renfrew, Nicholas Thomas, Abba Tijani, Theophilus Umogbai, Ivie Uwa-Igbinọba, Pauline Von Hellermann, Hermione Waterfield and Johanna Zetterstrom-Sharp. Like many others, I benefited from the wisdom of Ekhaguosa Aisien and Folarin Shyllon, both of whom sadly died in 2021.

Julie Hudson at the British Museum went out of her way to help on many occasions. So did Marjorie Caygill. Thank you also to the museum's Sam Nixon and Lissant Bolton, and to Malcolm McLeod and John Mack for their recollections.

A special mention for internet sleuth extraordinaire, Elwood Taylor in Pennsylvania.

I am indebted to Mark Dunton, Principal Records Specialist, Contemporary, at the National Archives, and Maggie Smart, Private Secretary to Lord David Owen.

My friends Simon Robinson and Adam Roberts, and my father Adrian Phillips, took time and trouble to read earlier manuscripts. They had excellent suggestions for improvements, and weeded out many embarrassing mistakes. Tamsin Shelton was a razor-sharp copy editor, and thank you to Erica Milwain for the maps. Any mistakes that remain are, of course, my responsibility.

In the world of elephant conservation, John Stephenson, Miles Geldard and John Scanlon have been accommodating and flexible as I sought time off from my day job.

Sam Carter at Oneworld believed in this project from the moment I suggested it, and has been an incisive and sympathetic editor throughout. His assistant, Rida Vaquas, has been supportive and resourceful. Thank you to Juliet Mabey and Novin Doostdar at Oneworld for their vision and enterprise. Thank you also to Oneworld's Laura McFarlane, Paul Nash, Juliana Pars, Matilda Warner, and Kate Bland.

Apologies to fellow Noel Road alumnus and comic genius, the late Joe Orton.

Finally, my greatest debt is to my dear wife Nicole. The events of 2020–21 threw unexpected and unwelcome complications in the paths of so many families, and ours was no exception, and yet somehow she was accommodating and encouraging throughout.

NOTES

Preface

1 Details of this meeting in the British Museum are based on author's interview with Julie Hudson at the British Museum, 31 October 2019; Enotie Ogbebor in Benin City, 12 March 2019; and Prince Gregory Akenzua in Benin City, 13 March 2019.

2 Author's interview with Giles Peppiatt, London, 2 December 2019.

3 https://www.nytimes.com/2017/05/10/arts/design/damien-hirst-controversy-at-venice-biennale.html

4 Author's interviews with Victor Ehikhamenor, London, 23 November 2017, and Lagos, 15 March 2019.

5 https://www.nytimes.com/2020/01/28/opinion/looted-benin-bronzes.html

6 Dark, *An Introduction to Benin Art and Technology*, plate 34.

7 Author's interview with Julie Hudson, London, 30 January 2020.

8 https://www.nytimes.com/2020/01/28/opinion/looted-benin-bronzes.html

1. The closer one gets to Benin, the farther away it is

1 Igbafe, 'A History of the Benin Kingdom: an Overview' in Plankensteiner (ed.), *Benin Kings and Rituals*, p. 53.

2 I spoke with Patrick Oronsaye in Benin City on 10 March 2019. The quotes that follow all come from that conversation.

3 Connah, *African Civilizations*, p. 134.

4 Ibid.

5 Nevadomsky, Půtová and Soukup, 'Benin Art and Casting Technologies'.

6 Correspondence with the UNESCO press office confirmed that Igun Street is not a World Heritage Site. Perhaps it should be.

7 c.120 members citing Chief Kingsley Inneh: https://www.bbc.co.uk/news/av/business-50466986/the-ancient-trade-of-benin-bronzes

8 Interview with Phil Omodamwen: https://www.trouw.nl/cultuur-media/interviews-finally-we-get-to-see-the-benin-bronzes-in-benin-city~b7b59c2c/?referer=https%3A%2F%2Fwww.google.com%2F

9 Nevadomsky, Půtová and Soukup, 'Benin Art and Casting Technologies'.

10 BBC, *The Tribal Eye – Kingdom of Bronze*.

11 Author's interview with Femi Akinsanya, Lagos, 16 March 2019.

12 Author's interview with Phil Omodamwen, Benin City, 12 March 2019.

13 BBC, *The Tribal Eye – Kingdom of Bronze*.

14 Egharevba, *A Short History of Benin*, p. 18.

15 Author's written correspondence with Dr Uyilawa Usuanlele, 6 June 2020.

16 Green, *A Fistful of Shells*, p. 165.

17 Peek and Picton, 'The Resonances of Osun across a Millennium of Nigerian History'. Also, author's telephone conversation with John Picton, 13 November 2019.

18 Ibid.

19 Igbafe, *Benin Under British Administration*, p. 1.

20 Bradbury, *The Benin Kingdom and the Edo-Speaking Peoples of South-Western Nigeria*, p. 35.

21 Barley, *The Art of Benin*, p. 23.

22 For examples see Ben-Amos, *The Art of Benin*: a plaque depicting Oba's leopard sacrifice, p. 30, and depicting Oba's victory, p. 35.

23 Ibid., p53.

24 Ben-Amos, *The Art of Benin*, p. 19.

25 Egharevba, *A Short History of Benin*, p. 1 (1960 edition).

26 Igbafe, 'A History of the Benin Kingdom: an Overview' in Plankensteiner (ed.), *Benin Kings and Rituals*, p. 41.

27 Jacob Egharevba, quoted in ibid., p. 43.

28 Ibid., p. 44.

29 Ogba, review of *The Benin-Ife Controversy*.

30 Egharevba, *A Short History of Benin*, p. 17.

31 Connah, *African Civilizations*, p. 134. Gérard Chouin of William & Mary University, US, is reinterpreting these skeletal remains and disagrees with Connah on the age and gender of the deceased, as well as the sacrifice hypothesis.

32 Igbafe, 'A History of the Benin Kingdom: an Overview' in Plankensteiner (ed.), *Benin Kings and Rituals*, p. 44.

33 Darling, *Archaeology and History in Southern Nigeria*, p. 6.

34 Egharevba, *A Short History of Benin*, p. 21.

35 Ben-Amos, *The Art of Benin*, p. 32.

36 Igbafe, 'A History of the Benin Kingdom: an Overview' in Plankensteiner (ed.), *Benin Kings and Rituals*, p. 46.

37 Ekhator, review of *Ewuare: The Oba of Benin*.

38 Igbafe, 'A History of the Benin Kingdom: an Overview' in Plankensteiner (ed.), *Benin Kings and Rituals*, p. 47.

39 See, for example, https://risdmuseum.org/art-design/projects-publications/articles/head-focus

40 Dark, *An Introduction to Benin Art and Technology*, plate 16.

2. Easily as big as the town of Haarlem and enclosed by a remarkable wall

1 Ryder, *Benin and the Europeans 1485–1897*, p. 25.

2 Egharevba, *A Short History of Benin*, p. 26.

3 Ryder, *Benin and the Europeans 1485–1897*, p. 30.

4 Green, *A Fistful of Shells*, p. 158.

5 Barley, *The Art of Benin*, p. 18.

6 Hakluyt, *Hakluyt's Collection of the Early Voyages, Travels and Discoveries of the English Nation*, Vol. 2, Account by Richard Eden, p. 466.

7 Ryder, *Benin and the Europeans 1485–1897*, p. 33.

8 Ibid., p. 47.

9 Ibid., p. 50.

10 Egharevba, *A Short History of Benin*, p. 36 (1936 edition).

11 Nevadomsky, 'The Benin Bronze Horseman as the Ata of Idah'.

12 Patrick Oronsaye in conversation with author, Benin City, 10 March 2019.

13 Ryder, *Benin and the Europeans 1485–1897*, p. 40.

14 Ben-Amos, *The Art of Benin*, p. 38.

15 Barley, *The Art of Benin*, p. 97.

16 Green, *A Fistful of Shells*, p. 160.

17 Ryder, *Benin and the Europeans 1485–1897*, p. 32.

18 Ibid., p. 71.

19 BBC Radio 4, *A History of the World in 100 Objects*, no. 77 – Benin Plaque, the Oba with Europeans.

20 Hakluyt, *Hakluyt's Collection of the Early Voyages, Travels and Discoveries of the English Nation*, Vol. 2, Account by Richard Eden, p. 466.

21 Ibid.

22 Ibid., p. 467.

23 Connah, *African Civilizations*, p. 121.

24 Gallwey, 'Journeys in the Benin Country, West Africa'.

25 Hakluyt, *Hakluyt's Collection of the Early Voyages, Travels and Discoveries of the English Nation*, Vol. 2, Account by Richard Eden, p. 467.

26 Ibid.

27 Egharevba, *A Short History of Benin*, p. 30 (1936 edition).

28 Hakluyt, *Hakluyt's Collection of the Early Voyages, Travels and Discoveries of the English Nation*, Vol. 2, Account by Richard Eden, p. 469.

29 Ibid., 'A Voyage to Benin beyond the countrey of Guinea made by Master James Welsh, who set foorth in the yeere 1588', p. 616.

30 Ibid., Letter from Anthony Ingram to John Newton and John Bird, p. 617.

31 Ibid., 'The Second Voyage to Benin' by Master James Welsh, p. 618.

32 Egharevba, *A Short History of Benin*, p. 39 (1936 edition).

33 Ryder, *Benin and the Europeans 1485–1897*, p. 84.

34 This account by D.R, who is thought to be Dierick Ruiters, is cited in Hodgkin, *Nigerian Perspectives*, p. 156.

35 Again, thought to be Dierick Ruiters, written up by Artus of Dantzick, and cited by Astley, *Astley's Voyages*, Vol. III, Book II, *Voyages and Travels to Benin*, p. 94.

36 Ibid., p. 103.

37 All quotes from Olfert Dapper taken from Hodgkin, *Nigerian Perspectives*, pp. 159–71.

38 Hugh Trevor-Roper, *The Rise of Christian Europe* (London, Thames & Hudson, 1965), cited in Worden, *Hugh Trevor-Roper: The Historian*, p. 17.

39 Quotes from Van Nyendael from Roth, *Great Benin*, p. 162.

40 Quotes from Van Nyendael cited by Astley in *Astley's Voyages*, Vol. III, Book II, *Voyages and Travels to Benin*, p. 100.

41 Ryder, *Benin and the Europeans 1485–1897*, p. 101.

42 Ibid., p. 105.

43 Egharevba, *A Short History of Benin*, p. 36 (1960 edition).

44 Ibid., p. 38.

45 Ryder, *Benin and the Europeans 1485–1897*, p. 119.

46 Ibid., p. 113, note 3, citing Lourenço Pinto's deposition in *A.S.C. Acta Generalia*, vol. 64, f. 55, no. 27, 20 April 1694.

47 Astley, *Astley's Voyages*, Vol. III, Book II, *Voyages and Travels to Benin*, p. 95.

48 Olfert Dapper cited in Hodgkin, *Nigerian Perspectives*, p. 164.

49 For examples, see Astley, *Astley's Voyages*, and Green, *A Fistful of Shells*.

50 Ojo, 'Slavery and Human Sacrifice in Yorubaland: Ondo 1870–94'.

51 Bradbury, *The Benin Kingdom and the Edo-Speaking Peoples of South-Western Nigeria*, p. 54.

52 Ben-Amos, *The Art of Benin*, p. 69.

53 Adams, *Remarks on the Country Extending from Cape Palmas to the River Congo*, p. 115.

54 Law, 'Human Sacrifice in Pre-colonial West Africa'.

55 All quotes from Patrick Oronsaye in conversation with author, Benin City, 10 March 2019.

56 Snelgrave, *A New Account of Guinea and the Slave Trade*, pp. 160–1.

57 Law, 'Human Sacrifice in Pre-colonial West Africa'.

58 Cunliffe-Jones, *My Nigeria*, p. 45.

59 Bondarenko, 'Benin and Slavery', p. 57

60 Quotes of Jacobus Munnickhoven and Hugh Crow from Ryder, *Benin and the Europeans 1485–1897*, p. 169.

61 Ibid., p. 198.

62 Astley, *Astley's Voyages*, Vol. III, Book II, *Voyages and Travels to Benin*, p. 91.

63 Adams, *Remarks on the Country Extending from Cape Palmas to the River Congo*, p. 115.

64 Lieutenant Levinge quoted in Crowder, *The Story of Nigeria*, p. 128.

65 Graham, 'The Slave Trade, Depopulation and Human Sacrifice in Benin History'.

66 Ryder, *Benin and the Europeans 1485–1897*, p. 232.

67 Crowder, *The Story of Nigeria*, p. 131.

3. The white men, greater than me and you, are coming shortly to fight and remove you

1 All Richard Burton quotes taken from Burton, 'My Wanderings in West Africa: A Visit to the Renowned Cities of Warri and Benin'.

2 All *Royal Gold Coast Gazette* quotes taken from 25 March 1823.

3 Law, 'Human Sacrifice in Pre-colonial West Africa'.

4 Ojo, 'Slavery and Human Sacrifice in Yorubaland: Ondo 1870–94'.

5 Akenzua, 'Benin-1897, A Bini's View'.

6 Ryder, *Benin and the Europeans 1485–1897*, p. 248.

7 Ibid., p. 256.

8 Cunliffe-Jones, *My Nigeria*, p. 50.

9 Home, *City of Blood Revisited*, p. 22.

10 Ibid., p. 3.

11 Egharevba, *A Short History of Benin*, p. 65 (1936 edition).

12 Ibid., p. 66, and see also Ryder, *Benin and the Europeans 1485–1897*, p. 262.

13 Author's interview with Patrick Oronsaye, Benin City, 10 March 2019.

14 Ibid.

15 Home, *City of Blood Revisited*, p. 4.

16 Galway, 'Benin City'.

17 Galway, 'Nigeria in the Nineties', and Galway, 'West Africa Fifty Years Ago'. (NB Henry Gallwey had changed the spelling of his name to Galway.)

18 Galway, 'Benin City'.

19 Gallwey, 'Journeys in the Benin Country, West Africa'.

20 Ibid.

21 Galway, 'Nigeria in the Nineties', and Galway, 'Benin City'.

22 Galway, 'Nigeria in the Nineties'.

23 Report on visit to Ubini (Benin City) by H. M. Gallwey, 1892, from PRO, FO 84/2184, cited in Ryder, *Benin and the Europeans 1485–1897*, Appendix IX, p. 344.

24 Ibid.

25 Galway, 'Nigeria in the Nineties'.

26 Egharevba, *A Short History of Benin*, Appendix X, p. 97 (1936 edition).

27 Galway, 'Nigeria in the Nineties'.

28 Gallwey, 'Journeys in the Benin Country, West Africa'.

29 Galway, 'West Africa Fifty Years Ago'.

30 Galway, 'Nigeria in the Nineties'.

31 Ryder, *Benin and the Europeans 1485–1897*, p. 249.

32 Roth, *Great Benin*, p. 66.

33 Egharevba, *A Short History of Benin*, p. 97.

34 *The Times*, 13 January 1897.

35 Igbafe, 'The Fall of Benin: A Reassessment'.

36 Home, *City of Blood Revisited*, p. 8.

37 Gallwey, 'Journeys in the Benin Country, West Africa'.

38 Igbafe, 'The Fall of Benin: A Reassessment'.

39 Jaja obituary in *New York Times*, 1891, https://web.archive.org/web/20110714072156/http://mendnigerdelta.com/wp-content/uploads/2010/03/King_JaJa_of_Opobo_death_annoucement_NYtimes_1891_mendnigerdelta.pdf

40 Gallwey, 'Journeys in the Benin Country, West Africa'.

41 Ikime, *Merchant Prince of the Niger Delta*, pp. 97–140.

42 Anonymous account of sailor, presumably on board HMS *Philomel* under command of Rear-Admiral F. G. Bedford, in Caird Library, National Maritime Museum, Greenwich, MSS 73/089.

43 Home, *City of Blood Revisited*, pp. 8–9.

44 Salubi, 'The Establishment of British Administration in the Urhobo Country (1891–1913)'.

45 Egharevba, *A Short History of Benin*, p. 67 (1936 edition).

46 Home, *City of Blood Revisited*, pp. 12–13.

47 Blathwayt, *Through Life and Round the World*, pp. 317–28.

48 Igbafe, 'The Fall of Benin: A Reassessment'.

49 Ibid., and Karpinski, 'A Benin Bronze Horseman at the Merseyside County Museum'.

50 Ryder, *Benin and the Europeans 1485–1897*, pp. 278, 282.

51 Egharevba, *A Short History of Benin*, p. 66 (1936 edition).

52 Moor to Foreign Office, 14 June 1896, quoted in Ryder, *Benin and the Europeans 1485–1897*, p. 282.

53 Ibid.

54 Morris, *Pax Britannica*, p. 109.

55 Home, *City of Blood Revisited*, p. 28.

56 Morris, *Pax Britannica*, p. 220.

57 Notes from *Uppingham School Magazine* kindly given to author by Robert Home.

58 Home, *City of Blood Revisited*, p. 31.

59 CSO 1/13, 6, Phillips to FO no. 105 of 16 November 1896, quoted in Igbafe, 'The Fall of Benin: A Reassessment'.

60 Home, *City of Blood Revisited*, p. 62.

61 CSO 1/13, 6, Phillips to FO no. 105 of 16 November 1896, quoted in Igbafe, 'The Fall of Benin: A Reassessment'.

62 Home, *City of Blood Revisited*, p. 31.

63 Douglas, *Niger Memories*, p. 35.

64 Ryder, *Benin and the Europeans 1485–1897*, p. 285.

4. No revolvers, gentlemen, no revolvers

1 Author's visit to Ugbine, 8 March 2019.

2 Douglas, *Niger Memories*, p. 35.

3 *Daily Telegraph*, 18 January 1897.

4 Boisragon, *The Benin Massacre*, p. 68, and Ryder, *Benin and the Europeans 1485–1897*, p. 280.

5 Curnow, 'The Art of Fasting: Benin's Ague Ceremony'.

6 Home, *City of Blood Revisited*, p. 41.

7 Boisragon, *The Benin Massacre*, p. 81.

8 Ibid., p. 83.

9 Ibid., p. 86.

10 [Lagos] *Guardian*, 16 February 1997, quoting village elder Ogieva Osunde, who said he was 112 years old and could remember the events of 1897.

11 Boisragon, *The Benin Massacre*, p. 66.

12 Ibid., p. 102, and Bacon, *Benin*, p. 17.

13 *The Times*, 12 January 1897.

14 *Daily Telegraph*, 12 January 1897.

15 *The Times*, 13 January 1897, while *Lagos Weekly Record*, 23 January 1897, says twenty Africans survived.

16 *Daily Telegraph*, 12 January 1897.

17 Ibid., 16 January 1897.

18 Boisragon, *The Benin Massacre*, p. 102.

19 Ibid., p. 134.

20 Ibid., p. 151.

21 *Daily Telegraph*, 18 January 1897.

22 Hernon, *Britain's Forgotten Wars*, p. 411.

23 Notes from *Uppingham School Magazine* kindly shared with author by Robert Home.

24 War Memorials Register, Imperial War Museum, https://www.iwm.org.uk/memorials/item/memorial/70542

25 Hopwood and Godwin, *A Photographer's Odyssey*, p. 162.

26 Accounts of this meeting in Benin City come from proceedings of the Oba's trial, PRO FO 2/123, quoted in Ryder, *Benin and the Europeans 1485–1897*, p. 287.

27 Akenzua, 'Benin – 1897, A Bini's View'.

28 Papers relating to the massacre of British officials near Benin, August 1897, Cd.8677, HMSO London, 1897, quoted in Ryder, *Benin and the Europeans 1485–1897*, p. 289, and Roth, *Great Benin*, Appendix III: The Surrender and Trial of the King, p. xvi.

29 Akenzua, 'Benin – 1897, A Bini's View'.

30 Queen Victoria's Journal, 12 January 1897, http://www.queenvictoriasjournals.org/home.do

31 *Manchester Guardian*, 12 January 1897.

32 Ibid.

33 *Daily Telegraph*, 14 January 1897.

34 *Morning Post*, 14 January 1897.

35 *The Times*, 16 January 1897.

36 Home, *City of Blood Revisited*, p. 51.

37 Ibid.

5. English justice, when outraged, is something to be feared

1 Rawson, *Life of Admiral Sir Harry Rawson*, p. 159. According to the Australian Maritime Museum, the author Geoffrey Rawson was Harry Rawson's son. But in genealogy records, obituaries and Harry Rawson's will (which names two sons and a daughter) I can find no evidence the two men are related.

2 https://www.bonhams.com/auctions/21761/lot/18/

3 Biographical details of Rawson from ibid., and obituary, *The Times*, 4 November 1910.

4 *The Times*, 9 March 1914.

5 Hernon, *Britain's Forgotten Wars*, p. 397.

6 https://www.bonhams.com/auctions/21761/lot/1/?category=list

7 George Curzon quoted in Morris, *Pax Britannica*, p. 122.

8 John Davidson quoted in ibid., p. 129.

9 Dickens, *Bleak House*, p. 234.

10 *Daily Telegraph*, 12 January 1897.

11 *London Illustrated News*, 23 January 1897.

12 *The Times*, 12 January 1897.

13 *Manchester Guardian*, 12 January 1897.

14 *Daily Telegraph*, 14 January 1897.

15 Galway, 'Benin City'.

16 *Daily Telegraph*, 22 January 1897.

17 *Western Mail*, 18 January 1897.

18 *Daily Telegraph*, 18 January 1897.

19 *The Times*, 13 January 1897.

20 https://durhamweather.co.uk/wp-content/uploads/2018/10/bonacina.html

21 *Daily Telegraph*, 25 January 1897.

22 Admiral Sir Vernon Harry Stuart Haggard Private Papers in Imperial War Museum Documents, 19510.

23 Bacon, *Benin*, p. 23.

24 Ibid., and Admiral Sir Vernon Harry Stuart Haggard Private Papers in Imperial War Museum Documents, 19510.

25 Home, *City of Blood Revisited*, p. 61.

26 *Daily Telegraph*, 22 January 1897.

27 Home, *City of Blood Revisited*, p. 49.

28 Press clipping datelined 'Lagos, January 21st' in private diary of Herbert Walker. According to other accounts, the Oba sent down the amputated finger of Thomas Gordon with a signet ring (*Liverpool Mercury*, 16 February 1897, cited in Karpinski, 'A Benin Bronze Horseman at the Merseyside County Museum') and/or two of Copland-Crawford's rings (Boisragon, *The Benin Massacre*, p. 159).

29 All details on Aisien's war are taken from Aisien, *Aisien: Son of Erhunmwunsẹe and the British – the 1897 War* and author's interview with Ekhaguosa Aisien, Benin City, 9 March 2019.

30 *The Times*, 15 January 1897.

31 *Daily Telegraph*, 16 January 1897.

32 Papers of Commander Stokes Rees of HMS *St George* STR 14, National Maritime Museum, Greenwich.

33 Rawson's report on the Benin Expedition, included in the private diary of Herbert Walker.

34 Home, *City of Blood Revisited*, pp. 62, 93.

35 Bacon, *Benin*, p. 34.

36 Letter from retired Vice-Admiral Gilbert Stephenson, 31 January 1964, to Robert Home, kindly shared with author.

37 Curtin, 'The End of the "White Man's Grave"? Nineteenth-Century Mortality in West Africa'.

38 *Daily Telegraph*, 16 January 1897.

39 Curtin, 'The End of the "White Man's Grave"? Nineteenth-Century Mortality in West Africa'.

40 All mortality data and history of quinine use in ibid.

41 Home, *City of Blood Revisited*, p. 59.

42 Bacon, *Benin*, pp. 48, 130.

43 Admiral Sir Vernon Harry Stuart Haggard Private Papers in Imperial War Museum Documents, 19510.
44 Papers of Commander Stokes Rees of HMS *St George* STR 8 and STR 9, National Maritime Museum, Greenwich.
45 Home, *City of Blood Revisited*, p. 76.
46 Bacon, *Benin*, p. 69.
47 Home, *City of Blood Revisited*, p. 60.
48 Papers of Commander Stokes Rees of HMS *St George* STR 8 and STR 9, National Maritime Museum, Greenwich.
49 *The Times*, 16 January 1897.
50 *Daily Telegraph*, 23 January 1897.
51 Gallwey, 'Journeys in the Benin Country, West Africa'.
52 *Daily Telegraph*, 21 January 1897.
53 Rawson, *Life of Admiral Sir Harry Rawson*, p. 22.
54 Admiral Harry Rawson, General Orders, p. 37, 30 January 1897, National Museum Lagos Nigeria, also National Archives ADM 123/128. A copy of these orders on sale at Peter Harrington Bookshop in London in 2022 for £5,750.

6. No force on Earth can stop the British from getting to Benin

1 Heneker, *Bush Warfare*, pp. 66–8.
2 Home, *City of Blood Revisited*, p. 65.
3 Admiral Sir Vernon Harry Stuart Haggard Private Papers in Imperial War Museum Documents, 19510.
4 Captain Herbert Walker obituary, one published obituary shared with author by family, and also in *Daily Telegraph*, 14 April 1932.
5 Captain Herbert Walker Diary of Benin Expedition, 11 and 12 February 1897, shared with author by family.
6 Ibid.
7 Aisien, *Aisien: Son of Erhunmwunse`e and the British – the 1897 War*, pp. 18–20, and author's conversation with Ekhaguosa Aisien, Benin City, 9 March 2019.
8 Ibid.
9 Author's conversation with Ekhaguosa Aisien, Benin City, 9 March 2019.
10 Home, *City of Blood Revisited*, p. 69.
11 Belloc, *The Modern Traveller*, p. 41.
12 Heneker, *Bush Warfare*, p. 120.
13 Bacon, *Benin*, p. 41.
14 Home, *City of Blood Revisited*, p. 71.
15 Bacon, *Benin*, p. 42.
16 Dawson, *The Sound of the Guns*, p. 35.
17 Home, *City of Blood Revisited*, p. 87.

18 Bacon, *Benin*, p. 42.

19 Ibid., p. 46.

20 Roth, *Great Benin*, Appendix II, Diary of Felix Roth, p. vi.

21 Ibid, p. vii.

22 Captain Herbert Walker Diary of Benin Expedition, 17 February 1897, shared with author by family.

23 Roth, *Great Benin*, Appendix II, Diary of Felix Roth, p. ix.

24 Bacon, *Benin*, p. 57.

25 Letter from retired Vice-Admiral Gilbert Stephenson, 31 January 1964, to Robert Home, kindly shared with author.

26 Home, *City of Blood Revisited*, p. 66, and Rawson, *Life of Admiral Sir Harry Rawson*, p. 161.

27 National Maritime Museum, Greenwich, AGC/12/25 Letter from Rawson, 21 January 1897, from 'Kings Palace, Benin City' to Sir Frederick Richards, First Sea Lord.

28 Rawson, *Life of Admiral Sir Harry Rawson*, p. 161.

29 Roth, *Great Benin*, Appendix II, Diary of Felix Roth, p. viii.

30 Home, *City of Blood Revisited*, p. 76.

31 Dawson, *The Sound of the Guns*, p. 34, and Bacon, *Benin*, p. 68.

32 Bacon, *Benin*, p. 68.

33 Dawson, *The Sound of the Guns*, p. 34.

34 *London Gazette*, 7 May 1897.

35 Home, *City of Blood Revisited*, p. 77.

36 *Manchester Guardian*, 25 March 1897. Walker and Haggard call this village 'Awoko'.

37 Roth, *Great Benin*, Appendix II, Diary of Felix Roth, p. ix.

38 Captain Herbert Walker Diary of Benin Expedition, 18 February 1897, shared with author by family.

39 Bacon, *Benin*, p. 81.

40 Ibid.

41 *Daily Telegraph*, 30 January 1897.

42 Home, *City of Blood Revisited*, p. 84.

43 *The Times*, 27 March 1897.

44 Roth, *Great Benin*, Appendix II, Diary of Felix Roth, p. x.

45 Home, *City of Blood Revisited*, p. 83.

46 *The Times*, 9 March 1914.

47 Letter from retired Vice-Admiral Gilbert Stephenson, 31 January 1964, to Robert Home, kindly shared with author, and Baker, *The Terror of Tobermory*, p. 10.

48 Captain Herbert Walker Diary of Benin Expedition, 18 February 1897, shared with author by family.

49 Bacon, *Benin*, p. 83.

50 Home, *City of Blood Revisited*, p. 86.
51 Roth, *Great Benin*, Appendix II, Diary of Felix Roth, p. x.
52 Home, *City of Blood Revisited*, p. 86.
53 National Maritime Museum, Greenwich, AGC/12/25 Letter from Rawson, 21 February 1897, from 'Kings Palace, Benin City' to Sir Frederick Richards, First Sea Lord.
54 Private Albert Lucy's diary sold at Bonhams, 3 December 2014, https://www.bonhams.com/auctions/21827/lot/160/
55 Allman, 'With the Punitive Expedition to Benin City'.
56 Home, *City of Blood Revisited*, p. 88.
57 Captain Herbert Walker Diary of Benin Expedition, 22 February 1897, shared with author by family.
58 Allman, 'With the Punitive Expedition to Benin City', and National Maritime Museum, Greenwich, HSR/2/2, Newspaper Report, 6 March 1897, from Benin City, via Lagos, 22 March 1897.
59 Edgar Dimsey's fascinating letter, from 27 February 1897, was displayed in a Christie's sale at Paris, 14 June 2004, https://www.christies.com/en/lot/lot-4308640.
60 Bacon, *Benin*, p. 89.
61 Author's interview with Aiko Obabaifo, Benin City, 8 March 2019.
62 Rowlands, 'The Good and Bad Death: Ritual Killing and Historical Transformation in a West African Kingdom'.
63 Author's Skype interview with Kathy Curnow, 28 July 2020.
64 Akenzua, 'Benin – 1897, A Bini's View'.

7. A regular harvest of loot!

1 *Manchester Guardian*, 25 March 1897.
2 Captain Herbert Walker Diary of Benin Expedition, 19 February 1897, shared with author by family.
3 Allman, 'With the Punitive Expedition to Benin City'.
4 Bacon, *Benin*, p. 91.
5 Ibid.
6 Bacon, *A Naval Scrap-Book 1877–1900*, p. 208.
7 Roth, *Great Benin*, Appendix II, Diary of Felix Roth, p. xi.
8 Galway, 'Nigeria in the Nineties'.
9 Captain Herbert Walker Diary of Benin Expedition, 20 February 1897, shared with author by family.
10 Home, *City of Blood Revisited*, p. 101.
11 Ibid.
12 Dawson, *The Sound of the Guns*, p. 36.

13 Read and Dalton, *Antiquities from the City of Benin and from Other Parts of West Africa in the British Museum*, Preface.

14 PRO FO 83/1528 and 83/1520 Crown Agents For The Colonies to FO, 30 June and 17 July 1897, quoted in Ratté, 'Imperial Looting and the Case of Benin', p. 77.

15 Private Albert Lucy's diary sold at Bonhams, 3 December 2014, https://www.bonhams.com/auctions/21827/lot/160/

16 Captain Herbert Walker Diary of Benin Expedition, 20 February 1897, shared with author by family.

17 Dawson, *The Sound of the Guns*, p. 36.

18 Admiral Sir Vernon Harry Stuart Haggard Private Papers in Imperial War Museum Documents, 19510.

19 Captain Herbert Walker Diary of Benin Expedition, 12 March 1897, shared with author by family

20 Ibid., 15 March 1897.

21 Ibid., 16 March 1897.

22 Lundén, 'Displaying Loot', p. 7, citing Felix von Luschan and Philip Dark.

23 National Maritime Museum, Greenwich, AGC/12/25 Letter from Rawson, 21 February 1897, from 'Kings Palace, Benin City' to Sir Frederick Richards, First Sea Lord.

24 Roth, *Great Benin*, Appendix II, Diary of Felix Roth, p. xii.

25 Akenzua, 'Benin – 1897, A Bini's View'.

26 Author's interview with Patrick Oronsaye, Benin City, 9 March 2019.

27 Private Albert Lucy's diary sold at Bonhams, 3 December 2014, https://www.bonhams.com/auctions/21827/lot/160/

28 Information on looting and burning of Maqdala from V&A Maqdala 1868 Exhibition 2018–19, and historian Richard Pankhurst, http://www.afromet.info/history/

29 Home, *City of Blood Revisited*, p. 89.

30 Rawson, *Life of Admiral Sir Harry Rawson*, p. 96.

31 Heneker, *Bush Warfare*, p. 5.

32 National Maritime Museum, Greenwich, AGC/12/25 Letter from Rawson, 21 January 1897, from 'Kings Palace, Benin City' to Sir Frederick Richards, First Sea Lord.

33 Captain Herbert Walker Diary of Benin Expedition, 21 February 1897, shared with author by family.

34 Home, *City of Blood Revisited*, p. 89.

35 Admiral Sir Vernon Harry Stuart Haggard Private Papers in Imperial War Museum Documents, 19510.

36 National Maritime Museum, Greenwich, Stokes Rees Papers, STR14, Cockburn letter.

37 Home, *City of Blood Revisited*, p. 90.

38 A British Museum list of Benin Objects from the 1970s, compiled by McLeod
 in AOA/Benin/BM collections. Individual Cockburn collections at AOA/
 Collection File: Af1897,0.528, AOA/Collection File: Af1897,0.498-0.563, AOA/
 Collection File: Af1897,0619.1, AOA/Collection File: Af1899,0515.1, AOA/
 Collection File: Af1905,1201.1-5.

39 Bacon, *Benin*, p. 104, and National Maritime Museum, Greenwich, AGC/12/25
 Letter from Rawson, 21 February 1897, from 'Kings Palace, Benin City' to Sir
 Frederick Richards, First Sea Lord.

40 Captain Herbert Walker Diary of Benin Expedition, 20 February 1897, shared
 with author by family.

41 Boisragon, *The Benin Massacre*, p. 171, and Heneker, *Bush Warfare*, p. 168.

42 Admiral Sir Vernon Harry Stuart Haggard Private Papers in Imperial War
 Museum Documents, 19510.

43 Heneker, *Bush Warfare*, p. 5.

44 A British Museum list of Benin Objects from the 1970s compiled by McLeod
 in AOA/Benin/BM collections (twenty-two objects bought, and one more
 came into the BM collection at a later date, probably directly from Heneker).
 Individual Heneker items at AOA/Collection File: Af1900,0720.2-23, AOA/
 Collection File: Af1979,01.4476.

45 *The Times*, 25 May 1939, William Charles Gifford Heneker obituary.

46 Akenzua, 'Benin – 1897, A Bini's View'.

47 Private correspondence seen by author.

48 *The Times*, 30 May 1972, Admiral Gilbert Stephenson obituary. He was one of
 several officers who'd been at Benin who played prominent roles in Gallipoli,
 including two Lieutenants from the *Theseus* who experienced wildly different
 fortunes. Edward Unwin earnt a VC for his courage in bringing soldiers ashore
 amid enemy fire, undeterred by injury and bitterly cold water (*The Times*,
 20 April 1950, Unwin obituary). 'No VC was better earned than his,' wrote
 Stephenson (Letter to Robert Home, 5 February 1964). In contrast, Sackville
 Carden, by 1915 a possibly over-promoted Vice-Admiral, received much of
 the blame for the fiasco of the Dardanelles and Gallipoli, suffered a nervous
 breakdown and retired in disgrace (*The Times*, 8 May 1930, Carden obituary,
 and Carden, *Carden and the Dardanelles*).

49 Baker, *The Terror of Tobermory*, p. 10.

50 Interview with Admiral Stephenson as told to author during interview with
 Lance Entwistle, London, 9 July 2019.

51 *The Times*, 1 February 1960, Haggard obituary.

52 Admiral Sir Vernon Harry Stuart Haggard Private Papers in Imperial War
 Museum Documents, 19510.

8. The white man is the only man who is King in this country

1 Callaghan, *Time and Chance*, p. 22.

2 Ibid., p. 23.

3 *Guardian*, 28 March 2005, Callaghan obituary.

4 Letter from James Callaghan to Robert Home, 23 July 1964, in which he writes, 'I am afraid I knew nothing about the expedition to Benin City and first heard of it on receiving your letter.' This is contradicted by his subsequent biography, p. 32, in which he says his father spoke to him about the Benin Expedition.

5 National Maritime Museum, Greenwich, Letter from Admiral Rawson to Sir Frederick Richards. AGC/12/25.

6 Home, *City of Blood Revisited*, p. 97.

7 Bacon, *Benin*, p. 129.

8 Admiral Sir Vernon Harry Stuart Haggard Private Papers in Imperial War Museum, 19510.

9 Ibid.

10 National Maritime Museum, Greenwich, Letter from Admiral Rawson to Sir Frederick Richards. AGC/12/25.

11 Bacon, *A Naval Scrap-Book 1877–1900*, p. 217.

12 Edgar Dimsey's letter to his father https://www.christies.com/en/lot/lot-4308640.

13 Bacon, *Benin*, p. 131.

14 Newspaper clipping, undated, March 1897, in National Maritime Museum, Greenwich, HSR/2/2.

15 *The Times*, 27 March 1897.

16 Bacon, *Benin*, p. 19.

17 Lundén, 'Displaying Loot', p. 130.

18 Home, *City of Blood Revisited*, p. 97, and Rawson's honours in *The Times*, 26 May 1897.

19 *The Times*, 19 February 1897, and *Manchester Guardian*, 23 February 1897.

20 Home, *City of Blood Revisited*, p. 90.

21 Letter from Captain L. Llewellyn to Robert Home, 23 January, probably 1964.

22 *Illustrated London News*, 27 March 1897.

23 Bacon, *Benin*, p. 110.

24 *Illustrated London News*, 27 March 1897.

25 Morris, *Pax Britannica*, p. 26.

26 *The Times*, 4 and 8 June 1897.

27 Ibid., 3 June 1897. For a list of ships that took part in the Diamond Jubilee Naval Review, see https://www.naval-history.net/xGW-RNOrganisation1897.htm

28 Allen, *Kipling Sahib*, p. 341.

29 Morris, *Pax Britannica*, p. 347.

30 *Illustrated London News*, 27 March 1897.

31 Letter from the Duke of Wellington to Lord Castlereagh, 23 September 1815, published in *The Times*, 14 October 1815.

32 Brodie, 'Problematizing the encyclopedic museum: the Benin bronzes and ivories in historical context'.

33 Ibid.

34 Herman, 'Law, Restitution and the Benin Bronzes'.

35 *Oxford Manual of the Laws of War on Land* quoted in ibid.

36 Ibid.

37 War Office Manual quoted in Brodie, 'Problematizing the encyclopedic museum: the Benin bronzes and ivories in historical context'.

38 Westlake quoted in ibid.

39 https://hansard.parliament.uk/Commons/1871-06-30/debates/0e763636-72ee-4a5c-bb3f-f6b19e10922f/AbyssinianWar%E2%80%94Prize%E2%80%94TheAbanaSCrownAndChalice

40 Herman, 'Law, Restitution and the Benin Bronzes'.

41 National Archives 83/1610 Moor to FO 9 June 1898.

42 Mr Clarke's memo of 7 May 1898 in Ratté, 'Imperial Looting and the case of Benin', p. 86.

43 National Archives 83/1610 Moor to FO 9 June 1898.

44 Ibid.

45 Herman, 'Law, Restitution and the Benin Bronzes'.

46 Letter 18 June 1897, *Golf: A Weekly Record of 'Ye Royal and Auncient' Game*, p. 295, Issue 362, quoted in Husemann, 'Golf in the "City of Blood": the Translation of the Benin Bronzes in 19th Century Britain and Germany', https://www.soas.ac.uk/doctoralschool/rsa/journalofgraduateresearch/edition-5/file84474.pdf

47 *The Times*, 19 October 1897.

48 Galway, 'Benin City'.

49 This account of Aisien's capture and trial taken from author's interview with Ekhaguosa Aisien, Benin City, 9 March 2019, and Aisien, *Aisien: Son of Erhunmwunsee and the British – the 1897 War*, pp. 22–8.

50 *Daily Telegraph*, 22 April 1897.

51 Captain Herbert Walker Diary of Benin Expedition, 8 and 9 March 1897, shared with author by family.

52 The descriptions of the Oba surrendering himself and the court case are taken from Roth, *Great Benin*, Appendix III, The Surrender and Trial of the King.

53 Galway, 'Benin City'.

54 Home, *City of Blood Revisited*, p. 112.

55 Roth, *Great Benin*, Appendix III, The Surrender and Trial of the King, p. xvii.

56 Home, *City of Blood Revisited*, p. 112.

57 Galway, 'Benin City'.

58 Egharevba, *A Short History of Benin*, p. 61.

59 Author's interviews in Ugbine village, 8 March 2019, and *Lagos Guardian*, 1 June 1997.

60 Sung to author by village elders in Ughoton, 8 March 2019.

9. See how their families fared

1 For details of Royal Military Tournament of 1898 see *The Times*, 20 May 1898, and *Daily Telegraph*, 1 June 1898.

2 Photographs of Lieutenant Norman Burrows and his Benin Bronzes in National Army Museum 1966-12-45.

3 For Burrows's sales in April, May and June 1898, see the database of the Augustus Pitt Rivers collection at http://web.prm.ox.ac.uk/rpr/index.php/databases.html. Money conversion from https://www.measuringworth.com

4 https://hansard.parliament.uk/Commons/1899-04-20/debates/96561fc4-bed8-4457-b14e-e7474878412e/BeninExpedition?highlight=benin#contribut ion-5b4e7089-f79f-46eb-add3-bb90e101483b

5 Igbafe, *Benin Under British Administration*, p. 102.

6 Home, *City of Blood Revisited*, p. 119.

7 Igbafe, *Benin Under British Administration*, p. 104.

8 Photo in Home, *City of Blood Revisited*.

9 Galway, 'Benin City'.

10 Igbafe, *Benin Under British Administration*, p. 105.

11 *The Times*, 10 June 1947, Bacon obituary.

12 Bacon, *From 1900 Onward*, p. 157.

13 *The Times*, 8 February and 17 February 1937, and *Daily Mirror*, 1 October 1927.

14 Ibid.

15 Benin Honours, *The Times*, 26 May 1897.

16 *The Times*, 22 July 1929, Stokes Rees obituary.

17 *The Times*, 27 September 1948, Startin obituary.

18 Photo of Child and Ovonramwen in chains on board *Ivy* in *Benin Kings and Rituals*, p. 87.

19 War Memorials Register, Imperial War Museum, https://www.iwm.org.uk/memorials/item/memorial/55425

20 Lives of the First World War, Imperial War Museum, https://livesofthefirstworldwar.iwm.org.uk/lifestory/1279921

21 *The Times*, 2 April 1940, Egerton obituary.

22 *The Times*, 15 February 1956, Cowan obituary, and Home, *City of Blood Revisited*, p. 94.

23 *The Times*, 11 September 1936, Nicholson obituary.

24　*The Times*, 17 January 1952, and Fagg, 'A Nigerian Bronze Figure from the Benin Expedition'.

25　National Maritime Museum, Greenwich, Object ID AAA0557, West African Flag.

26　*The Times*, 12 July 1939, Kennedy obituary.

27　*Daily Mail*, 12 July 1900.

28　Dodge Luhan, *Intimate Memories*, pp. 106–11.

29　*The Times*, 4 August 1938.

30　Hamilton's promotion in Benin Honours, *The Times*, 26 May 1897.

31　*The Times*, 7 July 1936, and Daily Telegraph, 7 July 1936, for obituary details. Parliamentary questions re 'Brute Hamilton' in https://hansard.parliament.uk/Commons/1901-02-18/debates/f049efd1-9ddb-4547-94ec-4e9f018cff5a/AddressInAnswerToHisMajestySMostGraciousSpeech and https://hansard.parliament.uk/Commons/1901-02-25/debates/ba44258a-f762-4682-b311-7d2b0e29ad9c/FarmBurningEtc%E2%80%94OperationsOfGeneralBruce Hamilton

32　Home, *City of Blood Revisited*, p. 94.

33　Rawson, *Life of Admiral Sir Harry Rawson*, p. 159, and *The Times*, 4 February 1898.

34　Queen Victoria's Journal, 18 August 1898 and 22 January 1899 http://www.queenvictoriasjournals.org/home.do

35　*The Times*, 4 November 1910, Rawson obituary.

36　Online Australian Dictionary of Biography, http://oa.anu.edu.au/obituary/rawson-hubert-wyatt-h-23509

37　Cunliffe-Jones, *My Nigeria*, p. 66. Money conversion from https://www.measuringworth.com

38　Home, *City of Blood Revisited*, p. 120.

39　Ibid., p. 123.

40　Ayandele, *Holy Johnson*, p. 271.

41　Home, *City of Blood Revisited*, p. 123.

42　*The Times*, 17 February 1897.

43　All details on Moor's death from *The Times*, 15 and 17 September 1909, *Daily Telegraph*, 16 September 1909, *Manchester Guardian*, 16 and 17 September 1909, and *Daily Mail*, 16 September 1909.

44　Bacon, *A Naval Scrap-Book 1877–1900*, p. 192.

45　Smith, M., 'The Seligman Mask and the R.A.I.'. For the detail of how the mask came via Captain John Sparks, see Fagg, W., 'The Seligman Ivory Mask from Benin: The Royal Anthropological Institute Christmas Card for 1957'.

46　*New York Tribune*, 27 December 1914.

47　Lady Moor's death date in Peraldi, 'Oba Akenzua II's Restitution Requests'.

10. Purely African, thoroughly and exclusively out and out African

1 Coombes, *Reinventing Africa*, p. 60.
2 *The Times*, 25 September 1897.
3 Author's interview with Julie Hudson, London, 30 January 2020.
4 *Illustrated London News*, 16 October 1897.
5 *Manchester Courier*, 25 September 1897.
6 *The Times*, 25 September 1897.
7 *The Times*, 20 August 1897.
8 *Illustrated London News*, 7 August 1897.
9 *The Times*, 13 August 1897.
10 Igbafe, *Benin Under British Administration*, p. 71.
11 National Archives 83 / 1610 Moor to FO 9 June 1898.
12 *The Times*, 25 September 1897.
13 *Manchester Courier*, 25 September 1897.
14 *Illustrated London News*, 16 October 1897.
15 *The Times*, 25 September 1897.
16 *Manchester Courier*, 25 September 1897.
17 *Illustrated London News*, 10 April 1897.
18 Coombes, *Reinventing Africa*, p. 150.
19 *The Times*, 1 July 1897.
20 Wilson, *The British Museum: A History*, p. 161.
21 Ibid., p. 200.
22 Kendrick, 'In the 1920s'.
23 Tonnochy, 'Four Keepers of the Department of British and Medieval Antiquities', Braunholtz, 'History of Ethnography in the Museum 1753–1938 (part II)', and *The Times*, 7 February 1945, Dalton obituary.
24 *The Apologia Diffidentis* (1908), *Sirenica* (1913) and *Domus Doloris* (1919) by 'W. Compton Leith'.
25 Coombes, *Reinventing Africa*, p. 4, and British Museum, 'Charles Hercules Read: A Tribute on His Retirement'.
26 Hiller, *The Myth of Primitivism*, p. 185, and see also Coombes, 'Blinded by "Science"' in Pointon (ed.), *Art Apart*.
27 British Museum Guidebook quoted in Lundén, 'Displaying Loot', p. 267.
28 Ibid.
29 Coombes, 'Blinded by "Science"' in Pointon (ed.), *Art Apart*, p. 109.
30 Record of the Meeting of 9 November 1898, *Journal of the Anthropological Institute*, vol. 27, 1898.
31 Shrubsall, 'Crania of African Bush Races'.
32 Roth, *Great Benin*, p. 233.
33 *The Times*, 25 September 1897.

34 Record of the Meeting of 9 November 1898, *Journal of the Anthropological Institute*, vol. 27, 1898.

35 Ormonde, 'Booty from Benin'.

36 Read and Dalton, *Antiquities from the City of Benin and from Other Parts of West Africa in the British Museum*, Preface.

37 Dalton, 'Booty from Benin'.

38 Read and Ormonde, 'Works of Art from Benin City'.

39 Ibid.

40 Forbes, 'On a Collection of Cast-Metal Work of High Artistic Value from Benin, Lately Acquired for the Mayer Museum'.

41 Ormonde, 'Booty from Benin'.

42 Coombes, *Reinventing Africa*, p. 27.

43 Allman, 'With the Punitive Expedition to Benin City'.

44 *Lagos Weekly Record*, 20 March 1897.

45 Ibid., 6 March 1897.

46 Ibid., 20 March 1897.

47 Roth, *Great Benin*, p. 223.

48 Coombes, *Reinventing Africa*, p. 45.

49 Roth, *Great Benin*, p. 232.

50 Ibid., p. 234.

51 Fagg, B., Introduction to Pitt Rivers, *Antique Works of Art from Benin*.

52 Bernard Fagg, in his introduction to Pitt Rivers' work on his own collection of Benin Bronzes, says it contained some 240 pieces. Hermione Waterfield, in her chapter in Waterfield and King, *Provenance*, estimates Pitt Rivers's collection of Benin Bronzes to number 420 pieces.

53 Roth, *Great Benin*, Appendix IV, On the British Loss of Antique Works of Art from Benin, p. xix.

54 Bernard Fagg quoting H. Ling Roth in his Introduction to Pitt Rivers, *Antique Works of Art from Benin*.

55 Coombes, *Reinventing Africa*, p. 46.

56 Pitt Rivers, *Antique Works of Art from Benin*, Foreword.

57 *The Times*, 28 July 1899.

58 Penny, *Objects of Culture*, p. 1.

59 Coombes, 'Blinded by "Science"'in Pointon (ed.), *Art Apart*, pp. 102–19.

60 Penny, *Objects of Culture*, p. 1.

61 Dalton's 1898 'Report on Ethnographical Museums in Germany' (HMSO 1898) quoted in Coombes, *Reinventing Africa*, p. 60.

62 Ibid., p. 59.

63 Ibid., p. 60.

64 Record of the Meeting of 9 November 1898, *Journal of the Anthropological Institute*, vol. 27, 1898.

65 Wilson, *The British Museum: A History*, p. 225.
66 Penny, *Objects of Culture*, p. 1.
67 A British Museum list of Benin Objects from the 1970s, compiled by McLeod in AOA/Benin/BM collections. Ling Roth collection at AOA/Collection File: Af1897,1217.1-6. Currency conversion from https://www.measuringworth.com
68 Roth, *Great Benin*, Appendix IV, On the British Loss of Antique Works of Art from Benin, p. xviii.
69 Eisenhofer, 'Felix von Luschan and Early German-Language Benin Studies'.
70 Ibid.
71 Penny, *Objects of Culture*, p. 75.
72 Eisenhofer, 'Felix von Luschan and Early German-Language Benin Studies'.
73 Luschan quoted in Lundén, 'Displaying Loot', p. 328.
74 *The Times*, 22 May 1899.
75 Three of the four cannons were subsequently given to the Royal Armoury. See Smith, R., 'Sir Ralph Moor and the "Benin" Cannon in the British Museum and the Royal Armouries'.
76 Letter from C. G. Seligman to H. Vischer, 16 July 1935, from National Archives (CO 583/204/21) in which he says he bought all of Moor's ivories from 'Old Sparks' for £50, in Peraldi, 'Oba Akenzua II's Restitution Requests'. Fee paid by British Museum in AOA/Benin/BM collections.
77 Read, 'Note on Certain Ivory Carvings from Benin'.
78 Luschan quoted in Lundén, 'Displaying Loot', p. 329.
79 For more on Luschan's complex ideas, see Smith, 'W.E.B. Du Bois, Felix von Luschan, and Racial Reform at the Fin de Siècle'.
80 Luschan quoted in Lundén, 'Displaying Loot', p. 330.

11. Strange harvests come home to King Street

1 Allingham, *Romance of the Rostrum*, p. 13.
2 Ibid., pp. 38–9.
3 Ibid., p. 281.
4 Ibid., p. 63.
5 Ibid., p. 176.
6 Ibid., p. 206.
7 Ibid., p. 78.
8 Ibid., p. 51.
9 Ibid., frontispiece.
10 *The Times*, 20 May 1897.
11 'Lt-General Augustus Henry Lane Fox Pitt Rivers', in Waterfield and King, *Provenance*, p. 45.
12 *The Times*, 20 August 1897.

13 1898 Stevens' catalogue cited in Allingham, *Romance of the Rostrum*, pp. 193–5.
14 Ibid.
15 Allingham, *Romance of the Rostrum*, p. 194.
16 Ibid., p. 196.
17 Webster biographical details all from 'W.D. Webster' in Waterfield and King, *Provenance*.
18 Lundén, 'Displaying Loot', p. 164.
19 Webster photo on cover of Waterfield and King, *Provenance*.
20 Penny, *Objects of Culture*, p. 78.
21 Plankensteiner, *Benin Kings and Rituals*, p. 34, and Dark, *An Illustrated Catalogue of Benin Art*, pp. xxi–xxiii.
22 Plankensteiner, *Benin Kings and Rituals*, p. 31.
23 Luschan and Webster letters in Penny, *Objects of Culture*, p. 77–8.
24 Ibid.
25 'W.D. Webster' in Waterfield and King, *Provenance*, p.62.
26 UK Currency Converter for wage and horse comparisons http://www.nationalarchives.gov.uk/currency-converter/ and https://www.measuringworth.com
27 Duchâteau, *Benin: Royal Art of Africa from the Museum für Völkerkunde*, p. 105.
28 Plankensteiner, *Benin Kings and Rituals*, p. 34.
29 Duchâteau, *Benin: Royal Art of Africa from the Museum für Völkerkunde*, p. 112.
30 Kingdon, *Ethnographic Collecting and African Agency in Early Colonial West Africa*, p. 30.
31 Read, 'Note on Certain Ivory Carvings from Benin'.
32 Penny, *Objects of Culture*, p. 79.
33 Author's telephone interview with Marjorie Caygill, 1 May 2020.
34 See essays by John Picton and Hermione Waterfield in 'William Fagg Tribute Edition'. Photo of Fagg in this edition.
35 Fagg, W., Foreword to Programme, 'Ancient Benin' Exhibition at Berkeley Galleries, December 1947–January 1948.
36 Fagg, W., *Nigerian Images*, pp. 19–20.
37 This paragraph based on Heymer, 'The Art of Benin in German-Speaking Countries' in Plankensteiner (ed.), *Benin Kings and Rituals*.
38 Hiller, *The Myth of Primitivism*, p. 12.
39 Lundén, 'Displaying Loot', p. 369.
40 'Les Arts du Bénin', *Le Monde Colonial Illustré*, CVIII, pp. 150–52.
41 Richardson, *A Life of Picasso*, p. 64. Apollinaire's bronze bird came from the Kingdom of Dahomey, in today's Republic of Benin.
42 Lundén, 'Displaying Loot', p. 369.
43 *The Times*, 12 March 1954, and for 1954 exchange rates see https://www.measuringworth.com/datasets/exchangeglobal/

44 Tythacott, 'The African Collection at Liverpool Museum', fn. 1, p. 93.

45 Personal communication between author and Hilary Spurling, 12 October 2019.

46 Lundén, 'Displaying Loot', p. 370.

47 Dark, *An Introduction to Benin Art and Technology*, p. 16.

48 Quotes from Einstein taken from Heymer, 'The Art of Benin in German-Speaking Countries' in Plankensteiner (ed.), *Benin Kings and Rituals*, p. 250.

49 Eisenhofer, 'Felix von Luschan and Early German-Language Benin Studies'.

50 Ibid.

51 Fagg, W., *Nigerian Images*, p. 34, and see also Fagg's Foreword to Programme, 'Ancient Benin' Exhibition at Berkeley Galleries, December 1947–January 1948.

52 Picton, 'William Fagg Tribute Edition'.

53 Fagg, W., *Nigerian Images*, p. 32.

54 For discussion around the chronology of the Benin Bronze heads see Willett, Tornsey and Ritchie, 'Comparison and Style: An Examination of the Benin "Bronze" Heads', and Junge, 'Age Determination of Commemorative Heads: The Example of the Berlin Collection' in Plankensteiner (ed.), *Benin Kings and Rituals*.

55 Fagg, W., Foreword to Programme, 'Ancient Benin' Exhibition at Berkeley Galleries, December 1947–January 1948.

56 Usuanlele, 'Jacob Uwadiae Egharevba: a Pioneer Indigenous Voice' in Plankensteiner (ed.), *Benin Kings and Rituals*, p. 227.

57 Author's correspondence with Dr Uyilawa Usuanlele, 6 June 2020.

58 Introduction to 1936 edition of Egharevba, *A Short History of Benin* quoted in Usuanlele, 'Jacob Uwadiae Egharevba: a Pioneer Indigenous Voice' in Plankensteiner (ed.), *Benin Kings and Rituals*, p. 230.

59 Eisenhofer, 'The Benin Kinglist/s: Some Questions of Chronology'.

60 See, for example, Willett, Tornsey and Ritchie, 'Comparison and Style: An Examination of the Benin "Bronze" Heads', and Junge, 'Age Determination of Commemorative Heads: The Example of the Berlin Collection' in Plankensteiner (ed.), *Benin Kings and Rituals*.

61 Nevadomsky, 'Art and Science in Benin Bronzes', and Nevadomsky, Půtová and Soukop, 'Benin Art and Casting Technologies'.

62 Barley, *The Art of Benin*, p. 28.

63 Junge, 'Age Determination of Commemorative Heads: The Example of the Berlin Collection' in Plankensteiner (ed.), *Benin Kings and Rituals*, p. 185.

64 Ben-Amos, *The Art of Benin*, p. 26.

65 William Fagg (1982) quoted in Picton, 'William Fagg Tribute Edition'.

66 Wonu Veys, *Provenance Volume 2, The Benin Collections at the National Museum of World Cultures*, p. 40.

67 Webster biographical details all from 'W.D. Webster' in Waterfield and King, *Provenance*.

68 Ibid., p. 59.
69 W.D. Webster' in Waterfield and King, *Provenance*. Corrected information on Webster marriage and burial in email from Waterfield to author, 5 November 2021. Also *DeceasedOnline.Com*. Author visited the cemetery on a whim 22 November 2021.
70 *The Times*, 18 April 1923.
71 Ibid., 4 January 1928.
72 Ibid., 25 September 1882, Boisragon obituary.
73 Boisragon, *The Benin Massacre*, p. 163.
74 *The Times*, 27 September 1897.
75 Home, *City of Blood Revisited*, p. 99, and Bickers, *Empire Made Me*, p. 68.
76 https://probatesearch.service.gov.uk/Calendar#calendar
77 *The Times*, 19 December 1956.
78 Ibid., 8 March 1897.
79 Ibid., 16 October 1933.
80 Home, *City of Blood Revisited*, p. 99.
81 http://www.hambo.org/lancing/view_man.php?id=277
82 *The Times*, 4 January 1928.
83 https://rammcollections.org.uk/object/202-1915/
84 *The Times*, 16 October 1933, and *Daily Telegraph*, 17 October 1933.
85 https://www.horniman.ac.uk/collections/browse-our-collections/authority/agent/identifier/agent-3764
86 https://www.bbc.co.uk/news/world-africa-13751583
87 Dowden, 'Saving the Africa Centre', https://africanarguments.org/2011/06/13/saving-the-africa-centre-by-richard-dowden/

12. Like ripping pages out of our history

1 Dennett, *At the Back of the Black Man's Mind*, pp. 188–9.
2 Author's interview with Dr Ekhaguosa Aisien, Benin City, 9 March 2019.
3 Ibid.
4 Granville and Roth, 'Notes on the Jekris, Sobos and Ijos of the Warri District of the Niger Coast Protectorate'.
5 *Daily Mail*, 4 and 8 November 1897.
6 Ibid., 4 November 1897.
7 For information on the Oba in exile, I have relied on the invaluable *Oba Ovonramwen N'Ogbaisi in Calabar* (Achievers Global Resources).
8 Ibid., pp. 180–1 and Appendix 5, p. 234.
9 https://hansard.parliament.uk/Commons/1908-10-29/debates/1f4e263f-59ca-4a7b-a661-cd7d9b69d1f5/TheExiledKingOfBenin?highlight=benin#contribution-04be1346-bdcc-4be0-8ebf-dd9c032f1eaa

10 Achievers Global Resources, *Oba Ovonramwen N'Ogbaisi in Calabar*, Appendix 6, p. 235.

11 Home, *City of Blood Revisited*, p. 127.

12 Galway, 'Nigeria in the Nineties'.

13 Achievers Global Resources,*Oba Ovonramwen N'Ogbaisi in Calabar*, pp. 99, 133.

14 Ibid., p. 161.

15 Author's interview with Prince Gregory Akenzua, Benin City, 13 March 2019.

16 Egharevba, *A Short History of Benin*, Chronology, Appendix XI, p. 103.

17 Igbafe, *Benin Under British Administration*, p.338.

18 Ibid., p. 350.

19 Ibid., p. 353.

20 Ibid., p. 74.

21 Ibid., p. 347.

22 Ibid., p. 367.

23 Author's correspondence with Dr Uyilawa Usuanlele, 9 June 2020, and Ayandele, *Holy Johnson*, p. 267.

24 Ayandele, *Holy Johnson*, pp. 199, 349.

25 Ibid., p. 268.

26 Author's interview with Dr Ekhaguosa Aisien, Benin City, 9 March 2019.

27 Igbafe, *Benin Under British Administration*, p. 241.

28 Egharevba, *A Short History of Benin*, p. 79.

29 Author's interview with Patrick Oronsaye, Benin City, 10 March 2019.

30 Egharevba, *A Short History of Benin*, p. 63.

31 Kaplan, 'Remembering Solomon Osagie Alonge' in Staples, Kaplan and Freyer, *Fragile Legacies*, p. 44.

32 http://peacenzemeke.com.ng/british-vs-owa-war-1906the-greatest-war-and-resistance-by-an-ika-kingdom-against-the-colonialist/

33 *The Times*, 15 June 1906.

34 https://hansard.parliament.uk/Commons/1906-11-05/debates/545ab4c0-7370-4300-900d-b2cc16bb47b1/TheAttackOnMrCreweRead

35 Osadolor, 'The Benin Royalist Movement and Its Political Opponents: Controversy over Restoration of the Monarchy, 1897–1914'.

36 Achievers Global Resources,*Oba Ovonramwen N'Ogbaisi in Calabar*, p. 166.

37 Ibid., p. 193.

38 Ibid., p. 199.

39 Igbafe, *Benin Under British Administration*, p. 145.

40 All taken from Rumann, 'Funeral Ceremonies for the Late Ex-Oba of Benin'.

41 Kaplan, 'Remembering Solomon Osagie Alonge' in Staples, Kaplan and Freyer, *Fragile Legacies*, p. 45.

42 Rumann, 'Funeral Ceremonies for the Late Ex-Oba of Benin'.

43 Igbafe, *Benin Under British Administration*, pp. 146–7.

44 Nevadomsky, 'Contemporary Art and Artists in Benin City'.
45 Kaplan, 'Remembering Solomon Osagie Alonge' in Staples, Kaplan and Freyer, *Fragile Legacies*, and Egharevba, *A Short History of Benin*, p. 80.
46 Boulton, 'Bronze Artists of West Africa. The Natives of Benin and Ife – Their Beliefs, Customs and Art Forms'.
47 Tong, *Figures in Ebony*, p. 36.
48 Kaplan, 'Remembering Solomon Osagie Alonge' in Staples, Kaplan and Freyer, *Fragile Legacies*, p. 45.
49 *Manchester Guardian* and *The Times*, 12 August 1950.
50 Boulton, 'Bronze Artists of West Africa. The Natives of Benin and Ife – Their Beliefs, Customs and Art Forms'.
51 Tong, *Figures in Ebony*, p. 1.
52 Ibid., p. 7.
53 Ibid., pp. 94, 90.
54 Ibid., p. 28.
55 Ibid., p. 53.
56 Ibid., p. 35.
57 Ibid., p. 32.
58 Ibid., p. 34.
59 Ibid., p. 75.
60 Ibid., p. 103.
61 Author's interview with Patrick Oronsaye, Benin City, 10 March 2019.
62 Ryder, *Benin and the Europeans 1485–1897*, p. 314.
63 History of elephant hunting in Edo culture from author's interview with Patrick Oronsaye, Benin City, 10 March 2019.
64 Roth, *Great Benin*, p. 144.
65 Ryder, *Benin and the Europeans 1485–1897*, pp. 133, 142.
66 Feinberg and Johnson, 'The West African Ivory Trade During the Eighteenth Century'.
67 Ibid.
68 Author's conversations with leading Nigerian conservationists and the IUCN 2016 African elephant status report, which says Nigeria may have fewer than 100 elephants, https://portals.iucn.org/library/sites/library/files/documents/SSC-OP-060_A.pdf
69 Roth, *Great Benin*, p. 193.
70 Park, *Travels in the Interior of Africa*, p. 247.
71 Ibid., p. 251.
72 Ibid.
73 https://news.mongabay.com/2019/10/expansion-of-a-famous-elephant-park-holds-out-hope-for-africas-big-tuskers/?fbclid=IwAR2RvM7ZHyrBWL5uaM8c2n16lhai1abm4ASGedngqz0d1KjzLAAgGv2WeB0

74 Alpers, 'The Ivory Trade in Africa, An Historical Overview', in Ross (ed.), *Elephant: The Animal and its Ivory in African Culture*, p. 356.

75 Ibid.

76 Somerville, *Ivory*, p. 54.

77 Roth, *Great Benin*, p. 193.

78 Blackmun, 'The Elephant and Its Ivory in Benin', in Ross (ed.), *Elephant: The Animal and its Ivory in African Culture*, p. 183, n. 24.

79 Haywood, 'Nigeria Preservation of Wild Life'.

80 In October 2019, an injured baby elephant strayed from Okomu Forest into the surrounding palm oil plantation. It was rescued by National Park staff, but died soon afterwards. Its mother may have already been killed by poachers.

81 Author's visit to Okomu National Park, 11–12 March 2019.

13. Family secrets

1 Author's interview with Peter Karpinski, London, 7 February 2019, and Probate Search for Mr John Swainson, died 21 March 1897.

2 Author's interview with Peter Karpinski, London, 7 February 2019, and telephone conversation, 4 February 2020.

3 Ibid., and Karpinski, 'A Benin Bronze Horseman at the Merseyside County Museum'.

4 *Liverpool Daily Post*, 21 January 1897, quoted in Christie's Catalogue, 'Important Tribal Art', 13 June 1978.

5 *Liverpool Graphic*, 20 February 1897.

6 Boisragon, *The Benin Massacre*, p. 65.

7 *Daily Mail*, 4 November 1897.

8 Ibid.

9 Boisragon, *The Benin Massacre*, p. 65.

10 *Manchester Guardian*, 15 January 1897.

11 Boisragon, *The Benin Massacre*, p. 151.

12 *Lagos Standard*, 31 March 1897, cited in Karpinski, 'A Benin Bronze Horseman at the Merseyside County Museum'. https://probatesearch.service.gov.uk/ to confirm date of Swainson's death.

13 *The Times*, 13 April 1978. For impending and then cancelled sale of horseman, see *The Times*, 8 June 1978, and *New York Times*, 9 June 1978.

14 Christie's Catalogue, 'Important Tribal Art', 13 June 1978.

15 *The Guardian*, 7 June 1978.

16 Author's telephone interview with Hermione Waterfield, 30 June 2020.

17 Author's interview with Hermione Waterfield, London, 24 May 2019.

18 Author's interview with Peter Karpinski, London, 7 February 2019.

19 Ibid.

20 https://probatesearch.service.gov.uk/ to confirm date of Florence Swainson's death.

21 https://www.lansdowneclub.com/about-the-club/

22 Author's interview with Lance Entwistle, London, 9 July 2019.

23 https://www.entwistlegallery.com/about

24 Not her real name.

25 Programme, 'Primitive Art' Exhibition at Berkeley Galleries, June–July 1945.

26 *The Times*, 3 January 1947, and Programme, 'Primitive Art' Exhibition at Berkeley Galleries, December 1946–January 1947.

27 *The Times*, 29 December 1947.

28 Fagg, W., Foreword to Programme, 'Ancient Benin' Exhibition at Berkeley Galleries, December 1947–January 1948.

29 Biographical details on William and Ernest Ohly from conversations with relatives, and also Waterfield, 'William Ohly' in Waterfield and King, *Provenance*.

30 Information on the 2011 and 2013 Ernest Ohly sales from https://www.antiquestradegazette.com/news/2013/ohly-pieces-underline-burgeoning-interest-in-tribal-art/

31 Author's interview with Lance Entwistle, London, 9 July 2019, and with Will Hobbs, by telephone, 20 January 2020.

32 Author's interview with Julie Hudson, London, 30 January 2020. The British Museum brought the piece up from the storeroom for me to see. British Museum collection no. Af1949,04.1.

33 Author's interview with Hermione Waterfield, London, 24 May 2019.

34 Author's telephone interview with Dale Idiens, 30 July 2020.

35 Idiens, 'New Benin Discoveries in Scotland', and https://www.nms.ac.uk/explore-our-collections/collection-search-results/?item_id=390114 and https://www.nms.ac.uk/explore-our-collections/collection-search-results/?item_id=390115

36 *East Lancashire Regimental Journal*, March 1936.

37 Letter from Brass Medical Officer James Irvine, 24 January 1898, kindly shared with author by Elwood Taylor.

38 Aldrick, *Northrup*, p. 101.

39 Ibid., p158, and letters between Roosevelt and McMillan kindly shared with author by Elwood Taylor.

40 Author's conversation and emails with Judy Aldrick, biographer of Northrup Williams, 3 July 2020. Further biographical details for Ringer taken from the amazing website http://www.europeansineastafrica.co.uk/ and The Times, 21 September 1912, obituary. Drowning details from *Falmouth Packet*, 20 September 1912.

41 Aldrick, *Northrup*, p. 223. Details of 1919 loan and 1925 acquisition by McLean Museum, and friend who was a local shipbuilder, from email correspondence with Assistant Curator Vincent Gillen, 9 July 2020.

42 *The Times*, 8 December 1953.

43 For example, *The Times*, 21 May 1964 and 13 July 1965.

44 *The Times*, 19 March and 26 June 1968.

45 https://collections.mfa.org/objects/558344

46 *The Times*, 27 March 1973.

47 Allingham, *Romance of the Rostrum*, pp. 199–200.

48 Waterfield, 'Augustus Henry Lane Fox Pitt Rivers' in Waterfield and King, *Provenance*, p. 50.

49 Author's interview with Hermione Waterfield, London, 24 May 2019.

50 William Fagg quoted in Cole, 'A Crisis in Connoisseurship'.

51 Author's interview with Hermione Waterfield, London, 24 May 2019, and with John Picton, London, 29 May 2019.

52 Cole, 'A Crisis in Connoisseurship'.

53 Blackmun, 'A Note on Benin's Recent Antiquities'.

54 Author's interview with Hermione Waterfield, London, London, 24 May 2019, and Nevadomsky, Půtová and Soukop, 'Benin Art and Casting Technologies'.

55 Blackmun, 'A Note on Benin's Recent Antiquities'.

56 Dark and Fagg quoted in Bodenstein, 'Notes for a Long-Term Approach to the Price History of Brass and Ivory Objects Taken from the Kingdom of Benin in 1897', in Savoy, Guichard and Howald, *Acquiring Cultures*, p. 286.

57 *The Times*, 20 November 1986.

58 Ibid., 5 July 1989.

59 http://www.sothebys.com/en/auctions/ecatalogue/2007/african-oceanic-and-pre-columbian-art-n08320/lot.121.html

60 Author's interview with Frieda Leithman, London, 25 June 2019.

61 Ernest Ohly catalogue shown to author by his family.

62 https://www.measuringworth.com

63 Not his real name.

64 Article sent to author by Leithman family.

65 Plankensteiner, 'The Benin Treasures' in Hauser-Schäublin and Prott (eds.), *Cultural Property and Contested Ownership*, fn. 4, p. 477.

66 Galway, 'West Africa Fifty Years Ago'.

67 Galway, 'Benin City'.

68 Galway, Marie Carola, *The Past Revisited*, p. 205.

69 Galway, 'West Africa Fifty Years Ago'.

70 *The Times*, 20 June 1949.

71 Letters from Jacob Epstein (27 January 1956) and Sydney Burney (5 May 1950) to Lady Galway and Galway family kindly given to author by Kathy Curnow. *Financial Times*, 20 December 2010, https://www.ft.com/content/28b807fe-0bd6-11e0-a313-00144feabdc0

72 FCO 65/1927, FCO internal document, 1 June 1977, quoting British Museum's Malcolm McLeod.

73 https://www.independent.co.uk/arts-entertainment/art/news/sothebys-cancels-sale-of-looted-benin-mask-2171125.html

74 Ibid.

75 https://www.christies.com/en/auction/art-africain-oceanien-et-precolombien-19194/. Details on Sotheby's and Christie's competition, and sale being directly on behalf of Dimsey family, in email to author from Hermione Waterfield, 29 May 2021.

76 http://www.bbc.co.uk/worldservice/africa/2010/12/101229_beninmask.shtml

77 Author's telephone interview with Jean Fritts, 2 June 2020.

78 Author's interview with owner of Benin Bronzes, 12 November 2019. I have made small alterations to biographical details to protect her anonymity.

14. Toochly-Poochly

1 Author's interview with Mark Walker, Caernarfon, 6 November 2017.

2 Letter from Bernard Fagg of Jos Museum to Josephine Walker, 3 September 1957.

3 Author's interview with Steve Dunstone, Essex, 20 January 2019.

4 Reception Programme, 'Two Looted Benin Bronzes Return Home', Benin City, 20 June 2014.

5 https://www.vanguardngr.com/2014/06/benin-monarch-ncmm-disagree-reception-returning-antiquities/

6 Author's interview with Lance Oduwa Imasuen, Lagos, 16 March 2019.

7 Rotimi, *Ovonramwen Nogbaisi*, p. 19.

8 Ibid., p. 31.

9 *Invasion 1897* is available on Netflix.

10 Author's interview with Julie Hudson, London, 1 October 2019.

11 Author's interview with member of the audience, September 2019.

12 Author's interview with Mark Walker, Caernarfon, 10 July 2019.

13 Captain Herbert Walker Diary of Benin Expedition, 18, 20 and 15 February 1897, shared with author by family.

14 Ibid., 6 March 1897.

15 Promoted to Major, Benin Honours, *The Times*, 26 May 1897.

16 Details of Herbert Walker's career from *Daily Telegraph*, 14 April 1932, another printed obituary provided by his family and https://www.bayanne.info/Shetland/getperson.php?personID=I183001&tree=ID1

17 More biographical details from Mark Walker. For the first motor car in Worcestershire, https://www.westernregional.co.uk/beat-goes-history-policing-worcestershire/

18 Captain Herbert Walker Diary of Benin Expedition, 20 February 1897, shared with author by family.

19 Ibid., 14 and 15 March 1897.

20 Fagg, W., 'The Allman Collection of Benin Antiquities'.

21 For example, Foster's Auction Catalogues, National Art Library, V&A Museum, OCLC Numbers 1030452822 (Neville collection), 1030469343, 1030488006, 1030464667.

22 Foster's Auction Catalogues, 'Fine Benin Bronzes. The Property of an Officer who was in the Benin Expedition', 16 July 1931, National Art Library, V&A Museum, OCLC Number 1030454878.

23 *The Times*, 13 July 1931.

24 https://www.measuringworth.com/calculators/ukcompare/

25 Author's interview with Julie Hudson, London, 30 January 2020, and chapter on Harry Beasley in Waterfield and King, *Provenance*.

26 Author's Skype interview with Felicity Bodenstein, 17 February 2020, and http://www.quaibranly.fr/en/explore-collections/base/Work/action/show/notice/823438-afrique---nigeria-benin-plaque-en-bronze-du-xvie-siecle/page/1/ and http://www.quaibranly.fr/fr/explorer-les-collections/base/Work/action/show/notice/215380-plaque-figurative/page/1/

27 Prices of sales taken from *The Times*, 18 July 1931.

28 Author's interview with Mark Walker's cousin, 6 September 2019.

29 Author's WhatsApp correspondence with Godfrey Ekhator in Benin City, 31 January 2020.

30 This description is based on surviving photographs and an inspection of the near-identical flute man in the British Museum collection, brought up from the storeroom at my request. British Museum collection no. Af1949, 46.156.

31 'Les Arts du Bénin', *Le Monde Colonial Illustré*, CVIII, pp. 150–52, and Bodenstein, 'Notes for a Long-Term Approach to the Price History of Brass and Ivory Objects Taken from the Kingdom of Benin in 1897' in Savoy, Guichard and Howald (eds.), *Acquiring Cultures*, p. 278.

32 *The Times*, 9 July 1974.

33 Ibid., and Bodenstein, 'Notes for a Long-Term Approach to the Price History of Brass and Ivory Objects Taken from the Kingdom of Benin in 1897' Savoy, Guichard and Howald (eds.), *Acquiring Cultures*, p. 279.

34 Author's interview with Hermione Waterfield, London, 24 May 2019.

35 Bodenstein, 'Notes for a Long-Term Approach to the Price History of Brass and Ivory Objects Taken from the Kingdom of Benin in 1897' Savoy, Guichard and Howald (eds.), *Acquiring Cultures*, p. 279.

36 Author's interview with Lance Entwistle, London, 9 July 2019.

15. All done for the sake of Nigeria

1 Letters from Kenneth Murray to his sister Elisabeth, February–April 1971, West Sussex Record Office, Acc 09601, Box 37.

2 Letter from Kenneth Murray to his mother Kate, 16 December 1949, West Sussex Record Office, Acc 09601, Box 35.

3 Account of Kenneth Murray's death taken from Willett in 'Kenneth Murray Through the Eyes of his Friends'. Willett says that the accident was on 21 April, whereas the *Times* 26 April obituary says it occurred on 22 April. I have plumped for the latter as it is the date mentioned by a friend of Murray's, J. D. Clark, in the same edition of *African Arts*.

4 https://artfield.com.ng/kenneth-crossthwaite-murray-second-nigerian-art-teacher-africanist-and-preserver-of-nigerias-antiquities/

5 Willett and Hunt Cooke in 'Kenneth Murray Through the Eyes of his Friends'.

6 Canoe quote from Vernon-Jackson in Willett (ed.), 'Kenneth Murray Through the Eyes of his Friends'. Funeral details from Frank Willett, J. D. Clark and Godfrey Allen in the same edition of *African Arts*.

7 Allen in 'Kenneth Murray Through the Eyes of his Friends'.

8 Author's interview with Sue Picton, London, 29 May 2019.

9 Murray, 'Draft and Notes for a History of the Nigerian Museum', kindly passed on by Staffan Lundén, who received it from Nikki Grout.

10 Hellman, 'The Grounds for Museological Experiments: Developing the Colonial Museum Project in British Nigeria'.

11 Murray, 'Art in Nigeria: The Need for a Museum'.

12 Hellman, 'The Grounds for Museological Experiments: Developing the Colonial Museum Project in British Nigeria', and on brother Donald's death see https://www.independent.co.uk/news/obituaries/obituary-elisabeth-murray-1146845.html

13 Murray, 'Art in Nigeria: The Need for a Museum', and author's telephone interview with Angela Rackham, 20 June 2019.

14 Murray, 'Art in Nigeria: The Need for a Museum'.

15 Hellman, 'The Grounds for Museological Experiments: Developing the Colonial Museum Project in British Nigeria'.

16 Ibid.

17 Willett, 'The Benin Museum Collection', and *Nigeria Magazine*, no. 32, 1949. Money calculation from https://www.measuringworth.com

18 *Nigeria Magazine*, no. 32, 1949.

19 Author's interview with John Picton, London, 29 May 2019.

20 Author's interview with Julie Hudson, London, 12 December 2019.

21 Author's telephone interview with Angela Rackham, 20 June 2019.

22 Author's telephone interview with John Picton (who was in possession of Murray's last letter), 13 February 2020.

23 *Nigeria Magazine*, no. 32, 1949.

24 Author's interview with Julie Hudson, London, 30 January 2020, in which she cited Lagos museum document 48.36.1-47.

25 See photos in Waterfield, 'William Ockelford Oldman' in Waterfield and King, *Provenance*.

26 The British Museum bought 815 items for £15,000 from Mrs Oldman, of which twenty-nine were from Benin, according to AOA/Benin/BM collections.

27 Fagg, W., 'Nigerian Antiquities in the Oldman Collection'.

28 Fagg, W., 'The Allman Collection of Benin Antiquities'.

29 Dr Allman biography at https://www.dnw.co.uk/auction-archive/special-collections/lot.php?specialcollection_id=112&lot_uid=134206, while https://probatesearch.service.gov.uk/#wills shows Dr Allman left his widow Constance an estate of £7,868 (roughly £433,000 today).

30 *The Times*, 28 November 1931, reports on one of the Foster's Allman sales, while the Foster's catalogue from January 1932 is in the National Art Library, V&A Museumm, OCLC Number: 1030464667.

31 *The Times*, 8 December 1953, while money value calculated at https://www.measuringworth.com

32 Letter from Kenneth Murray to his father Harold, 15 December 1953, West Sussex Record Office, Acc 09601, Box 36.

33 Fagg, W., 'The Allman Collection of Benin Antiquities'.

34 Ibid.

35 Hellman, 'The Grounds for Museological Experiments: Developing the Colonial Museum Project in British Nigeria'.

36 Bodenstein, 'Notes for a Long-Term Approach to the Price History of Brass and Ivory Objects' in Savoy, Guichard and Howald (eds.), *Acquiring Cultures*, p. 283.

37 Hellman, 'The Grounds for Museological Experiments: Developing the Colonial Museum Project in British Nigeria'.

38 *The Times*, 27 April 1954.

39 Bodenstein, 'Notes for a Long-Term Approach to the Price History of Brass and Ivory Objects' in Savoy, Guichard and Howald (eds.), *Acquiring Cultures*, pp. 282–3.

40 Lundén, 'Displaying Loot', p. 438, and British Museum AOA/Benin/Plaques: de-accessions.

41 Lundén, 'Displaying Loot', p. 437.

42 Author's telephone interview with Amanda Hellman, 3 July 2019, and letters from Kenneth Murray to his father Harold, March–April 1954, West Sussex Record Office, Acc 09601, Box 36.

43 Fagg, W., 'The Seligman Ivory Mask from Benin: The Royal Anthropological Institute Christmas Card for 1957'.

44 Letter from Kenneth Murray to Bernard Fagg, 6 August 1948, from National Museum Lagos archives, kindly shared with author by Felicity Bodenstein.

45 Letter from Kenneth Murray to his father Harold, 21 March 1954, West Sussex Record Office, Acc 09601, Box 36.

46 Quoted in Bodenstein, 'Cinq masques de l'Iyoba Idia du royaume de Bénin: vies sociales et trajectoires d'un objet multiple'.

47 Fagg, W., 'The Seligman Ivory Mask from Benin: The Royal Anthropological Institute Christmas Card for 1957'.

48 Smith, M., 'The Seligman Mask and the R.A.I.'.

49 Murray writes to Rockefeller and the Royal Anthropological Institute is 'astounded' by this, in RAI archives, Appeals A154, Correspondence 1947 onwards. Robert Goldwater to Marian Smith, 27 January 1958, and Smith to Goldwater, 3 February 1958. https://www.therai.org.uk/archives-and-manuscripts/archive-contents?start=20

50 Bodenstein, 'Notes for a Long-Term Approach to the Price History of Brass and Ivory Objects' in Savoy, Guichard and Howald (eds.), *Acquiring Cultures*, p. 284.

51 British Museum Press Release, 18 April 2002, in AOA/Benin/Kenneth Murray.

52 Murray, 'Our Art Treasures' in *Preserving the Past*, p. 15.

53 Fagg. W., 'Benin: The Sack that Never Was' in Kaplan (ed.), *Images of Power*, pp. 20–21.

54 Hellman, 'The Grounds for Museological Experiments: Developing the Colonial Museum Project in British Nigeria'.

55 Letter from Kenneth Murray to his father Harold, 27 April 1954, West Sussex Record Office, Acc 09601, Box 36.

56 Author's telephone interview with Tim Chappel, 8 June 2019.

57 Leith-Ross in 'Kenneth Murray Through the Eyes of his Friends'.

58 Murray, 'Art in Nigeria: The Need for a Museum'.

59 Leith-Ross, *Stepping Stones*, p. 153.

60 Murray, 'Draft and Notes for a History of the Nigerian Museum', kindly passed on by Staffan Lundén who received it from Nikki Grout.

61 Hopwood and Godwin, *A Photographer's Odyssey*, p. 210.

62 Letters from Kenneth Murray to his sister Elisabeth, September–October 1960, West Sussex Record Office, Acc 09601, Box 37.

63 Clark in 'Kenneth Murray Through the Eyes of his Friends'.

64 Murray, 'Draft and Notes for a History of the Nigerian Museum', kindly passed on by Staffan Lundén, who received it from Nikki Grout.

65 Letter from Kenneth Murray to his sister Elisabeth, 6 October 1960, West Sussex Record Office, Acc 09601, Box 37.

66 Eyo in Povey, Willett, Picton and Eyo, 'Bernard Fagg: 1915–1987'.

67 https://www.esquire.com/uk/culture/a27283913/still-becoming-at-home-in-lagos-with-chimamanda-ngozi-adichie/

68 I have visited the National Museum in Lagos many times between 1998 and 2019. My most recent visit, described here, was on 16 March 2019.

69 Author's interview with John Picton, London, 29 May 2019.

70 Author's telephone interview with Anna Craven, 11 June 2019.

71 Author's telephone interview with Angela Rackham, 20 June 2019.

72 Author's Skype interview with Etim Eyo, 12 June 2019.

73 Author's interview with Helen Kerri, London, 24 June 2019.

74 *The Times*, 17 June 1980.

75 'Matchet's Diary' in *West Africa* Magazine, 23 June 1980.

76 Eyo, 'Repatriation of Cultural Heritage: The African Experience' in Kaplan (ed.), *Museums and the Making of 'Ourselves'*, p. 338.

77 Author's interview with Helen Kerri, London, 24 June 2019.

78 A European museum internal document shared with author, and further correspondence between a curator and author.

79 For more on this extraordinary saga, see author's June 2021 article in Apollo: https://www.apollo-magazine.com/benin-bronzes-metropolitan-museum-barnaby-phillips/.

80 The intervention of NCMM confirmed in telephone interview, 7 July 2020, with Yusuf Abdallah, Director General of NCMM 2009–17.

81 Author's interview with art expert, 2 June 2020.

82 Eyo, 'Repatriation of Cultural Heritage: The African Experience' in Kaplan (ed.), *Museums and the Making of 'Ourselves'*, p. 342, Obayemi and Pemberton, 'The Recovery of a Benin Bronze Head', and author's telephone interview with Angela Rackham, 20 June 2019.

83 http://archives.icom.museum/redlist/afrique/english/page03.htm and http://www.ipsnews.net/1996/08/nigeria-culture-at-wits-end-to-save-reminders-of-a-glorious-past/

84 http://archives.icom.museum/redlist/afrique/english/page02.htm

85 http://content.time.com/time/world/article/0,8599,2056125,00.html and Willett, 'Restitution or Re-circulation: Benin, Ife and Nok'.

86 Willett, 'Restitution or Re-circulation: Benin, Ife and Nok'.

87 http://archives.icom.museum/redlist/afrique/english/page02.htm

88 Ojedokun, 'Trafficking in Nigerian Cultural Antiquities: A Criminological Perspective'.

89 http://www.ipsnews.net/1996/08/nigeria-culture-at-wits-end-to-save-reminders-of-a-glorious-past/

90 https://www.bostonglobe.com/lifestyle/style/2014/06/26/museum-fine-arts-returns-artifacts-nigeria/z2RenPtuhh9qyPoSi05fRO/story.html and https://chasingaphrodite.com/tag/galerie-walu/.

91 https://www.jfklibrary.org/asset-viewer/archives/JFKSG/JFKSG-MO-1963-2295/JFKSG-MO-1963-2295

92 Museum tried to resist Balewa, and colourful details of how the tusk was transported, in email to the author from John Godwin and Gillian Hopwood, 27 March 2021.

93 Author's telephone interview with Angela Rackham, 20 June 2019.

94 This anecdote recounted by John Picton 'verbatim' as told to him by the late Ekpo Eyo, author's interview with John Picton, London, 29 May 2019.

95 National Archives 65/1797, Internal FCO 10/11/76.

96 Author's interview with Helen Kerri, London, 24 June 2019.

97 *The Times*, 18 February 2005, *Art Newspaper* no.155, February 2005, and http://news.bbc.co.uk/1/hi/entertainment/2260924.stm

98 https://www.rct.uk/collection/search#/1/collection/72544/bronze-head

99 Willett, 'Restitution or Re-circulation: Benin, Ife and Nok'.

100 John Picton's note at the end of Willett, 'Restitution or Re-circulation: Benin, Ife and Nok'.

101 Author's interview with Helen Kerri, London, 24 June 2019.

102 https://guardian.ng/news/with-300-items-on-display-47000-in-store-national-museum-lagos-begs-for-attention/

103 https://guardian.ng/news/with-300-items-on-display-47000-in-store-national-museum-lagos-begs-for-attention/ and https://punchng.com/how-47000-artefacts-are-wasting-away-in-ageing-national-museum/

104 Author's telephone interview with leading Lagos artist and arts administrator, 5 June 2019.

105 Bonham's website profile of Giles Peppiatt, https://www.bonhams.com/specialist/2497/

106 Author's interview with Giles Peppiatt, London, 2 December 2019.

107 Author's interview with Helen Kerri, London, 24 June 2019.

108 https://punchng.com/how-47000-artefacts-are-wasting-away-in-ageing-national-museum/

109 I've spoken to four people who've visited the National Museum's storeroom in recent years, including two leading museum curators who saw it during a twelve-month period between 2018 and 2019.

110 These numbers compiled by adding up entries in Dark, *An Illustrated Catalogue of Benin Art*.

111 This paragraph based on interviews with a senior official in the NCMM, and three Europe-based curators in close contact with the NCMM.

112 Plankensteiner, 'The Benin Treasures' in Hauser-Schäublin and Prott (eds.), *Cultural Property and Contested Ownership*, p. 445.

113 Author's interview with Helen Kerri, London, 24 June 2019.

16. Please, sir, when will Britain give back the Benin Bronzes?

1 Author's interview with Joseph Alufa, Benin City, 13 March 2019.
2 FCO 65/1797, 'Nigerian Comment on Britain's Refusal to Return Benin Mask', 1 November 1976.
3 Whiteman, *Lagos*, p. 172.
4 TV interview with Erhabor Emokpae, believed to be from 1970s, tweeted by *ASIRI Magazine*, 15 September 2020.
5 Email to author by Isaac Emokpae (son of late Erhabor), 24 June 2020.
6 Wilson, *The British Museum: Purpose and Politics*, p. 113.
7 Author's interview with John Picton, London, 29 May 2019.
8 FCO 65/1797, British High Commission to FCO, selection of Lagos press cuttings, 1 November 1976.
9 Wilson, *The British Museum: Purpose and Politics*, p. 113.
10 Author's interview with Julie Hudson, London, 30 January 2020.
11 FCO 65/1927, British High Commission to FCO 6/7/77, and money valuation from https://www.measuringworth.com
12 Letter from David Owen to Lord Trevelyan, 6 October 1977, in British Museum AOA/Benin/FESTAC: Ivory Mask.
13 FCO 65/1797, British High Commission to FCO, selection of Lagos press cuttings, 1 and 15 November 1976.
14 https://artsandculture.google.com/exhibit/eddie-ugbomah-a-nigerian-pioneer-filmmaker-driven-by-value-pan-atlantic-university/qQKiZ1nUZRbPIA?hl=en
15 British Museum Trustees Minutes, 14 September 1974.
16 British Museum Trustees Minutes, 6 December 1975.
17 FCO 65/1927, British High Commission to FCO 17 August 1977.
18 *The Times*, Le Quesne obituary, 28 April 2004.
19 FCO 65/1797, British High Commission to FCO, 12 November 1976.
20 FCO 65/1797, FCO internal, 29 October 1976.
21 FCO 65/1797, FCO internal, 27 October 1976.
22 FCO letters to BM, 11 December 1974, 5 October 1976 and 19 October 1976 in British Museum AOA/Benin/FESTAC: Ivory Mask.
23 BM has 'the finest' in internal document from 12 July 1982, while suggestion that FCO buy Gallwey Mask in 25 May 1977 and 2 June 1977, British Museum AOA/Benin/FESTAC: Ivory Mask.
24 FCO 65/1797, FCO internal, 5 October 1976.
25 FCO 65/1797, FCO internal, 20 January 1976.
26 FCO 65/1797, FCO internal, 10 November 1976.
27 Author's telephone conversation with Malcolm McLeod, 30 June 2020.
28 FCO 65/1927, David Owen briefing notes, 24 May 1977.
29 Author's telephone conversation with Malcolm McLeod, 5 May 2020.

30 Malcolm McLeod to John Mack, 9 September 1992, in British Museum AOA/Benin/Festac: Ivory Mask.

31 Felix Idubor is mentioned in https://www.washingtonpost.com/archive/lifestyle/1977/02/11/the-controversial-mask-of-benin/f6845f66-ffbd-40e5-8bc4-b7a551bdb8d0/. Erhabor Emokpae is another artist credited with making the replica mask, https://en.wikipedia.org/wiki/Erhabor_Emokpae. His son Isaac told me Erhabor designed the logo and selected the artists, but did not actually make the replica. Five artists being commissioned from Bodenstein, 'Cinq masques de l'Iyoba Idia du royaume de Bénin: vies sociales et trajectoires d'un objet multiple'.

32 Gerald Creasey, writing from Downing Street, 11 July 1935, quoted in Peraldi, 'Oba Akenzua II's Restitution Requests'.

33 Peraldi, 'Oba Akenzua II's Restitution Requests'.

34 Plankensteiner, 'The Benin Treasures' in Hauser-Schäublin and Prott (eds.), *Cultural Property and Contested Ownership*. Egharevba says this took place in 1938, and Osula says it was in 1939.

35 Kaplan, 'Nigerian Museums: Envisaging Culture as National Identity'in Kaplan (ed.), *Museums and the Making of 'Ourselves'*, p. 55.

36 Egharevba, *Brief Autobiography*, p. 43.

37 Willett, 'The Benin Museum Collection'.

38 Fagg, W., 'A Bronze Figure in Ife Style At Benin Museum'.

39 Willett, 'The Benin Museum Collection'.

40 Eyo, 'Repatriation of Cultural Heritage: The African Experience' in Kaplan (ed.), *Museums and the Making of 'Ourselves'*, p. 337.

41 Egharevba, *Brief Autobiography*, p. 63.

42 Eyo, 'Nigeria: Return and Restitution of Cultural Property'.

43 Eyo, 'Repatriation of Cultural Heritage: The African Experience' in Kaplan (ed.), *Museums and the Making of 'Ourselves'*, p. 337.

44 Osula, *My Impressions of Great Britain*, pp. 12, 33.

45 Ibid., pp13–14, 22–3.

46 BBC, *The Tribal Eye – Kingdom of Bronze*.

47 Author's interview with Julie Hudson, London, 30 January 2020, in which she explained the most recent 'probably historic' acquisition was 1986, fragment of cross-wearing figure, from a Dr Hood.

48 Quote from wall display in the Bishopsgate Institute, 230 Bishopsgate, London, EC2.

49 https://www.theguardian.com/news/2000/apr/10/guardianobituaries.obituaries?INTCMP=SRCH

50 Bernie Grant Archive, Bishopsgate BG/ARM/4/7.

51 Bernie Grant Archive, Bishopsgate BG/ARM/4/3, and letter from museum security, 11 July 1994, in British Museum AOA/Benin/100th Anniversary.

52 Bernie Grant Archive, Bishopsgate BG/ARM/4/4.
53 Nevadomsky, 'The Benin Centenary'.
54 The Oba's and High Commissioner's centenary speeches are in *African Arts*, vol. XXX, no. 3, Summer 1997.
55 Letter from John Mack to Dr Robert Anderson, 21 February 1996, in British Museum AOA/Benin/100th Anniversary.
56 *Herald*, 25 January 1997, https://www.heraldscotland.com/news/12083191.glasgow-museum-director-rejects-request-from-africa-for-return-of-looted-artefacts-battle-royal-for-benin-relics/
57 Bernie Grant Archive, Bishopsgate BG/ARM/4/1 to 11.
58 Bernie Grant's Repossession Notice, 15 March 1997, in British Museum AOA/Benin/100th Anniversary. Duty Officer's recollections passed on to author by Marjorie Caygill.
59 Bernie Grant Archive, Bishopsgate BG/ARM/4/10.
60 Letters exchanged 13 and 24 February 1997 and 13 March 1997 in British Museum AOA/Benin/100th Anniversary.
61 Author's interview with John Picton, London, 29 May 2019.
62 https://publications.parliament.uk/pa/cm199900/cmselect/cmcumeds/371/371ap27.htm
63 Willett, 'Restitution or Re-circulation: Benin, Ife and Nok'.
64 Author's interview with Theophilus Umogbai and visit to museum, Benin City, 12 March 2019.
65 https://www.bbc.co.uk/news/uk-england-cambridgeshire-39126667
66 https://www.liverpoolecho.co.uk/whats-on/whats-on-news/world-museum-plans-blitz-online-10844411 and author's telephone interview with Zachary Kingdon, 8 April 2020.
67 Dark, *An Illustrated Catalogue of Benin Art*, and Roth, *Great Benin*, Figure 268, p. 230. The disfigured leopard can be seen in its former glory in Roth, *Great Benin*, Figure 258, p. 222.
68 Author's conversation and subsequent emails with Marjorie Caygill of the British Museum, 30 April 2020.
69 Wilson, *The British Museum: A History*, pp. 249–51. (Wilson erroneously locates Drayton House in Nottinghamshire.) Aldwych detail from Marjorie Caygill.
70 Eisenhofer, 'Felix von Luschan and Early German-Language Benin Studies'.
71 Lundén, 'Displaying Loot', p. 171.
72 Author's interviews with Patrick Oronsaye, 10 March 2019, and Ivie Uwa-Igbinoba, 13 March 2019, both in Benin City.
73 Author's interview with Ekhaguosa Aisien, Benin City, 9 March 2019.
74 Author's interview with Frank Irabor, Benin City, 13 March 2019.

17. A lot of history we just never heard about

1 Kaplan, 'Article 172 Rooster' in Plankensteiner (ed.), *Benin Kings and Ritual*, p. 398.
2 Ezra, *Royal Art of Benin*, p. 85.
3 Jesus College Annual Report, 1905, p. 27.
4 *The Times*, 30 November 1929.
5 Fry, *Bankers in West Africa*, p. 15.
6 Ibid., p. 17.
7 Captain Herbert Walker Diary of Benin Expedition, 1 March 1897, shared with author by family.
8 *Lagos Weekly Record*, 20 March 1897.
9 *The Times*, 4 July 1908.
10 A picture of Neville's Weybridge fireplace can be seen on Bruno Claessens's blog, http://brunoclaessens.com/2014/09/benin-treasures-on-a-pre-1930-interior-photo/#.XkrPz5P7Rn6
11 *The Times*, 30 November 1929.
12 *The Times*, 7 April 1930.
13 *The Times*, 2 May 1930, and money conversions taken from https://www.measuringworth.com
14 Bodenstein, 'Notes for a Long-Term Approach to the Price History of Brass and Ivory Objects Taken from the Kingdom of Benin in 1897' in Savoy, Guichard and Howald (eds.), *Acquiring Cultures*, p. 283.
15 Fry, *Bankers in West Africa*, p. 15.
16 *Lagos Weekly Record*, 7 April 1897.
17 Fry, *Bankers in West Africa*, p. 16.
18 George Neville interviewed in *Lagos Weekly Record*, 20 March 1897.
19 Documents on the Nana/Neville friendship belonging to Voyager Press were sold on Ebay. https://www.ebay.ie/itm/1891-1929-G-W-Neville-LAGOS-COLONY-FIRST-NIGERIA-BANK-Chief-Olomu-Letters-/391972427549
20 Fry, *Bankers in West Africa*, p. 17.
21 Ibid.
22 Author's Skype interview with Ọrẹ Ogunbiyi, 19 July 2018, and interview with Amatey Doku, London, 6 February 2020.
23 Author's interview with Amatey Doku, London, 6 February 2020.
24 https://www.theguardian.com/education/2016/jan/28/cecil-rhodes-statue-will-not-be-removed--oxford-university
25 *Daily Telegraph* Letters, 15 March 2016.
26 Author's interview with Francis Bown, Claridge's, 22 October 2019.
27 Renfrew, *Loot, Legitimacy and Ownership*.
28 Author's telephone interview with Professor Colin Renfrew, 5 January 2020.

29 Email sent to Jesus College alumni, 27 November 2019, forwarded to author.

30 Author's interview with Amatey Doku, 6 February 2020.

31 Orẹ Ogunbiyi on Twitter, 27 November 2019.

32 Figures supplied to author by Professor Nicholas Thomas, Cambridge, 5 April 2019.

33 Description of Cambridge Museum of Archaeology and Anthropology based on visit, 5 April 2019.

34 Author's interview with Professor Nicholas Thomas, Cambridge, 5 June 2019.

35 Author's telephone interview with Professor Nicholas Thomas, 21 February 2020.

36 Oba Erediauwa, Preface to Plankensteiner (ed.), *Benin Kings and Ritual*, p. 13.

37 Dr Usman's appeal in Carol Vogel, 'Nigeria Wants Museum of Fine Arts, Boston to Return Trove of Benin Artifacts', ArtsBeat, *New York Times* blog, 23 July 2012.

38 https://www.mfa.org/news/benin-kingdom

39 Shyllon, 'Imperial Rule of Law Trumping the Return of Benin Bronzes and Parthenon Sculptures and the Failure of the Dialogue for the Return of Benin Bronzes'.

40 Plankensteiner, 'The Benin Treasures' in Hauser-Schaublin and Prott (eds.), *Cultural Property and Contested Ownership*, p. 464.

41 Author's telephone interview with key member of Benin Dialogue Group, January 2020.

42 Author's Skype interview with Professor Folarin Shyllon, 28 July 2020.

43 Author's interview with Governor Godwin Obaseki, Benin City, 10 March 2019.

44 Author's interview with Professor Nicholas Thomas, Cambridge, 5 April 2019.

45 https://www.varsity.co.uk/news/12683

46 Author's telephone interview with Barbara Plankensteiner of Benin Dialogue Group, 6 January 2020.

47 Author's interview with Julie Hudson, London, 31 October 2019.

48 Author's interview with Theophilus Umogbai, Benin City, 12 March 2019.

49 For the Benin Dialogue Group Statement at the end of the Leiden meeting, see https://www.volkenkunde.nl/en/about-volkenkunde/press/statement-benin-dialogue-group-0

18. How do you think your ancestors got these?

1 *Black Panther* earnings from 'Museums, Restitution and Colonial-Era Artefacts: Law, Ethics and France's Sarr-Savoy Report', a lecture at the V&A Museum by Alexander Herman, Institute of Art and Law, 3 July 2019.

2 This scene can be watched on YouTube, https://www.youtube.com/watch?v=pfBWPhsiN_w

3 Author's interview with Dr Sam Nixon, London, 31 October 2019.

4 Author's interviews with British Museum staff who requested anonymity.

5 Author's telephone interview with Professor John Mack, 13 May 2020.

6 https://www.nytimes.com/2017/11/29/arts/emmanuel-macron-africa. html?auth=login-email&login=email

7 The Sarr-Savoy Report, 'The Restitution of African Cultural Heritage', p. 12, http://restitutionreport2018.com/sarr_savoy_en.pdf

8 Ibid., p. 3.

9 Ibid., p. 61.

10 https://www.theartnewspaper.com/news/french-senate-backs-bill-to-return-colonial-era-objects-to-benin-and-senegal

11 https://www.nytimes.com/2020/06/05/arts/design/emmanuel-kasarherou-quai-branly-museum.html

12 https://news.artnet.com/art-world/restitution-report-critics-1446934

13 https://www.theartnewspaper.com/news/germany-presents-code-of-conduct-on-handling-colonial-era-artefacts

14 'Perilous Gestures', a lecture at the V&A Museum by Henrietta Lidchi, 4 February 2020.

15 On the Namibia (Portuguese) Stone Cross, https://www.bbc.com/news/world-europe-48309694. On the twenty-five remains of Herero Genocide Victims, https://www.bbc.com/news/world-africa-45342586. On the sword to Senegal, https://www.bbc.com/news/world-africa-50458081. On the Norway– Easter Island (Chile) agreement, https://www.bbc.com/news/world-europe-47745112

16 On Manchester Museum to Australia, https://www.museum.manchester. ac.uk/about/repatriation/. On the National Army Museum to Ethiopia, https://www.reuters.com/article/us-ethiopia-britain/ethiopians-cheer-as-london-museum-returns-plundered-royal-hair-idUSKCN1R21CA

17 https://www.theartnewspaper.com/news/arts-council-england-wades-into-restitution-debate-with-pledge-to-publish-guidance

18 Author's telephone interview with Johanna Zetterstrom-Sharp of the Horniman Museum, 6 March 2020.

19 https://www.theartnewspaper.com/news/benin-prince-calls-on-bristol-museum-to-return-benin-bronze

20 https://www.theguardian.com/education/2019/nov/27/bronze-cockerel-to-be-returned-to-nigeria-by-cambridge-college

21 https://www.lrb.co.uk/blog/2019/july/on-resigning-from-the-british-museum-s-board-of-trustees

22 Author's interview with a British Museum Trustee, London, 18 December 2019.

23 'Uncomfortable Art Tour' with Alice Procter, at the British Museum, 9 August 2019.

24 Geoffrey Robertson in *New York Times*, https://www.nytimes.com/2019/11/22/arts/design/restitution-france-africa.html

25 Author's interview with a British Museum Trustee, London, 18 December 2019.

26 Martin Bailey, 'The British Museum Sold Benin Bronzes', *Art Newspaper*, Edition 13.124, and British Museum AOA/Benin/Plaques: de-accessions.

27 https://www.gov.uk/government/news/uk-government-renews-its-commitment-to-return-nazi-looted-art-to-rightful-owners

28 https://www.theguardian.com/culture/2019/apr/23/theyre-not-property-the-people-who-want-their-ancestors-back-from-british-museums

29 Author's interview with a British Museum Trustee, London, 18 December 2019.

30 Hitchens, *The Parthenon Marbles*, pp. 97–9.

31 Wilson, *The British Museum: Purpose and Politics*, p. 116.

32 https://www.theguardian.com/artanddesign/2004/jul/24/heritage.art

33 MacGregor, 'To Shape the Citizens of "That Great City, The World"', in Cuno (ed.), *Whose Culture?*, p. 39.

34 Author's telephone interview with Barbara Plankensteiner, 6 January 2020.

35 Author's interview with Professor Nicholas Thomas, Cambridge, 5 April 2019.

36 Author's conversation with UK Museum director, April 2019.

37 Author's interview with Julie Hudson, London, 31 October 2019.

38 Author's interview with a British Museum Trustee, London, 18 December 2019.

39 Okediji, 'On Reparations, Exodus and Embodiment'.

40 https://www.lrb.co.uk/blog/2019/july/on-resigning-from-the-british-museum-s-board-of-trustees

41 Author's interview with Julie Hudson, London, 30 January 2020.

42 Author's interview with Helen Kerri, London, 24 June 2019.

43 Author's telephone interview with key member of Benin Dialogue Group, January 2020.

44 Author's interview with Enotie Ogbebor, Benin City, 12 March 2019.

45 Author's interview with Governor Godwin Obaseki, Benin City, 10 March 2019.

46 A 'substantial number', Hartwig Fischer in *New York Times*, 22 November 2019, https://www.nytimes.com/2019/11/22/arts/design/restitution-france-africa.html

47 Author's interview with Julie Hudson, London, 31 October 2019.

48 Author's interview with Julie Hudson, London, 12 December 2019, and with John Randle Centre trustee and architect, London, 11 August 2021.

49 Author's telephone interview with Barbara Plankensteiner, 6 January 2020.

50 Author's Zoom interview with Phillip Ihenacho, 5 May 2020.

51 Author's Zoom interview with Sir David Adjaye, 23 April 2020.

52 See, for example, 'Haunted Museum' by Killian Fox in *1843* magazine, June/
 July 2020, published by *The Economist*.
53 Braunholtz, 'History of Ethnography in the Museum 1753–1938 (part II)'.
54 Author's Zoom interview with Sir David Adjaye, 23 April 2020.
55 https://blog.britishmuseum.org/a-message-from-director-hartwig-fischer/
 and online responses taken from Twitter and https://news.artnet.com/art-
 world/british-museum-black-lives-matter-1882296
56 'Museums, Restitution and Colonial-Era Artefacts: Law, Ethics and France's
 Sarr Savoy Report', a lecture at the V&A Museum by Alexander Herman,
 Institute of Art and Law, 3 July 2019.
57 Ahdaf Soueif quoted in https://www.nytimes.com/2020/08/27/arts/design/
 british-museum-reopening.html
58 Updated panels in the British Museum in the Sainsbury Gallery next to the
 Benin plaques, on public display from 27 August 2020.
59 Author's conversation with a British Museum curator, 28 August 2020.
60 Charles Moore in *The Spectator*, https://www.spectator.co.uk/article/in-
 defence-of-hans-sloane
61 Author's telephone interview with Bruno Claessens, 30 June 2020.
62 Author's telephone interview with Jean Fritts, 2 June 2020.
63 Author's interview with Lance Entwistle, London, 9 July 2019.
64 Author's interview with Giles Peppiatt, London, 2 December 2019.
65 Author's telephone interview with Professor Nicholas Thomas, 21 February
 2020.

19. We can make it win-win

1 Author's interview with Nosa Okundia, Benin City, 10 March 2019.
2 Author's Whatsapp conversation with Phil Omodamwen, 14 April 2020.
3 Author's interview with Enotie Ogbebor, Benin City, 12 March 2019.
4 Author's interview with Governor Godwin Obaseki, Benin City, 10 March
 2019.
5 Author's telephone interview with museum director, February 2020.
6 Author's Zoom interview with Phillip Ihenacho, 5 May 2020.
7 WhatsApp message from Enotie Ogbebor to author, 20 September 2020.
8 Author's telephone interview with Barbara Plankensteiner, 6 January 2020.
9 Author's interview with Helen Kerri, London, 24 June 2019.
10 Author's interview with Theophilus Umogbai, Benin City, 12 March 2019.
11 Author's Skype interview with Professor Folarin Shyllon, 28 July 2020.
12 https://www.theguardian.com/education/2019/nov/27/bronze-cockerel-to-
 be-returned-to-nigeria-by-cambridge-college
13 Author's interview with Victor Ehikhamenor, Lagos, 15 March 2019.

14 Author's Zoom interview with Sir David Adjaye, 23 April 2020.
15 Author's interview with Prince Gregory Akenzua, Benin City, 13 March 2019.

Afterword

1 Jesus College has put the ceremony of 27 October 2021 on its website https://www.jesus.cam.ac.uk/articles/jesus-college-returns-benin-bronze-world-first.
2 Author's telephone interview with Amatey Doku, 11 November 2021.
3 Francis Bown letter to *Daily Telegraph*, 18 October 2021.
4 Herman, *Restitution, The Return of Cultural Artefacts*, p. 16.
5 https://www.dw.com/en/france-returns-26-looted-artworks-to-benin/av-59770913
6 https://www.theguardian.com/world/2021/jul/07/belgium-unveils-plans-to-return-drc-artworks-stolen-during-colonial-rule and https://www.theartnewspaper.com/2021/03/10/forging-ahead-with-historic-restitution-plans-dutch-museums-will-launch-euro45m-project-to-develop-a-practical-guide-on-colonial-collections.
7 German museums have published a database of all their Benin Bronzes https://cp3c.org/benin-bronzes/
8 https://www.nytimes.com/2021/04/30/arts/design/benin-bronzes-germany.html.
9 Author's telephone interview with Professor Nicholas Thomas, 14 October 2021.
10 Author's telephone interview with Phillip Ihenacho, 9 November 2021.
11 Author's telephone interview with British Museum curator, 9 April 2021.
12 Nigeria's formal letter shown on Channel 4 News, 26 October 2021 https://www.channel4.com/news/nigeria-sends-formal-letter-to-british-museum-demanding-return-of-looted-benin-bronzes.
13 Off the record conversations with British Museum staff, April, October and November 2021
14 https://www.gov.uk/government/publications/letter-from-culture-secretary-on-hm-government-position-on-contested-heritage.
15 Author's telephone conversation with Horniman curator 7 October 2021.
16 Author's telephone interview with Professor Abba Tijani 21 October 2021.
17 https://www.gov.uk/government/publications/the-british-museum-annual-report-and-accounts-2020-to-2021, British Museum Reports and Accounts 2020–21, figures taken from p. 14.
18 *The Spectator*, Diary by George Osborne, 30 October 2021 edition.
19 Author's telephone interview with Ngaire Blankenberg, who was visiting Nigeria, on 3 November 2021, and subsequent emails.

20 Statement by His Royal Majesty Omo N'Oba N'Edo, Ewuare II, Oba of Benin on the Repatriation of the Looted Benin Artifacts, 9 July 2021.
21 https://legacyrestorationtrust.org/
22 https://blog.britishmuseum.org/major-new-archaeology-project-on-site-of-new-museum-in-benin/.
23 Author's telephone interview with historian in Benin City, 20 May 2021.
24 Several in-person and phone conversations with close relatives and advisor to the Oba, as well as LRT members, from May to October 2021.
25 Author's telephone interview with curator, 2 November 2021.
26 Author's telephone interview with museum director, 25 May 2021.
27 Author's telephone interview with Ngaire Blankenberg, 3 November 2021.
28 Author's telephone interview with German government official, 16 October 2021.
29 Benin Dialogue Group press release, 29 October 2021.
30 Author's telephone interview with Phillip Ihenacho, 9 November 2021.
31 Author's telephone interview with Victor Ehikhamenor, 12 July 2021.
32 Email from Neil Curtis of Aberdeen University Museum 16 November 2021.
33 Aberdeen University Press Release, 24 March 2021.

BIBLIOGRAPHY

Author's interviews

UK

Francis Bown, writer on travel and etiquette, alumnus of Jesus College, Cambridge

Marjorie Caygill, British Museum

Tim Chappel, Nigeria Department of Antiquities

Anna Craven, Nigeria Department of Antiquities

Neil Curtis, Aberdeen University

Amatey Doku, management consultant, alumnus of Jesus College, Cambridge

Steve Dunstone, policeman and adventurer

Lance Entwistle, art dealer

Jean Fritts, Sotheby's

Will Hobbs, Woolley & Wallis auction house

Julie Hudson, British Museum

Dale Idiens, National Museum of Scotland

Peter Karpinski, art writer

Helen Kerri, Nigeria National Commission for Museums and Monuments

Zachary Kingdon, National Museums Liverpool

'Freida Leithman', owner of Ohly Head

John Mack, British Museum

Malcolm McLeod, British Museum

Sam Nixon, British Museum

Ore Ogunbiyi, speechwriter, alumna of Jesus College, Cambridge

Giles Peppiatt, Bonhams

John Picton, Nigeria Department of Antiquities and British Museum

Sue Picton, Nigeria Department of Antiquities

Angela Rackham, Nigeria Department of Antiquities

Colin Renfrew, Cambridge University
Nicholas Thomas, Cambridge Museum of Archaeology and Anthropology
Mark Walker, medical doctor, sailor
Hermione Waterfield, Christie's
Johanna Zetterstrom-Sharp, Horniman Museum
Anonymous British Museum Trustee
Anonymous owner of Benin Bronzes

FRANCE

Felicity Bodenstein, Sorbonne
Bruno Claessens, Christie's

GERMANY

Barbara Plankensteiner, Hamburg Museum of Ethnology

USA

Ngaire Blankenberg, Smithsonian National Museum of African Art
Kathy Curnow, Cleveland State University
Etim Eyo, media consultant
Amanda Hellman, Emory University
Uyilawa Usuanlele, State University of New York

GHANA

David Adjaye, architect

KENYA

Phillip Ihenacho, entrepreneur

NIGERIA

Abuja

Abba Tijani, Nigeria National Commission for Museums and Monuments

Benin City

Ekhaguosa Aisien, historian and medical doctor
Prince Gregory Akenzua, medical doctor
Joseph Alufa, artist
Frank Irabor, secretary to the Oba

Aiko Obabaifo, historian
Godwin Obaseki, Governor
Enotie Ogbebor, artist
Nosa Okundia, activist
Phil Omodamwen, brass caster
Patrick Oronsaye, historian and artist
Theophilus Umogbai, Nigeria National Commission for Museums and
 Monuments
Ivie Uwa-Igbinoba, Nigeria National Council for Arts and Culture
Ugbine village elders
Ughoton village elders

Lagos

Femi Akinsanya, art collector
Victor Ehikhamenor (also interviewed in London), artist
Lancelot Oduwa Imasuen, film-maker
Anonymous arts administrator

Ibadan

Folarin Shyllon, Ibadan University

Unpublished sources

ARCHIVES

Bernie Grant Archive, Bishopsgate

BG/ARM/4/1 through to BG/ARM/4/11

British Museum

AOA/Benin/BM collections
AOA/Benin/FESTAC: Ivory Mask
AOA/Benin/Kenneth Murray
AOA/Benin/Plaques: de-accessions
AOA/Benin/100th Anniversary
Trustees Minutes, 14 September 1974
Trustees Minutes, 6 December 1975

Caird Library, National Maritime Museum, Greenwich

Anonymous account of sailor, presumably on board HMS *Philomel* under
command of Rear-Admiral F. G. Bedford, MSS 73/089
Letter from Rawson, Sunday 21/2/97 from 'Kings Palace, Benin City' to Sir
Frederick Richards, First Sea Lord, AGC/12/25
Newspapers March 1897 HSR/2/2
Papers of Commander Stokes Rees of HMS *St George*, STR 8, 9, 14

Imperial War Museum

Admiral Sir Vernon Harry Stuart Haggard Private Papers, 19510

National Archives

FCO 65/1797, Antiquities of Nigeria: refusal of British Museum to loan Benin
Ivory Mask
FCO 65/1927, Antiquities of Nigeria, including Benin Ivory Mask
FO 83/1610

National Museum Lagos

Kenneth Murray, 'Draft and Notes for a History of the Nigerian Museum'
Letter from Kenneth Murray to Bernard Fagg, 6 August 1948

Royal Anthropological Institute

Appeals A/154 Correspondence and papers 1958

West Sussex Record Office, Chichester

Kenneth Murray papers. Acc 09601, Boxes 35–37

OTHER UNPUBLISHED SOURCES

Diary of Captain Herbert Sutherland Walker
Letters from members of the 1897 Benin Expedition – Vice-Admiral Gilbert
Stephenson and Captain L. Llewellyn
Letter from Brass medical officer, 1898
Letter from James Callaghan, 1964
Letters from Jacob Epstein and Sydney Burney
Letter from Bernard Fagg, 1957
Letters between Teddy Roosevelt and William Northrup McMillan, 1911

Mary Lou Ratté, 'Imperial Looting and the Case of Benin', MA Thesis, 1972, University of Massachusetts Amherst

NEWSPAPERS/MAGAZINES/WEBSITES

African Arguments
Antiques Trade Gazette
Apollo
Art Newspaper
Artnet News
BBC News
Boston Globe
Chasing Aphrodite
Daily Mail
Daily Mirror
Daily Telegraph
Esquire
Falmouth Packet
Financial Times
[Lagos] *Guardian*
[Glasgow] *Herald*
Independent
IPS News
Lagos Weekly Record
Le Monde Colonial Illustré
Liverpool Echo
Liverpool Graphic
London Gazette
London Illustrated News
London Review of Books
Manchester Courier
Manchester Guardian, and *The Guardian*
Morning Post
New York Times
New York Tribune
Nigeria Magazine
Punch
Royal Gold Coast Gazette
The Spectator
The Times
Time
Trouw

Vanguard
Varsity
Washington Post
Western Mail

OTHER WEBSITES

Afromet (The Association for the Return of the Maqdala Ethiopian Treasures)
Artfield Nigeria
Australian Dictionary of Biography
Bonham's Auction Sales
Bruno Claessens art blog
Christie's
Deceasedonline.com
Europeans In East Africa
German Contact Point for Collections from Colonial Contexts
Gov.UK
Hansard
Horniman Museum
Imperial War Museum (Lives of the First World War, War Memorials Register)
International Council of Museums Red List
Jesus College, Cambridge
JFK Library
Lancing College War Memorial
Manchester Museum
Mongabay
Musée du Quai Branly–Jacques Chirac
Museum of Fine Arts, Boston
National Museum of Scotland
NavalHistory.Net
Pitt Rivers Museum
Probate Records
QueenVictoriasJournals.org
Royal Albert Memorial Museum, Exeter
Sotheby's
The Royal Collection Trust
UK Parliament

RADIO

BBC Radio 4, *A History of the World in 100 Objects*, no. 77 – Benin Plaque, the
Oba with Europeans, 21 September 2010

TV

BBC, *The Tribal Eye – Kingdom of Bronze*, presented by David Attenborough, 1975
Channel 4 News, 26 October 2021

FILMS

Black Panther, directed by Ryan Coogler (2018)
Invasion 1897, directed by Lancelot Oduwa Imasuen (2014), on Netflix

MISCELLANEOUS

Christie's catalogue for sale of 'Important Tribal Art', London, 13 June 1978
Edo State / Oba of Benin, 'Two Looted Benin Bronzes Return Home', Reception
 Programme 20 June 2014
Jesus College Cambridge Annual Report 1905
The Oba's Palace, Statement by His Royal Majesty, 9 July 2021
Uppingham School Magazine
V&A Lectures: 1) 'Museums, Restitution and Colonial-Era Artefacts: Law,
 Ethics and France's Sarr Savoy Report', Alexander Herman, 3 July 2019
V&A Lectures: 2) 'Perilous Gestures', Henrietta Lidchi, 4 February 2020
V&A Maqdala Exhibition, 2018–19

Published sources

Achievers Global Resources (President Simeon Owie), *Oba Ovonramwen N'Ogbaisi in Calabar: The Untold Story*, Benin City, Achievers Global Resources, 2007

Adams, John, *Remarks on the Country Extending from Cape Palmas to The River Congo*, originally printed by G. and W. Whittaker, reprinted Frank Cass and Co., 1966

Akenzua, Edun, 'Benin –1897, A Bini's View', *Nigeria Magazine*, no. 65, June 1960

Aisien, Ekhaguosa, *Aisien: Son of Erhunmwunsee and the British – the 1897 War*, Benin City, Aisien Publishers, 2013

Aldrick, Judy, *Northrup: The Life of William Northrup McMillan*, Kijabe, Old Africa Books, 2012

Allen, Charles, *Kipling Sahib: India and the Making of Rudyard Kipling*, London, Abacus, 2007

Allen, Godfrey, 'Kenneth Murray Through the Eyes of His Friends', ed. Frank Willett, *African Arts*, vol. 6, no.4, Summer 1973

Allingham, E. G., *A Romance of the Rostrum: being the business life of Henry Stevens, and the history of thirty-eight King street, together with some account of famous sales held there during the last hundred years*, London, Witherby, 1924

Allman, Robert, 'With the Punitive Expedition to Benin City', *Lancet*, 3 July 1897, vol. 150, issue 3853

Alpers, Edward, 'The Ivory Trade in Africa, An Historical Overview', in Doran H. Ross (ed.), *Elephant: The Animal and its Ivory in African Culture*, Los Angeles, UCLA, 1992

Astley, Thomas, *Astley's Voyages*, Vol. III, Book 2, *Voyages and Travels to Benin*, London, 1746

Ayandele, E. A., *Holy Johnson: Pioneer of African Nationalism, 1836–1917*, London, Frank Cass and Co., 1970

Bacon, Reginald, *Benin: The City of Blood*, London, Edward Arnold, 1897

—— *A Naval Scrap-Book 1877–1900*, London, Hutchinson and Co., 1925

—— *From 1900 Onward*, London, Hutchinson and Co., 1940

Baker, Richard, *The Terror of Tobermory: An Informal Biography of Vice-Admiral Sir Gilbert Stephenson*, London, W. H. Allen, 1972, reissued by Birlinn, 1999

Barley, Nigel, *The Art of Benin*, London, British Museum Press, 2010

Belloc, Hilaire, *The Modern Traveller*, London, Edward Arnold, 1898

Berkeley Galleries, 'Primitive Art', Programmes June–July 1945 and December 1946–January 1947

Bickers, Robert, *Empire Made Me: An Englishman Adrift in Shanghai*, London, Allen Lane, 2003

Blackmun, Barbara, 'The Elephant and Its Ivory in Benin', in Doran H. Ross (ed.), *Elephant: The Animal and its Ivory in African Culture*, Los Angeles, UCLA, 1992

——'A Note on Benin's Recent Antiquities', *African Arts*, vol. XXXVI, no. 1, Spring 2003

Blathwayt, Raymond, *Through Life and Round the World*, London, Allen & Unwin, 1917

Bodenstein, Felicity, 'Notes for a Long-Term Approach to the Price History of Brass and Ivory Objects Taken from the Kingdom of Benin in 1897', in Bénédicte Savoy, Charlotte Guichard and Christine Howald, *Acquiring Cultures: Histories of World Art on Western Markets*, Boston and Berlin, De Gruyter, 2018

—— 'Cinq masques de l'Iyoba Idia du royaume de Bénin: vies sociales et trajectoires d'un objet multiple', *Perspective*, 2019-2

Boisragon, Alan, *The Benin Massacre*, London, Methuen, 1897

Bondarenko, Dimitri, 'Benin and Slavery', in Toyin Falola and Amanda Warnock (eds.), *Encyclopedia of the Middle Passage*, Westport, Greenwood, 2007

Boulton, Laura, 'Bronze Artists of West Africa. The Natives of Benin and Ife – Their Beliefs, Customs and Art Forms', *Natural History*, vol. XXXVI, 1936

Bowden, Mark, *Pitt Rivers: The Life and Archaeological Work of Lieutenant-General Augustus Henry Lane Fox Pitt Rivers*, Cambridge, Cambridge University Press, 1991

Bradbury, Raymond, *The Benin Kingdom and the Edo-Speaking Peoples of South-Western Nigeria, Western Africa, Part XIII*, Ethnographic Survey of Africa, 1957, reissued by Routledge, 2017

Braunholtz, Hermann, 'History of Ethnography in the Museum 1753–1938 (part II)', *The British Museum Quarterly*, vol. XVIII, 1953

British Museum, *Charles Hercules Read: A Tribute on His Retirement*, London, British Museum, 1921

Brodie, Neil, 'Problematizing the Encyclopedic Museum: the Benin Bronzes and Ivories in Historical Context', in Bonnie Effros and Guolong Lai (eds.), *Unmasking Ideologies: The Vocabulary and Symbols of Colonial Archaeology*, Los Angeles, Cotsen Institute, 2018

Burton, Richard, 'My Wanderings in West Africa: A Visit to the Renowned Cities of Warri and Benin', *Fraser's Magazine for Town and Country*, vol. 67, February 1863 and March 1863

Callaghan, James, *Time and Chance*, London, Collins, 1987

Carden, Arthur, *Carden and the Dardanelles: The Papers of Admiral Sir Sackville Hamilton Carden*, Horsham, Lulu Enterprises, 2015

Clark, J. D., 'Kenneth Murray Through the Eyes of His Friends', ed. Frank Willett, *African Arts*, vol. 6, no.4, Summer 1973

Cole, Herbert, 'A Crisis in Connoisseurship', *African Arts*, vol. XXXVI, no. 1, Spring 2003

Connah, Graham, *African Civilizations: An Archaeological Perspective*, Cambridge, Cambridge University Press, 1987

Coombes, Annie, 'Blinded by "Science"' in Marcia Pointon (ed.), *Art Apart: Art Institutions and Ideology across England and North America*, Manchester, Manchester University Press, 1994

—— *Reinventing Africa: Museums, Material Culture and Popular Imagination in Late Victorian and Edwardian England*, New Haven, Yale University Press, 1994

Crowder, Michael, *The Story of Nigeria*, London, Faber and Faber, 1966

Cunliffe-Jones, Peter, *My Nigeria: Five Decades of Independence*, New York and Basingstoke, Palgrave Macmillan, 2010

Curnow, Kathy, 'The Art of Fasting: Benin's Ague Ceremony', *African Arts*, vol. 3, no. 4, Fall 1997

Curtin, Philip, 'The End of the "White Man's Grave"? Nineteenth-Century Mortality in West Africa', *The Journal of Interdisciplinary History*, vol. XXI, no. 1, Summer 1990

Dalton, Ormonde, 'Booty from Benin', *English Illustrated Magazine*, January 1898

Dark, Philip, *An Introduction to Benin Art and Technology*, Oxford, Clarendon Press, 1973

—— *An Illustrated Catalogue of Benin Art*, Boston, G. K. Hall, 1982

Darling, Patrick, *Archaeology and History in Southern Nigeria: The Ancient Linear Earthworks of Benin and Ishan*, Cambridge Monographs in African Archaeology 11, BAR International Series 215 (i), 1984

Dawson, Lionel, *The Sound of the Guns*, Oxford, Pen-In-Hand, 1949

Dennett, Richard, *At the Back of the Black Man's Mind*, n.p., Macmillan Thorp, 1906

Dickens, Charles, *Bleak House*, London, Penguin Books, 1994

Dodge Luhan, Mabel, *Intimate Memories: Vol. 2 European Experiences*, New York, Harcourt, Brace and Company, 1935

Douglas, A. C., *Niger Memories*, Exeter, J. Townsend, 1927

Dowden, Richard, 'Saving the Africa Centre', African Arguments, 13 June 2011

Duchâteau, Armand, *Benin: Royal Art of Africa from the Museum für Völkerkunde*, Vienna, Prestel, 1994

Egharevba, Jacob, *A Short History of Benin*, Lagos, CMS Bookshop, 1934, and 3rd edition, Ibadan, Ibadan University Press, 1960

—— *Brief Autobiography*, 1968, Nendeln, Kraus Reprint, 1973

Eisenhofer, Stefan, 'The Benin Kinglist/s: Some Questions of Chronology', *History in Africa*, 24, January 1997

—— 'Felix von Luschan and Early German-Language Benin Studies', *African Arts*, vol. XXX, no. 3, Summer 1997

Ekhator, Godfrey, Review of *Ewuare: The Oba of Benin* by Ekhaguosa Aisien, *Umawaen Journal of Benin and Edo Studies*, vol. 3, 2018

Erediauwa, Oba, Preface, in Barbara Plankensteiner (ed.), *Benin Kings and Rituals: Court Arts from Nigeria*, Ghent, Snoeck, 2007

Eyo, Ekpo, 'Nigeria: Return and Restitution of Cultural Property', *Museum International*, vol. 31, no. 1, 1979

—— 'Repatriation of Cultural Heritage: The African Experience', in Flora Kaplan (ed.), *Museums and the Making of 'Ourselves': The Role of Objects in National Identity*, London, Leicester University Press, 1994

Ezra, Kate, *Royal Art of Benin: The Perls Collection in the Metropolitan Museum of Art*, New York, Metropolitan Museum of Art, 1992

Fagg, Bernard, Introduction, in Augustus Pitt Rivers, *Antique Works of Art from Benin*, 1900, reissued by Dover Publications, 1976

Fagg, William, *Ancient Benin*, Berkeley Galleries, 1947

—— 'A Bronze Figure in Ife Style at Benin Museum', *MAN, A Monthly Record of Anthropological Science*, vol. L, article 98, June 1950

—— 'Nigerian Antiquities in the Oldman Collection', *The British Museum Quarterly*, vol. XVI(4), January 1952

—— 'A Nigerian Bronze Figure from the Benin Expedition', *MAN, A Monthly Record of Anthropological Science*, vol. LII, article 210, October 1952

—— 'The Allman Collection of Benin Antiquities', *MAN, A Monthly Record of Anthropological Science*, vol. LIII, article 261, November 1953

—— 'The Seligman Ivory Mask from Benin: The Royal Anthropological Institute Christmas Card for 1957', *MAN, A Monthly Record of Anthropological Science*, vol. LVII, article 143, August 1957

—— *Nigerian Images*, London, Lund Humphries, 1963

—— 'Benin: The Sack that Never Was' in Flora Kaplan (ed.), *Images of Power: Art of the Royal Court of Benin*, New York, New York University, 1981

Feinberg, Harvey and Johnson, Marion, 'The West African Ivory Trade During the Eighteenth Century', *International Journal of African Historical Studies*, vol. 15, no. 3, 1982

Forbes, Henry, 'On a Collection of Cast-Metal Work of High Artistic Value from Benin, Lately Acquired for the Mayer Museum', *Bulletin of the Liverpool Museums*, vol. 1, 1898

Foster's Auction Catalogues, 'Fine Benin Bronzes. The Property of an Officer who was in the Benin Expedition', 16 July 1931, OCLC Number 1030454878, National Art Library, V&A Museum. Also OCLC Numbers 1030452822 (Neville collection), 1030469343, 1030488006, 1030464667, National Art Library, V&A Museum

Fry, Richard, *Bankers in West Africa: The story of the Bank of British West Africa Limited*, London, Hutchinson Benham, 1976

Gallwey, Henry, 'Journeys in the Benin Country, West Africa', *The Geographical Journal*, vol. 1, no. 2, 1893

[Henry Gallwey changed his name to Galway in 1911]

Galway, Henry, 'Nigeria in the Nineties', *Journal of the Royal African Society*, vol. 29, no. 115, April 1930

—— 'Benin City', *East Lancashire Regimental Journal*, May 1936

—— 'West Africa Fifty Years Ago', *Journal of the Royal African Society*, vol. 41, no. 164, April 1942

Galway, Marie Carola, *The Past Revisited*, London, The Harvill Press, 1953

Girshick Ben-Amos, Paula, *The Art of Benin*, London, British Museum Press, 1995

Graham, James, 'The Slave Trade, Depopulation and Human Sacrifice in Benin History', *Cahiers d'Études Africaines*, vol. 5, no. 18, 1965

Granville, Reginald K., and Roth, Felix, 'Notes on the Jekris, Sobos and Ijos of the Warri District of the Niger Coast Protectorate,' *The Journal of the Anthropological Institute of Great Britain and Ireland*, vol. 28, no. 1/2, 1899

Green, Toby, *A Fistful of Shells: West Africa from the Rise of the Slave Trade to the Age of Revolution*, London, Allen Lane, 2019

Hakluyt, Richard, *Hakluyt's Collection of the Early Voyages, Travels and Discoveries of the English Nation*, London, R. H. Evans, 1801

Haywood, Austin, 'Nigeria Preservation of Wild Life', Society for the Preservation of the Fauna of the Empire, Part XVII, 1932

Hellman, Amanda, 'The Grounds for Museological Experiments: Developing the Colonial Museum Project in British Nigeria', *Journal of Curatorial Studies*, vol. 3, no. 1, 2014

Heneker, William, *Bush Warfare*, London, Hugh Rees, 1907

Herman, Alexander, 'Law, Restitution and the Benin Bronzes', *The Art Newspaper*, 21 December 2018

—— *Restitution, The Return of Cultural Artefacts*, London, Lund Humphries, 2021

Hernon, Ian, *Britain's Forgotten Wars: Colonial Campaigns of the 19th Century*, Stroud, Sutton Publishing, 2003

Heymer, Kay, 'The Art of Benin in German-Speaking Countries', in Barbara Plankensteiner (ed.), *Benin Kings and Rituals: Court Arts from Nigeria*, Ghent, Snoeck, 2007

Hiller, Susan (ed.), *The Myth of Primitivism: Perspectives on Art*, London, Routledge, 1991

Hitchens, Christopher, *The Parthenon Marbles: The Case for Reunification*, London, Verso, 2008

Hodgkin, Thomas (ed.), *Nigerian Perspectives: An Historical Anthology*, London, Oxford University Press, 1975

Home, Robert, *City of Blood Revisited: A New Look at the Benin Expedition of 1897*, London, Rex Collings, 1982

Hopwood, Gillian and Godwin, John, *A Photographer's Odyssey: Lagos Island 1954–2014*, Lagos, Prestige, 2015

Hunt Cooke, Arthur, 'Kenneth Murray Through the Eyes of His Friends', ed. Frank Willett, *African Arts*, vol. 6, no.4, Summer 1973

Husemann, Manuela, 'Golf in the City of Blood: the Translation of the Benin Bronzes in 19th Century Britain and Germany', *Polyvocia – The SOAS Journal of Graduate Research*, vol. 5, 2013

Idiens, Dale, 'New Benin Discoveries in Scotland', *African Arts*, vol. XIX, no.4, August 1986

Igbafe, Philip, 'The Fall of Benin: A Reassessment', *Journal of African History*, vol. 11, no. 3, 1970

—— *Benin Under British Administration: The Impact of Colonial Rule on an African Kingdom 1897–1938*, London, Longman, 1979

—— 'A History of the Benin Kingdom: An Overview', in Barbara Plankensteiner (ed.), *Benin Kings and Rituals: Court Arts from Nigeria*, Ghent, Snoeck, 2007

Ikime, Obaro, *Merchant Prince of the Niger Delta: The Rise and Fall of Nana Olomu, Last Governor of the Benin River*, London, Heinemann, 1968

International Union for the Conservation of Nature, African Elephant Status Report, 2016

Journal of the Anthropological Institute, vol. 27, 1898, Record of the Meeting of 9 November 1898

Junge, Peter, 'Age Determination of Commemorative Heads: The Example of the Berlin Collection' in Barbara Plankensteiner (ed.), *Benin Kings and Rituals: Court Arts from Nigeria*, Ghent, Snoeck, 2007

Kaplan, Flora, 'Nigerian Museums: Envisaging Culture as National Identity' in Flora Kaplan (ed.), *Museums and the Making of 'Ourselves': The Role of Objects in National Identity*, London, Leicester University Press, 1994

—— 'Article 172 Rooster' in Plankensteiner (ed.), *Benin Kings and Ritual: Court Arts from Nigeria*, Ghent, Snoeck, 2007

—— 'Remembering Solomon Osagie Alonge' in Amy Staples, Flora Kaplan and Bryna Freyer, *Fragile Legacies: The Photographs of Solomon Osagie Alonge*, Washington DC, National Museum of African Art, Smithsonian Institute, 2016

Karpinski, Peter, 'A Benin Bronze Horseman at the Merseyside County Museum', *African Arts*, vol. XVII, no.2, February 1984

Kendrick, Sir Thomas, 'In the 1920s', *The British Museum Quarterly*, vol. XXXV, 1971

Kingdon, Zachary, *Ethnographic Collecting and African Agency in Early Colonial West Africa: A Study of Trans-imperial Cultural Flows*, New York, Bloomsbury, 2019

Law, Robin, 'Human Sacrifice in Pre-colonial West Africa', *African Affairs*, vol. 84, no. 334, January 1985

Leith-Ross, Sylvia, 'Kenneth Murray Through the Eyes of His Friends', ed. Frank Willett, *African Arts*, vol. 6, no.4, Summer 1973

—— *Stepping Stones: Memoirs of Colonial Nigeria, 1907–1960*, London, Peter Owen, 1983

Lundén, Staffan, 'Displaying Loot. The Benin Objects and the British Museum', PhD Thesis, University of Gothenburg, 2016

MacGregor, Neil, 'To Shape the Citizens of "That Great City, The World"', in James Cuno (ed.), *Whose Culture? The Promise of Museums and the Debate over Antiquities*, Princeton, Princeton University Press, 2009

Morris, Jan, *Pax Britannica: Vol II, The Climax of an Empire*, London, Faber and Faber, 1968, reissued 2012

Murray, Kenneth, 'Art in Nigeria: The Need for a Museum', *Journal of the Royal African Society*, vol. 41, October 1942

—— 'Our Art Treasures', in *Preserving The Past – The Nigerian Museum And Its Art Treasures*, Federal Ministry of Information, Lagos, 1959

Nevadomsky, Joseph, 'The Benin Bronze Horseman as the Ata of Idah', *African Arts*, vol. 19, no. 4, August 1986

Nevadomsky, Joseph, 'The Benin Centenary', *African Arts*, vol. 30, no. 3, Summer 1997

—— 'Contemporary Art and Artists in Benin City', *African Arts*, vol. 30, no. 4, Fall 1997

—— 'Art and Science in Benin Bronzes', *African Arts*, vol. 37, no. 1, Spring 2004

Nevadomsky, Joseph, Půtová, Barbora and Soukup, Václav, 'Benin Art and Casting Technologies', *West Bohemian Historical Review*, 1/2014

Obayemi, Ade and Pemberton, John, 'The Recovery of a Benin Bronze Head', *African Arts*, vol. 24, no. 3, April 1991

Ogba, Mark, Review of *The Benin-Ife Controversy: Clash of Myths of Origins*, compiled and edited by Wajeed Obomeghie, *Umawaen Journal of Benin and Edo Studies*, vol. 1, 2016

Ojedokun, Usman, 'Trafficking in Nigerian Cultural Antiquities: A Criminological Perspective', *African Journal of Criminology and Justice Studies*, vol. 6, November 2012

Ojo, Olatunji, 'Slavery and Human Sacrifice in Yorubaland: Ondo 1870–94', *Journal of African History*, vol. 46, no. 3, 2005

Okediji, Moyo, 'On Reparations, Exodus and Embodiment', *African Arts*, vol. 31, no. 2, Spring 1998

Osadolor, Osarhieme Benson, 'The Benin Royalist Movement and Its Political Opponents: Controversy over Restoration of the Monarchy, 1897–1914,' *International Journal of African Historical Studies*, vol. 44, no. 1, 2011

Osula, Usman Lawal, *My Impressions of Great Britain*, Lagos, Nigerian National Press, 1966

Park, Mungo, *Travels in the Interior of Africa*, originally printed 1798, reprinted in *The Life and Travels of Mungo Park in Africa*, Edinburgh, William and Robert Chambers, 1877

Peek, Philip and Picton, John, 'The Resonances of Osun across a Millennium of Nigerian History', *African Arts*, vol. 49, no. 1, Spring 2016

Penny, H. Glenn, *Objects of Culture: Ethnology and Ethnographic Museums in Imperial Germany*, Chapel Hill, University of North Carolina Press, 2002

Peraldi, Audrey, 'Oba Akenzua II's Restitution Requests', *Kunst & Kontext*, January 2017

Picton, John, 'William Fagg Tribute Edition', *African Arts*, vol. 27, no. 3, July 1994
—— Note at end of 'Restitution or Re-circulation: Benin, Ife and Nok', Frank Willett, *Journal of Museum Ethnography*, no. 12, 2000

Pitt Rivers, Augustus, *Antique Works of Art from Benin*, privately published, 1900

Plankensteiner, Barbara (ed.), Introduction, in *Benin Kings and Rituals: Court Arts from Nigeria*, Ghent, Snoeck, 2007
—— 'The Benin Treasures', in Brigitta Hauser-Schäublin and Lyndel Prott (eds.), *Cultural Property and Contested Ownership: The Trafficking of Artefacts and the Quest for Restitution*, London, Routledge, 2016

Povey, John, Frank Willett, John Picton and Ekpo Eyo, 'Bernard Fagg: 1915–1987', *African Arts*, vol. 21, no. 2, February 1988

Rawson, Geoffrey, *Life of Admiral Sir Harry Rawson*, London, Edward Arnold, 1914

Read, Charles, 'Note on Certain Ivory Carvings from Benin', *MAN, A Monthly Record of Anthropological Science*, vol. X, no. 29, 1910

Read, Charles and Dalton, Ormonde, 'Works of Art from Benin City', Anthropological Institute of Great Britain, vol. 27, 1898
—— *Antiquities from the City of Benin and from Other Parts of West Africa in the British Museum*, London, British Museum, 1899

Renfrew, Colin, *Loot, Legitimacy and Ownership: The Ethical Crisis in Archaeology*, London, Duckworth, 2000

Richardson, John, *A Life of Picasso: Vol 2*, London, Jonathan Cape, 1997

Roth, Henry Ling, *Great Benin: Its Customs, Art and Horrors*, Halifax, F. King & Sons, 1903

Rotimi, Ola, *Ovonramwen Nogbaisi*, Benin City, Ethiope, 1974

Rowlands, Michael, 'The Good and Bad Death: Ritual Killing and Historical Transformation in a West African Kingdom', *Paideuma*, 39, 1993

Rumann, W. B., 'Funeral Ceremonies for the Late Ex-Oba of Benin', *Journal of the African Society*, vol. 14, no. 52, 1914

Ryder, Alan, *Benin and the Europeans 1485–1897*, Harlow, Longmans, Green and Co., 1969

Salubi, Adogbeji, 'The establishment of British administration in the Urhobo country (1891–1913)', *Journal of the Historical Society of Nigeria*, vol. 1, no. 3, 1958

Sarr, Felwine and Savoy, Bénédicte, *The Restitution of African Cultural Heritage. Towards a New Relational Ethics*, translated by Drew S. Burk, Paris, November 2018

Seppings Wright, Henry, *Soudan '96. The Adventures of a War Artist*, London, Horace Cox, 1897

Shrubsall, F., 'Crania of African Bush Races', *Journal of the Anthropological Institute*, vol. 27, 1898

Shyllon, Folarin, 'Imperial Rule of Law Trumping the Return of Benin Bronzes and Parthenon Sculptures and the Failure of the Dialogue for the Return of Benin Bronzes', Faculty of Law, University of Ibadan, 2016

Smith, John David, 'W.E.B. Du Bois, Felix Von Luschan, and Racial Reform at the Fin de Siècle', *Amerikastudien/American Studies*, vol. 47, no. 1, 2002

Smith, Marian, 'The Seligman Mask and the R.A.I.', *MAN, A Monthly Record of Anthropological Science*, vol. LVIII, June 1958

Smith, Ronald Bishop, 'Sir Ralph Moor and the "Benin" cannon of the British Museum and the Royal Armouries', *Journal of the Hong Kong Branch of the Royal Asiatic Society*, vol. 38, 1998

Snelgrave, William, *A New Account of Guinea and the Slave Trade*, London, W. J. Wren, 1754

Somerville, Keith, *Ivory: Power and Poaching in Africa*, London, Hurst & Co., 2016

Tong, Raymond, *Figures in Ebony: Past and Present in a West African City*, London, Cassell, 1958

Tonnochy, A. B., 'Four Keepers of the Department of British and Medieval Antiquities', *The British Museum Quarterly*, vol. XVIII, 1953

Tythacott, Louise, 'The African Collection at Liverpool Museum', *African Arts*, vol. 31, no. 3, Summer 1998

Usuanlele, Uyilawa, 'Jacob Uwadiae Egharevba: a Pioneer Indigenous Voice', in Barbara Plankensteiner (ed.), *Benin Kings and Rituals: Court Arts from Nigeria*, Ghent, Snoeck, 2007

Vernon-Jackson, H. O., 'Kenneth Murray Through the Eyes of His Friends', ed. Frank Willett, *African Arts*, vol. 6, no.4, Summer 1973

Waterfield, Hermione, 'William Fagg Tribute Edition', *African Arts*, vol. 27, no. 3, July 1994

Waterfield, Hermione and King, J. C. H., *Provenance: Twelve Collectors of Ethnographic Art in England 1760–1990*, London, Paul Holberton Publishing, 2009

Whiteman, Kaye, *Lagos: A Cultural and Literary History*, Oxford, Signal Books, 2012

Willett, Frank, 'The Benin Museum Collection', *African Arts*, vol. 6, no. 4, Summer 1973

—— 'Kenneth Murray Through the Eyes of His Friends', ed. Frank Willett, *African Arts*, vol. 6, no.4, Summer 1973

—— 'Restitution or Re-circulation: Benin, Ife and Nok', *Journal of Museum Ethnography*, no. 12, 2000

Willett, Frank, Tornsey, Ben and Ritchie, Mark, 'Comparison and Style: An Examination of the Benin "Bronze" Heads', *African Arts*, vol. 27, no. 3, July 1994

Wilson, David, *The British Museum: Purpose and Politics*, London, British Museum Publications, 1989

—— *The British Museum: A History*, London, British Museum Press, 2002

Wonu Veys, Fanny (ed.), *Provenance Vol 2, The Benin Collections at the National Museum of World Cultures*, Rotterdam, Nationaal Museum van Wereldculturen, 2021

Worden, Blair (ed.), *Hugh Trevor-Roper: The Historian*, London, I. B. Tauris, 2016

INDEX

References to images are in *italics*.

BARNABY PHILLIPS spent over twenty-five years as a
journalist. He was based for the BBC in Mozambique,
Angola, Nigeria and South Africa. He is the author of
Another Man's War: The Story of a Burma Boy in Britain's
Forgotten African Army, also published by Oneworld.
He grew up in Kenya and Switzerland and now lives
in London, where he works for an elephant conser-
vation organisation